NATIVE UNIVERSE

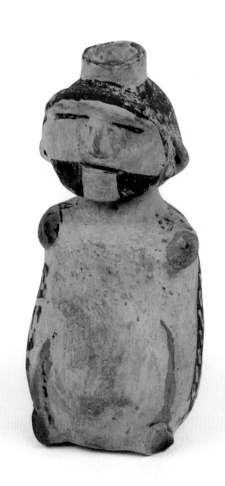

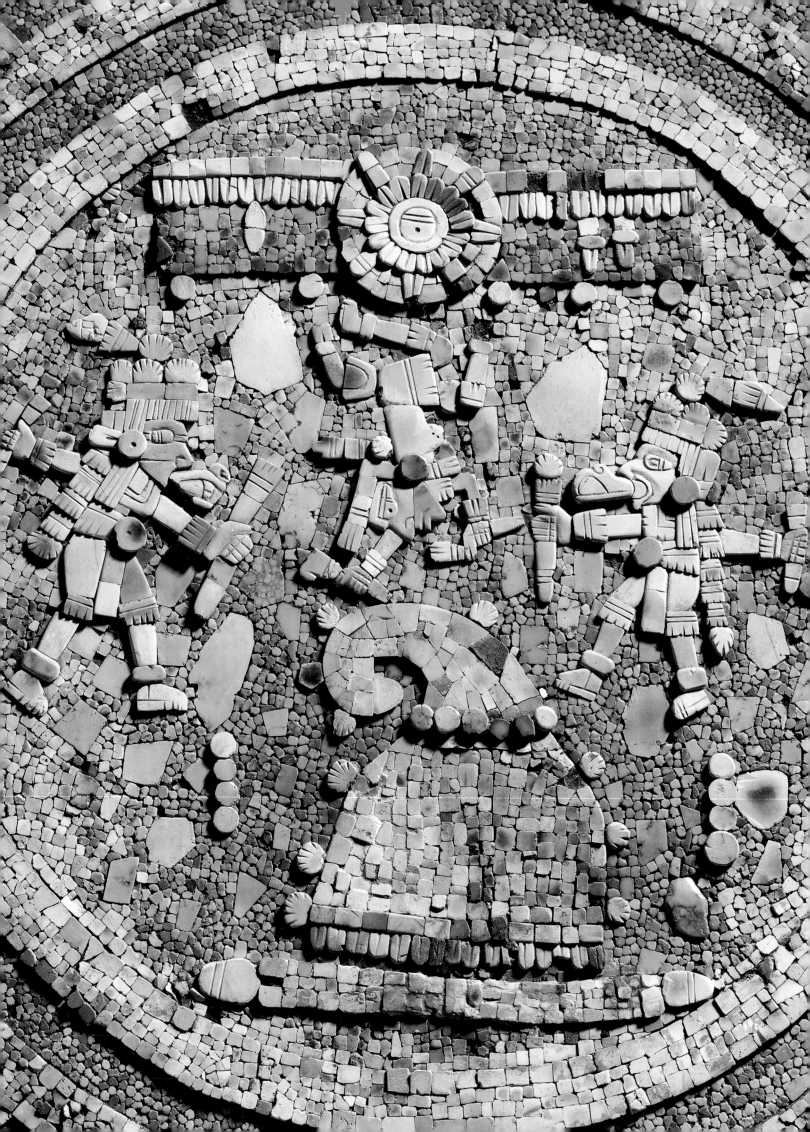

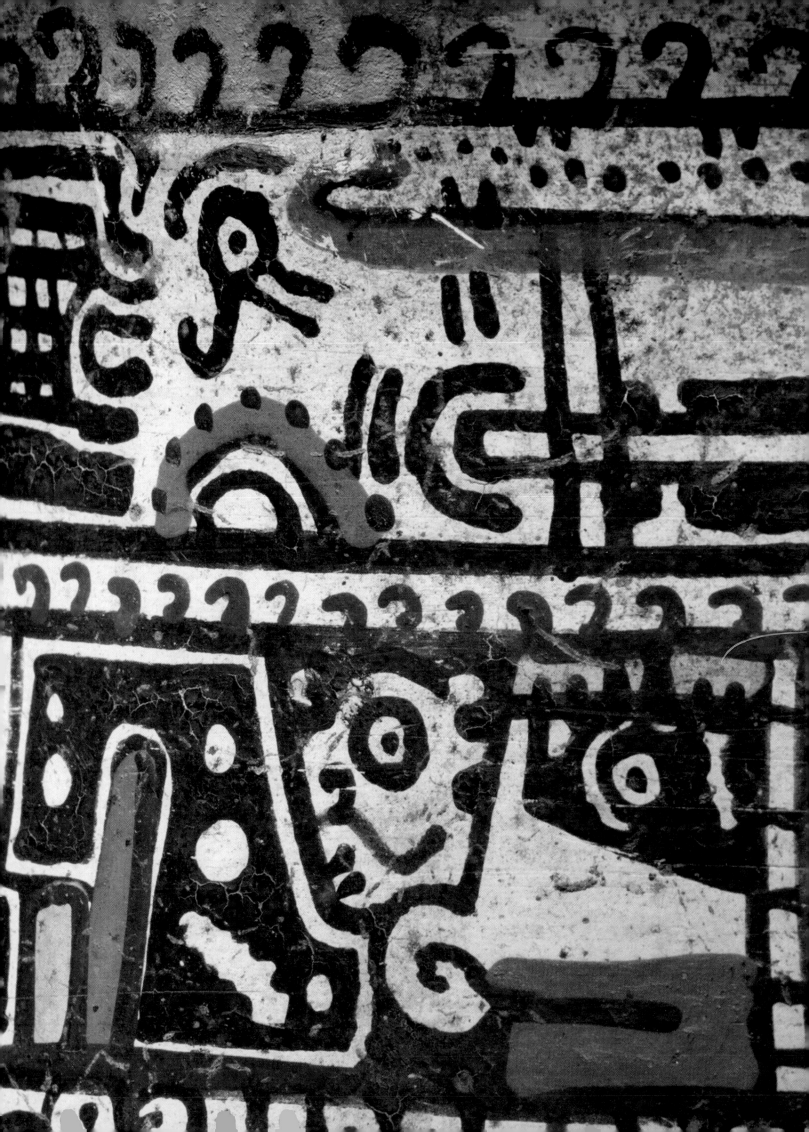

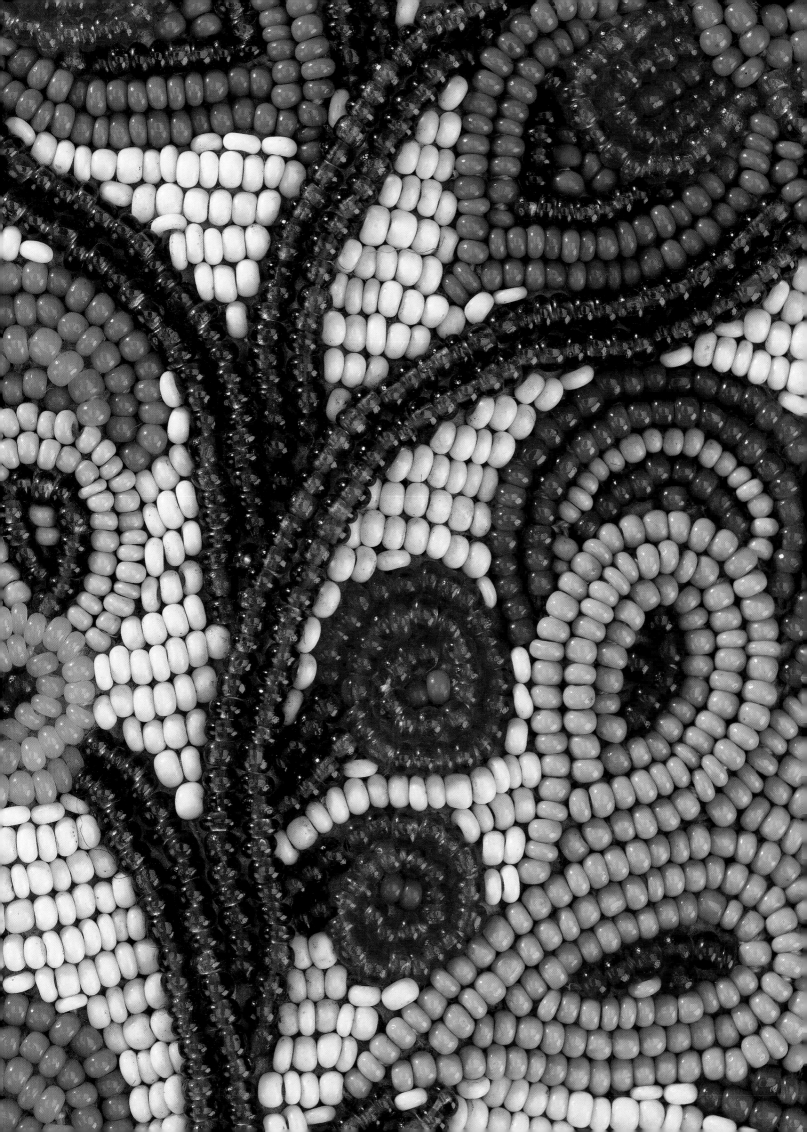

NATIVE
UNIVERSE

VOICES OF INDIAN AMERICA

GERALD McMASTER AND CLIFFORD E. TRAFZER, EDITORS

NATIONAL MUSEUM OF THE AMERICAN INDIAN, SMITHSONIAN INSTITUTION

in association with

NATIONAL GEOGRAPHIC

WASHINGTON, D.C.

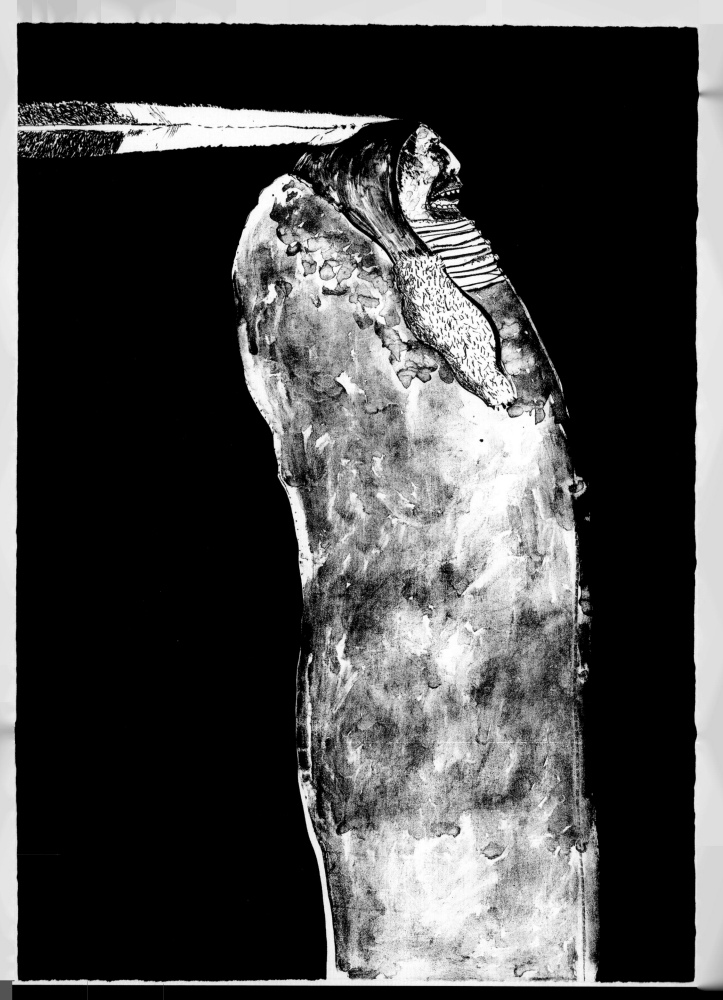

CONTENTS

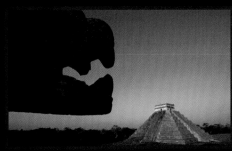

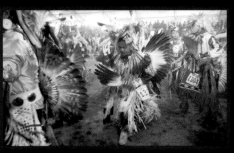

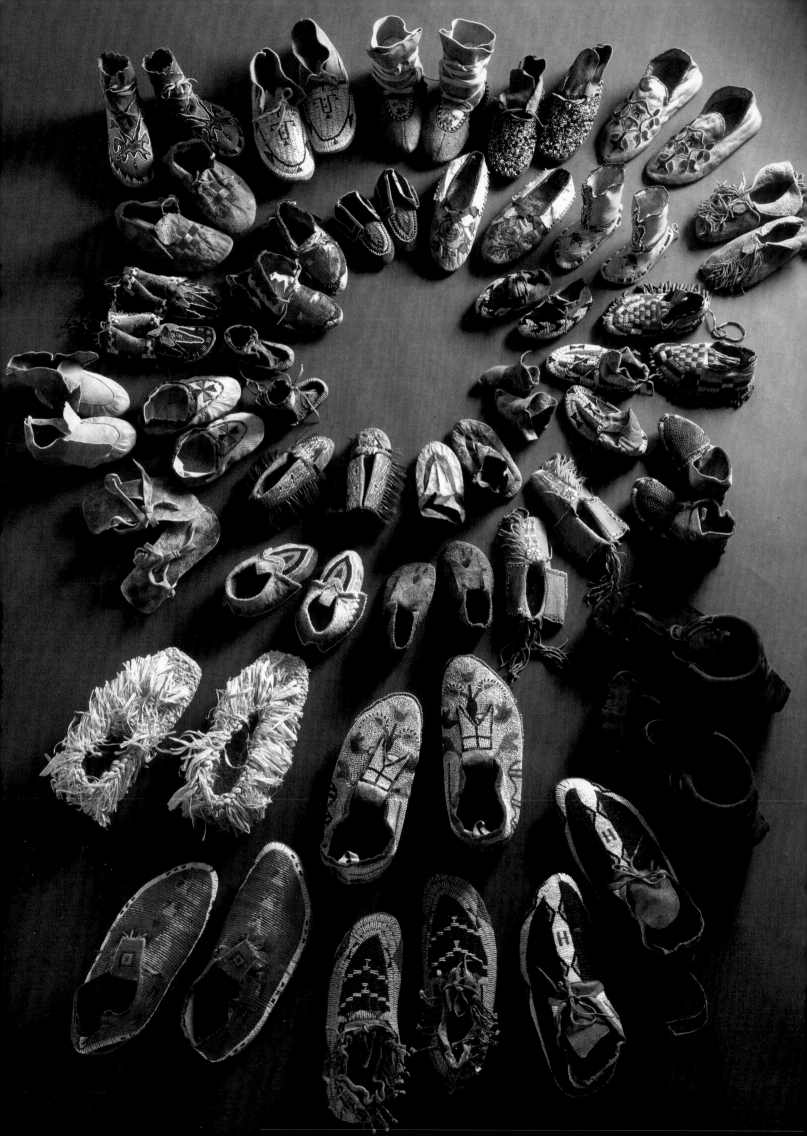

Defining Past and Future

The thoughts of men...should rise high as eagles do.

—BLACK ELK (Oglala Lakota)

Is there a Native universe—a place different and distinct, geographically and otherwise, from other cultures and places? I believe the answer is yes, and I think, after you have read this book, you will agree. We Indians spend much time contemplating and affirming our Native identity. And we do this not only because of the terrible assault on our way of life after 1492, but because we discover in our sense of ourselves as Indians a world that we love inhabiting. The Native universe does not extend only backward into the past, nor is it one marked by unrelenting suffering. We move backward and forward in time, mindful of our history, but optimistic about our future.

It has been gratifying for me and many others to have lived long enough to witness all the old stereotypes stood on their heads: Indians are not vanishing, we are multiplying; we are not stoic, but abound in humor and play. Our universe is no longer defined by others, but by our own scholars, artists, and seers. That power to define ourselves is enormously significant and liberating, and you will discover one of the finest examples of what I am talking about in *Native Universe.*

Some of the most gifted Native writers and thinkers I know of collaborated to bring us this brilliant and original work, which, of the many distinguished titles we have published at the National Museum of the American Indian, stands out as a landmark book. I am very grateful to NMAI's Gerald McMaster (Plains Cree and member of the Siksika Nation) and our loyal friend Cliff Trafzer, of Wyandot ancestry, for their monumental work as editors of and contributors to *Native Universe.* I also want to acknowledge former colleague and friend Tim Johnson (Mohawk), who helped launch the project's concept. Many of our staff at the museum, along with our partners from the National Geographic Society, worked very hard on this project, and I extend my heartfelt appreciation and gratitude to all of them, too.

We feel strongly that the opening of our new museum building on the National Mall is an event of great moment in the Indian world and in the cultural life of our hemisphere, and we are very pleased to have *Native Universe* to serve as the printed complement to this historic event.

—W. RICHARD WEST, JR.

(Southern Cheyenne and member of the Cheyenne and Arapaho Tribes of Oklahoma)

Founding Director, National Museum of the American Indian

MOCCASINS AND OTHER FOOTWEAR FROM THE NMAI COLLECTION.

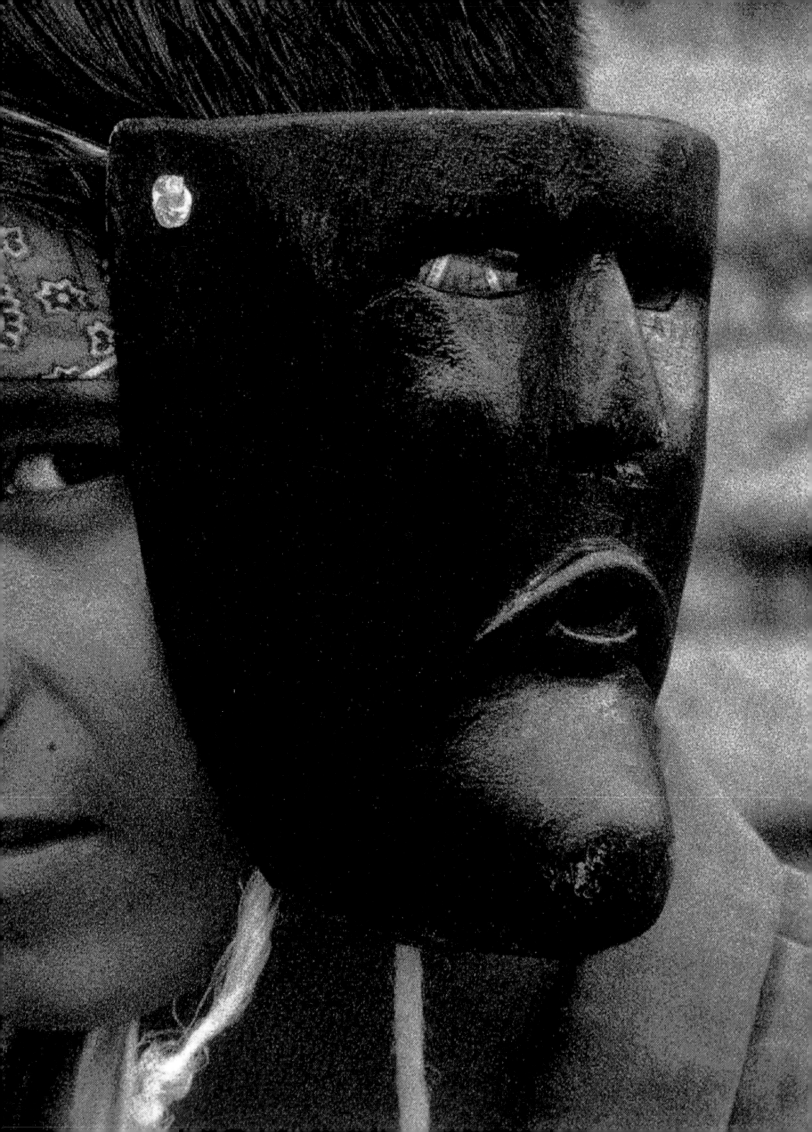

A New Journey

In the final months of 2002, Chickasaw astronaut John Herrington made history as the first enrolled member of a Native American tribe to travel in outer space. Circling the Earth almost 250 miles up in the space shuttle *Endeavor*, Herrington could see the great expanse of the Native universe—commonly known as the Western Hemisphere. Traveling at speeds of up to 17,085 miles per hour, he journeyed 5.67 million miles and made 216 orbits around Earth. Yet Navy commander, trained pilot, and NASA flight engineer Herrington remembered ancient traditions. He carried a small Hopi pot with a design of corn; he flew with eagle feathers, a symbol of prayer to Native peoples who revere this powerful bird. The exquisite pot, returned from its sojourn in space, is now part of the collection of the Smithsonian's National Museum of the American Indian (see page 15).

Witnessing the cosmos, Herrington said, gave him a "spiritual sense" of how magnificent is "the grand scheme of Mother Earth." As Mohawk Tim Johnson, executive editor of *Indian Country Today*, observes, "To the new Indian generation, this is a wonderful example of capacity and humility. From the vanishing American Indian to Indian policymakers in Washington and Ottawa; Indians at the United Nations; Indian business leaders; Indians in the cosmos…. We celebrate what it tells us about the fulfillment of vision and what it signals about this time of American Indian renewal." Or as John Herrington himself expressed it in a letter addressed "To My Many Friends in Indian Country": "We have looked over the horizon together and what lies before us is a universe of possibilities."[1]

From space, Herrington saw the larger landforms below, but he could not fully comprehend the complexities of the peoples and cultures that have inhabited North, Central, and South America for many thousands of years. No one can. To be sure, Herrington could see something of the depth and shadows that make up Native America, but the Earth presented itself to the astronauts much like a mask used in Native ceremonies.

The viewers could see the outlines of distinct features, watch the shadows change with time and movement, and sense the bright colors that illuminated the panorama. But Herrington and the others could not see through the mask to the uniqueness and diversity of American Indian peoples and lands.

Mysterious and enchanting, provocative and ever changing, the complex worlds of Native peoples are too layered in time and space to be comprehended in a single volume. *Native Universe*, however, brings its readers insight into the varied lives of Native Americans through the words and creations of Indian people. Native and non-Native visitors to the magnificent new National Museum of the American Indian on the National Mall in Washington, D.C., are often greeted with the phrase, "Welcome to a Native place"; similarly, this splendid book invites all to enter and learn about the past and present, and hopes for the future, of our peoples. In her essay "Keeping the Original Instructions," Piscataway writer and scholar Gabrielle Tayac examines the ancient origins, continuance, and place of her tribe in the Chesapeake region that includes Washington, D.C., a special site in the culture of the Piscataway and their neighbors. As she points out, beneath Washington's asphalt, concrete, marble halls, and glittering domes there is a Native presence that endures. So it is throughout the Americas.

NATIVE VOICES

Although the National Museum of the American Indian has the largest and most extensive collection of Native American art and artifacts in the world—approximately 800,000 objects representing over 10,000 years of history, from more than 1,000 indigenous cultures throughout the Western Hemisphere—this new and very different museum is far more than artifacts and galleries. It seeks to help Native people revive and sustain their cultural heritage, and its work is rooted in knowledge shared by American Indian communities, tribal elders, and Native writers and scholars. The hallmark of all its programs and exhibitions, including the

three opening exhibitions in its new museum building, is that they are presented from the Native perspective—"in the Native voice." With eloquent Indian voices expressing our deeply held truths, *Native Universe* articulates this concept even further.

The objects as well as the words in this book have power; as Tuscarora scholar Richard Hill has observed of Native art and material culture: "The objects speak across the generations, across cultural boundaries, and allow us to see what the Indian way of thinking is all about."[2] Curator Mary Jane Lenz offers an apt example: "Totem poles, those giant red cedar poles elaborately carved with images of animals and people, can be thought of as three-dimensional family histories; histories that began in the time before people lived on the Earth, when birds and animals spoke to each other; histories that tell of journeys from distant places, marriages and births, supernatural transformations and heroic deeds. For the Tlingit, Haida, Tsimshian, Nisga'a, Gitksan, Kwakiutl, and other people living along the wooded shores and rivers of the Pacific Northwest, totem poles embody their tribal, clan, family and individual identities, and serve as visible reminders of the past and the present."[3]

Values, traditions, and beliefs inspired, and are expressed in, the varied treasures of the Native Americas, which include intricate wood and stone carvings and masks from the Northwest Coast of North America; elegantly painted, quilled, and beaded hides, clothing, and adornments from the North American Plains; pottery, basketry, and weavings from the southwestern United States; ceramics from Costa Rica, central Mexico, and Peru; beautifully carved jade from the Olmec and Maya peoples; textiles and gold from the Andean cultures; and elaborate featherwork from the peoples of Amazonia, to name but a few. Working closely with the National Museum of the American Indian's dedicated photography, collections, conservation, and cultural resources departments, we tried to present the works in this book in a manner that honors and brings forth their innate life and spirit. In many cases, we have added further richness of meaning by including historic photographs that lend cultural context. We hope that *Native Universe* takes you on an intimate journey into the worlds of Native Americans, providing you new ways of thinking about the Native nations of this land.

NATIVE DIVERSITY

In spite of what you have seen at the movies, watched on television, heard from others, or read in books and magazines, no generic Indian ever lived. Native Americans—many millions of whom live throughout the Western Hemisphere from the Arctic Circle to the tip of Tierra del Fuego—are as diverse as any peoples on Earth, particularly in terms of their languages. No one speaks "Indian." People speak Cree, Cherokee, Kiowa, Mohawk, Miwok, Muscogee, Maya, Mapuche, Quechua, Wintu, Yurok, and many other Native languages. Of the estimated 300 original languages spoken within the North American continent, some 175 living languages remain. Often, elders and adults are the only speakers of these surviving languages. Of the 175 living languages, 55 are spoken by only one to six people. Only 20 of the remaining languages are spoken widely by children. The number of Native speakers has declined over time for many reasons. Still, distinctive languages are a characteristic of Native America, and many Indian and non-Indian people are working to preserve and perpetuate the languages of Native peoples. For thousands of generations, we have listened and learned from tribal elders who passed along knowledge and wisdom to children and grandchildren through their words. Stories and songs are treasures kept by individuals, communities, and tribes to be shared with those who would listen well. Throughout this book, the editors and authors hope to engage you in this way of thinking.

Not all Native Americans think alike about any one issue or topic. The sacred, the connection between humans and the spiritual world, is one case in point. Not all contemporary Indian people share in the close connection between humans and the animate and inanimate life that surrounds us—the creative spirits,

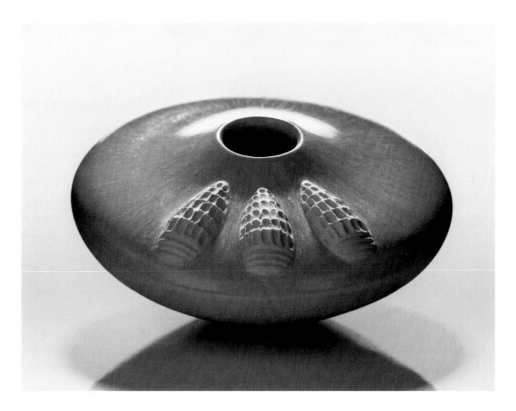

FIRST IN ORBIT

In 2002 Chickasaw astronaut John Herrington became the first enrolled member of a Native American tribe to orbit the Earth. He carried along a ceramic pot (left) made by Hopi artist Al Qöyawayma, who is also a mechanical engineer and has developed and patented internal guidance systems. Herrington and the ceramic with its corn motifs traveled 5.67 million miles on 216 orbits. The pot is now in the collection of the National Museum of the American Indian (NMAI).

SIKYATKI STYLE MINIATURE POT WITH CORN MOTIF. MADE BY AL QÖYAWAYMA (B. 1938), HOPI. CERAMIC, DIAM. 7 CM. 26/605

animal people, plants, and places. Yet today, these ancient belief systems still live in the cultures of many Native nations, and they are the heart and soul of many contemporary indigenous peoples who honor tradition while living in a modern world. The old ways of knowing about this sacred connection—through songs, stories, ceremonies, and rituals—still exist. For many Indians, the ancient philosophies are fundamental in everyday life. Tribal elders and heads of families still teach young people about the sacred relationship of their people with the land and with the seen and unseen forces around them. They still sing the old songs, create new ones, and, in the words of Anishinaabe scholar and writer Gerald Vizenor, "tell stories of survivance" from the remembered past. Contemporary sophistication and ancient tradition coexist in the Native universe.

American Indians throughout the Western Hemisphere have unique cultures reflected through different laws, stories, dances, songs, ceremonies, and religions. Indian peoples living at the southern tip of Argentina differ from those living near the North Pole. The annual blessing of the llamas and alpacas among Quechua-speaking peoples of Peru and Ecuador is unknown to Indian peoples of Guatemala and Mexico. The First Salmon Ceremony of the Lummi, Nisqually, Chinook, Umatilla, Yakama, and Nez Perce is not a part of Potawatomi culture. Some tribes have close-knit clan systems, while others do not. Differences of

many kinds existed and persist today among Native Americans, even among those speaking the same language. Various dialects of the same language create differences on a most basic level. Furthermore, within specific regions of the Americas, several different languages and cultures coexisted, encouraging many Indians to learn one another's languages or adopt a general sign language understood by many. Native Americans adapted other cultural elements from their Native neighbors, and later, from non-Natives. Languages and cultures have always been dynamic and adaptive.

SHARED BELIEFS

There is no doubt that great diversity exists within every region of the Native Americas, but there is also no question that most American Indians of the Western Hemisphere share profound and overarching beliefs. Native Americans of South, Central, and North America believe that the Western Hemisphere, the site of our origins, contains many sacred places. Serrano elder Ernest Siva once explained that his people "did not come from the land bridge" but "from another world in the sky." Serrano Indian people of Southern California believe that the first people followed a great White Eagle south until it landed on top of the San Bernardino Mountains, the origin place of the people. In similar fashion, Wyandot elder

Eleonore Sioui contends that all Iroquoian peoples came from the sky and are the children of Aataentsic, the Woman Who Fell from the Sky, who used her creative powers and those of the female Big Turtle and female Little Turtle to fashion an island known today as North America.

Native people believe that unseen powers and creative forces formed the Earth, sun, stars, moon, mountains, oceans, rivers, lakes, valleys, plains, and other elements of the natural environment. The Creator made the Native universe in a variety of ways with forethought and knowledge, not in a haphazard manner. Emergence came with spirit, imagination, and design, and humans are only one small portion of the creation, a part of the universal whole that remains a great mystery. Creative forces set the world in motion, establishing natural laws by which the animate and inanimate live, sometimes in harmony and sometimes in conflict. Creative forces exist today, often manifesting themselves in the work of Native peoples, particularly poets, artists, dancers, and singers. These spirits are alive in every cell, every atom of the Native universe. They are a part of the whole, the agent that brought forth and keeps life in motion. The power is found within select rivers, rock formations, and riparian regions—places Native Americans define as sacred. Mountains, plateaus, and plains are origin sites for power beings, spirits, and gods. They may be sites sanctified by first ceremonies, rites, dances, and songs. They may be places where tobacco, corn, acorns, or potatoes originated.

Native Americans of the past and present consider many places holy. In northern California, people often look to Mount Shasta for its "land use." They think of skiing, hiking, camping, and timber-cutting, but to the Pit River Indians and other tribes of the region, Akoyet (Mount Shasta) is a sacred place that must not be desecrated by recreation or economic development. In southern California, a Dream Trail runs for miles along the California side of the Colorado River, and the Quechan, Mojave, and Cocopa consider the entire path to be sacred. But these are only two of myriad sacred sites recognized by contemporary American Indians who have a profound relationship with the land, which has been blessed many different ways, including with the flesh, blood, and bones of our relatives. Like many people, Native Americans believe that cemeteries are sacred ground. The burial remains recently found along the Columbia River and labeled by archaeologists as Kennewick Man are sacred in the estimation of Umatilla, Yakama, Cayuse, Walla Walla, Palouse, and other Indian people. Native Americans abhor the destruction of burial sites and the exhumation of human remains, for any reason. Many tribes and peoples believe that when the remains of the dead are disturbed, the souls of those persons are not at peace. The repatriation of human remains and cultural patrimony, in fact, constitute two of the most important issues facing contemporary Indian people. During the 1800s, American institutions gathered up vast numbers of objects from "vanishing" Indian cultures, including human remains and funerary materials. One surgeon general of the Army, for example, ordered thousands of Indian human remains to be taken from battlefields and burial sites to the Army Medical Museum. These were later transferred to the Smithsonian Institution. Important ceremonial objects were stolen or collected under duress from people experiencing great economic and other hardships. After long years of disregard, Native objections to this disrespect are finally being acknowledged. Legislation such as the Native American Graves Protection and Repatriation Act (NAGPRA), which passed in 1990, has resulted in many of these objects and remains being returned to their proper homes.

OUR CIRCLES

All of the essays and artwork found here contribute to a large and ever-expanding circle that we call the Native universe. Yet, numerous circles exist within the overarching circle: cultures, tribes, clans, families, and individuals. Our circles today are based on ancient teachings, values, and beliefs handed down through the oral tradition. Stories, songs, languages, medicines, music, paintings, pottery, basketry, beadwork, clothing, and a host of other arts and teachings convey these

circles. Some have changed dramatically over time, but others have remained the same for centuries. Each is part of living Native cultures that continue to pass on their knowledge, beliefs, and feelings to subsequent generations. In presenting this book, the authors and editors have recognized and affirmed Native communities by authentically portraying historical and contemporary cultural knowledge in consultation with Native peoples. We share the perceptions that Cheyenne Chief W. Richard West, Jr., Director of the National Museum of the American Indian, gleaned from meetings that were held with Native communities throughout the hemisphere during the creation of this truly innovative museum: "Native peoples want to remove themselves from the category of cultural relics and, instead, be seen and interpreted as peoples and cultures with a deep past that are very much alive today. They want the opportunity to speak directly to our audiences through our public programs, presentations, and exhibits, to articulate in their own voices and through their own eyes the meaning of the objects in our collections and their import in Native art, culture, and history."

We have felt a special responsibility in presenting these living cultures and people. Through writings and illustrations, we offer diverse voices of Native Americans so that Indian people themselves may define their representation. We hope that you may come to understand that Native views of the world, of reality, of cosmology, are profoundly different from those that have grown out of the Euroamerican cultural experience—and that these differences have a real impact on the meaning and interpretation of Native America today. We have made every effort to represent our people honestly and impart a small measure of the immense beauty and complexity of Native peoples and their cultures. We have made a creative circle that is inseparable from our collective past—one that we now share with you, hoping that you will learn from your journey into the Native universe.

—Gerald McMaster
 (Plains Cree and member of the Siksika Nation)

—Clifford E. Trafzer
 (Wyandot ancestry)

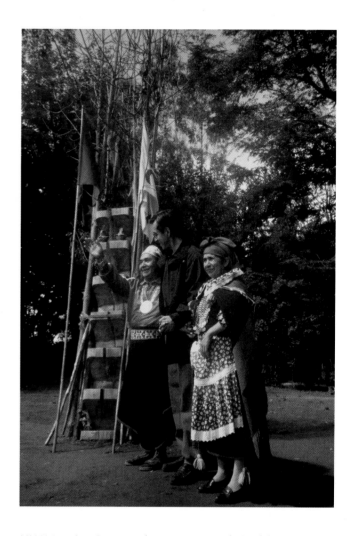

NMAI Associate Curator Emil Her Many Horses (Lakota) (center) in Trumpulo, Chile, January 2003, with *Machi* Gerardo Queupucura (left) and Machi Yolanda Curinao (right). The Mapuche spiritual leaders are among the Native people from throughout the hemisphere who contributed their knowledge and expertise to the opening exhibitions at NMAI's new museum on the National Mall by serving as community curators. The *rewe*, or personal totem, to Machi Gerardo's side is carved with steps showing the levels of his spiritual authority.

NATIVE UNIVERSE
REFERENCE MAP

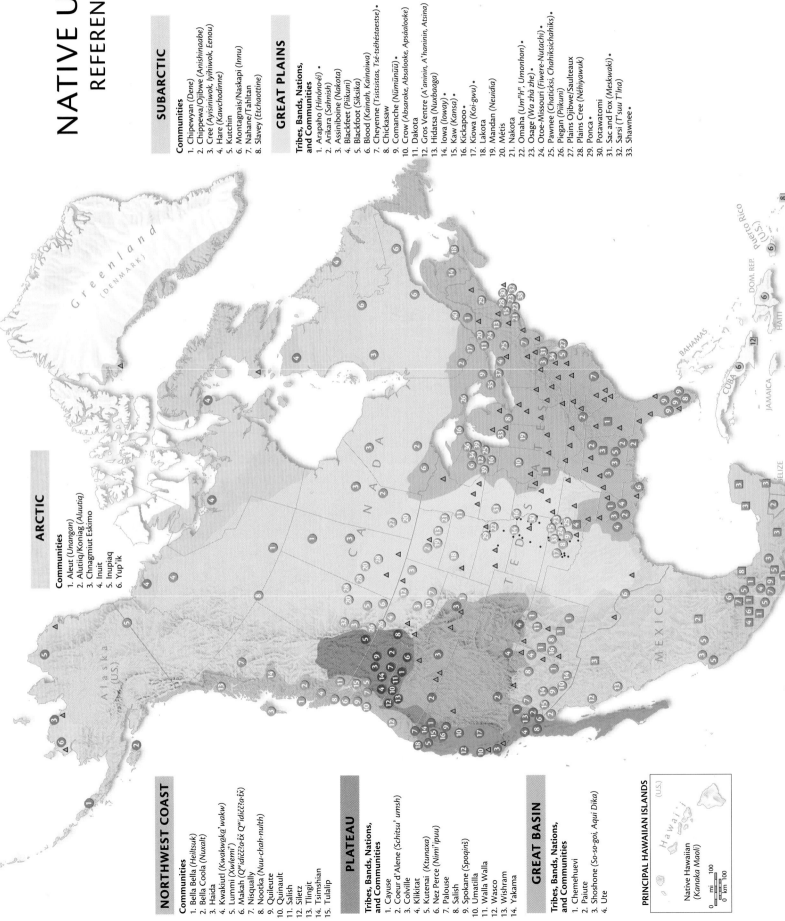

ARCTIC

Communities
1. Aleut (Unangan)
2. Alutiiq/Koniag (Alutiiq)
3. Chnagmiut Eskimo
4. Inuit
5. Inupiaq
6. Yup'ik

NORTHWEST COAST

Communities
1. Bella Bella (Heiltsuk)
2. Bella Coola (Nuxalt)
3. Haida
4. Kwakiutl (Kwakwakaʼwakw)
5. Lummi (Xwlemiʼ)
6. Makah (Qʷ'idičča·tx̣ Qʷ'idičča·tx̣)
7. Nisqually
8. Nootka (Nuu-chah-nulth)
9. Quileute
10. Quinault
11. Salish
12. Siletz
13. Tlingit
14. Tsimshian
15. Tulalip

PLATEAU

Tribes, Bands, Nations, and Communities
1. Cayuse
2. Coeur d'Alene (Schitsu' umsh)
3. Colville
4. Klikitat
5. Kutenai (Ktunaxa)
6. Nez Perce (Nimi'ipuu)
7. Palouse
8. Salish
9. Spokane (Spoqínš)
10. Umatilla
11. Walla Walla
12. Wasco
13. Wishram
14. Yakama

GREAT BASIN

Tribes, Bands, Nations, and Communities
1. Chemehuevi
2. Paiute
3. Shoshone (So-so-goi, Aqui Dika)
4. Ute

PRINCIPAL HAWAIIAN ISLANDS

Native Hawaiian (Kanaka Maoli)

0 mi 100
0 km 100

SUBARCTIC

Communities
1. Chipewyan (Dene)
2. Chippewa/Ojibwe (Anishinaabe)
3. Cree (Ayisiniwok, Iyihiwok, Eenou)
4. Hare (Kawchodinne)
5. Kutchin
6. Montagnais/Naskapi (Innu)
7. Nahane/Tahltan
8. Slavey (Etchaottine)

GREAT PLAINS

Tribes, Bands, Nations, and Communities
1. Arapaho (Hinónoʼéí) •
2. Arikara (Sahnish)
3. Assiniboine (Nakota)
4. Blackfeet (Piikuni)
5. Blackfoot (Siksika)
6. Blood (Kainah, Kainaiwa)
7. Cheyenne (Tsistsistas, Tse-tséhéstaestse) •
8. Chickasaw
9. Comanche (Nʉmʉnʉʉ) •
10. Crow (Absaroke, Absáalooke, Apsáalooke)
11. Dakota
12. Gros Ventre (Aʼaninin, Aʼhaninin, Atsina)
13. Hidatsa (Nuxbaaga)
14. Iowa (Ioway) •
15. Kaw (Kansa) •
16. Kickapoo •
17. Kiowa (Koi-gwu) •
18. Lakota
19. Mandan (Neuidia)
20. Métis
21. Nakota
22. Omaha (Umʼhⁿ, Umonhon)
23. Osage (Wa zhá zhe)
24. Otoe-Missouri (Fiwere-Nutachi)
25. Pawnee (Chaticksi, Chahiksichahiks)
26. Piegan (Piikuni)
27. Plains Ojibwe/Saulteaux
28. Plains Cree (Néhiyawok)
29. Ponca •
30. Potawatomi
31. Sac and Fox (Meskwaki) •
32. Sarsi (Tʼsuu TʼIna)
33. Shawnee •

NORTHEAST

Tribes, Bands, Nations, and Communities
1. Abenaki (Waban-aki)
2. Algonquin
3. Anacostan
4. Cayuga (Gayogohoːno)
5. Chickahominy
6. Chippewa/Ojibwe (Anishinaabe)
7. Delaware (Lenni Lenape) •
8. Fox
9. Huron (Wendat)
10. Illinois
11. Iroquois (Haudenosaunee)
12. Kickapoo •
13. Mahican
14. Maliseet (Wolastoqewiyik)
15. Massachusett
16. Menominee
17. Métis
18. Miʼkmaq
19. Miami (Myaamia) •
20. Mohawk (Kanienʼkéha)
21. Mohegan
22. Narragansett
23. Niantic
24. Oneida (Onyotaʼaːka)
25. Onondaga (Onondagegaʼ)
26. Ottawa (Odawa) •
27. Pamunkey
28. Patuxet
29. Penobscot (Penawahpskewi)
30. Pequot
31. Piscataway
32. Pocanet
33. Potawatomi (Neshnabek) •
34. Powhatan
35. Seneca/Onandaga (Näd-doh-wá-gá) •
36. Stockbridge (Mohican)
37. Tuscarora
38. Wampanoag
39. Winnebago (Ho-Chunk)
40. Wyandot (Wendat) •

Noted archaeological culture
1. Mississippian (Cahokia)

SOUTHEAST

Tribes
1. Caddo (Kadohadacho) •
2. Cherokee (Tsalagi, Aniyvwiya) •
3. Choctaw •
4. Coushatta
5. Creek (Muscogee, Maskoke) •
6. Houma
7. Lumbee
8. Miccosukee
9. Seminole •

Noted archaeological cultures
1. Mississippian (Etowah)
2. Mississippian (Fort Walton)
3. Mississippian (Moundville)
4. Mississippian (Spiro)

CALIFORNIA

Bands, Communities, Rancherias, and Missions

1. Achomawi/Pit River
2. Cahuilla
3. Chumash
4. Cupeno
5. Hupa
6. Kumeyaay
7. Kurok
8. Kickapoo
9. Maidu
10. Miwok (*Mewuk*)
11. Ohlone
12. Pomo
13. Serrano
14. Shasta
15. Wintu
16. Yahi/Yana
17. Yokuts
18. Yurok

AMAZONIA

Linguistic Families

1. Arawak
2. Arecuna
3. Karajá (*Caraja*)
4. Gê (*Mebêgôkre*)
5. Karib
6. Pano (*Shipibo-Conibo*)
7. Quechua (*Inga*)
8. Shuar/Achuar
9. Tucano
10. Tupí-Guaraní
11. Yanomami

Noted archaeological sites

1. Machiguenga
2. Pemon
3. Santa Catarina

GRAN CHACO

Nations

1. Lengua (*Enxet*)
2. Wichi

SOUTHWEST

Tribes, Bands, Nations, and Communities

1. Apache •
2. Cocopa (*Hagiopas*)
3. Cora
4. Hopi
5. Huichol (*Wixarika*)
6. Kickapoo
7. Mohave (*Aha Makav, Jamajabs*)
8. Navajo (*Diné, Dineh*)
9. Papago (*Tohono O'odham*)
10. Pima (*Akimel O'odham*)
11. Pueblo
12. Seri
13. Yaqui (*Yeome*)
14. Yavapai
15. Yuma
16. Zuni (*A:Shiwi*)

Noted archaeological cultures

1. Ancestral Pueblo (Hawikuh, Piro)
2. Chalchihuites (Zacatecas)
3. Mogollón (Casas Grandes)

ANDES

Nations and Linguistic Families

1. Aymara
2. Cayapa
3. Quechua

Noted archaeological cultures

1. Atacames
2. Aymara
3. Cañaris
4. Catamarca
5. Chimú
6. Chono
7. Colán
8. Colima/Quimbaya
9. Inka
10. Ica
11. Lambayeque
12. Moche
13. Nariño
14. Proto-Lima
15. Recuay
16. San Pedro
17. Tiwanaku
18. Tucumán

MESOAMERICA

Nations and Linguistic Families

1. Chontal
2. Maya
3. Mixé
4. Mixtec
5. Nahua
6. Otomí
7. Zapotec

Noted archaeological cultures

1. Aztec
2. Cuscatlan
3. Maya
4. Mezcala
5. Mixtec
6. Olmec
7. Tolteca
8. Totonac
9. Zapotec

CIRCUM-CARIBBEAN

Nations and Linguistic Families

1. Emberá
2. Karib
3. Kuna
4. Lenca
5. Misumalpan
6. Taíno

Noted archaeological cultures

1. Chibcha
2. Chiriquí
3. Coclé
4. Kuna
5. Las Mercedes
6. Managua (site)
7. Maya
8. Montserrat Island (site)
9. Nicoya
10. Ocampo
11. Sinú
12. Taíno
13. Tairona

PAMPAS & PATAGONIA

Nation

1. Mapuche

Noted archaeological site

1. Charrúa

TIERRA DEL FUEGO

Communities

1. Kaweshkar
2. Yagán

FRENCH GUIANA (France)
SURINAME
GUYANA
VENEZUELA
COLOMBIA
ECUADOR
PERU
BRAZIL
BOLIVIA
PARAGUAY
CHILE
ARGENTINA
URUGUAY
NICARAGUA
PANAMA
COSTA RICA
GUATEMALA
EL SALVADOR

MILES
0 500 1000

KILOMETERS
0 500 1000

KEY

◉ Indicates the current geographical center of location of tribes, bands, communities, nations, rancherias, missions, and linguistic families

▣ Indicates noted archaeological cultures and sites which have a representative object on exhibition

△ Indicates other archaeological sites which have a representative object on exhibition

• Indicates Native groups in the United States forcibly 'removed' from their homelands and 'relocated' to federally designated land west of the Mississippi River referred to as 'Indian Territory' or 'Indian Country' (today's Oklahoma, Kansas, Nebraska and eastern Colorado) during the 19th century. Some members of the 'removal' groups remain on their original homeland and are also noted there.

MAP NOTES

Culture Area Designations

Areas designated are based on locations of indigenous cultures throughout the Western Hemisphere as recognized by curators at the National Museum of the American Indian, the authors in this book, and current scholarship. Culture areas are geographic regions within which Native peoples are seen as sharing similar ways of life, such as values, beliefs, and attitudes. Culture areas do not necessarily coincide with what are recognized as physiographic locations.

Indigenous Representation

Due to space limitation, indigenous peoples and sites noted on this map are those mentioned in this book and those represented in the opening exhibitions at the Smithsonian's National Museum of the American Indian in 2004. Some names are representative of many subgroups. Not all locations of primary groups and/or their related subgroups are able to be shown.

Locations

The names and locations of indigenous peoples of the Western Hemisphere have historically been in flux. First peoples sought locations beneficial for safety and access to food. Natural environmental changes resulted in further movement of peoples. A period of unwanted relocation was manifest after 1492, the result of European intrusion across all borders. In North America after that date, some Native peoples were involuntarily relocated from their homelands; some onto federally reserved lands, others into missions by colonial governments. Other Native peoples migrated to coastlines to take advantage of the newly established foreign trade. In the 20th and 21st centuries, commercialization and the devastation of natural environments for profit continue to force still more movement. Today, the location of indigenous peoples cannot be defined within original homelands or reservations as many contemporary Native people are now a major part of the mixed urban populations throughout the Americas.

Self-naming Practice

Names indigenous peoples originally called themselves were replaced by names misunderstood, misinterpreted, or given to them by European invaders. Today, some indigenous groups have returned to their original names, here represented in parentheses.

Tribal Orthographies

Some original Native names cannot be totally represented using the Roman or English alphabet. In those cases, familiar symbols such as the question mark (?) are used to characterize a vocal sound or inflection.

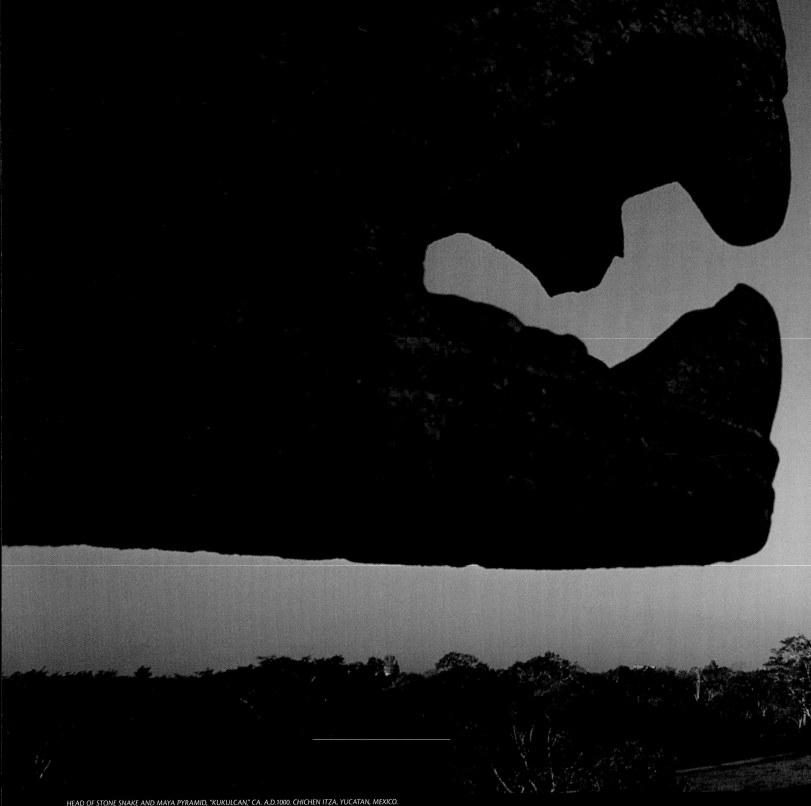

HEAD OF STONE SNAKE AND MAYA PYRAMID, "KUKULCAN," CA. A.D. 1000. CHICHEN ITZA, YUCATAN, MEXICO.

4. OUR UNIVERSES

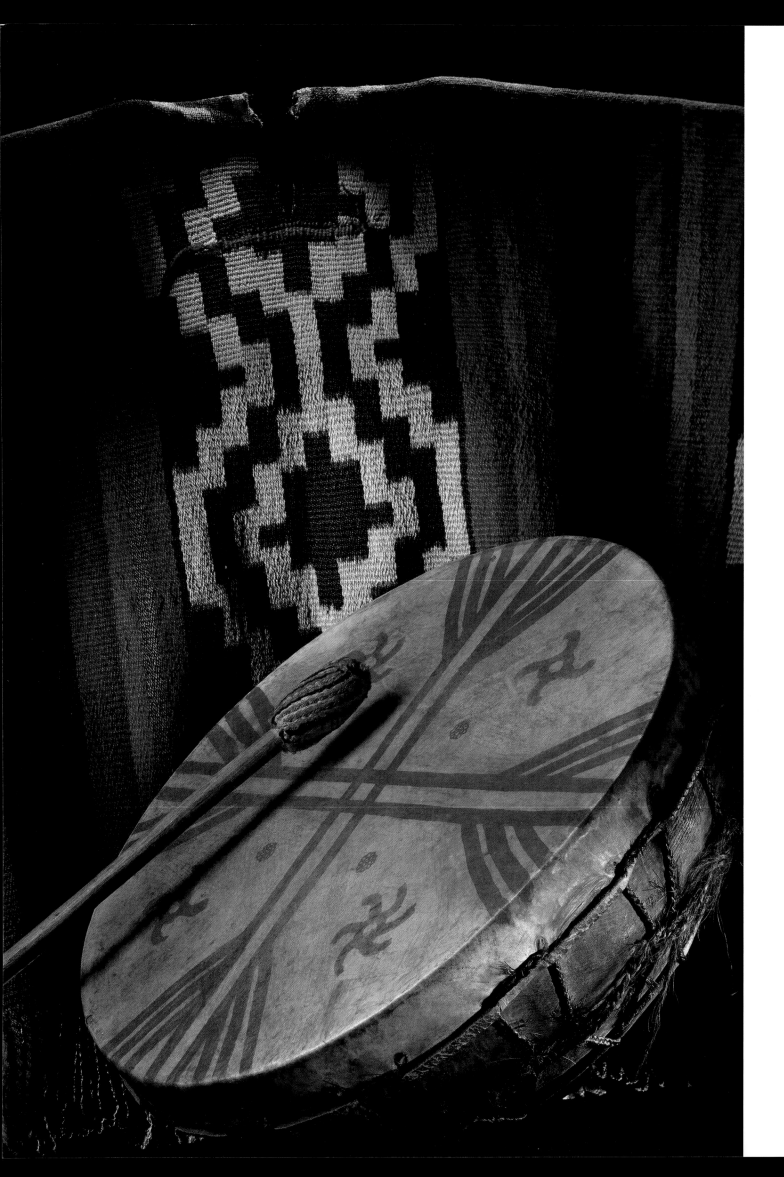

ORAL TRADITIONS OF AMERICAN INDIANS — IN STORIES, SONGS, CHANTS, prayers, and poems—have always been a powerful means of communicating the realities of Native universes. Rather than "fish tales that grow with the telling," they are tribal histories that detail specific cultures and languages and are central to any understanding of Native peoples. Wyandot elder Eleonore Sioui says that the stories provide insight into the law, literature, religion, and philosophy of particular peoples. Their creation stories provide outsiders a path into the Native realm. In his Pulitzer Prize-winning book, *House Made of Dawn*, Kiowa author N. Scott Momaday invites readers to enter his world through the power of words:

> The stories were old and dear; they meant a great deal to my grandmother. It was not until she died that I knew how *much* they meant to her. I began to think about it, and then I knew. When she told me those old stories, something strange and good and powerful was going on. I was a child, and that old woman was asking me to come directly into the presence of her mind and spirit; she was taking hold of my imagination, giving me to share in the great fortune of her wonder and delight. She was asking me to go with her to the confrontation of something that was sacred and eternal. It was a timeless, *timeless* thing; nothing of her old age or of my childhood came between us.[1]

This account illustrates the Native belief that through storytelling people connect with the sacred manner of knowing. Through stories and art objects, we may experience the unbroken tie of spirit and know some of the cultural treasures of Native America. For Momaday's grandmother, her "great fortune" was stories, those of her Kiowa people and nation. She was linked to all her relatives through her stories, and she wanted her grandson to share in her wealth. Equally important, his grandmother wanted Momaday to enter a timelessness where neither age nor chronology had meaning, where time stands still and we live in the story to delight and come into ways of knowing.

MAPUCHE KULTRUNG (DRUM) WITH STICK AND MAKUÑ (PONCHO), EARLY 20TH C. 17/5797, 17/6736

Ceremony and ritual are intimately tied to story, song, and dance. Seneca scholar Tom Hill observed that anthropologists Franz Boas and Claude Lévi-Strauss "began eventually to understand the meaning and purpose of ceremonial art." By learning something of ceremonial art the anthropologists began to grasp a new way of knowing, which had eluded them because of their cultural biases. They had to reeducate themselves and learn about Indians from a new perspective, one that did not fit into their Eurocentric intellectual constructs. Non-Indians can come into the presence revealed by Momaday's grandmother to gain "a realization of how complex and subtle" Native universes are and always have been.[2]

WORD MEDICINE

For thousands of years, Indians communicated primarily through oral tradition, which required the talents of revered storytellers. It also required listeners to open their minds and hearts, to listen with care so that they might in turn become keepers of the traditions. For tribal elders, words were magical, invisible, and powerful. Words were medicine, the means by which the people knew themselves and the wider world around them.

The telling and retelling of the ancient truths provided Native peoples a means of educating their young. Storytellers imagined the world and made it stir with life. They created new stories to add to the ancient oral narratives, and they never stopped building onto the body of literature. As time passed, non-Natives began to commit Indian oral traditions to paper, creating a new tradition of written Native narratives. Some of the stories, recorded by missionaries, soldiers, and others on into the twentieth century, became part of world literature. Many Indian people who nurture stories in their own languages share them among themselves to this day. Other people took the words for granted and have forgotten the power of stories. Although non-Indians encouraged Indians to forget the old ways and look to the future by teaching their children only in English, many people held the stories close in their own languages, and in English, to preserve the treasures.

There are many universes within the Western Hemisphere's Indian Americas, universes that came into being at the beginning of time, the work of creative forces that put the Earth, stars, sun, and moon into motion and have kept them moving ever since. On Earth, creative spirits made the first plants and animals. They made mountains, rivers, lakes, and valleys. They brought the clouds and rains, thunder and lightning. They prepared the earth for the coming of human beings. The holy ones breathed life into being in many different ways, creating a variety of people grouped together to share common languages, beliefs, geographical areas, songs, and stories. The people imagined themselves and their worlds in diverse ways, but their stories became their first truths. Using song, symbol, and story, they manifested their beliefs through ceremony and ritual. Although there is no one worldview that applies to all indigenous peoples, Native cultures share certain underlying aspects. As Tuscarora scholar Richard Hill observes, the Native way of thinking can be seen in such things as "the use of the circle as a symbol of unity, in the use of animal totems to represent the sharing of power between the people and the animal world, and in a different attitude about the land—one that sees the earth as alive and sacred, to be shared by all."[3]

Each Native community has its own story of creation. Thus, there are diverse ways in which the creative powers made the Native universes. Stories tell American Indians who we are and where we have been. Stories explain the sovereignty of Indians and our place on Earth and within the Native universes. Stories also help non-Natives understand elements of American Indian cultures by

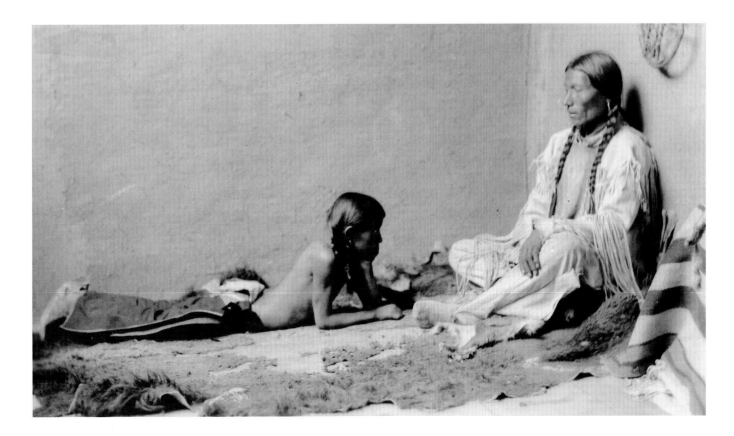

explaining the masks that obscure their complex worlds. Elders today usually spend little time telling stories about the Spanish, French, Russian, or English invasions. Rather, the core cultures of Native peoples are found in stories, songs, ceremonies, and poems often given to them at the time of creation—a time that is at once old and contemporary. Creation happened and is happening. Creation, like stories, is circular, ever present, ever moving.

When elders share their stories, they teach us. In this work, following the ways of our elders and ancestors, we offer a few of their stories that teach, but now through the written word. The history and cultures of many Indian peoples are more than facts and dates. They are beliefs and emotions, ways of thinking, ways of doing. History and culture are known through spoken words, the objects we used, and the creations of the people. Not so long ago, elders taught us only in Native languages, but in recent years, many elders teach in new languages, speaking English, Spanish, French, and Portuguese. Regardless of the language, elders have felt a deep responsibility to tell the stories correctly, to get them right in accordance with the evidence and perspectives of the people. Although different versions of the same story can emerge within Native American communities, differences are generally minor and reflect the cultural choices of the storytellers. Where historical events are concerned, Native versions might differ dramatically from those of non-Natives. Yet these are not the important narratives in Native universes. Traditional stories of the people are far more compelling and enlightening. By retelling them, we unleash the story's life and power. Stories are word medicine and they are sacred truths, carefully shared to illuminate the many Native universes that are as compelling as the stars in the night sky.

Oglala Lakota scholar Emil Her Many Horses once explained that creative art forms of specific tribes "help to show us that Native peoples had an understanding and appreciation for all aspects of their universe; nothing was unimportant or insignificant." For his people, the buffalo, drum, and Paha Sapa, or Black Hills, are sacred elements of their universe in the past and present. In similar fashion, the telling of the origin story of Lakota people is also sacred and timeless, particularly

TEACHING THE WAYS

Although romanticized in composition, photographer Carl Moon's image of a man instructing a boy of Taos Pueblo at the turn of the 20th century reflected a central condition of Indian life. Practical, historical, and spiritual knowledge of the world and beyond was transmitted orally. Boys and girls were taught the necessities of manhood and womanhood by their parents, grandparents, other relatives, and tribal elders. Storytelling was both a gift and a responsibility, for it conveyed tales of the gods and ancients, histories of the people, moral principles, right actions, and the necessity for harmony and balance in life.

A TALE OF THE TRIBE, CA.1909.
TAOS PUEBLO, NEW MEXICO. PHOTO BY CARL MOON.
BRYON HARVEY III COLLECTION. P19644

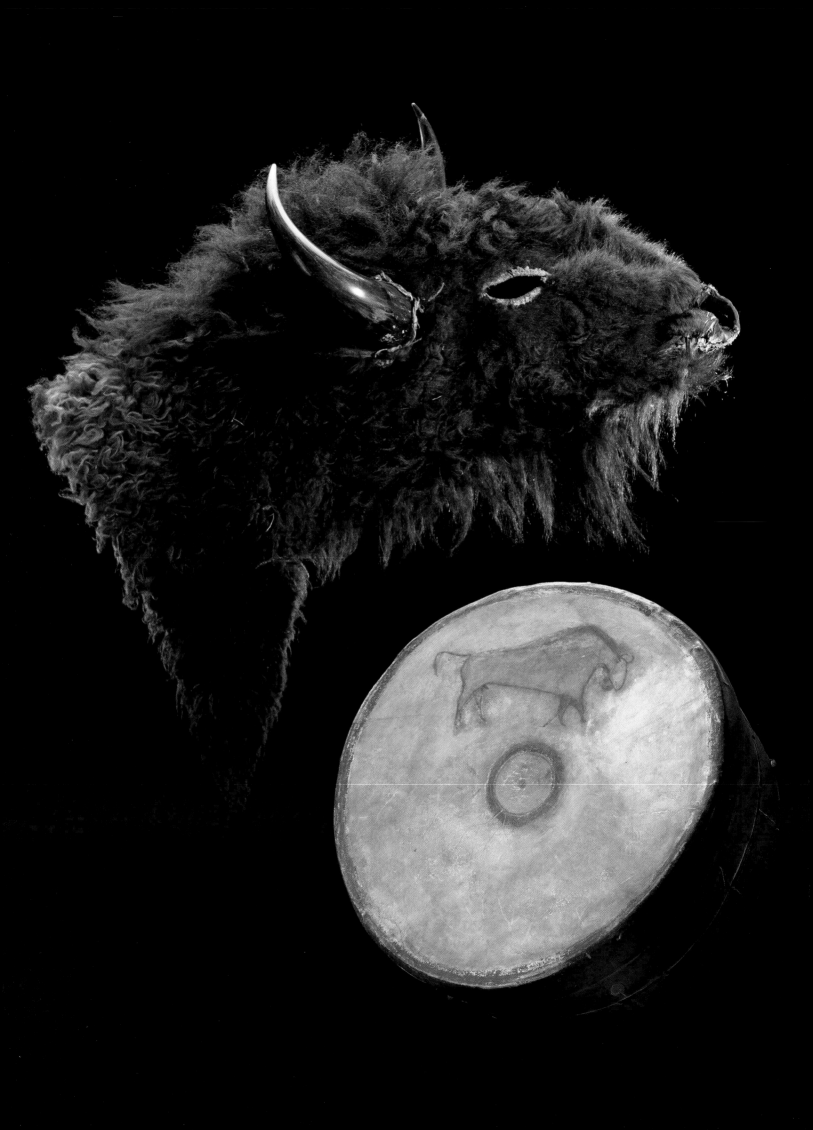

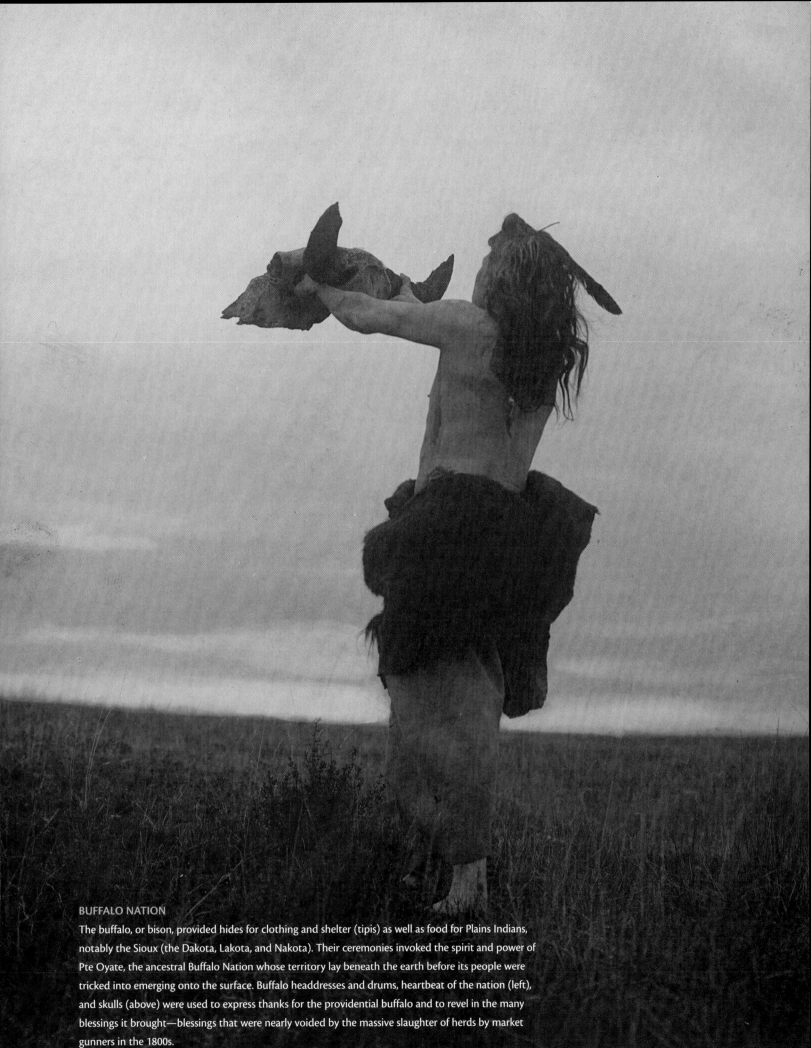

BUFFALO NATION

The buffalo, or bison, provided hides for clothing and shelter (tipis) as well as food for Plains Indians, notably the Sioux (the Dakota, Lakota, and Nakota). Their ceremonies invoked the spirit and power of Pte Oyate, the ancestral Buffalo Nation whose territory lay beneath the earth before its people were tricked into emerging onto the surface. Buffalo headdresses and drums, heartbeat of the nation (left), and skulls (above) were used to express thanks for the providential buffalo and to revel in the many blessings it brought—blessings that were nearly voided by the massive slaughter of herds by market gunners in the 1800s.

the narrative of the Lakota arrival on the Great Plains. According to storytellers, Iktomi the trickster, with the help of a woman named Double Face—the female element of creation—tricked the people into leaving their domain inside the Earth and moving to the Great Plains. Iktomi gave Wolf a backpack filled with delicious meats and beautiful garments, instructing Wolf to take it to a strong, brave man.

Entering the Earth through a great cave, Wolf gave the food and clothing to a courageous and upright man named Tokahe, convincing him and three others to visit Earth's surface. Double Face made more clothing to show these people, and she cooked them a savory meal. Impressed, the four men returned to encourage their people to move to Earth, and although Old Man and Old Woman warned them of cold winds and scant food, six families followed Wolf through the cave to the surface. They found life hard on Earth, but Old Man and Old Woman taught them how to survive by hunting the buffalo and building tipis. Because life on Earth was difficult, the Lakota learned to be close to their universe and give thanks through drumming and singing. They learned that Mother Earth, Sky World, spirit beings, plant people, and animal kin all had a close relationship with each other and with humans. Lakota say the buffalo are their relatives, and these animal people gave their lives so the Lakota could live on this Earth. But the Lakota universe was just one of many Native universes, one of many circles within a larger Native American circle.[4]

CREATION OF NATIVE UNIVERSES

According to several creation stories, the present world began in the Sky World. The thick forests of the Eastern Woodlands were a sacred place to Native Americans because of their connection to the creation of Turtle Island, which is what many tribes call North America. Several Iroquoian groups share a story about the creation of their people, and various versions persist to this day. For the Wyandot, life began in the world above, where a chief's daughter became ill and faced death. A medicine man ordered men to dig at the base of a wild apple tree and lay the young woman near the tree's healing touch. While she was there, a sudden roar enveloped the Sky World, and the tree fell toward a vast body of water in the world below. The girl's arms became entangled in the roots, and she tumbled with the tree. Swans saw her falling and bent their necks to soften her fall. Big Turtle offered his back as a resting place for Aataentsic, the Woman Who Fell from the Sky, as he summoned the animal people to discuss how best to save her. Otter, Muskrat, and Beaver all tried unsuccessfully to dive for some of the soil that had fallen with the tree. Finally, Toad brought a bit of soil to the surface, and she spit it upon Big Turtle's back. Small Turtle used her claws to spread the soil, "and it began to grow into an island" that could support Aataentsic. As the animals watched, the soil on Big Turtle's back grew "larger and larger until it had become our island [world]."[5]

American Indian narratives provide a rich and diverse means of understanding the creation of the animals, plants, and places that make up Native universes. In South America, the Mapuche of Chile and Argentina believe that Ngünechen (the Creator) formed the universe. The center of power for a *machi*, or spiritual leader, is a carved wooden ladder called a *rewe*. In a spiritual sense, the rewe is the center of the universe. From its steps, the machi communicates with the people of his community and with Wenu Mapu, the land above, where deities and ancestors live, to bring harmony to both worlds. Machi Gerardo Queupucura prays to "You Mother of Wenu Mapu, You Father of Wenu Mapu, Young Man of Wenu Mapu, Young Woman of Wenu Mapu, all of you live there in Wenu Mapu…You live in the land above…. There goes my prayer, there goes the breath of my bones, there goes the breath of my heart."[6]

As in the Wyandot story and the Mapuche prayer, most American Indian oral narratives recognize the active role of female and male characters. In the Wyandot story, the female characters Toad and Small Turtle play significant roles. More important is the Woman Who Fell from the Sky, the creative force and representative of the ever-changing Earth that provides sustenance to all life. And in the Lakota story, the female trickster Double Face creates delicious foods and fine clothing; acts that the people would emulate.

Native American history began before humans, when plants, animals, and places of nature interacted with each other to make the world ready for humans. American Indian art often depicts the significance of animal people through paintings, carvings, stories, and songs that link humans to their relatives, the animal and plant people. Stories weave this time together, establishing laws by which all things should function and forming the foundation of each tribe's governance, its marriage laws, kinships, philosophies, and cultural values.

After Aataentsic walked upon Big Turtle's back, she watched the Earth grow. As she went about the business of creation, the Woman Who Fell from the Sky became aware that she was pregnant with twin boys, Tsensta', Man of Fire or the Good One, and Taweskare, Man of Flint or the Evil One. Tsensta' came into the world in normal fashion, but Taweskare tore and kicked his way out of his mother's side, emerging from her armpit and killing her. Tsensta', the kind, unselfish one, had "greater powers than his mean brother" and he prepared "the island for the coming of the people." Taweskare, the selfish, willful, and wicked one, spent his life disturbing the creation so "that the people should not find life so easy on the island." These Iroquoian culture heroes have their counterparts among many Indian nations.

Such powerful figures mirror life on Earth, a place of many wondrous creations, of snow-covered mountains, deep purple canyons, and sandy beaches. It is also a place where earthquakes tear down schools, hurricanes pound coastlines, and volcanoes spew lava indiscriminately, harming plants, animals, and people—all the while adding land to the Earth's surface. Within every person, the potential for positive, constructive action and negative, destructive behavior exists. The stories teach that this is the way of life on Earth.

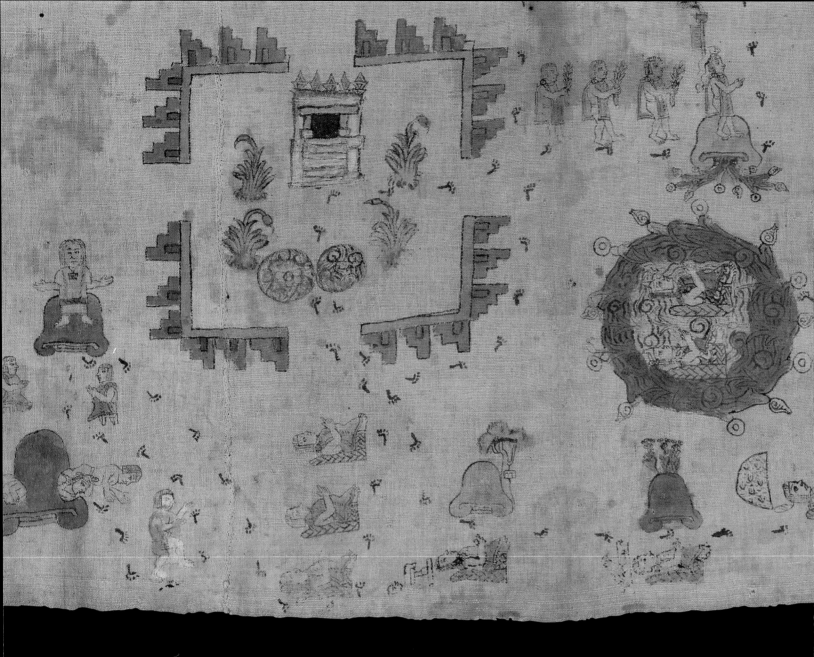

A GREAT MIGRATION

Part history, part geography, part mythology, this *lienzo*, or painted cloth, records the pre-Columbian migration of a people who spoke the Nahuatl language in what is now central and southwest Mexico. Their principal journey, whose progress is marked by stylized footprints, begins in the middle of the far left side. It moves downward, entering and leaving a cave in the far lower left corner. This may represent Chicomoztoc, legendary cave of origin for the Nahua people. Footsteps continue rightward to a temple surrounded by crenellated walls, which represents Tula, the cultural capital of the Nahua people. Some footsteps enter the temple. Others pass around a circular lake, the site of future Mexico City. They then move counterclockwise until they reach an assembly of seated lords. At their center stands a Temple of Corn Ears and an Altar of Snakes. From this scene the journey diverges. One branch goes to the right where 28 villages are arrayed and arrives at the most prominent, Izucar, the "mountain of knives" (five clearly visible). In this way the epic story of Izucar's founding is told. The remaining villages represent the Izucar Province. Yet another trail leads from the Altar of Snakes. It circles counterclockwise until it reaches two seated figures located near where the journey began. Slightly below and to the right of those figures is a smoking mountain, Popocatepetl, the most active and threatening volcano in Mexico. The migration theme is common in the documents painted by the Nahua people and reflects the memory of real migrations from the arid north in prehistoric times. Another theme, less graphic than the footprints of the migration, is the relationship of the other villages and their inhabitants to each other, a story readily comprehended then but not easily understood now.

NAHUATL LIENZO DE IZUCAR (PICTOGRAPHIC TEXT ON CLOTH), CA. 1560. COTTON AND NATURAL DYES, 152 x 119.5 CM. 15/3358

Dark motifs are necessary in representing worlds that encompass powerful, harmful forces as well as good. According to one translation of the *Walam Olum*, the poetic narrative that presents the origin, movement, and history of the Lenape (Delaware), the universe began when "The Great Spirit moved" and brought forth the earth, sky, clouds, and heavens. The Great Spirit formed "The creator spirits" and "The Souls [for] Everything" including "The First Mother," and providers of fish, turtles, beasts, and birds. Not long afterward, a "Bad Spirit" emerged, bringing "The Snakes and Sea Monsters." Then, quietly, "An evil snake, / A sorcerer, / Came to the earth." And with it came "Wickedness, / Wrongfulness, / Criminal acts." The Great Serpent brought "Black weather," illnesses, and death. All of this came in the early stages of creation.[7]

Creation narratives throughout the Western Hemisphere emphasize the power of spirits and their sacred nature. Over the years, tribal elders began to use written symbols to record oral traditions—on rock, wood, hide, stone, bone, and ceramic. The Lenape recorded the *Walum Olum* in symbols that remind storytellers about important details of the oral narratives. In a sense, the symbols offered Native storytellers shadows that provided them an understanding of the story's depth.[8]

Many material objects made and used by Native people are containers of meaning. As San Carlos Apache tribal historian Dale Curtis Miles observes, "We do not like our stories referred to as myths; our sense of who we are and our world view are wrapped up in these stories. Even clothing, tools, baskets, and other material culture so important in everyday life have direct links to the stories of the people." At an interpretive session of the National Museum of the American Indian, Tewa/Santa Clara Pueblo artist and scholar Rina Swentzell tenderly held a large Pueblo pot in her hands. For her, the pot possessed great meaning as art and as an element of her community. She remarked that the piece reminded her of all the grandmothers who had made pottery for centuries. She then told the story of Little Water Jug Boy, a narrative of a woman's devotion to the clay and the animation of pottery with personality, spirit, and life. According to Swentzell, a woman from Santa Clara loved to make pottery so much that one day while she worked the clay along the river, squishing the mud between her toes, a stream of clay moved up her leg and impregnated her. She gave birth to Little Water Jug Boy who, although he became an integral part of the family, wanted to be like other children. Every time his father went hunting, Boy begged to go, eventually convincing his reluctant parent by promising to roll himself down each hill so he would not be a burden. But on one hill, Boy rolled faster and faster, finally breaking into a thousand pieces. When his father reached the spot where Boy had smashed to bits, he wept until he heard Boy calling him. Little Water Jug Boy had become flesh and blood, a real boy who could run and play. This story is kept in the oral tradition of the Santa Clara people, and Native artists represented it in a pictograph on the wall of a rocky canyon near Santa Fe, New Mexico. Storytelling and identity have always been intimately connected with the land. As Laguna Pueblo writer Leslie Marmon Silko has observed:

> Pueblo potters, the creators of petroglyphs and oral narratives, never conceived of removing themselves from the earth and sky. So long as the human consciousness remains *within* the hills, canyons, cliffs, and the plants, clouds, and sky, the term *landscape*, as it has entered the English language, is misleading. "A portion of territory the eye can comprehend in a single view" does not correctly describe the relationship between the human being and his or her surrounding. This assumes the viewer is somehow *outside* or *separate*

from the territory she or he surveys. Viewers are as much a part of the landscape as the boulders they stand on.[9]

Monsters appear in many Native American stories, woven into the fabric of traditional beliefs. They are often dangerous, selfish characters that break the positive laws of creation, distorting the natural world. Adversity and danger brought by monsters often called forth heroes willing to challenge the creatures. Maidu Indians of California traditionally explained the origin of thunder in such a framework. As Maidu elder Dalbert Castro relates, thunder emerged after man's creation, when people lived in villages scattered in the foothills of the mountains. In one village, the people began to disappear, until only three people remained: a grandfather, his granddaughter and grandson. They hid in their lodge in fear, but as the days passed, their need for water became desperate. Grandfather left for the creek but never returned.

Despite his sister's fears and protests, the grandson then ventured out each day for food, fuel, and water, traveling farther away from home each day. His sister noticed that each time he left the lodge, he came back bigger and stronger—not only physically, but spiritually, and emotionally as well. One day when the boy was out hunting, he found the people of the village lying along a hillside as if in a trance. While the boy watched and wondered, his thoughts were abruptly interrupted by crashing sounds from the forest. Suddenly a giant lizard man appeared, threatened the boy, and engaged him in combat. The lizard initially took the upper hand in the fight but was eventually killed by the boy. The boy returned home and told his sister about finding the villagers and fighting Giant Lizard. He then announced that he had to leave for a far-off land. His sister implored him to stay, but he explained that he now knew what he was meant to do with his life. However, he promised he would send a sign that he was alive and well. The boy then ascended on a cloud to live in the heavens. The people came back to the village, since the death of Giant Lizard had ended the spell cast over them. Dark clouds rolled over the mountains to the east, settling upon the village, and before the rain came, the people heard thunder for the first time. The boy had become Thunder Man, one of the thunder beings that still rumble and roar to remind the people of the ancient story.[10]

The boy who became Thunder Man faced more than Giant Lizard. He confronted the monsters within himself, the fear that naturally came from facing danger and death. He had lost Grandfather, the one remaining elder, and feared venturing out of his home to seek water and food. Importantly, he overcame this fear and left the security of his sister and home. Each time he went off by himself, he became better prepared to meet life's challenges.

In another story, curiosity and desire for knowledge enticed an Inuit from Greenland to risk his life. The people of Smith Sound in the far northwest of the island speak of a monster that once ate the dead. Every time a person died, the body vanished, dug up by someone or something unknown. Finally, a brave soul determined to solve the mystery by asking his relatives to bury him alive. The night of his burial, a mountain spirit dug up the "corpse," which he presented to his wife, who then left home to gather firewood to cook the body. Tired from his task, Mountain Spirit decided to take a nap. Before he fell fast asleep, his children cried out that the corpse was alive, but he ignored them. The Inuit killed the monster and raced back to his village. Along the way, he encountered the monster's wife who pursued him. The Inuit called to the power to create hills, and hills formed, slowing the monster woman. Still she followed him to a river. After crossing, the Inuit called to the river to overflow. From the opposite bank, the woman asked him how he had

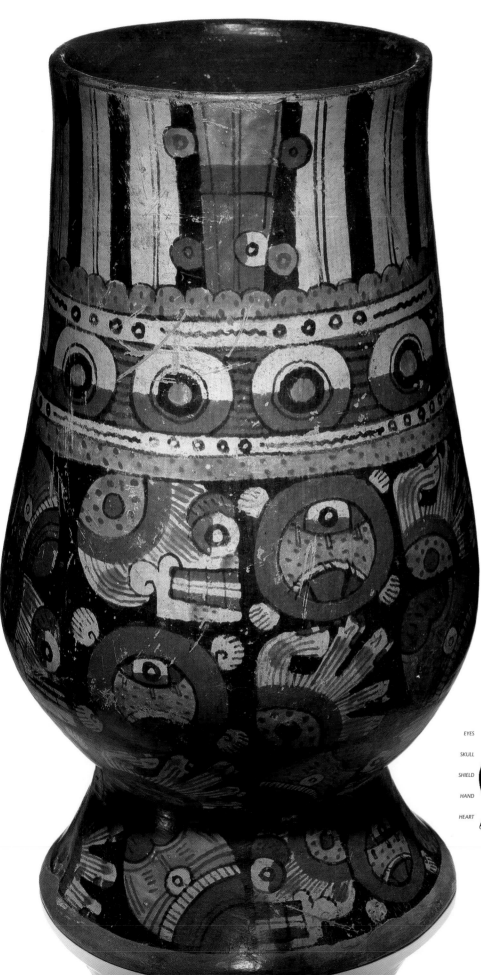

DIPLOMACY CUP

A ceramic drinking vessel made in the central highlands of Mesoamerica in the 14th or 15th century was filled with ritual beverages such as cacao or fermented agave consumed at feasts held to form or reestablish alliances among ruling elites. The motifs of human hearts, skulls, long bones, hands with long-nailed fingers, eyes, and shields constitute symbolic references to warfare and sacrifice. The arrangement of the images, "unrolled" below, strongly suggests that the arrangement is an acrostic puzzle—as yet undeciphered—serving as a visual incantation related to diplomatic intents or agreements.

MIXTECA-PUEBLA CYLINDRICAL POLYCHROME VASE, CA. A.D. 1350–1520. HEIGHT 25.4 CM. 16/3394

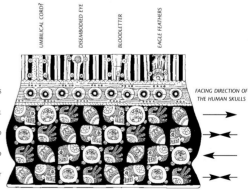

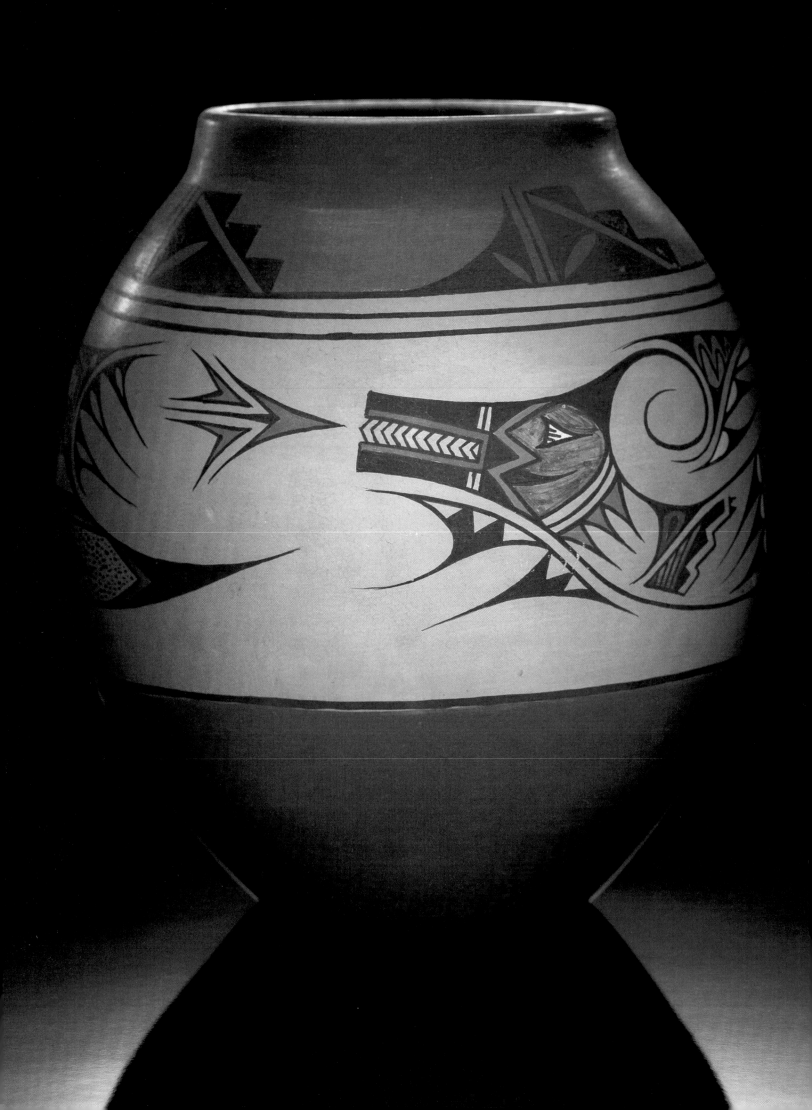

WATERS OF LIFE

Pueblo people of the high arid country in the American Southwest have been ever attuned to the critical importance of water, as reflected in the design of a polychrome painted jar (left and details above). The figure is of Avanyu, the beneficial horned water serpent. Women collecting water in earthenware jars (below) at Acoma Pueblo were photographed by Edward S. Curtis, who recalled that the men of Coronado's Spanish expedition in the 16th century had recorded "cisterns to collect snow and water on the rock of Acoma."

SANTA CLARA PUEBLO POLYCHROME REDWARE JAR, EARLY 20TH C., SIGNED BY LELA AND VAN GUTIERREZ. HEIGHT 23.2 CM; DIAM. 21 CM. 24/3732

AT THE OLD WELL OF ACOMA, 1904. PHOTO BY EDWARD S. CURTIS. P17089

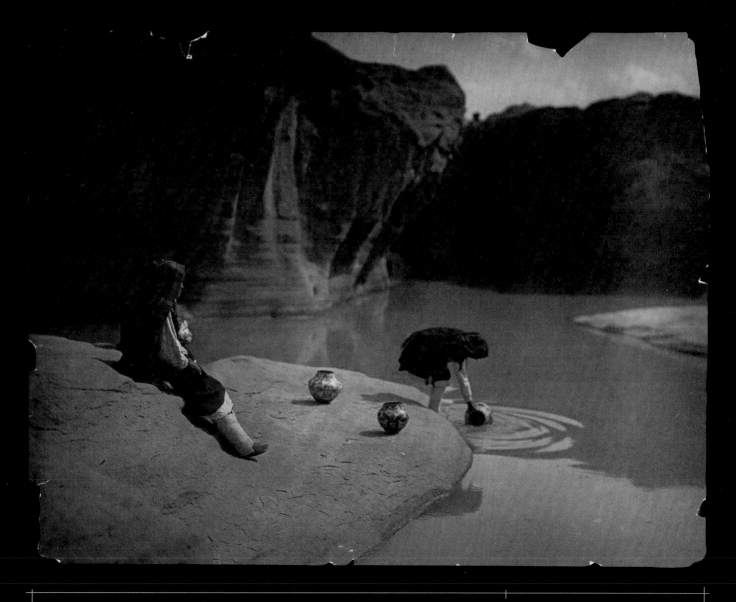

gotten to the other side. He told her that he had drunk all the water, so she tried to do the same, and overfilled her stomach. Just before she burst, her white tunic was touching the ground, which appeared as a white mist that can be seen between the hills. The fog is still a reminder of danger, the presence of Mountain Spirit's Wife that moves in the hills and valleys, obscuring our vision and tricking our sense of sound and direction. She is also a reminder of the law that people must not disturb a grave or harm the dead. To do so is to put yourself in jeopardy because the dead are not powerless. They can become upset and undo the balance of harmony in the world.[11]

Mountain Spirit and his family had broken a universal law. Many Native people believe that our dead ancestors continue to influence our lives. Saying that our relatives surround and help us, elders teach us to remember and honor the dead through good thoughts and prayers. Plateau Indians feed the spirit of the dead at funerals, and some Indians set aside a day each year to remember the dead. In southern California, the Kumeyaay, Quechan, Cocopa, and Mojave hold a sacred memorial ceremony called Karuk to entreat the dead to return to Earth and celebrate with the living. Native peoples in Central and South America honor the dead on November 2 of each year, the celebrated Day of the Dead, lighting candles in cemeteries and saying prayers for their people.

SONGS, POEM STORIES

Indian people often sing their stories. In everyday life, people sing about buffalo, salmon, dragonflies, horses, and deer. They enjoy song stories about sandstorms, hurricanes, and snowstorms. Serrano, Chemehuevi, Luiseño, and Cahuilla Indians of southern California sing about mountain sheep, acorns, and birds. In fact, the Bird Songs of many different Native peoples of the Greater Southwest are ancient stories that establish the movement of animal people, including the birds, and their relationship with human beings. The songs tell of special places and the animal people found there. Since the origins of peoples, Bird Singers have shared their songs, and they continue to sing as they watch men and women dance the Bird Dances. In Southern California, Anthony Madrigal, Leroy Miranda, Paul Apodaca, Luke Madrigal, Mark Macarro, James Ramos, and other young men carry on the tradition of Bird Songs. They keep the songs alive among the Cahuilla, Serrano, and Cupeño at social gatherings held on and off the reservations. While the Bird Singers stand singing their songs, women dancers often join them. Serrano and Cahuilla elder Pauline Murillo explains that she always supports the Bird Singers by dancing, remembering her mother, her grandmother, and all the women who came before her who danced to the ancient songs of her people. In this way, she puts the songs into motion and makes them live again.

Indians everywhere sang songs about various elements of the creation, the plants, animals, and places of Native America. Elders told stories in poetic ways to ensure their remembrance, narrating in a rhythmic manner much like singing. Year after year, they recounted the same stories. Elder storytellers created the world and its many components so the children would learn. They would then ask a child to retell a story or sing a particular song. If the child relayed the narrative incorrectly, the elder corrected him or her and asked the child to begin anew, rendering the story exactly as it had been taught. Indian people still tell stories, sometimes in formal storytellings and at other times in informal conversations. A Yakama storyteller once shared a series of stories at the tribal cultural center in Toppenish, Washington, telling of a great monster in the Columbia River that created chaos through wild, swirling eddies. In a more informal setting, Navajo elder Chancellor Damon brings people together near his home in Window Rock, Arizona, building a

fire outside and inviting people to tell stories. Storytellers spoke in Diné Bizaad and English, spinning stories long into the night, telling us tribal histories about monster slayers, corn maidens, rainbow boys, and stricken twins.

Different versions of the same creation story can exist within particular communities. Indeed, when B. N. O. Walker related his version of the Wyandot creation story to C. M. Barbeau in 1911, the scholar noted that to his knowledge nine versions of the creation story existed, including those taken down by Jesuit missionaries in the colonial period. Barbeau stated that the various versions of the story made "it clear

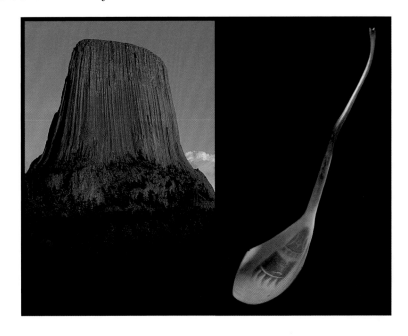

that these cosmological myths are ancient, and have not been seriously altered since the advent of Europeans." For thousands of years, Native American children heard and reheard, learned and relearned the oral narratives of their people.[12]

Different tribes attributed creative power to many animals and plants, depending on their association with particular species. Rabbit, Raven, Eagle, Deer, Turtle, Ant, and many other animal people have creative powers, and their stories are vividly woven into the lives of many contemporary Indian peoples. Corn, kouse, camas, tobacco, squash, acorns, beans, yucca fruit, mesquite, and other plants also have creative powers and appear in the stories. Corn is central to many diverse Indian peoples. The Maya say they are related to corn. Maya elder Don Francisco Caal explains that, "Our first grandparents were made of maize, and they are the four strengths." This is a belief shared by many Indian peoples from the Hopi, Navajo, and Apache of the Southwest to Wyandot of Quebec.

In many ways, Native Americans imagined themselves into being. We dared to conceive of ourselves as special people, and our diverse stories speak of the many ways we think of ourselves through our origins. Groups of people shared common languages, cultures, and histories, and in so doing they became one. Their first historical events are recorded in oral traditions, the ancient stories about the beginning of the Earth, stars, moon, and sun. The stories provide rich accounts of these origins, and they teach those who will listen about the proper ways to think and act.

RULES TO LIVE BY

The collective wisdom and belief contained in oral tradition encompasses many levels of human experience. Vivid characters are full of narrative and emotional complexity. Coyote, one of the leading creative forces in Native American narrative, is a hero and a fool, a trickster who sometimes teaches through his positive actions and sometimes through his negative behavior. He represents the human capacity to be a hero, hypocrite, and buffoon. In many American Indian stories, Coyote is present at the beginning of time. The Chemehuevi and other Southern Paiute people of southern Nevada and Utah, eastern California, and western Arizona, say they "went the way of Coyote." That is, they are human by nature, and although they admire and try to emulate the superior qualities of creatures such as Wolf, they are an earthy people who sometimes follow the positive path and sometimes the negative.

Certain stories explained the rules of nature that governed the world and Indian people. Among Indians of northern California, Oregon, Washington, and

CLOSE ENCOUNTERS

Mato Tipi (Bear's Lodge), also known as Devil's Tower (above left), America's first National Monument, is reserved during June for Native spiritual observances. In one version of its creation, seven sisters were lifted up by the formation to escape a bear whose claws left the enormous fluted gashes seen on its flanks. The sisters escaped into the sky and can be seen as the starry cluster known to astronomers as the Pleiades. Bear motifs are widespread on Indian-made objects, such as a spoon fashioned from mountain-sheep horn by an Arikara craftsperson (above), while bear and bear claw images are worked into much contemporary jewelry.

MATO TIPI (BEAR'S LODGE), WYOMING.
ARIKARA SPOON, LATE 19TH C. FORT BERTHOLD
RESERVATION, NORTH DAKOTA. 40.7 x 7.7 CM. 13/2827

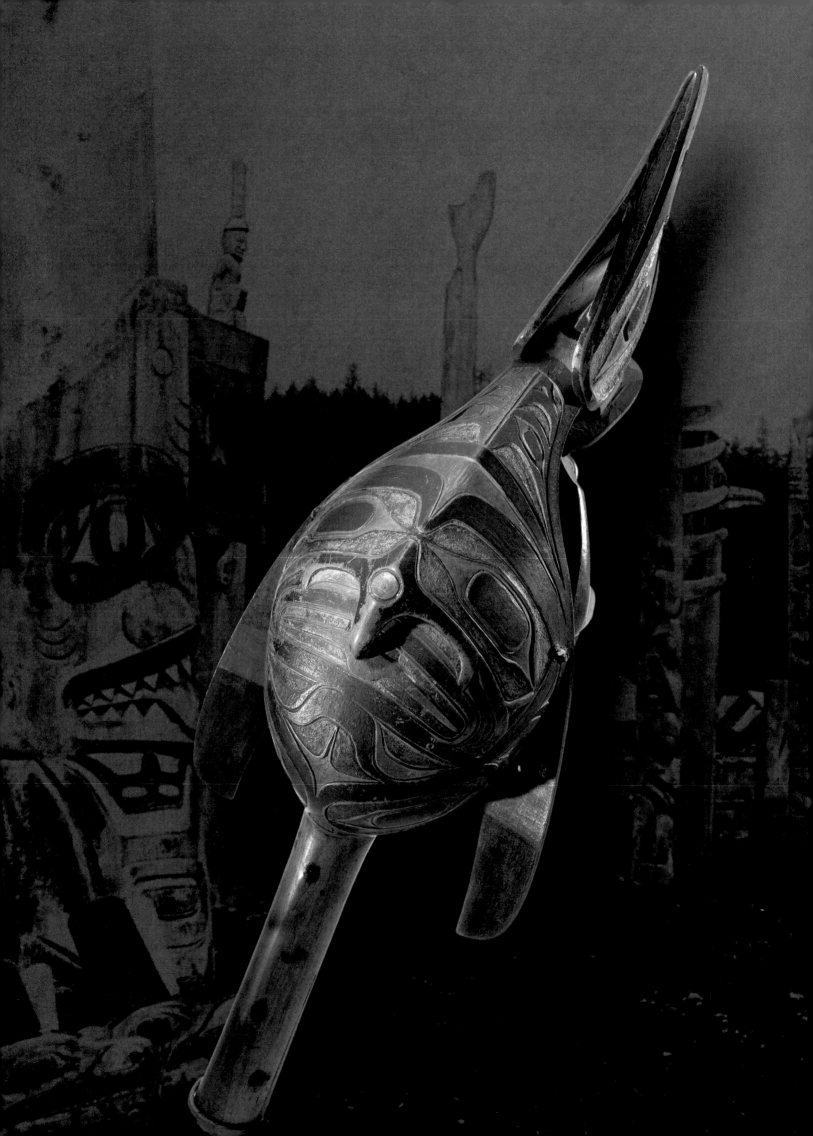

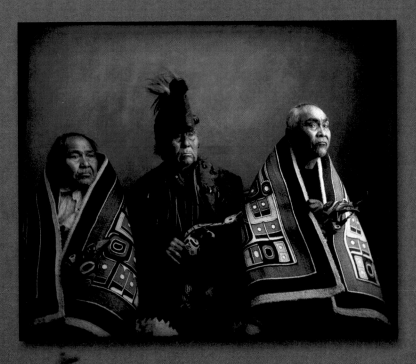

He dazzles you right out of water,
right out of the moon, the sun and fire.
Cocksure smooth talker, good looker,
Raven makes a name for himself
up and down the coast from the Nass River,
stirs things up.

Hurling the first light, it lodges
in the ceiling of the sky,
everything takes form—
creatures flee to forest animals,
hide in fur. Some choose the sea,
turn to salmon escaping.
Those remaining in the light
stand as men, dumb and full of fear.

Raven turns his head
and laughs in amazement,
then dives off the landscape,
dividing the air
into moment before
and instant after.

—Robert H. Davis (Tlingit)
from *Saginaw Bay: I Keep Going Back*

RAVEN RATTLES

To people of the Pacific Northwest Coast, Raven is the great Creator and also a great rascal. Raven stole the sun to bring light to the world; his footprints made the lakes; his greediness trapped him in a whale; stories about him spin endlessly. Raven appears on clan regalia, on totem poles (background), and on elaborately carved rattles (top view facing page and side view below) that are still shaken at contemporary dances. In earlier times Chilkat Tlingit clan leaders (left) held the rattles with beaks pointed downward, so that Raven would not fly away. The figures on rattles were not limited to Raven but also included a frog or other small animal on a man's chest. Another bird, often a kingfisher, makes Raven's tail. A creature representing a hawk/sea monster—a symbol of great wealth—marks Raven's belly.

Idaho, many believed that once there were five giant women called the Tah Tah Kleah. They disobeyed the laws of creation in many ways, showing little concern for others. In order to provide for themselves, they dammed the Columbia and other rivers of the region so that the salmon could not make their annual runs to spawn. The Tah Tah Kleah violated the laws of nature, because the Creator always intended for the salmon people to travel up the rivers to give birth to their smolt and replenish their families.

The Tah Tah Kleah thus prevented Salmon Chief from leading his people to their spawning grounds. Worried that the giants had broken the law and put many salmon-eating people in jeopardy of starvation, all of the animal people living upstream met in council to discuss the matter. In a democratic council with males and females, they decided that someone had to confront the giants and destroy the dam. But who? Cougar, Bear, Bobcat, Antelope, Deer, and Rabbit all had excuses why they could not face the Tah Tah Kleah. After much discussion, Coyote volunteered. Everyone laughed, saying that he would meet certain death. Everyone laughed again when Coyote entered his lodge and came out wearing the clothing of a small baby. Coyote placed a large woven basket in the river and climbed in, all the while sucking his thumb. He continued to suck his thumb as the Columbia's current carried him downstream. The people laughed, thinking this was the last they would see of Coyote.

The trickster floated downstream, his basket bobbing in the water near the fish dam. The five Tah Tah Kleah saw the baby and decided to adopt him, although the youngest woman warned her sisters that something was not right about this baby. They ignored her, a common mistake among siblings. They treated Coyote as their own baby, caring for and fussing over him. The next morning when they left their village to hunt, fish, and gather, they tethered their baby with a rope around his waist so that he would not harm himself. Coyote quickly gathered five digging sticks and five horn spoons. With the sticks, he began to dig out the dam each day when the giants left. For four days Coyote dug at the dam, each night returning to the village to put the rope around his waist just as the giants had left him that morning. On the fifth day, however, one of the Tah Tah Kleah broke her own digging stick. This was a sign that something was wrong, so they rushed back to the village to check on their baby. They found Coyote digging out the fish dam, and the youngest woman shook her finger at her sisters. They all made clubs and went after Coyote. As they drew back to hit him, Coyote used one hand to place a horn spoon on his head and kept digging with the other. They beat him hard, breaking the helmet, so Coyote grabbed another, until all of the helmet spoons were broken. But by then, Coyote had opened the dam, allowing a flood of fresh water from the Columbia to flow into the Pacific. His heroic deed also allowed Salmon Chief to bring his people upstream to spawn. Coyote had made the law right again.[13] Other stories remind humans not to take too many salmon people or endanger the annual salmon runs. This was the law, one that non-Indians broke many times in the twentieth century.

SUN, MOON, AND STARS

Many tribes have stories of the origin of the various constellations. The Arikara say that the stars that Euroamericans know as the Pleiades represent seven sisters chased by a black bear and raised up into the sky by a large rock known today as Mato Tipi, or Bear's Lodge (Devil's Tower in Wyoming), which pitied their plight. An Arikara artist depicted this story in a colorful incised painting of a bear's claw with celestial imagery placed on a long spoon made of mountain sheep's horn. In similar fashion, Palouse Indians have portrayed the image of the Big Dipper on pipe bags, saddles, shields, and other items. Palouse Indians say that

FISHING GROUNDS

Dip-netting for salmon at dusk from wooden platforms (near right), members of the Warm Springs Indian Reservation still fish the waters of Shears Falls on the Deschutes River, a tributary of the Columbia River in Oregon. In 1855 the Warm Springs Confederation signed a treaty that ceded some 10,000,000 acres, but retained 600,000 acres and perpetual rights to fish, hunt, gather, and pasture. The Columbia River was subsequently heavily dammed, and this has contributed to a marked decline in salmon stocks. The fishery extended to Alaska, where about a century ago a Nuwukmiut Eskimo carved an exquisite group of salmon swimming upstream (far right).

SALMON FISHING, SHEARS FALLS, OREGON.
NUWUKMIUT ESKIMO IVORY CARVING OF SALMON SWIMMING, CA. 1900. POINT BARROW, ALASKA. 17.8 X 5.5 X 3.2 CM. 5/4325

Grizzly Bear chased Five Wolf Brothers into the sky and that Coyote ran along to watch what would happen, thus creating the Big Dipper.

Sun plays a significant role in traditional oral narratives of virtually all Native Americans as a symbol of abundance, well-being, fire, strength, brilliance, and light. Most often, Sun is male, although Sun is female to the Cherokee, Inuit, and Yuchi.[14] Sun is often married to Mother Earth or Moon, but in either case, when Sun is male he is potent and powerful. Among Diné people of the American Southwest known as Navajo, Sun made love to Changing Woman while she sunned

herself after a bath. Sun had cast a spell and had coupled with her without her knowledge. This is a common motif in American Indian stories, including an Anishinaabe (Ojibwe) story of Ahki (Earth) who became pregnant when Wind lifted her skirt, allowing Sun to penetrate her body. In the Ojibwe story, Ahki gave birth to twins, including Stone Boy, the rock heated in the sweat lodge, and another culture hero named Waynaboo'zhoo.[15]

Native American art depicting Sun is common throughout the Western Hemisphere. Paintings, carvings, mosaics, drawings, pottery, and other art objects tell stories about Sun. A rare and splendid ceremonial shield found near Puebla, Mexico, is a solar disk representing the birthplace of Huitzilopochtli, the Aztec god of the Sun and of war. Thousands of small turquoise pieces arranged in a finely made mosaic cover the wooden shield. Perforations around the rim suggest that feathers may once have been attached. The shield would be carried on a circular path that describes not only the emergence of the god from the underworld, but also the birth of the Aztec nation.

Another magnificent object is a Kwakwaka'wakw (Kwakiutl) Sun Mask from Alert Bay, Vancouver Island, Canada, which would be danced ceremonially. Carved from red cedar, sacred to the Kwakwaka'wakw community, it is a mechanical mask representing a human face; upon opening, another human face is disclosed. The transformation mask may symbolize the dual elements of Sun, which on a daily level brings night and day, and annually brings summer and winter. Above the central face, the carver cut the image of a human figure surrounded by other characters. The central figure wears a head ornament with spikes of light radiating from his head.

The people known as the Kamaiura of Brazil say that Sun had a beautiful village that Red Macaw visited each day, circling and soaring in a spectacular fashion. Sun asked his brother, Moon, to come and see Red Macaw. Moon marveled at Red Macaw's beauty and reported that a tribal leader named Vanivani made macaws. Sun and Moon traveled to Vanivani's village, and the chief asked what the two brothers wanted. At first, Sun said that he and Moon were just out for a walk, but

Sun soon confessed that he and his brother wanted macaws of their own. Vanivani agreed to make them. He bled the Sun, making five circles with his blood. He did the same to Moon. Brilliant red birds emerged from the blood, and Vanivani gave Sun and Moon five each. The story links the great birds to holy people, the everlasting Sun and Moon, and creates a blood relationship between Red Macaw and the two celestial bodies, all sacred people among the Kamaiura. The story presents Sun and Moon as brothers, while for many Native groups Sun is the husband of Moon. The narrative closely links the special birds and two sky people, in a sense creating a circle connecting the winged and the people floating in the heavens.[16] Many Indian people honor the birds of their area by making them live again in beautiful artwork that incorporates their feathers, talons, and bodies. Artists also paint and carve birds on many material items important to their peoples.

MEDICINE, RITUAL, AND CEREMONY

Medicine men often learned their stories and songs by dreaming and being taught by spirits. Traditional Quechans of Arizona and California and their neighbors believe that some people actually experienced the creation through their dreams. One Quechan medicine man reported that he "was present from the very beginning, and saw and heard all." He "lived" the creation while it occurred by dreaming the creation story and learning it firsthand. After the medicine man saw, heard, and felt the creation, he awoke to relate it to his elders who either confirmed his version of creation or would say, "You have dreamed badly. This is not right." Then the Quechan would learn the story correctly. He became proficient in the origin story about Kwikumat, the Creator, and his son Kumastamho, which took four nights to tell.[17]

This Quechan medicine man learned of his destiny by dream travel. Before his birth, he "would sometimes steal out of my mother's womb while she was sleeping," traveling to the sacred mountain of Avekwame (along the Colorado River not far from present-day Needles, California) and learning to be a blowing, sucking, and rubbing doctor. Contact with non-Natives led to new diseases, and many medicine men had difficulty treating their people for smallpox, measles, cholera, whooping cough, and tuberculosis.

In the twentieth century, Quechans suffered severely from tuberculosis, so the Quechan doctor traveled to Avekwame where he found Kumastahmo spitting up blood. The spirit called to the Indian doctor: "Come here, little boy, and suck my chest." So the medicine man placed his "hands on his ribs and sucked his sickness out." As a result of this teaching, the Quechan doctor became a consumption doctor with instructions from the Creator to "lay your hands on" anyone with tuberculosis "and suck the pain out continually, and in four months he will be well." The nature of most Indian medicine centered on one's relationship with other humans, the spirit world, and tribal laws. Although Indians understood the contagious nature of new diseases, they did not understand bacteria and viruses. Indian illnesses did not travel like those brought by Europeans, Asians, and Africans. They remained within Native communities where local shamans treated them.

Indian doctors received spiritual power to diagnose, locate illness in the body, and remove the illness. They organized the power through songs, stories, paintings, and ritual acts. The Navajo enjoy a rich history and culture of medicine, and most Navajo ceremony revolves around making a person *hozho*—in harmony or whole. The causation of the illness is often a violation of tribal laws or codes. Navajo people are forbidden from touching objects struck by lightning, and Amy Kindle of Shiprock, New Mexico, once explained that "I was stricken with a big sore" because of the ill effects of lightning. Baali, a hand trembler, or diagnostician, determined

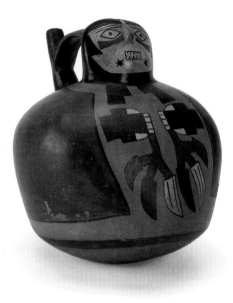

HEALING POWER

A vessel of the Nazca people, who lived in the sere coastal landscape now mainly within Peru, is a humanlike figure holding what may represent stalks of a medicinal plant. Traditional healing is still widespread on the south coast and highlands of Peru. During curing sessions, shamans may hold medicinal plants and gourd rattles, ingest hallucinogenic drugs, and invoke supernatural power. Such contemporary practices have counterpart scenes on Nazca ceramics dating to pre-Columbian times.

NAZCA POLYCHROME VESSEL, A.D. 400–600.
HEIGHT 19 CM. 24/7135

that Kindle's illness stemmed from her mother seeing lightning strike a sheep herd a few days before she gave birth. Kindle's parents hired a medicine man to conduct a Lightning Way Ceremony, which successfully removed the lightning power and cured the sore.[18]

In addition to ceremony and ritual, Native peoples throughout the Americas use plant medicines, often making medicinal teas and direct applications to heal. Many Indian people of the Southwest and northern Mexico make a tea from the creosote bush to heal sore throats and skin irritations. Eastern Woodlands Indians use the root of the sassafras tree to treat colds and stomach ailments. And Iroquoian peoples cured sailors with French explorer Jacques Cartier of scurvy by brewing a tea from the fronds of the white cedar tree. Indian peoples continue to use medicinal plants placed on the Earth at the time of their creation, and they pass down their medical knowledge through oral traditions and art forms.

MEDICINE LODGE AND SACRED PIPE

The healing power of the Earth appears in traditional stories among numerous peoples. The Tsistsistas (Cheyenne) say that the people learned the Medicine Lodge Ceremony inside the bosom of the Earth after suffering a horrendous drought. When rivers lost most of their water, trees and plants wilted, and the buffalo went away, the elder men conceived the idea that each man should ask a woman to cook him whatever food was available. A young medicine man named Horns Standing Up approached the chief's wife, and she fixed him dog soup. He told her that in a dream Maheo the Creator had directed him to take a woman on a holy journey to learn a sacred ceremony to renew the Cheyenne. The two moved north together, each night sleeping separately as the medicine man had been instructed.

The couple journeyed until they came to a forested land where a great mountain rose up to touch the clouds. They rolled away a rock at the base of the mountain and entered. There they found the mountain's great medicine lodge. For four days, the pair heard the voices of Maheo and Great Roaring Thunder, who taught them the Medicine Lodge Ceremony, known also as the Sun Dance. The holy people told them that when the Cheyenne conducted the ceremony, the sun, moon, stars, and heavens would move in harmony. They said that the rain would return and plants would turn green again. Maheo gave the man the *issiwun*, or sacred buffalo headdress, to wear during the ceremony, an object that would please Grandmother Earth and bring forth the game. After learning these things and much more, the couple left the mountain followed by a huge buffalo herd. Wearing buffalo hides painted red, the couple returned to their village, bringing the sacred ceremony and the issiwun. They shared the ceremony with the people, teaching the children to make clay figures of buffalo, elk, deer, and antelope to bring into the medicine lodge as symbols of new life. Through telling the story and conducting these rituals, the Cheyenne continue to renew the world so that the people may live.[19]

Many tribes of the Great Plains share this renewal ceremony, and they honor it to this day. They also celebrate through other ancient ceremonies brought to them by *wakan* or sacred people. Lakota people say that long ago Chief Standing Hollow Horn sent two young men to hunt. They found no signs of buffalo, so they climbed a hill where they observed a speck moving along the horizon. When it drew closer they saw that it was a beautiful woman. One man had lustful thoughts and reached out to touch her. But this woman was wakan, and lightning struck the man dead. Ptesan-Wi, White Buffalo Calf Woman, told the

PHARMACY IN HAND

Dan Smith, a Tuscarora herbalist active in the 1920s, bears a bundle for healing. A few of the plants in the Native pharmacopoeia include: rabbit tobacco (respiratory ailments), pokeweed (asthma), sassafras (fevers), calamus (many uses), bloodroot (pain), yellow dock (skin parasites), witch hazel (ulcers), lobelia (stomach ache), may apple (snakebite), wild cherry (wounds), white willow (fever), horse mint (headaches), hops (intestinal problems), wild onion (insect stings), purple coneflower (toothache).

TUSCARORA HERBALIST DAN SMITH, 1929.

other man that she had come to bring a gift from the Buffalo Nation and that he should return to his people and build a medicine lodge of twenty-four poles. She gave him other instructions before sending him back to his people. He did as she directed, and the people prepared for her.

When White Buffalo Calf Woman met Standing Hollow Horn, she instructed him and took from her bundle the *chanunpa*, or sacred pipe. Holding the stem in her right hand and bowl in her left, she filled the pipe with red willow bark tobacco, and walked around the lodge sun-wise, in a circle, four times to symbolize the sacred hoop of life. She taught them about the fire without end and that the smoke rising skyward represented the breath of Tunkashila, Grandfather Mystery. She taught the people many things, saying the pipe was a Living Prayer. The bowl represented the buffalo and flesh and blood of Indian people. Since the buffalo stood on four legs, it symbolized the universe and four sacred directions. The wood stem, she said, stood for the Earth and all that grows on her. The twelve eagle feathers attached to the stem represented Spotted Eagle, the messenger of the people, and Wakan Tanka, the creative force.

White Buffalo Calf Woman spoke to the women, reminding them of their creative power and relationship to Mother Earth. She told them that the pipe bound men and women alike in a circle of love. She showed them how the men and women should hold the pipe when they married to bind them together symbolically. White Buffalo Calf Woman told the children that they were precious, the coming generation who would keep the pipe alive and the teachings sacred. She taught all this, then left the lodge, walking some distance before rolling over four times. She changed into a black buffalo, then a brown buffalo, and then a red buffalo. Finally, she turned into a white buffalo, the most sacred of the Buffalo Nation. She had brought the people a gift and a promise that the buffalo would give of themselves so that the people might live. White Buffalo Calf Woman walked west as a four-legged one, leaving the people a holy gift that is used to this day. Before leaving, she said *"wacinyanktin ktelo,"* or "I will see you again."[20]

White Buffalo Calf Woman brought the pipe to the Sioux, and other tribes of the Great Plains. It has endured as a symbol of the relationship between the Earth and sky, temporal and spirit worlds, and plants, animals, and humans. In the summer of 2002, A'aninin elder George Horse Capture and his family gathered at the Arapaho Sun Dance in Wyoming, where he presented his youngest son with a pipe. "This is where my two older sons and I each accomplished our own Sun Dance vows, making this a very special place for us," Horse Capture explained. Through the four-day ceremony, George and his family would be "closer to Our Maker and our roots." For the Horse Capture family and many Native Americans, the gift of the pipe and Sun Dance represent a continuance and renewal of the human spirit and the relationship of people, plants, animals, and places with the gifts of creation.

Among many different Indian peoples, the songs of the Earth, medicine powers, and holy rituals keep the Earth alive and moving. The grass grows and rivers flow. With one sky above, Indians conduct many internal and external expressions of our cultural ways. We sing our songs, perform our dances, and pray. In many ways, we remember the old traditions, and by telling our stories of being, we reenter and renew our sacred circles. With each song, story, or ceremony, the Native world is re-created, linking the present with the past. In so doing, we bring ourselves into the larger circle of Indian people, nurtured by sweet medicine that lives today. Native Americans stand in the center of a sacred circle, in the middle of four directions. At this time and for all time, American Indians are in the presence of, and part of, many vast, living, and diverse Native universes.

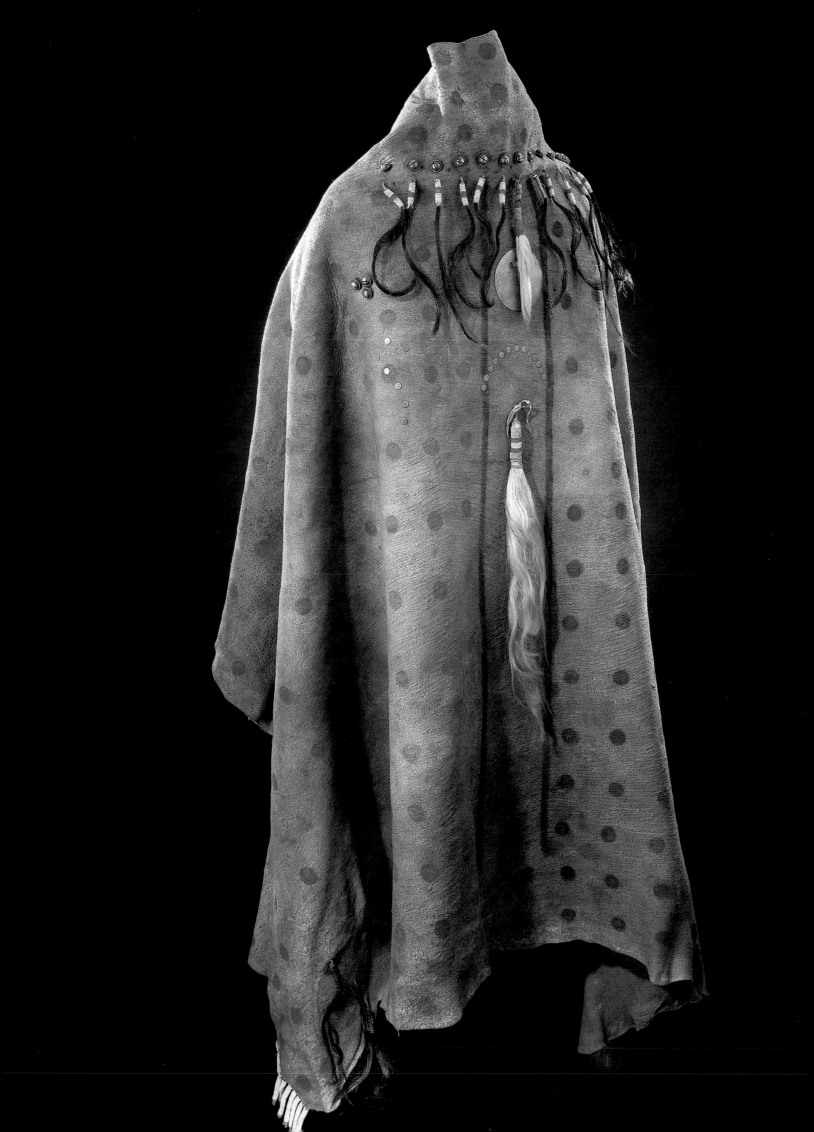

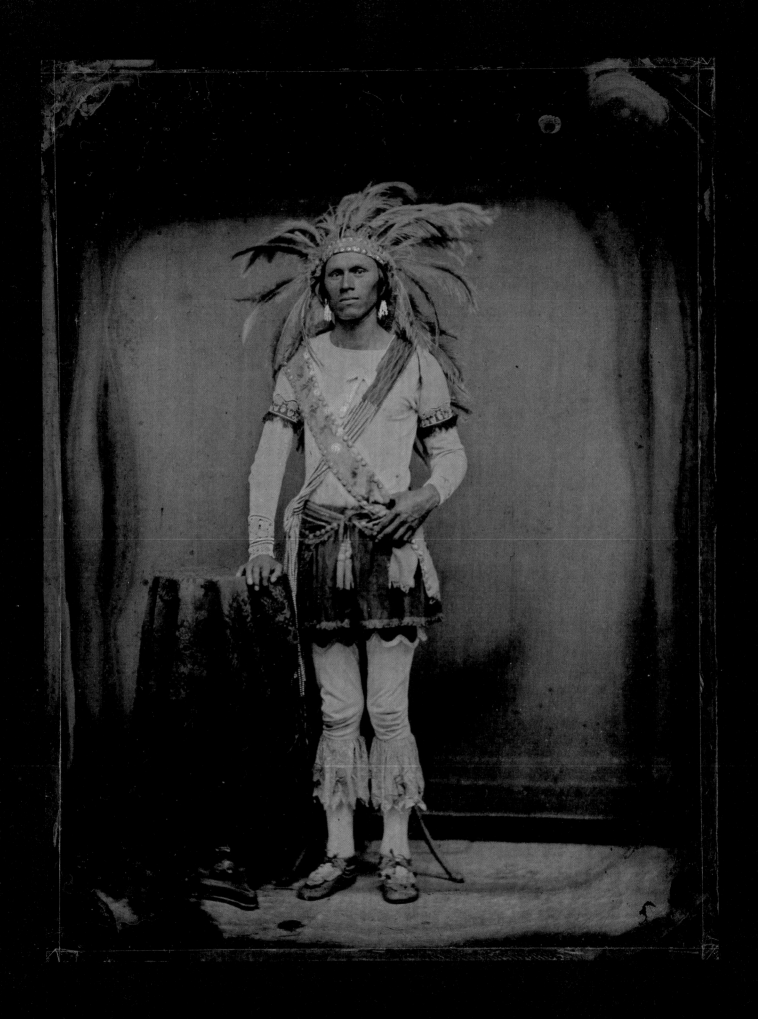

Ceremony and Ritual:
Life in Motion

John C. Mohawk

Seneca author John Mohawk invites us into a new day through the Dawn Song of his people. Contemporary Native Americans continue many ceremonies today that their ancestors conducted in the past to make the world whole and right, performing sacred rites in accordance with ancient laws established when the Earth was young and known through story, song, prayer, and practice. Ceremony and ritual keep the world in motion, perpetuating life through gifts and thanksgiving. Mohawk provides examples to illustrate the place of ceremony, including the Tablita Dance of Santa Clara Pueblo in New Mexico.

Native Americans give thanks in other ways, making prayers through medicine bundles, feathers, sticks, tobacco, dances, stories, and masks. The Yup'ik of Alaska are master mask-makers, creating a variety of intricate masks that have meaning and play important roles within communities. Mohawk offers examples of various Yup'ik ceremonies and specific masks such as the *Negakfok* representing the cold north wind and *Isanuk*, the spirit of the walrus. He also takes us into the culture of the Hupa of northern California, introducing us to the Jump Dance and the sacred White Deerskin Ceremony. Health, well-being, and honor are much a part of these and other ceremonies, not just for the participants but for people throughout the world. The Hupa pray and sing for others, as they pray for themselves. Through all of these ceremonies, the Hupa entreat the spirits of the dead to be a part of contemporary ceremony. Ceremonies provide the means for people to give thanks, ask for help, and renew their relationship with the temporal and spiritual worlds around them.

SACHEM NISHANEANENT (CHAUNCEY ABRAMS) OF THE TONAWANDA SENECA, 19TH C. AMBROTYPE PRINT. P08167

O N A COLD JANUARY MORNING, ABOUT AN HOUR BEFORE THE FIRST light of day, darkness was part of an unfolding moment. A crowd had gathered not far from the longhouse—the community's traditional ceremonial lodge on Seneca territory. At the appropriate time, someone lit a pile of dry wood, and as the sparks began to fly skyward, we moved closer to the heat, stamping our feet against the cold.

Then we heard it, at first faintly, and then rising. Song filled the air, and soon we saw three men emerging like dark shadows in the gray morning light, their voices strong. When they had arrived, an orator, carrying a tobacco basket, began to speak. He threw sacred tobacco into the fire, and the smoke carried his words to the world above, as it did for prayers from the entire group. When the oration ended, bright yellow sunlight reached the tops of the tallest trees nearby, signifying another day, another year—the continuation of life on Earth.

For countless generations, this ceremony, *Kanieo:wi,* or Dawn Song, has been performed among my people, the Haudenosaunee. (The traditional communities of the Six Nations or Iroquois, composed of the Seneca, Cayuga, Onondaga, Oneida, and Mohawk peoples, and since around 1721 the Tuscarora, refer to themselves as the Haudenosaunee—People of the Longhouse.) Today it is the opening ceremony of a cycle of thanksgiving that so characterizes Seneca society, past and present. The Dawn Song is a Midwinter Ceremony, and its origins date back to the time of Iroquoian creation when the people reported to the Great Creator the plans for the upcoming ceremonial year. The thanksgiving speech given during the ceremony also acknowledged the gifts of creation that support all life and sustain the lives of the Haudenosaunee. About two hundred years ago, the people developed the thanksgiving speech of Midwinter into the Dawn Song to greet the day and begin the new year.

For the Haudenosaunee, the Dawn Song marks the beginning of the annual ceremonial calendar, a time filled with songs, dances, ceremonies, and ritual acts offering thanks to the Creator and the creation for the good life on this Earth. Long before the arrival of the Pilgrims in 1620 and the "First Thanksgiving," Indian people throughout the Western Hemisphere gave thanks continually for the bounty of the Earth, the gifts of creation.

SANTA CLARA CEREMONIES

In the American Southwest, Tewa-speaking people of Santa Clara continue to conduct ceremonies that have been a part of their culture since the beginning of time. Like other Pueblos of Arizona and New Mexico, those at Santa Clara hold most of their ceremonies in private. Entering and understanding the complex ceremonial world of any people is difficult, but even members of the Santa Clara community are not able to know full details of many of their ceremonies. Sacred knowledge is given only to certain individuals and groups. This is true in all Native American societies,

but the ceremonial world of Santa Clara people and other Pueblos is incredibly sophisticated and layered. The people separate their ceremonial calendar into summer and winter events when moieties and societies conduct initiation, pledging, and induction ceremonies.

At Santa Clara, Summer and Winter moieties as well as summer and winter katsina societies exist that conduct ceremonies biannually. The people perform Solstice Ceremonies, Salt Gathering Rites, Basket Dances, Buffalo Dances, Mountain Sheep Dances, and Deer Dances. Some of the more commonly known dances include the Hoop Dance, Butterfly Dance, and Eagle Dance. The people are also known for their Bow and Arrow Dances, Shield Dances, Pipe Dances, and Rainbow Dances. All of the ceremonies and dances are sacred in the larger sense of the word, but some are far more religious than others, and one of the best known at Santa Clara Pueblo is the Tablita Dance, or Corn Dance.

SANTA CLARA PUEBLO TABLITA

The Tablita is a communal dance, asking for good weather, rain, and bountiful crops. "All the dances," one person from Santa Clara explained, "were for happiness and good crops. You were supposed to think of these things when you danced." Another person remarked, "You never get something for nothing. You ought to do something for what you get." Thus, the Pueblos dance "for what you received." Through the ceremony, the dancers and their community ask the creative forces to bless the people with corn. The people view the Tablita as "something beautiful" that is always in "the mind of all dancers."[1]

Although the number of Tablita dancers varies, an equal number of men and

women are paired in two parallel lines. They are young people past puberty, and no elders dance, likely symbolic of young corn plants that contain both male and female properties. The people usually hold the ceremony in the spring just before planting, and the Big Dance begins at midday, continuing until nightfall. The women are dressed in mantas worn over brightly colored dresses, and they wear bright white wrapped leather moccasins, stepping lightly on the earth as they dance. On their heads, each woman wears a wooden tablita, a terraced headpiece painted an orange-yellow at the top and turquoise blue at the bottom. On the uppermost portions of

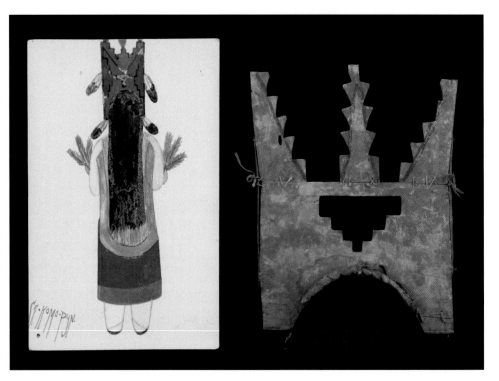

the headdress are eagle down feathers. The common name for the dance comes from these beautiful art forms alive with movement.

The men move with grace beside the women. Some have their upper bodies painted yellow, while for others the color is blue gray. On their chests the men have dots or short lines painted in white. Their hands and upper legs are painted white, and each man wears a white kilt embroidered with beautiful geometric designs. The kilts are secured with broad woven white belts, with a foxtail in the back. The men sport blue or white armbands holding freshly cut spruce sprigs. Some wear bells, and all are in moccasins. During the Tablita Ceremony, men display rosettes of feathers on their heads, including parrot feathers. In their right hand, they carry flat gourd rattles, and in their left hand, they carry evergreens. In unison, the women and men dance to the beat of a large round drum with a deep tone. Near this yellow-and-black-painted drum, a group of singers provides songs that mix with the dancers' movement, music, footsteps, and actions to make the ceremony come alive.[2]

DANCING YUP'IK MASKS

Balance among mankind, medicine, natural forces, and unseen spirits has a special place in many Native cultures, including the Yup'ik (from *yuk*, meaning person, and *pik*, meaning real). The Yup'ik people are part of the larger Inuit (Eskimo) culture and live in Alaska along the Pacific. They have a rich culture tied to a strong ceremonial cycle that begins with the *Ingulaq*, or harvest festival. Yup'ik

people traditionally celebrated six major ceremonies, the most important of which re-create the relationship of human beings with the spirit world. Ceremonies of the past, which provide a historical link to the present, effectively bring the world into balance through song, music, and dance. A significant element is the making, dancing, displaying, and wearing of masks. Drums and whistles provide the music in Yup'ik ceremonies, offering the heartbeat and shrill sounds of spirit voices. Dance puts the songs, stories, traditions, and music into motion, projecting them into the visual realm.[3]

The Yup'ik also celebrate the Bladder Festival, Feast for the Dead, and annual masked dances. During these ceremonies, the people invite, host, feast, and thank all the spirit, human, and animal dead who were and are today part of their lives. The Yup'ik share this belief with many Native nations throughout the Americas, and they use masks as reminders of the various "peoples" who are a part of their communities. For them "everything has personhood—every animal, every plant, every stone—and human thought and deed constantly take this shared personhood into account." Everything is part of creation, and as Yup'ik elder Paul John explained, "everything has *yuk* [person or personhood]."[4] Traditional Yup'ik people believe that at one time the earth was "thin" and its elements had a greater relationship with one another, speaking with one another, and marrying one another. "It is believed," scholar Edward William Nelson wrote in 1899, that "all animate beings had a dual existence, becoming at will either like man or the animal forms."[5]

The *Negakfok* mask represents the cold north wind. The large tube under its mouth and chin suggests wind blowing hard from the north, driving polar air into the atmosphere and bringing freezing winds and blinding snow. Indeed, the spirit of Negakfok enjoys the cold and wants nothing more than to bring stormy weather to the lands of Yup'ik people. In recognition of Negakfok's power, the people use the mask in the March dances, in part to honor the spirit but also to announce publicly that the spirit is about to recede with the coming spring. This is why the expression painted and cut on this mask indicates surprise and disappointment; having had its way for several months, it realizes that soon it must retreat.

With the approach of spring, the Yup'ik look to *Chalarok*, the spirit of the east wind and other good winds, for favorable hunting and weather. This oblong mask with droopy eyes and toothy mouth is painted gray blue, the color of rain clouds. White dots on the mask's forehead and chin are reminiscent of hail or rain drops. On each of its cheeks, the Chalarok mask sports a hand with fingers reaching out and a hole in each to allow the wind to flow through, bringing rain clouds, warm spring winds, and rain.[6]

Yup'ik also dance with *Isanuk*, the mask representing the walrus spirit. After the spring thaw, hunters leave their homes for the ocean in search of walrus, sea lions, and seals. Through the mask, Yup'ik request the help of Isanuk, the walrus, asking the spirit to drive the sea animals closer to shore where the hunters may take them more easily. Like all Native hunting peoples, the Yup'ik observe a spiritual side to killing animals, asking the help of key spirits who aid hunters so that the people may live. In similar fashion, Yup'ik dance with the *Andlu* mask, representing the muskrat spirit.[7]

Yup'ik hunters kill muskrats in the spring, and they tan their hides and make fur clothing. The spirit is responsible for providing muskrats for the people, so they dance the mask in honor of Andlu. The mask is quite complex, containing a round center face with two eyes, nose, and mouth containing four large front teeth, just like muskrats. Below the muskrat's chin is a short staff with four disks attached, representing the bubbles muskrats produce when they are underwater. And below

DANCES OF THE SEASONS

Kiva steps, evergreen branches, and mountain designs are depicted on a tablita, or woman's carved wood headdress, from Santa Clara Pueblo (opposite, right), which was worn in ceremonial dances of the Summer society. That society shared responsibility for the community's well-being with the Winter society. Richly colored clothing was worn with the tablita, as seen in a striking painting (opposite, left) depicting a woman dancer of Santa Clara Pueblo. Each member of the two societies of various pueblos—women, men, and children alike—participated in dances set according to ceremonial calendars.

SANTA CLARA PUEBLO TABLITA HEADDRESS, EARLY 20TH C. WOOD, PAINT, VEGETAL MATTER, 32 X 26.4 CM. 9/294

CE KOMO PYN (SANTA CLARA PUEBLO), WOMAN TABLITA DANCER. PAPER, WATERCOLOR PAINT. HAND PRINTED, TINTED, AND SIGNED, 14 X 9 CM. 23/3362

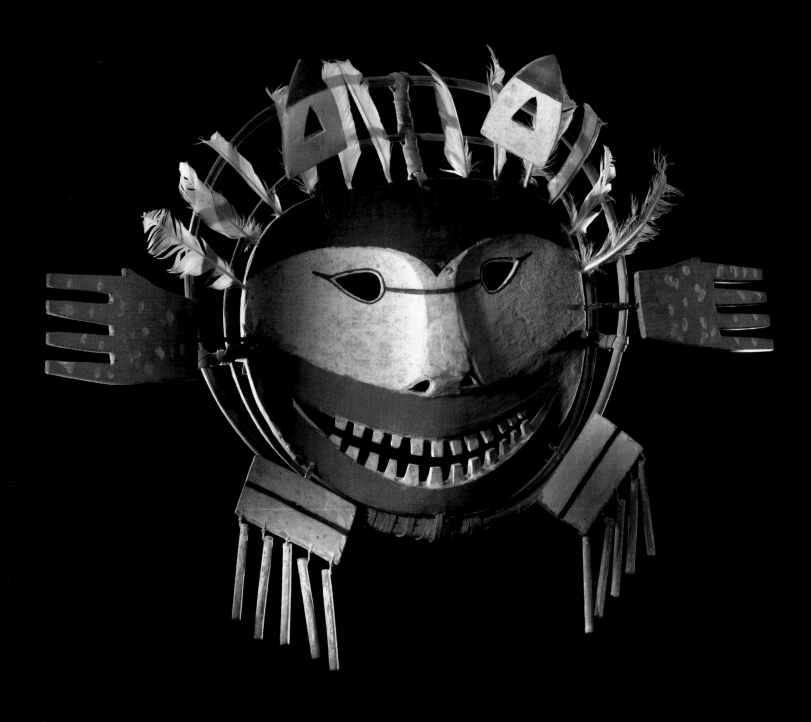

POWER MASKS

According to the account of Paul John, a Yup'ik Elder: "...Since our ancestors were created by Ellam Yua (Creator of the Universe), they created masks to honor life [and this knowledge] was passed down from ancient times.... People used the masks (*agayut*) to have communion with Ellam Yua and ask for things they needed.... And their faith and confidence in the use of the mask as prayers was manifested when things they had asked for were granted...land and ocean animals, edible plants, berries, birds.... Masks were used in healing a sick person... they also honored the winds and asked for good hunting weather." (Above) *Amekak* is a spirit that lives in the ground. He will jump through a man he dislikes. He leaves no mark, but the man lies down and dies. (Opposite, top left) *Negakfok* is the cold weather spirit and has a sad expression because spring approaches. (Opposite, top right) When the mask of *Andlu*, the muskrat god, is turned downward, it represents a muskrat house. The white face has four large front teeth, the same as muskrats. The god provides muskrats whose skins are used for clothing. (Opposite, bottom left) A mask representing *Isanuk*, the spirit of the walrus. (Opposite, bottom right) This spirit helps the medicine man heal the sick.

YUP'IK MASKS, CA. 1905. ALASKA. WOOD, PAINT, FEATHERS. 9/3421, 9/3431, 9/3403, 9/3398, AND 9/3419.

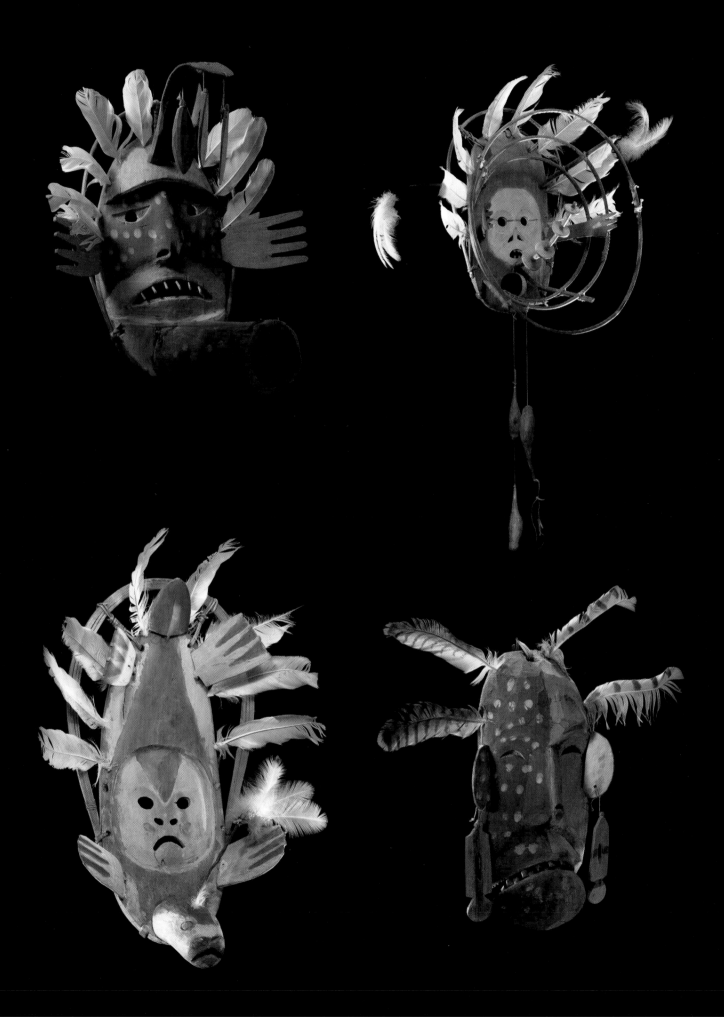

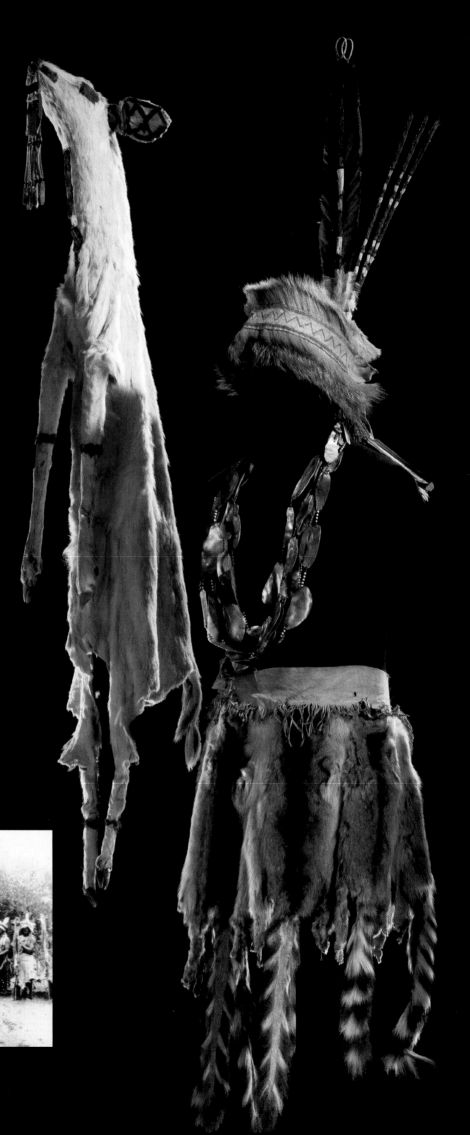

RENEWAL DANCES

The Hupa people living along the lower course of California's Trinity River perform ritual dances to renew the world and to prevent disease, famine, or other disasters. Before the White Deerskin Ceremony can begin, fish, game, acorns, and other foods must be gathered. The dancers (below), here arrayed in 1890, progress through different locations over the course of ten days. Their elaborate costumes are made from such elements as a white deerskin (near right), a wolf-fur headband (far right) with eagle feather plumes above it, an abalone necklace (beneath the headband) and a skirt made of ringtail cat fur and hide (bottom). The Hupa today maintain their traditions and are the most populous Native group in California.

HUPA DEER DANCE, 1890. CALIFORNIA.
PHOTO BY COL. C. E. WOODRUFF. N11789

HUPA WHITE DEERSKIN DANCE REGALIA, EARLY 20TH C.
12/2866, 1209, 1/2536, 24/9099, 4/1439, 5/810, AND 5/2345

the staff is a large hole with wood representing water hemlock, the food of the muskrat, attached with sinew. By honoring the muskrat through the Andlu mask, Yup'ik ask for a good hunt that will offer the people many muskrats. The people danced other masks to ensure good hunting of caribou, bears, seals, fish, and other animals they ate or used for clothing. At one time, all of the songs sung honoring the spirits had stories associated with the masks, including this one by Yup'ik singer Nicholai Berlin: "In the land behind it back there / Look around and see / Two young caribou / The two you promised me."[8]

At Yup'ik ceremonies, elders want the people to know the meaning of the masks and to share this cultural knowledge with future generations, keeping the masks, dances, songs, ceremonies, and stories alive. Thousands of masks exist, representing a number of different spirits, including *Amekak*. The mask of this spirit is horizontal and oblong of gray, white, and red. It appears with smiling teeth and a row of feathers on its head, encircled by two wooden rings to which hands and feet are affixed. Amekak is a mischievous mask, representing a being that swims within the earth and has the ability to come out of the ground without detection. If this spirit enters a human's body, it can swim about making the person weak and even killing its host. In recognition of this powerful force, the Yup'ik honor it through the mask, dancing it and asking the spirit to be kind to the people.[9]

When Amekak and other harmful spirits affect the lives of people, the Yup'ik turn to their *angalkut*, or medicine people, for help. Such healers continue to be important among many Native peoples, and they call on a variety of powers to help put their patients back into balance. Some use the power of masks to help them in their healing, but rather than wear the mask (such as the one seen on page 53) the healer hangs it from the wall or ceiling near the patient. The mask represents the dualities of human life—light and darkness, health and illness, the conscious and unconscious that can either enlighten or confuse. All need help from the spirit world, and Yup'ik call on medicine people who use masks to help ensure and secure good health.[10]

HUPA JUMP DANCE AND WHITE DEERSKIN CEREMONIES

The Hupa people of northern California perform ceremonies that help their community renew itself every two years by entreating the power of the spiritual world. Traditional Hupa conduct the Jump Dance to ward off disease and disaster. In their creation story, an ominous cloud containing sickness and disease appeared in the eastern sky, so Yimantuwinyai, the principal spirit being, instructed other spirits, the Kixunai, to hold a special dance to defend against the cloud. They noticed that with each song and dance, the cloud receded. They danced for two periods of time, each five days in length, until on the tenth day the cloud disappeared, and the community was spared the ravages of pestilence.

The Jump Dance proved so successful that the Hupa adopted it as a means of fending off negative power that could harm the people. It is an elaborate and beautiful ceremony that involves men, women, and children. They conduct the dance for ten days, and then it is the Kixunai's turn to dance. In this way, the community is protected in the years to come. The people watch for a sign that the Kixunai approved of the dance. If rains visit Hupa lands, it is a sign that the earth is renewed and cleansed.[11]

During the Jump Dance, Hupa wear elaborate regalia made of elements of their rich environment. Male dancers wear bright red headdresses made of white deer belly and large bands of red woodpecker scalps and mallard duck feathers,

which fit tightly on the head with the end flaps loose so that they swing back and forth like the wings of a bird. They also wear *kaseiko* headdresses tied around the head with a flap hanging down the back, colorfully painted in red, blue, or other bright colors. Depending on the color of the design, there may be blue jay, white dove, grouse, and flicker feathers at the bottom of the headdress. Men also wear deer hides around their waists, abalone necklaces, and other items. Women wear leather dance dresses, bear grass skirts, a colorful sash from the left shoulder made of hundreds of acorn woodpecker scalps, and necklaces made of dentalium shells. Standing in a line,

the dancers begin a slow rhythm by raising a basket above their shoulders and stamping one foot. Women dancers lift up their bodies in two motions, following the beat of the song, making themselves rise toward the sky but keeping their toes planted in the earth. Two singers stand on each side of the center man, who leads the dance by stepping forward and keeping rhythm with the song.

The White Deerskin Dance is perhaps the most dramatic of the Hupa ceremonies. The "purpose of the dance is to wipe out the evil brought into the world by

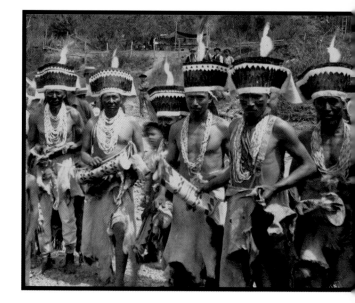

members of the society who have broken taboos. In this way it is a purification or world-renewal ceremony as no other Hupa dance is."[12] As in all Hupa dances, those participating have knowledge about the ceremony that is not shared with the public. The central dancers include a singer and two helpers. Male dancers stand in a line holding white deerskins on poles. To the side and front of the dancers are two hook men who wear sea lion tusk headbands and headpieces made of woven iris, and use crane leg bone whistles. Each hook man carries a long obsidian blade and a decorated otter skin filled with river willows. During the first part of the ceremony, the hook men kneel until they begin to move in time to the song in front of the dancers, switching sides and holding their large obsidian knives skyward as if cutting the universe vertically. When they reach the opposite side, they cut the universe horizontally. Thus they open the world between man and spirit and bring the dancers and participants into the presence of the holy ones.

Deer dancers wear a short headband of wolf fur, concealing the dancer's forehead and eyes. The singers have a ringtail fur skirt and eagle feather plumes. The dancers hold a large pole that supports a white or rare colored deerhide, ornamented with red woodpecker scalps, black woodpecker tails, and eagle feathers. Dancers stuff the deerskins with rolled oats, and they attach the entire skin, head, and legs to the poles that the dancers raise during the ceremony making them come alive again.

At the close of the third day of the ten-day White Deerskin Ceremony, the people perform the Boat Dance. Hook men with their hands and faces painted black lay the deer poles across the top of four canoes, tying them together. As the men peer into the water as if looking for something long gone, singers share the Boat Dance song while crossing to the other side, the hook men blowing their whistles over the water. They symbolically move across the boundaries of the world from one level of being to another. When they arrive on the other side, the dancers conduct a

contrary dance, doing things backward and incorrectly on purpose, perhaps to demonstrate their human, imperfect nature.

The last day of the White Deerskin Ceremony is characterized by greater veneration, because the Kixunai have returned to watch, and the people must fast and stay on their best behavior. At the conclusion of the human element of the ceremony, the Kixunai take over, doing their work on behalf of the people. The earth is renewed, the world prepared for another year of life in accordance with Hupa law.[13]

REMEMBERING OUR PLACE IN THE UNIVERSE

In the creation story of my people, the Haudenosaunee, two ancestral twins from the Sky World—Flint, the spirit of ice or winter, and Skyholder, called the Giver of Life and Creator of Human Life, struggle for predominance on Earth. Skyholder preserves the fragile life forms he has created by winning a game in which six peach stones, each colored on one side, are shaken in a bowl. The victory of the life-giving twin is celebrated in the *Kanehweko:wa:h*, the Great Gamble for Life, which is one of the sacred ceremonies of Haudenosaunee traditional religion. In some longhouses today, it is played with great enthusiasm, with cheering voices of birds and animals, as in the beginning of time. Other Haudenosaunee stories tell of the Faces (*Kako:sah*), spirits of the forest who also provide medicine for the sick and infirm, and songs and dances that are to be used in celebration at the time of the ceremonials of thanksgiving. There are, in all, four sacred ceremonies central to Haudenosaunee practice: the Great Feather Dance; the Drum Feather Dance; the Great Gamble or Peachstone Game; and the Personal Song, or *Adonweh*. It is said by the elders that the beings of the Sky World are continuously performing the Four Sacred Ceremonies.[14]

Indian people from the Arctic to the tip of South America use ceremony to bless and balance their relationship with the world around them and the invisible realm of spirits. The people give thanks for their lives, families, and peoples. They thank the plants and animals for providing foods that nourish them. They thank the Creator for their place on Earth and within the cosmos. Through ritual and ceremony, American Indians form and re-create their relationship with spiritual powers, and they link themselves with the dead, asking for help in coping with life's many trials. Spirits abound in Indian Country, influencing everyday life in all quarters of the Native universe. Unseen powers still exist, and Indian people call on this spirit power through hundreds of ceremonies that are alive today with songs, dances, music, and motion.

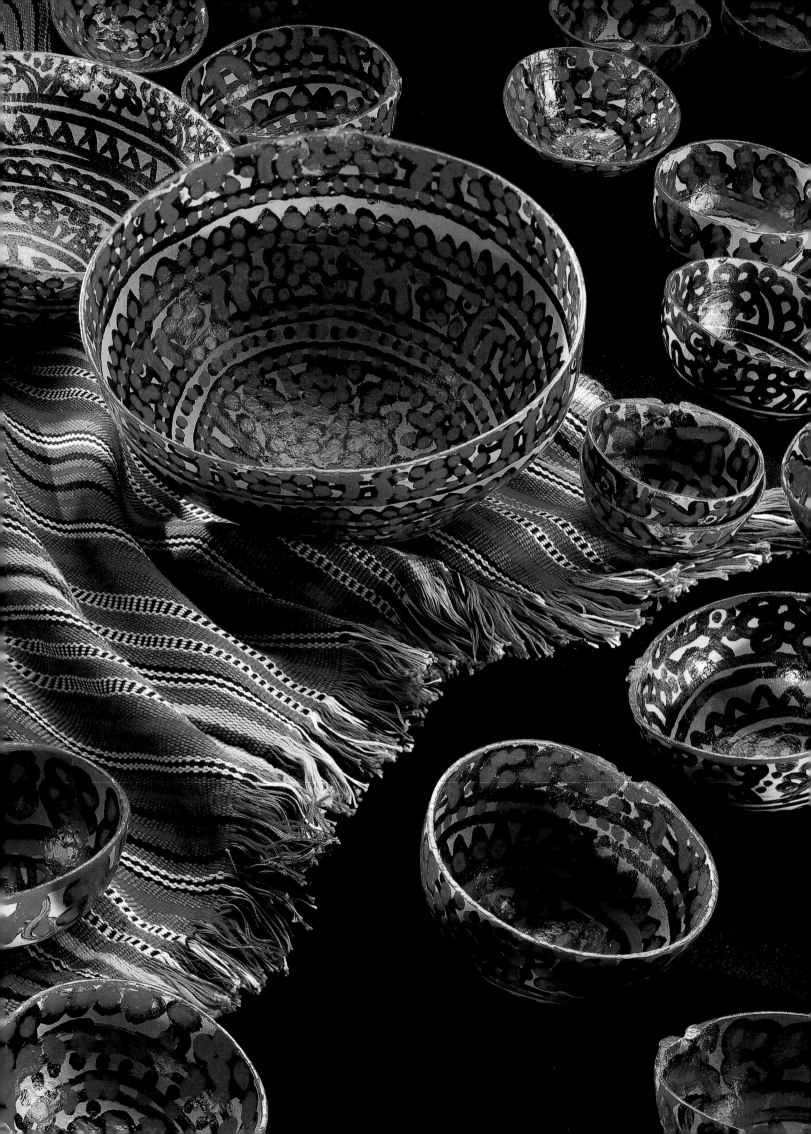

Heart of Heaven, Heart of Earth:
The Maya Worldview

Victor Montejo

The Maya are composed of many diverse peoples who share a similar culture. They also share a rich and profound past that ties the people to each other and to the larger world. Traditional stories of their creation and development still have meaning today, particularly those that connect the people to corn. Maya author and scholar Victor Montejo tells us that corn—most significant to the Maya as food and an integral part of their communities—originated in the valleys of Central America. Maya know about the holy connection between themselves and corn through the ancient teachings of the *Popol Vuh*, the sacred Maya text that links the creation of humans to corn, the essence of life for the Maya and many others. Every part of the corn plant has special meaning for Native peoples across the hemisphere who view the plant as a spirit.

By focusing on corn, Montejo shares a common truth about historical and contemporary Native peoples who personify plants and animals that are integral to understanding their world. These spiritual relationships remain central to numerous Indian peoples, including contemporary Maya. Montejo invites readers to enter a portion of his world by sharing a prayer Maya offer to Tzuultaq'a, the spirit of the earth. When the Maya approach their fields, they do so with great reverence. The people believe that Tzuultaq'a is nestled in the hills, mountains, and valleys surrounding their ancient land, and they pray to this power that surrounds their world. But, Montejo informs us, some peoples and communities have abandoned elements of their culture, in part because of cultural change linked to migration and a developing market economy. He concludes, however, that the spirit of traditional beliefs is still alive among Native Americans throughout the Western Hemisphere.

MAYA PAINTED AND LACQUERED GOURD BOWLS AND COTTON CLOTH WRAPPING, 2000. 25/5162

MAYA CULTURE CONTINUES TO AMAZE US AS WE LEARN MORE ABOUT its past and present history. Early Mayanists have told us that the Maya were members of a great civilization of pre-Columbian America that flourished from A.D. 250–900 (Classic period) in an enormous territory that is now Guatemala, Belize, and El Salvador, and parts of Honduras and Mexico, building large temples, ceremonial plazas, and palaces, and creating highly accurate calendars. Above all, they discovered the mathematical uses of the zero and created a written hieroglyphic language that eluded real decipherment until recently. The Maya landscape is punctuated with multitudes of astonishing carved monuments called stelae. Inscribed with glyphic texts and sculpted images, they remain as pages in stone that speak of the cosmic order of the Maya.

Ancient Maya culture looms powerfully, and practically overshadows the cultural and intellectual expressions of the contemporary Maya. Obviously, the achievements of the ancient Maya are exceptional. But if we focus our attention solely on the ancient Maya, we miss something equally important, the knowledge and creativity of the contemporary Maya. Those who have visited the Maya region and archaeological sites know that Maya culture is still alive and that the language is used to pass on oral histories to younger generations. Numbering about six million, today's Maya constitute many different ethnic groups who speak around thirty different languages. The descendants of those ancient Maya have much to offer the world, too, in terms of knowledge about a balanced and reciprocal relationship with the environment. We should open our eyes and see more than what standard tourists enjoy looking at: ancient ruins or "colorful" Indian images sold on postcards.

FOUNDATIONS OF THE MAYA WORLDVIEW

The *Popol Vuh*, or "Council Book," the sacred book of the Maya, is the key document that can help us understand Maya cosmology and the concept of human interrelationship with other living beings. This sacred text is believed to have been written in glyphs in pre-Columbian times and perhaps the original was lost or destroyed during the Spanish conquest. While its precise date of composition and authors are unknown, the version that we know was written in Mayan language after the invasion of the Spanish by a Maya who learned how to read and write with Roman characters. This version was also lost until Friar Francisco Ximénez discovered the manuscript and translated it into Spanish during the early eighteenth century. Sometimes called the Bible of the New World, this extraordinary holy book tells the Maya story of creation.

In the *Popol Vuh*, the Creator and Maker, also known as the Heart of Heaven and Heart of Earth, names all of the creatures on Earth and provides them with their habitat. Humans were not created first, but rather plants and animals that later helped in the creation of human beings. In this process of creation, humans

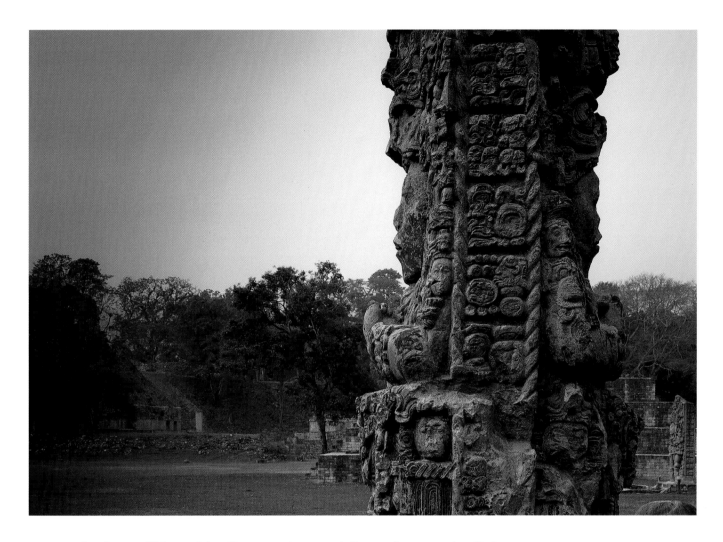

were made of corn. This explains the respect, appreciation, and compassion that Maya have toward the plants and animals for which they pray and perform rituals every Maya New Year. This tri-dimensional relationship—humans, environment, and the supernatural world—is the foundation of a religious tradition that emphasizes respect for all life on Earth. Thus, the *Popol Vuh* tells us that animals found the corn that formed the first people:

> The corn used to create the first men was found in the place called Paxil and K'ayala'. Yak the wild cat, Utiu the coyote, K'el the parrot, and Joj the crow were the creatures who discovered this food. They were the ones who showed the way to Paxil so that the corn could be brought back…. Then, our makers Tepew and Q'uk'umatz began discussing the creation of our first mother and father. Their flesh was made of white and yellow corn. The arms and legs of the four men were made of corn meal. Then, Grandmother Ixmukane ground the white and yellow ears of corn to make enough gruel to fill nine gourds to provide strength, muscle and power to the four new men.[1]

In this passage of the *Popol Vuh* we can see the role of plants (corn) and animals (those who found the corn) in creating humans and giving them strength to live. This is a metaphorical expression of the interrelationship and dependency among humans, plants, and animals necessary for survival on Earth. In this way, we can argue that creation for the Mayas was not anthropocentric, but ecocentric. Despite being created as the most intelligent among all creatures, humans were not given supremacy over creation. According to Maya creation stories, the first ancestors created were very thankful for the gift of life. As soon as they opened their eyes

and saw the plentitude of earth, they began to give thanks: "We are truly grateful to you, many times over, O Creator and Maker. We've been created with a mouth and a face. We can speak, hear, think and walk. We can grasp objects and recognize those things both near and far from us. We can also see the large and small things in the sky and the four corners of the earth. We give you thanks, O Creator and Maker, for the life you have given us."[2]

OUR MOTHER CORN

Corn, or maize, which originated in the fertile valleys of Central America 10,000 years ago when it was cultivated from the wild teosinte plant, plays a central role in Maya culture. It is considered a sacred substance (*komi' ixim* or our mother corn), and traditionally men and women showed it extraordinary respect. There is a belief that if kernels of corn were abandoned at the edge of rivers where women wash corn, those abandoned kernels would cry as forsaken babies. According to the oral tradition of the Jakaltek Maya (the Maya group to which I belong), the First Father distributed the corn among the leaders of other, distant communities and thus it spread across this continent. As corn was shared throughout the Indian Americas, it became a staple of life and assumed a central place in many Native American rituals and beliefs. Later, with the Spanish invasion of the Americas, corn reached around the world. Just as corn did, contemporary Mayas (men made of corn according to the *Popol Vuh*) are spreading around the world as a result of migration and transnationalism.

Although the relationship between humans and corn has been considered sacred since the beginning of creation, in many Maya communities today traditional corn seeds are being rejected in favor of foreign and commercial seeds, and export crops such as coffee are replacing the cultivation of corn. Industrial corn varieties are hybrids that tend toward uniformity, while the indigenous corn has high genetic biodiversity and is well adapted to the microclimates of the myriad valleys where it has been farmed. I remember my father cultivating a type of corn called *tewah* (corn hard as wood), which was very hardy. Even if a farmer became sick and could not weed his cornfield, he was always able to harvest some corn, since this type was resistant to drought and weeds, and was well suited to the climate. Some elders are now predicting that the spirit of corn will disappear from the land of the Maya because the teachings of the ancestors are being forgotten. The ancestors will collect the corn and seeds that once were cherished by the Maya and hide them inside a hill, since Maya do not respect corn now as they did in the past.

While traveling in the countryside in western Guatemala, I heard about a case where the spirit of corn appeared to a poor family in a town called Concepción. I visited the family, and the owner of the house related that late in the afternoon on a certain day in March 1997, a strange lady came to this community and asked the favor of spending the night at this little house. The owners gave the lady a sleeping mat, and she was put in a small room to sleep. Early in the morning, the owners of the house went to see the visitor, but she had already slipped away unnoticed. They rolled up the sleeping mat and discovered under it twenty-one grains of corn of a kind that is not produced in the region. With this discovery and the disappearance of the odd lady, the owners of the house were convinced that their visitor was the spirit of corn who had abandoned the regions where coffee was now replacing corn. They built an altar to hold the grains of corn. People started to come to this little dwelling to see the corn collected from the ground where the woman had slept. As the report spread, more people traveled to this village of Concepción, bringing candles and flowers to adorn the household altar. The oldest daughter began to have

Heart of Heaven, Heart of Earth

RITUAL RESPONSIBILITIES

This masterful painted ceramic vase depicts a procession in which a Maya lord or ruler is being borne in a basketlike litter. He is carried by two bearers above a dog with a collar and forked tongue, guardian of the entrance to the Underworld. Seven people follow holding objects including a sacred bundle, a giant trumpet and fan, and a conch shell signifying a religious occasion. Rituals intended to ensure proper relationships with the gods and balance in the cosmos were the duty of the Maya ruling elite and the foundation of their power.

MAYA POLYCHROME CERAMIC VASE, A.D. 550–850. NEBAJ, GUATEMALA. HEIGHT 17 CM. 23/3800

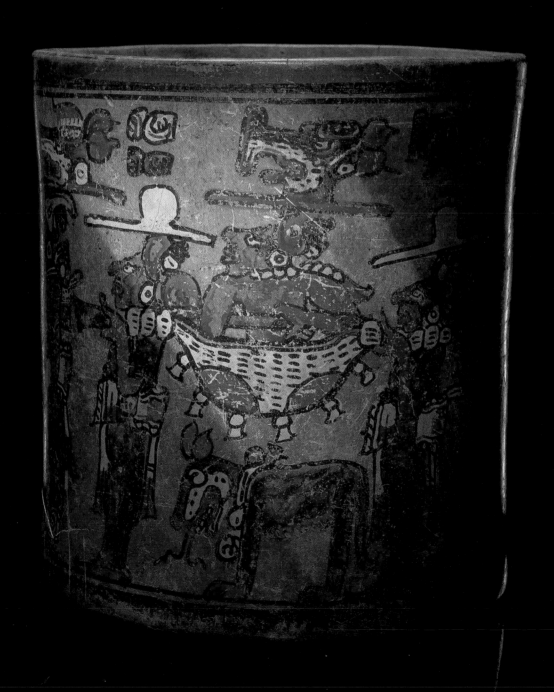

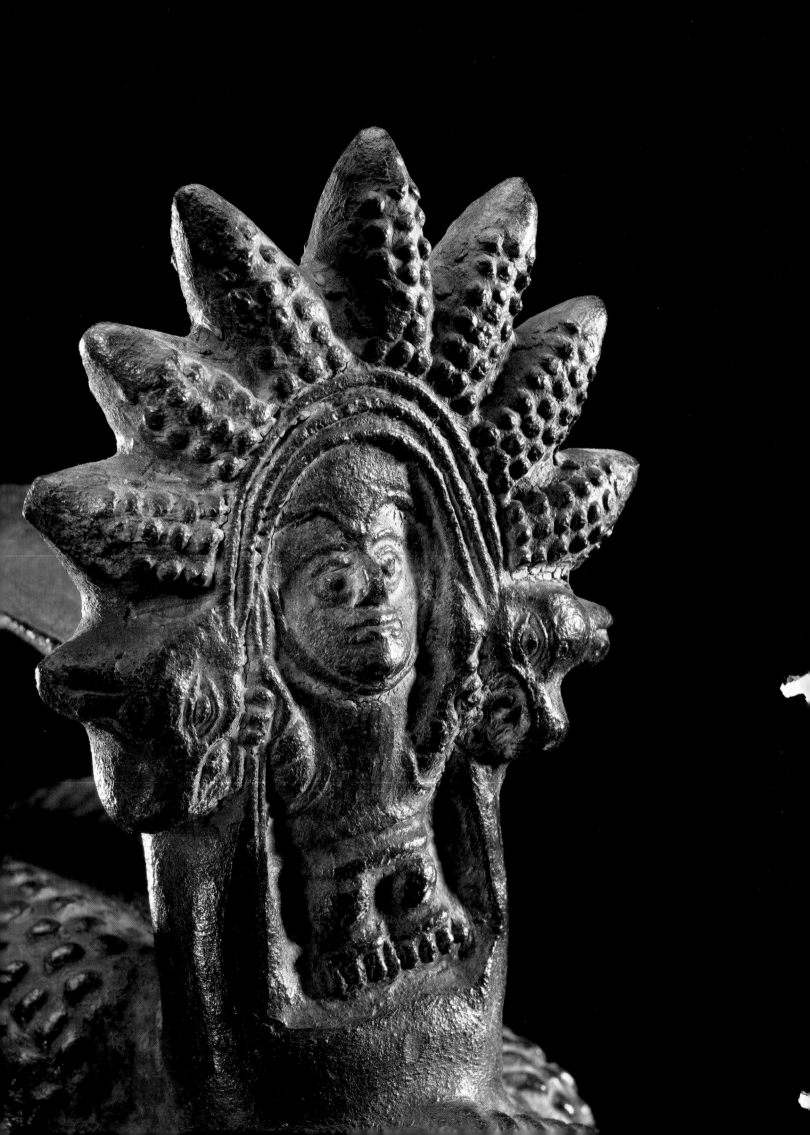

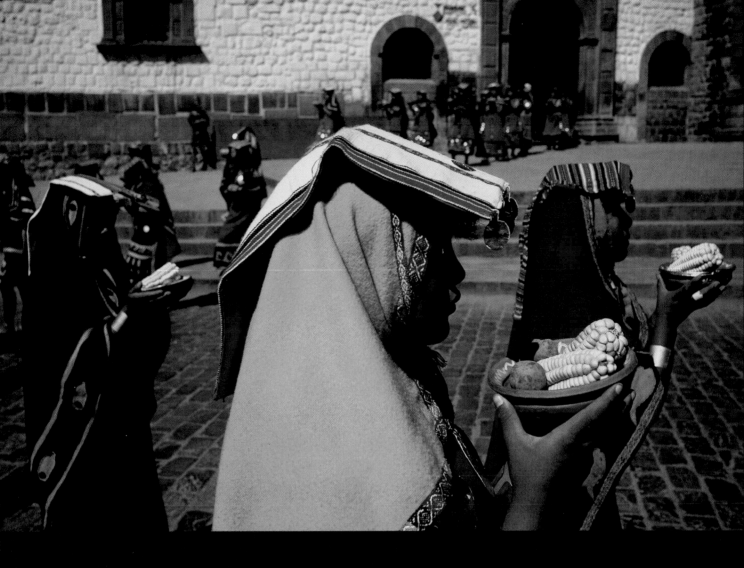

DIVINE CORN

The one indispensable staple of Native agriculture was corn (maize). For the Chimu, who preceded the Inka and were absorbed by them, the Spirit of Corn took human shape in a ceramic ritual vessel bearing a figure (right, and detail opposite) with ears of corn radiating from its head like rays of the sun. The figure perhaps represents a shaman with a corn band, a type of headdress that is still used in Andean harvest ceremonies. The Inka knew their ancestors as the Children of the Sun, and corn was considered to be of divine origin. They planted seeds from the first crop in all temples to honor the Sun. When harvested, the best seeds were offered to the spirits. The second best were planted, and only the least best were eaten. Spaniards of the 16th century noted the Inka festival of the Sun, *Inti Raymi*, which is still reenacted yearly in Cuzco, Peru (above), where women bear ears of corn in stately procession.

visions and became the spokesperson, or oracle, for the spirit of corn. This family had followed Catholic beliefs but with the apparition of the spirit of corn in their house they started to promote traditional Maya religion by making an altar to corn. Some people in the community believed in the story and some didn't, but the reality is that there is a great concern among the elders that the spirit of corn will disappear, and corn will lose its central role in Maya culture.

THE HUMANS MADE FROM WOOD

When men harden their hearts and lack compassion for other creatures, their abuse and carelessness bring destruction upon humanity. This lesson is symbolized in the rich tapestry of the *Popol Vuh* by the story of an earlier, unsuccessful creation of humans made from wood before the wise men and women, the respectful human beings, were formed from corn. The story tells us these humans made from wood multiplied and covered the face of Earth, but they were careless and soon forgot their creators. Because they abused nature and mistreated animals and their own artifacts, these humans made of wood were punished. The sky darkened and a boiling rain began to fall day and night for a very long time. All the creatures, both big and small, attacked the wooden people. Their tools, water jugs, tortilla griddles, dishes, cooking pots, and grinding stones rose up against them. Even their dogs were angry and condemned their actions, crying out:

> Why didn't you feed us? We lay very patiently at your feet waiting for something to eat, but you screamed and chased us out of the house. You always kept a stick nearby to beat us if we came too close to you while you ate. You treated us like this because we could not talk and complain about your cruel ways. Why didn't you care? Why did you think only of yourselves and your own future? Now we will destroy you, crush you with our teeth.[3]

If principles of respect, care, and compassion for other living beings that interact with us are not observed, nature itself can be destructive. According to the creation story, when the humans made of wood futilely tried to escape destruction, they climbed up trees, but the trees shook their branches, throwing them down. They scrambled atop houses to defend themselves, but the roofs collapsed and flung them to the ground. Even caves closed their entrances.

Scientists in industrialized countries today, worried that the destruction of rain forests and global warming may bring on natural disasters, are heeding the ecological wisdom embedded in indigenous teachings—talking about the intimate relationship that must be developed between humans and the natural world, telling us to take responsibility for our acts and to search for solutions to the problems of pollution and ecological destruction. Native Americans have been warning us about these problems, too, but this indigenous approach to nature was seen as not scientific but merely folkloristic. Now some biologists and environmentalists favor approaches to nature such as biophilia, or love and kinship with nature, and what is also called deep ecology: "This philosophy of deep ecology teaches us biocentric or ecocentric values in which humans are seen as part of nature and not above or against it."[4]

HEAVENLY COMMUNITY

Human life is interwoven with all of heaven and Earth. For the Maya, natural forces such as rain, wind, and lightning are animate. The creation narrative fea-

tures Hero Twins, Hunahpu and Xbalanque, who defeat the evil lords of the underworld in a pivotal ballgame. After the victory, the twins rise to the sky as celestial beings—Hunahpu as the sun and Xbalanque as the moon. The ancient Maya corn deity, Hun-Nal-Ye—reborn from a cracked turtle shell after being sacrificed by the lords of death—set three huge stones in the constellation of Orion to form the great hearth of the universe. One of the tales in the *Popol Vuh* relates the story of four hundred boys who tried to kill an arrogant, threatening giant called Zipakna. But the young men were defeated and after death were transformed into the Pleiades constellation, or *naj motz* (a male group of stars).

In Maya culture, the heavenly bodies are given names as persons having kinship relationships with humans on Earth. The Jakaltek Maya call the sun Komam Tz'ayik (our father the sun) and name the moon Komi' X'ahaw (our mother the moon). Maya people see them as subjects in the sky who help to give being and beauty to Earth, playing the role of fathers and mothers or givers of life. Maya recognize that the heavenly bodies are not humans, but they have the category of persons on which humans are dependent and linked for the continuance of life on this planet. Thus the Maya concept of interrelated worlds in balance extends not only to humans and the environment, but also to the cosmos itself. This respectful relationship with the universe is reinforced through traditional Maya ways of knowing and teaching. Contemporary Maya still teach their children with sacred prayers, stories, and parables containing symbolic and ethical messages that mold their behavior for the future.

To the Maya, the hills, mountains, and volcanoes have personal names and display human characteristics. According to the elders, these natural features are the materialization of the ancestors in order to perpetuate their presence on Earth. For example, Xhuwan Q'anil, ancestor and hero of the Jakaltek Maya, was immortalized in a hill that bears his name. Such an indigenous cosmology or way of seeing the world around us helps us to understand the relationship between humans and their natural environment. This Maya worldview is maintained through stories that communicate moral principles for not transgressing sacred places. I remember the elders in my town (Jacaltenango in Guatemala) telling these types of stories during the excavation of a tunnel for road construction at the foot of the Santa María volcano in Quetzaltenango. According to the Maya workers, the spirit of the hill was angry about this construction and caused a landslide inside the hill, endangering the life of those who worked there. They needed to pray and ask permission before cutting a tunnel into a sacred mountain.

Rigoberta Menchú, a K'iche' Maya who won the Nobel Peace Prize in 1992, refers in her autobiography to the rituals in which respect for nature and the sacredness of the Earth are inculcated in the child at an early age:

> Four candles are placed on the corners of the bed to represent the four corners of the house and show him that this will be his home. They symbolize the respect the child must have for his community, and the responsibility he must feel towards it as a member of the household. The candles are lit and give off an incense which incorporates the child into the world he must live in. When the baby is born, his hands and feet are bound to show him that they are sacred and must only be used to work or do whatever nature meant them to do. They must never steal or abuse the natural world, or show disrespect for any living thing.[5]

Among adults, respect for nature and the rightful treatment of Earth and its resources are also encouraged in prayers and ceremonies. Before clearing trees for planting corn, a Maya farmer will burn candles at the four corners of his plot. Then he will beg forgiveness and ask permission to cut the trees from the guardian of the mountains, named Witz. Maya approach the hills and the forest with care and respect whenever they work the cornfield or go out to hunt. Below is part of a prayer to Tzuultaq'a, or spirit of the hills, mountains, and valleys, given by an elder in a contemporary Maya community in Guatemala five days before he was due to plant. "Paying" refers to offerings such as raw cacao, corn dough baked in leaves, or turkey, and the burning of pom, the resin of the copal tree.

> I am paying and burning in the face
> of our Father our Mother Tzuultaq'a,
> so that you will show us and guide us.
> Here I am to pay the sacred forest, the sacred jungle.
> O great God, O Father Tzuultaq'a, please help me.
> Give your blessing on my cornfield. We will soon be planting.
> I am requesting permission to work in the face of holy Tzuultaq'a
> where we find our food and water.
> O Father Siyab', please give my message to our Father God.
> Please don't send the animals to eat our maize.
> Have mercy upon me and my children.

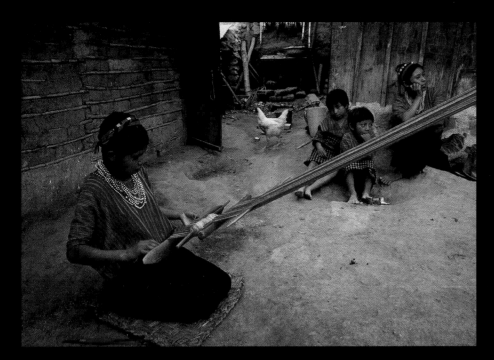

WEAVING TRADITION

In Maya story, the art of weaving was originated by Ixchel (Rainbow Lady), goddess of childbirth and medicine. She is always depicted accompanied by a backstrap loom, as is this ancient Maya clay figurine (left). An identical weaving technique is used today, as by Maria Perez of San Antonio, Guatemala (above, left), kneeling at a backstrap loom. She has just inserted the weft; next she will strike home the thread with a batten. As weaving progresses, colored threads are woven into brilliant geometric patterns (above, right) with warm colors predominating.

MAYA CERAMIC FIGURINE OF A WEAVER, A.D. 600–900.
HEIGHT 15.2 CM. 23/2865

We are doing as our ancestors the Mayas did,
They who loved our Tzuultaq'a.
You give us our food, our tortillas and drink, our happiness,
our chickens, our crops, our animals.[6]

The holistic view of the Native universe begins in the house itself, which was traditionally oriented according to the four directions of the universe. A central aspect of Maya belief is the division of the cosmos into four parts or directions. Four Year Bearers, or Bacabs—placed by the supreme god at the four corners of Earth to uphold the universe—sustained the sky. Each direction was assigned its sacred color: red for the east, white for north, black for west, and yellow for south. A fifth color, green-blue, corresponded to the center or the *axis mundi*.

After material for a new house was gathered from the forest and a spot selected for building, a prayer-maker and the owner of the house placed four candles at the four corners of the site. Another candle was placed at the center to symbolize the navel of Earth. The place was sanctified with candles and prayers to help the soon-to-be-built house protect the family who will live in it. When constructed, the four posts at the corners that support the house became, symbolically, the living posts or Bacabs that uphold the sky over the Earth. The house thus becomes sacred for the Maya, because it replicates the universe in microcosm. An altar is also built inside the house at the center of the back wall. Here, offerings of food and drink are placed for the spirits of the relatives who will visit the family

in their new home. Houses are still blessed in Maya communities, although the ancient tradition of sanctifying the ground before construction is not commonly practiced. People now are more individualistic and modern houses are built from cement blocks and iron.

DISLOCATION OF MAYA COMMUNITIES AND CHANGES IN WORLDVIEW

In modern times, some indigenous people are abandoning their communities and settling at archaeological sites, with hopes of selling their arts and crafts to tourists. In 1999 I visited Palenque, a renowned Maya archeological site, with my family. We saw men from the small Lacandón Maya community of this region posted at the entrance of the ruins selling their traditional bows and arrows to tourists. This has become a good business for the Lacandón Maya, who are being pushed off their land by cattle ranchers, loggers, and even revolutionaries. It is unfortunate that the Lacandón Maya are being pressed to abandon their traditional culture and adapt to the industrialized world. Among all of the Maya linguistic communities, the Lacandón are the only group that has maintained continuous pilgrimages to the classic Maya sites. They believe that a proper connection to Earth and heaven could be achieved by performing their rituals at the ancient Maya centers such as Yaxchilan and Palenque. The modern Lacandón Maya believe that they are the direct descendants of the Maya who built these temples, and they talk about the creation of Earth that their oral tradition tells them took place in these sites. For them, Yaxchilán is the navel of Earth. Creation occurred there when the supreme god created his helpers from the *bak nikte'* or the divine flower. There, too, grew a cosmic tree that reached the different levels of heaven.

The Lacandón have norms that control their behavior in the use rather than abuse of nature. To live a truthful and appropriate life, humans must respect nature, even those animals that are to be taken as food by hunters. Each animal should be hunted with specific arrows to avoid any cruelty. "To waste game by killing more than is really needed is very bad."[7] Those who do not comply with the rules and ethics of community relationship that extends to the natural world commit an offense against nature.

There is no doubt that the worldviews and identity of the Lacandón Maya are changing rapidly. The younger generation of Lacandón men does not remember much of the traditional lore of their fathers and grandfathers. The fundamentalist protestant religions that are settling in among them are changing their traditional worldviews through conversion. The young men have started to cut their long hair and are now wearing jeans instead of the long white tunics they formerly wore and which identify them with their ancestors, the Maya.

In spite of the many changes and dislocations that are affecting the Lacandón and other Maya communities, the people are continuously re-creating their traditions and maintaining their links to the historical past. In indigenous Maya communities *Aj Q'ij*, or spiritual leaders, continue to consult and use the Maya calendar for the maintenance and revival of ancient traditions and the creation of new ceremonies. The Maya are in the process of creating a pan-Maya movement for cultural revival. Maya spiritual leaders are preparing indigenous communities to enter their fifth millennium, which is the closing of a great cycle called 13 Baktun in December 2012. This is a prophetic cycle, and the Maya want to receive the new Maya millennium by saying: Five thousand years after the counting in our calendar began, our culture is still here and flourishing once more.

ETERNAL HARVEST

In the hills of the Puuc region of Mexico's northern Yucatan Peninsula, famed for such great temples as Uxmal and Chichen Itza, the daily lives of Maya people go on as they did some 15 centuries ago. Santos Lopez works his field (opposite). He harvests some ears of corn and bends down the stalks of others to protect them from moisture so that they will safely dry. The care of corn, gift of the gods and treasure of the humans they created, is a duty little changed since the days of the ancestors.

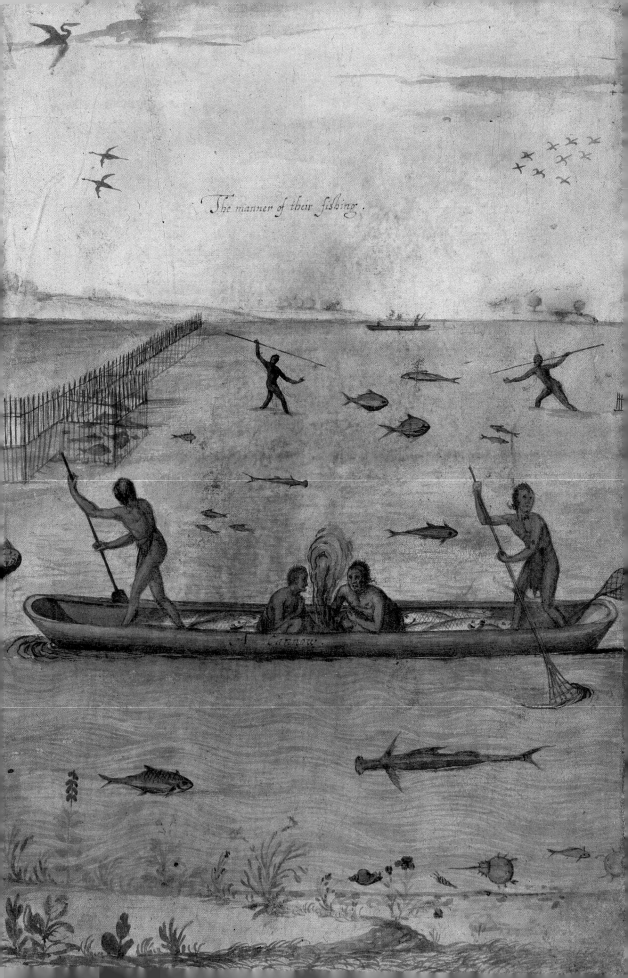

The manner of their fishing.

Keeping the Original Instructions

Gabrielle Tayac

Many creation stories shared within the Native universe start with water, which as vapor forms clouds, mist, and fog. For Piscataway writer and scholar Gabrielle Tayac, whose people were indigenous to the Washington, D.C., region, the hot, humid summers of the capital city offer the populace a form of purification, much like in a sweatlodge where one enters the womb of the Earth to pray, sing, and learn. The city also offers people an opportunity to think and reflect on change, to remember the days when the Piscataway, whose very name means, "where the waters blend," inhabited the area and made productive use of the waterways and the woods.

Tayac tells us about the importance of corn and the Green Corn Ceremony among her people, linking the plant to enduring spiritual beliefs. She points out that the "living spirit" was found in corn as well as rock forms of the Eastern Woodlands. In both the Chesapeake Bay region and New York, Native peoples carved Living Solid Faces, or forest guardian spirits, into large boulders. The Lenni Lenape made these representations of power in New York, while the Piscataway did so along the Potomac River. Tayac links the cities of New York and Washington, D.C., recalling how the shattering events of September 11, 2001, brought Native and non-Native peoples together in a shared sense of the role of memory in the attachment to the land. She emphasizes throughout that memory "creates and re-creates time, affixing it to hallowed places that are alive." She points out that in the 1940s, one Living Solid Face fifteen miles south of Washington refused to be "captured." The power of these spirits remains in this region of blending waters, just as the power remains in every corner of the Native universe. The Western Hemisphere remains, in its geographic origins, "Indian land."

The earth is breathing through the streets.

—Linda Hogan (Chickasaw)

O
N SEPTEMBER 11, 2001, THE AMERICAN PSYCHE EXPERIENCED A
shock that forever changed the course of individual and collective
histories. On that day, literally out of a clear blue sky, terrorists
hijacked domestic airliners and destroyed the World Trade Center
in New York City, part of the Pentagon in Washington, D.C., and
thousands of lives. And that tragic moment overtly linked, for the first time, feelings
I had for my New York hometown (I was born and raised by my seafaring Piscataway
father and avant-garde Jewish mother in lower Manhattan) and those I felt for my
Native Piscataway homeland along the Chesapeake Bay in Maryland and D.C. Both
were eternally changed by cataclysmic world events wrought by cultural clashes.

In the days and weeks that followed 9/11, droves of people made pilgrimage to
the disaster sites. To bear witness and to pay respect were certainly motivations.
But there was another reason, deeper than a need to know that something unprece-
dented had really happened, one that applied to a basic human imperative: to make
meaning of memory.

For the first time in general American reportage, I heard a resonating, heart-
felt sentiment concerning modern urban landscape that extended beyond the imme-
diacy of events. A series of commentators spoke of the disaster site in New York as
sacred ground. They spoke of using memory to reconstruct a presence that now
could be seen only internally.

The ways that ancient and enduring indigenous knowledge illuminate a con-
temporary path were startlingly revealed. In many Native conceptions, memory is
the vehicle that creates and re-creates time, affixing it to hallowed places that are
alive. It brings us back, codified through ceremony, all the way to time's beginning.
To the birth of Isanaklesh, the Apache female Creator. To the submergence of the
Lords of Xibalba, underworld forces among the Maya. To the enlightenment of
Ayonwatha (Hiawatha), disciple of Deganawidah, the Iroquois Peacemaker. Speak
their names, dance the self to become them, and they live again.

Much written about Native philosophies deals with worldviews attached to
specific places, often far distant from the majority of people that read poetic narra-
tives or study anthropological analyses. But what of Native peoples themselves, the
majority of whom in the United States do not live in their ancestral homelands?
How is it that we "heed the voices of our ancestors," as Mohawk political scientist
Taiaiake Alfred frames the question, wherever in the world our journeys take us?
What if our ancestral territories, like the Lenape's Manhattan or the Piscataway's
Washington, D.C., include geographies upon which vast metropolises are built? It is
through the active remembrance of Creation's "original instructions" that the spir-
its of place, however altered, keep breathing.

MEMORY, RESILIENCE, AND FRAGILITY

What many Native peoples see extends beyond the overt surroundings. Our per-
ceptions are often shaped by the knowledge of collective memory, by the traditional

URBAN RHYTHMS

Ducking out of the rain, members of
the song and dance troupe called
SilverCloud Singers take refuge in a
New York City Subway stop under
Manhattan's SoHo district. On this day
Vincent Kitcheyan, Jr. (Ho-Chunk/
Apache), Preston Tonepahhote, Jr.
(Kiowa/Maya), Walter George Stonefish
Willis (Ojibwe/Delaware), Larenia Felix
(Diné), Kevin Tarrant (Hopi/Ho-Chunk),
and Lance Richmond (Mohawk) set up
an impromptu session.

knowledge that tells us what our places really mean. Across the Native universe, memory conveyed in different forms exists as one force strong enough to peel back concrete and steel. In our mind's eye, many of us imagine even urban landscapes in this hemisphere as our ancestors saw them. Regardless of modern urban surroundings, Native lands persist as sacred places and must be properly cared for by all of the people who now live upon them.

I once heard Floyd Red Crow Westerman, a Dakota performing artist and activist, talk about his experience as an Indian visiting New York City. Manhattan is Indian land and is an Indian word, he reminded his audience. "So, when you see me here, I'm just coming back to the old neighborhood," Westerman joked. And indeed, New York City today is home to a vibrant urban Indian community whose members are engaged in every sector of urban society. Most of the city's 27,000 Indians have ties back to their own indigenous homelands, but at the same time they have constructed a new Native base right in the heart of Manhattan where the American Indian Community House is located.

There are reminders that exist yet of the times when New York City itself was completely Indian land. Native peoples have lived there for as many as 12,000 years. George Gustav Heye, founder of New York's Museum of the American Indian, which is now the Smithsonian's National Museum of the American Indian, collected samples of this ancient legacy. Some of the most striking examples are the carved stone faces found within the city limits. Known as the Living Solid Face, these sculptures are the embodiment of a forest guardian spirit pertaining to the Lenni Lenape or Delaware people. Some of these have been found in caves throughout the city, such as those in Staten Island. As millions of people bustle through their lives in the city, unconscious of the Lenape legacy, Living Solid Face still watches them.

Memory can be at once resilient and fragile. Four hundred years after English colonization, Piscataway still pray by burning tobacco and have knowledge of their Native selves. Yet, by the twentieth century, everything that our people had in

tradition had come down to one man, my grandfather, Turkey Tayac. He practiced old ways, using eels and cedar, among other medicines. He asserted his "Indian" name over his "Christian" name, Phillip Proctor, decades before it became safe to be a Native person again. These were acts of resistance through an insistence on memory for which I am grateful.

I think sometimes, what if he had never come back from World War I, where he was nearly killed by mustard gas? What then? What if he gave in to the crushing racism of Southern Maryland, a slave state until 1862, and moved north into an anonymous assimilation like many of his compatriots? We came so close to losing any knowledge of our names, our medicines, and our burial places. In fact, countless Native peoples across the continent were indeed lost. There is the fragility. We did not lose. There is the resilience.

INDIAN COUNTRY UNPAVED

Walking the streets of Washington, D.C., I can literally see the steam rising on a summer day. Vapor, filtering off the Potomac River, presents itself as a hazy wall that the populace walks through on a daily basis. Pouring from storm drains, escaping through deep puddles, and rising out of manhole covers, minuscule droplets surround the land. Inescapable and pervasive, the humidity remains a constant.

Attempts to stop water's nature have not been completely successful. Draining Washington's original swampy marshes, capping the springs, and tunneling or filling in the streams are all measures that have been progressing since L'Enfant's city plans were undertaken in the 1790s. Yet, upon a map of groundwater paths at the National Museum of Natural History, a persistence of deep courses becomes revealed. The subterranean rivers still flow and seep along the old drainage patterns of filled-in streams. Deep below an apparent surface of concrete, marble halls, and glittering domes there is another presence that endures. You just have to look for it.

This humid heat is an annoyance to many modern-day D.C. residents, but I understand it as a life force, a purifier. In an enduring indigenous perspective passed to a current generation through the spoken word, the presence of the air intermixed with water shows that the Earth is unstoppable. How we choose to experience our lives within its many environments depends on culturally based decisions, or more properly, that we are responsible for following our original instructions—those given by the Creator.

Every component of the universe, in an indigenous conception, has a set of original instructions to follow so that a balanced order can be kept. Water, for instance, strives to maintain a cyclical nature and to retain roundness. As Mohawk elder Ray Fadden pointed out, when water is cast into the air it immediately becomes round. Humans are part of the natural order also, and exist in a reciprocal relationship accorded by original instructions. Although we may be cast out of primal environments, like water, we cannot truly ignore these mandates.

Airborne, water forms steam. Steam, in some Native traditions, can be the Creator's breath. It can draw out poisons and toxins through inducing sweat, so I have been taught. Especially when it is produced under ceremonial conditions, water, when carefully poured onto red-hot rocks, results in a vapor that induces introspection. It is also the sharing of a life essence between humans and other beings, as rocks are the oldest beings on the planet. On city streets, which are only fully divorced from the natural world by our perceptions, steamy air might be produced as well. Steam derives from the intersection of rock, water, air, and fire—constituent elements. Elders instruct, "Take in the breath of the Creator. Now open your eyes. What do you see?"

As an adult, I decided to go back to my father's homeland. I come from a people with a traditional territory encompassing the metropolitan Washington area, defined by the swath of land between the Potomac River and the Chesapeake Bay in Maryland. We are called the Piscataway. Our very name translates to mean, "where the waters blend," and refers to the location of our main village at the confluence of Piscataway Creek and the Potomac River when the English explored our shores in the early seventeenth century. The Potomac is a vein of Mother Earth's blood.

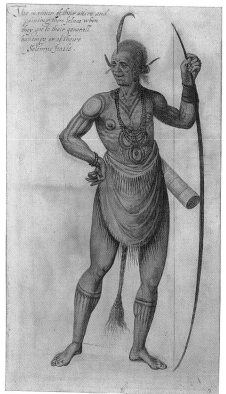

More specifically, Washington, D.C., was the home of the Anacostan, a tributary member of the Piscataway chiefdom. They lived under the influence of the Piscataway central chief, titled the *tayac*, although it is probable that they maintained a high level of autonomy. Their name has been translated to mean "trading town," and reflects their dynamic lifestyle at a crossroads mediated by rivers. Rivers (the Anacostia is named for them) were not borders, but highways and connectors between disjointed lands and peoples. As a distinct people, the Anacostan could not withstand disease epidemics, land loss, or trading wars that Europeans visited upon them.

To the Iroquois Confederacy who protected them after the establishment of English hegemony, and in many scholarly writings, the Piscataway are known as the Conoy. Conoy is believed to be an English linguistic corruption of the Iroquoian word *Kanawa*, meaning "the rapids." The title alludes to the entry point of our lands at Great Falls where water rushes over boulders, forming a divide between mountains and coastal plains. In either case, our point of view seems to be defined over time by waterways.

What I see here in Washington, just as in New York City, goes deeper than what appears on the surface. These lands reach into deep time—and they have been cultured for millennia. Like the groundwater flows, indigenous peoples of this place—as well as those across the Western Hemisphere—have sought different means to endure. Some peoples did not survive the onslaught of colonial and national expansions. Others did so by various means including resistance, adaptation, or retreat. According to Cherokee demographer Russell Thornton, between five and thirteen million individuals existed within contemporary United States boundaries in 1492, and on record 250,000 lived to tell their tales by 1900.

Although many peoples were lost, and across the continent many still face ethnic persecution, the people are on their way back. In the year 2000, the U.S. Census Bureau reported that 2.5 million American Indians lived in this country—an extraordinary population recovery. An additional 1.6 million reported being American Indian as well as one or more races, for a total of 4.1 million. In fact, the Census Bureau predicts that the American Indian population will double by the year 2050. South of the country's artificially constructed border, there are as many as 44 million indigenous people today. As Native poet-activist John Trudell teaches, "we rise, we fall, we rise."

In the Chesapeake Bay region, a closer look behind the numbers shows countless stories of lives lived and unlived. The story of this particular area is just one of many like it throughout the hemisphere. Its lessons are particularly germane to places that are seemingly devoid of a Native presence, yet nowhere in this hemisphere can be truly described as vacant of an indigenous aspect. Chesapeake has been interpreted to mean "the great shellfish bay," or the "mother of waters," and holds a position as one of the world's richest biospheres. When Captain John Smith led expeditions throughout the Chesapeake between 1607 and 1608, seeking and seizing resources for his settlement at Jamestown, he recorded dozens of distinct

THE GREAT BAY PROVIDES

Such Chesapeake Bay favorites as blue crabs, oysters, and rockfish (striped bass) were only part of the Native diet taken from the vast, shallow estuary. Eels were fished with traps of woven wood strips (above) by indigenous people, who used them for food and medicine. (Piscataway Chief Turkey Tayac wrapped eel skins around his head and joints as a remedy for arthritis.) There are individuals among Chesapeake area tribes who still know how to make these traps. A Nanticoke gourd container with fish motif (left) reflects reverence for rivers and fish. Both the Nanticoke and Piscataway conceived of the Earth as Mother and rivers as the veins of her life's blood. The Chickahominy do as well, and have long netted fish in Virginia's waters (background).

WOVEN WOOD EEL TRAP, EARLY 20TH C. MADE BY GORDON BULLOCK, POWHATAN POTOMAC. LENGTH 57 CM; DIAM. 21 CM. 25/701
GOURD CONTAINER WITH FISH MOTIF, EARLY 20TH C. MADE BY OSCAR WRIGHT, NANTICOKE. HEIGHT 27 CM. 21/2681
CHICKAHOMINY FISHERMEN, 1918. PHOTO BY FRANK G. SPECK. N12631

peoples. Some of these locations were noted as chief's towns, and marked on his map with a drawing of a longhouse.

Recently, I had the chance to view Geographic Information System maps with archeological details that clearly confirmed Smith's record. Viewing the Potomac River and its drainages on the maps, I searched for Native American sites on the computer from the colonial period back to earliest human occupation. Red dots indicating sites emerged. They were so densely clustered on the waterways that the dots fused. Our peoples were truly numerous in and around Washington, D.C., at one time.

Before and just after the time of European contact, peoples were primarily arranged by allegiances to several chiefdoms varying from the more coercive and cohesive Powhatan to the laissez-faire and loosely organized Piscataway. On the Eastern Shore of the Chesapeake, the Nanticoke also held an incipient chiefdom. There were some peoples who apparently staved off incorporation into chiefdom systems and maintained their autonomy, such as the Chickahominy and the Patuxent.

The peoples of the Chesapeake were primarily Algonquian speakers, belonging to the largest linguistic family of North America. According to documented oral narrative, the Piscataway as a people descended from the Lenni Lenape. For many peoples in the East, the Lenni Lenape are recalled as the grandfathers because they are the progenitors of nations.

Story tells us that a group split from the Lenni Lenape, perhaps a thousand years ago or more. The people then settled on the Eastern Shore of the Chesapeake, and were one and the same as the Nanticoke. Then, for some reason, the first tayac, Uttapoingassenum, led his people to the other side of the Bay. Upon their arrival, they encountered peoples who had been living on that land for more than 8,000 years, according to various archaeological estimates. For thirteen generations prior to English settlement, as told to Jesuit and Moravian missionaries, the tayac's inheritance passed from brother to brother, and then to the sister's sons. Each led the people until his death. Although the tayacs were always men, town chiefs called *werowances* were sometimes women—known as *werowansquas*.

Although the Piscataway chiefdom was a stratified society, chiefs served the people. Councilors—men who formed an advisory board known as the Matchcomoco, or great house—helped a chief arrive at decisions. There were those who came to prominence at times of war or peace, certain of them war leaders and others civil leaders. Everyone ideally worked for a common good; no one led a life of leisure.

LIVING THE INSTRUCTIONS

The people lived in accordance with their original instructions, tempered and ordered by the natural world around them. Through ceremony, they aspired to a reciprocal relationship with this realm. Of special importance were the ancestors, who guided the living as they carried out their spirit journeys. Ancestors were among the forces that mediated between the living and the Creator. With bones under Earth, and spirits on a star path, the ancestors are unseen, but known nonetheless.

The new year arrived with the harvest of the staple crops. Most central to life was the corn. Growing as a green stalk of abundance, the corn also represented womanhood. Embracing corn were her sisters, the beans and the squash. Planted together, as modern agricultural research now confirms, these plants nourish and protect each other. The corn is a pole for beans, and provides shade for squash. Broad squash leaves carpet the rows between corn, smothering harmful weeds. By August, peoples in the Chesapeake region as well as throughout the woodlands celebrated the Green Corn Ceremony. People dried and processed these vegetables for food resources throughout the year.

When the Maryland colonists arrived, they brought with them an English Jesuit, Father Andrew White. King Charles chartered Maryland's boundaries in 1632 before the first colonist ever set foot upon the land. The entire Piscataway territory had been deeded away to Lord Baltimore before the Native people had heard of him. By 1642, at least nominally, the Piscataway converted to Roman Catholicism. At the same time, the English began to seize land and interfere with Piscataway internal government, justified by the 1493 Papal Bull *Inter Caetera*: "barbarous nations [could] be overthrown and brought to the faith itself."

Eventually, the Green Corn merged with the Feast of the Assumption held every August fifteenth. Tucked beneath the cloak of Catholicism, an ancient aboriginal tradition could sometimes be practiced safely. This type of syncretism is practiced throughout the hemisphere so that Native peoples can carry out their original instructions while minimizing interference. The annual feast grew in popularity for whites and blacks as well, and was transformed by them into an annual church picnic. For Indian people, the event was not just a church picnic. They still would burn tobacco and inhale cedar smoke for purification on the banks of the Potomac River.

After the Green Corn, Earth transited through time, and the land would begin to change. Much of the plant life went to sleep. An exception was the red cedar, a sacred tree to the Piscataway. It was always full of life, and its heartwood was red like the blood of living creatures. In the fall of the year, it was time to lay the dead to rest. In the Chesapeake region, Native peoples buried the bones of their beloved dead all at one time in mass graves or ossuaries. Immediately after death, the bodies would be scaffolded or buried with a primary funeral that would hold them until the final communal burial.

The dead would be prepared for this final burial and spirit journey in a ceremony called Feast of the Dead, which was held every so often when enough people had passed away to be placed together. That way they would not have to go on their journey alone. The bodies of chiefs, however, were kept in a mortuary house tended by holy men, so that they could lead the people with their spirits. Eventually chiefs were buried, according to oral tradition, under a living red cedar tree. The spirit of the tree and the chief merged, to be an undying protector of the people.

We practice the Feast of the Dead every November, although we have adapted it to guidelines imposed by the broader society. The Piscataway no longer conduct mass ossuary burials, but we still honor the ancestors collectively at that time. A vigil is kept for four days at the Moyaone burial grounds on the Potomac's shores. On the fourth day, we gather for a procession. Led by the drum, the people carry a litter with small bundles of tobacco placed on a deerskin shroud. Each bundle, called a tobacco tie, represents someone who has passed into the spirit world. At the head of the litter sits a deceased chief's bonnet—he still leads the people. Flanking the litter and pallbearers are four people who carry a colored flag for each cardinal direction. We make four stops, one for each cardinal point, on the path to the old chief's ossuary.

When the people arrive at Moyaone, now in Piscataway National Park, they circle around a red cedar tree that my grandfather Chief Turkey Tayac planted to mark his burial spot. He was buried there a year after his death by an Act of

AT REST

Among the Piscataway people's ancient burial grounds at Moyaone within Piscataway Park, which lies across the Potomac River from Mount Vernon, stands the marker of Chief Turkey Tayac. He was buried there by a 1979 Act of Congress. Behind his picture stands one of four Spirit Posts, meant to protect the site from evil. The red cedar tree in the background was planted by Chief Turkey and is covered with hundreds of tobacco ties representing people who have died.

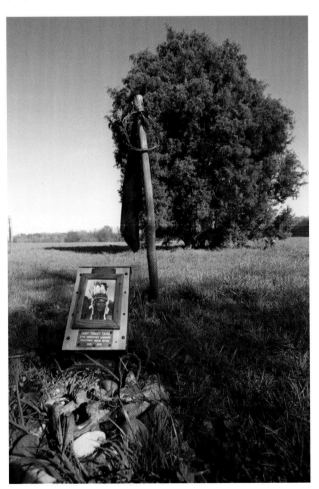

Keeping the Original Instructions

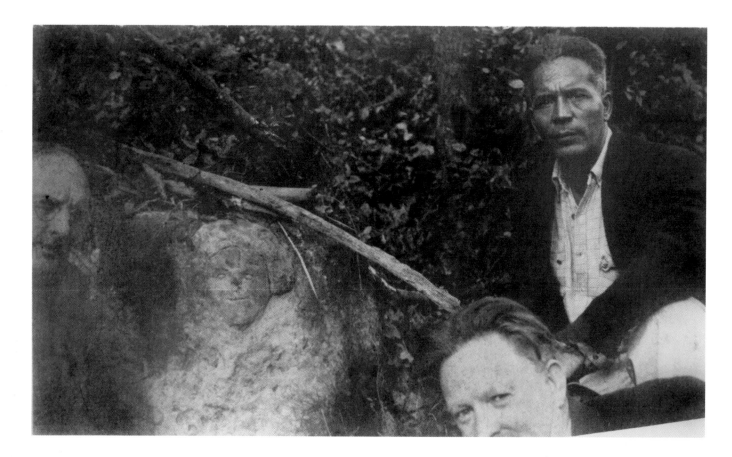

Congress in 1979, which finally upheld the Department of the Interior's verbal agreement made to him when he consented to participate in the creation of Piscataway National Park. He had established a firm brotherly relationship with a Lakota leader, Chief Bill Eagle Feather, who had participated in the revival of his people's Sun Dance ceremony. The two elders made a pact that whichever one died first, the other would come and bury him properly. When Grandpa died, Bill Eagle Feather came and sent him on his way.

All of the stories associated with the death and eventual legislated burial of my grandfather are repeated annually at Feast of the Dead. These are narratives that connect us to the land time and again, and also to our positions as Native peoples in today's world. My uncle Chief Billy Redwing Tayac talks to everyone about how essential it is to remember the ones who came before us. He reminds us of our responsibility to care for the dead who sleep at that very spot. Remember, my uncle directs, when you pass into the spirit world, your ancestors will be waiting for you. They will ask you what you did to fulfill your responsibility to them, your responsibility to the original instructions.

Thinking again back to the old days when Piscataway people lived in their stockaded village at Moyaone, I imagine the next phase of the Earth's journey around the sun. In pre-European times, during the winter, the people abandoned their villages for the season and broke down into smaller family bands to hunt and trap. People traditionally hunted animals with respect for their spirits. Piscataway families were also organized along clan lines, which they believed to originate in different animal lineages. Thus, members of the Beaver Clan, for example, could not take the life of beavers.

Here, as among the Lenape in what became New York City, Living Solid Face guarded the territories. He had a special stewardship over the animals and the men who hunted them. Living Solid Face would only release as many animals as could be honorably taken by the people. The spirit presided through man-made carvings on boulders or shell disks.

LOST SPIRIT

In the 1940s, a vigorous Chief Turkey Tayac of the Piscataway (above, top right) stopped with two archaeologists to examine a stone face found along Piscataway Creek. According to Turkey's son, later Chief Billy Tayac, the face on the stone was inadvertently destroyed in the attempt to remove it for transport to the Smithsonian's National Museum of Natural History. This was doubly troubling because the stone face was considered by the Piscataway to be a guardian spirit of the people.

In the early 1940s, when Uncle Billy was a little boy, he ran into Living Solid Face in the woods above Piscataway Creek. Covered by brush, the guardian spirit resided on a large boulder over this tributary of the Potomac River, only fifteen miles south of Washington, D.C. Grandpa Turkey decided to call Smithsonian scholars from the Bureau of American Ethnology to the site so that it could be officially recorded that there was still an old Piscataway chiefdom territory marker in modern times.

When the scholars arrived, they debated about the boulder face's age. To resolve the academic question, they decided to have it removed for further study. They came back with workmen and a jackhammer. As they attempted to remove it, the face disintegrated to dust. Living Solid Face refused to be captured that day.

My uncle told about the incident for decades and was met with skepticism. But one day, a researcher looking through the National Anthropological Archives found the picture that was taken of that very Living Solid Face, Grandpa Turkey, and the two scholars just before the removal started. The researcher called Uncle Billy right away and ordered copies printed of the picture. That photograph presides over my bulletin board at work. I look at it every day to remember that Living Solid Face was watching the Potomac not too long ago. Maybe there are still places where he survives today, undetected. Maybe one day soon we will call him back out of a rock so that he can guard us again.

At midwinter, the hunting groups came back together for a brief time to check in with one another. A literal way of expressing their concern for one another, they could assess needs and help those who were having a hard time. This gathering was a social way of breaking the monotony of winter, and seeing relatives outside of the small hunting bands. It was also a time to give thanks for the forces of ice and snow, which are cleansers.

We still mark this time in February. The families rent out a school cafeteria and enjoy a potluck dinner together. Some of us go to the burial grounds over a four-day period for sweatlodge ceremonies and tobacco burnings. The sweatlodge was recorded as a practice in the Chesapeake region by colonial authorities. There is actually a thoroughfare outside Baltimore called Sweathouse Road, with a state historic marker that describes in 1930s terminology what the ceremony was like in colonial times. Although it is winter, and the Earth seems dead, we trust that Creation will follow its original instructions to wake up again.

Grandpa Turkey taught his children about the original instructions through telling the following story. A hungry man walked by a bountiful orchard and hopped over the fence to pick some fruit. The owner of the orchard chased the man away, claiming that the fruit belonged to him, and no one else could have it. Since there was more than the owner could actually use himself, most of the fruit rotted on the ground. This was a violation of original instructions, simply stated. It was the fruit's responsibility to feed the hungry man, not to rot because of the human greed of the owner.

I hear this story every year in the springtime, at an annual ceremony called the Awakening of Mother Earth. The spring, with plants blossoming and animals returning, is an apt time to honor the natural responsibilities of the universe. In keeping with this ethic of responsibility, Grandpa Turkey practiced traditional herbal medicine in a particular way. When he would go out collecting healing plants,

he never dug up the whole plant. If you take out the whole root, he said, you kill the plant. Only take what you need, no more.

Mathew King, the late Lakota wise man, spoke of original instructions this way:

> God gives His Instructions to every creature, according to His plan for the world. He gave His Instructions to all the things of Nature. The pine tree and the birch tree, they still follow their Instructions and do their duty in God's world. The flowers, even the littlest flower, they bloom and they pass away according to his instructions. The birds, even the smallest bird, they live and they fly and they sing according to His Instructions. Should human beings be any different?[1]

A GATHERING FROM FOUR DIRECTIONS

In 1999 Native peoples and our allies from across the globe came together, in the very shadow of the United States Capitol, to launch a process of truth and reconciliation. On a September morning, with prayers and solemnity, we lovingly opened the skin of the Earth and broke ground for the National Museum of the American Indian.

We convened not far from old lands of the Anacostans, again to initiate exchange. But this time, we came not to take away lands or peoples, and not to protest or lobby. This time, we came to "return to a Native place," to recognize the aboriginality of the land, and also to bring the different Native peoples' experiences to light. Beginning with the drum group, we affirmed a promise to tell the truth: the truth about what happened to us, about who we are now, and about who we want to be. The Vietnam Era Veterans Intertribal Association and North American Iroquois Veterans Association color guards danced in flags—both those of the United States and Native nations. Smithsonian and government officials, those who had made the vision of the museum into a reality, were there to enact the promise. Hundreds of Native and non-Native people came to bear witness.

Then the blessing givers arrived. The spiritual leaders came in from four directions. They came from the south, Quechuas of Peru. They came from the west, Native Hawaiians. They came from the north, Inuit. They came from far away.

And they came from near. To bless the east, my uncle Chief Billy Tayac and his son Mark answered the museum's invitation. When Uncle Billy arrived that morning, he handed me a plastic bottle of water labeled with the word *Sipi*, which I knew meant river in Algonquian languages. "Hold this for me," he requested. I thought that he had brought the bottle in case he got thirsty. But it turned out to be for a much more serious purpose.

"The earth is still here," my uncle proclaimed as the blessing began, "the water is still here. And we are still here." With soil from our burial grounds at Moyaone, he sprinkled the ground. Then he opened the water bottle and poured its contents out. "This is water from the sacred Potomac," he explained. The ceremony ended with a phrase of song, the old anthem of the American Indian Movement.

It felt, in that moment, that centuries of history had completed the turn of a great wheel: A wheel that in its five-hundred-year revolution, beginning in 1492, had wrought shattering cultural cataclysms; but one that had left enough of us standing to begin a healing process for both Native people and those who had come to our shores. We still have a long journey, but this is one that many recognize we must take together. We are all part of the story of this land now, and the choice to follow the original instructions in our own ways is open wide before us.

DEDICATION

Blessing the construction site for the National Museum of the American Indian's new museum on the National Mall in Washington, D.C., on September 28, 1999, Chief Billy Tayac offers tobacco and earth from the Piscataway burial grounds. His son Mark carries a drum to sound in honor of activists who kept the spirit of Native pride alive. Sitting on the stage behind Chief Tayac are (from left) Senator Ben Nighthorse Campbell (Northern Cheyenne) of Colorado, Senator Daniel Inouye of Hawaii, National Museum of the American Indian Director W. Richard West, Jr. (Southern Cheyenne), and former Smithsonian Institution secretaries I. Michael Heyman and Robert McCormick Adams.

A maker often expresses a distinct way of seeing the world in the objects he or she creates. In an Algonquin story, the giant Glooskap comes from the heavens and teaches people their relationship to the plants and trees, and the stars—his brothers in the sky. This Maniwaki Algonquin birchbark box from Canada features an image of night etched with heart, star, and lily blossom designs.

The design was made with a technique in which stencils are placed over the container's dark "winter" bark. The exposed bark is then scraped to the lighter material underneath, forming the background to the striking design that encircles the container. As do the other extraordinary objects in the following pages, this exquisite creation provides a strong sense not only of natural materials skillfully transformed but also of the depth and power of the spiritual beliefs from which it arose—and which it embodies. A vibrant web of traditions, rituals, and beliefs, our universes come from our ancestors. They knew that the Earth, sky, and spirit world were one. They understood that a Creator placed all things in the world for a purpose—and that our purpose was to live in balance with all things, seen and unseen. This ancient wisdom endures in our language, religion, literature, and art. It defines who we are and how we live—no matter what we do or where we dwell. Our challenge is to pass this way of knowing to future generations.

OUR UNIVERSES

PORTFOLIO

Sun, Moon, and Stars

For thousands of years, Native peoples have looked to the skies to understand their place in the cosmos and organize their daily lives. Seasonal ceremonies marked the equinoxes and solstices, and tribes throughout the Americas used these solar cycles as guides for the best time to hunt, fish, and plant. The sun, moon, and stars are linked to stories of the origins of the universe, of different Native peoples, and of heroic figures. From carved house posts that gave the name "Moon House" to the Alaskan dwelling over which they presided, to a Plains horse ornament embellished with a beaded Morning Star, to a stunning turquoise mosaic shield with a solar motif found in Puebla, Mexico, objects of both ceremonial and daily life evoke the great mysteries of the universe and our spiritual relationship with its creative powers.

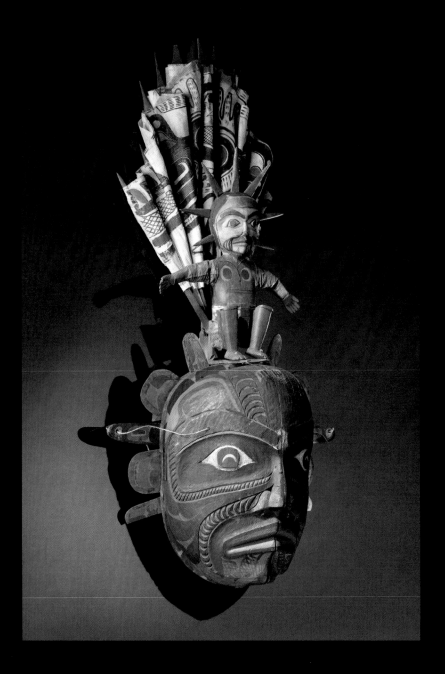

SPIRIT MASK

The face of the dramatic mask (above) opens to reveal another face (right), and the fabric atop the mask opens like a fan to show the course of the sun across the sky. The mask embodies the power of transformation, even as the sun gives way to the moon and summer to winter within the universe of four worlds: Sky, Mortal, Undersea, and Spirit. The dancer wearing the mask represents one being, then vanishes, but returns transformed into the spirit represented by the mask. Masks such as these are manifestations of the spirits who became Kwakwaka'wakw ancestors and established the relations between humans, animals, and spirits.

KWAKWAKA'WAKW (KWAKIUTL) MECHANICAL MASK, LATE 19TH C. WOOD, CLOTH, AND CORD, HEIGHT 132 CM. 11/5235

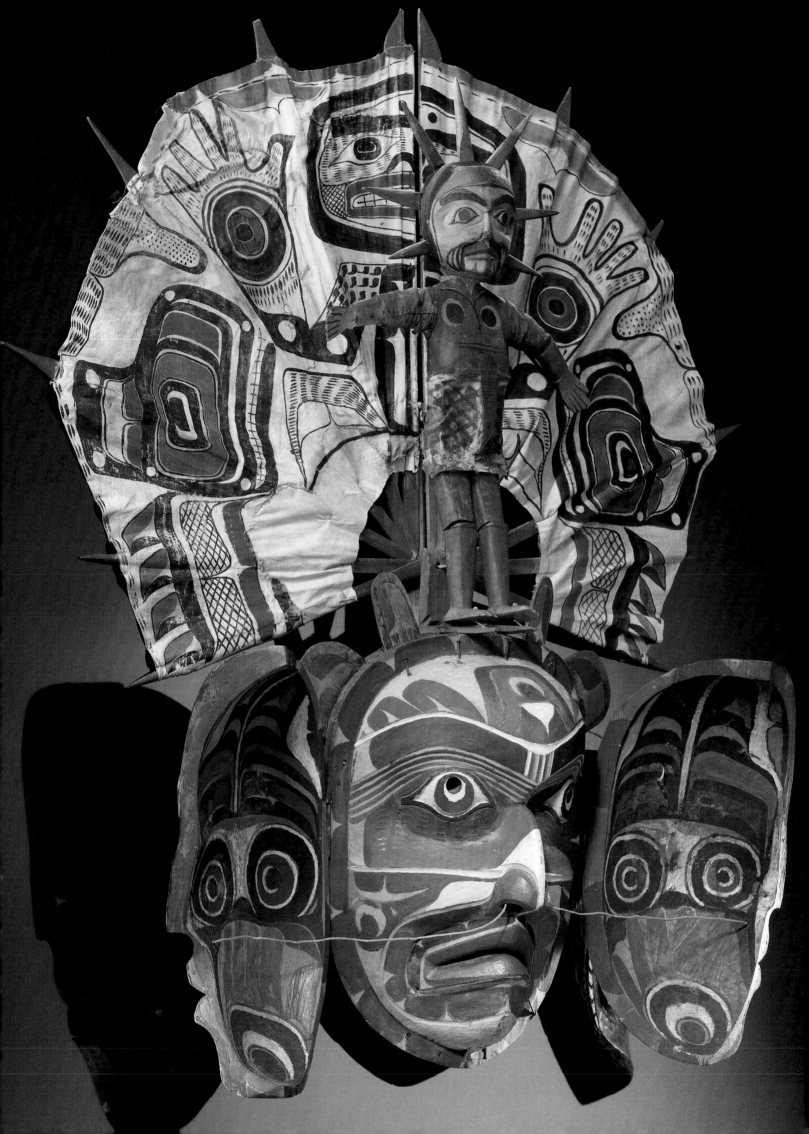

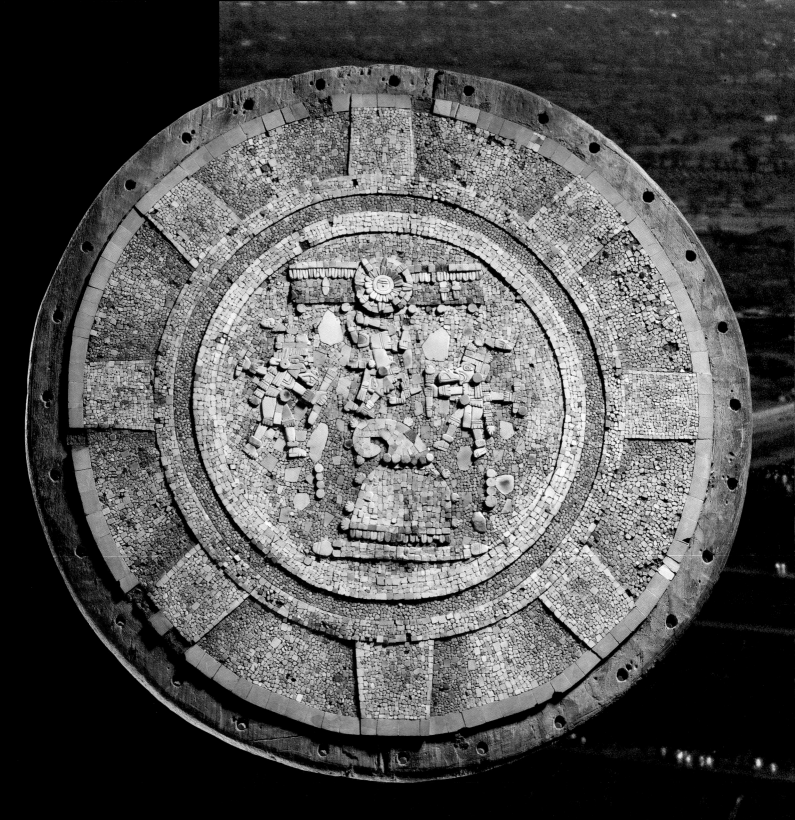

COLOSSUS AND EMBLEM

A rival in size to Rome in the mid-first millennium A.D., but unknown to it, Teotihuacan (background) rose as the first metropolis in Mesoamerica near what is now modern Mexico City. A marketplace, art center, and ritual site, the eight-square-mile city's influence was widespread. And it still is, for at sunrise on the vernal equinox visitors swarm over and atop the Pyramid of the Sun to observe their own rituals above the Street of the Dead, which stretches to the distant Pyramid of the Moon. What the origins of Teotihuacan were, what language its people spoke, or why it collapsed is unknown. Centuries later, the Mixtec culture in southern Mexico produced finely crafted work, often by order of the Aztec state, such as this ceremonial shield, a wooden solar disk inlaid with mosaic. It represents the birthplace of Huitzilopochtli (Blue Hummingbird on the Left), the Aztec god of the Sun and war. In the center of the disk, a woman floats in the celestial sky above the god's birthplace. His birth is associated with the Sun's lowest point on the horizon, when the Aztec prepared to celebrate the Sun's rising rebirth.

MIXTEC-AZTEC SHIELD, 15TH C. WOOD, TURQUOISE, AND RESIN, DIAM. 32.5 CM. 10/8708

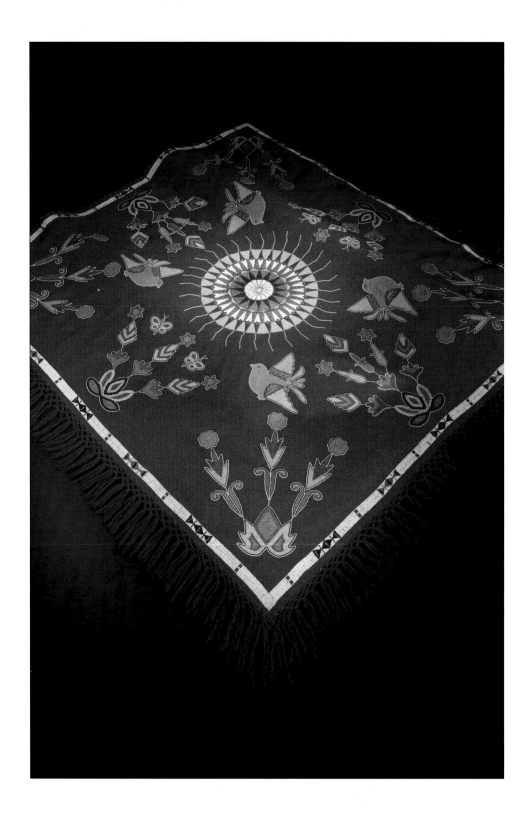

BOLD BEADWORK

This dazzling blanket or table cover (above) appears to be the work of an Eastern Sioux woman and is influenced by the floral beadwork style of the Métis, descendants of French fur traders and Native groups. Glass beads, as used in this piece, were introduced by fur traders and quickly replaced porcupine quills, since traditional designs were easily worked in beads. The central motif (right) was usually quilled or painted on men's buffalo robes. It represents an eagle-feathered war bonnet, a sign of authority and respect and also a representation of the Sun, the principal deity of the Sioux. Birds and flowers in the design may represent decorations or symbols seen in missionary churches.

SISSETON SIOUX BEADED CLOTH, CA. 1890. GLASS BEADS, WOOL TRADE CLOTH, COTTON, WOOL YARN, 165 X 152 CM. 12/814

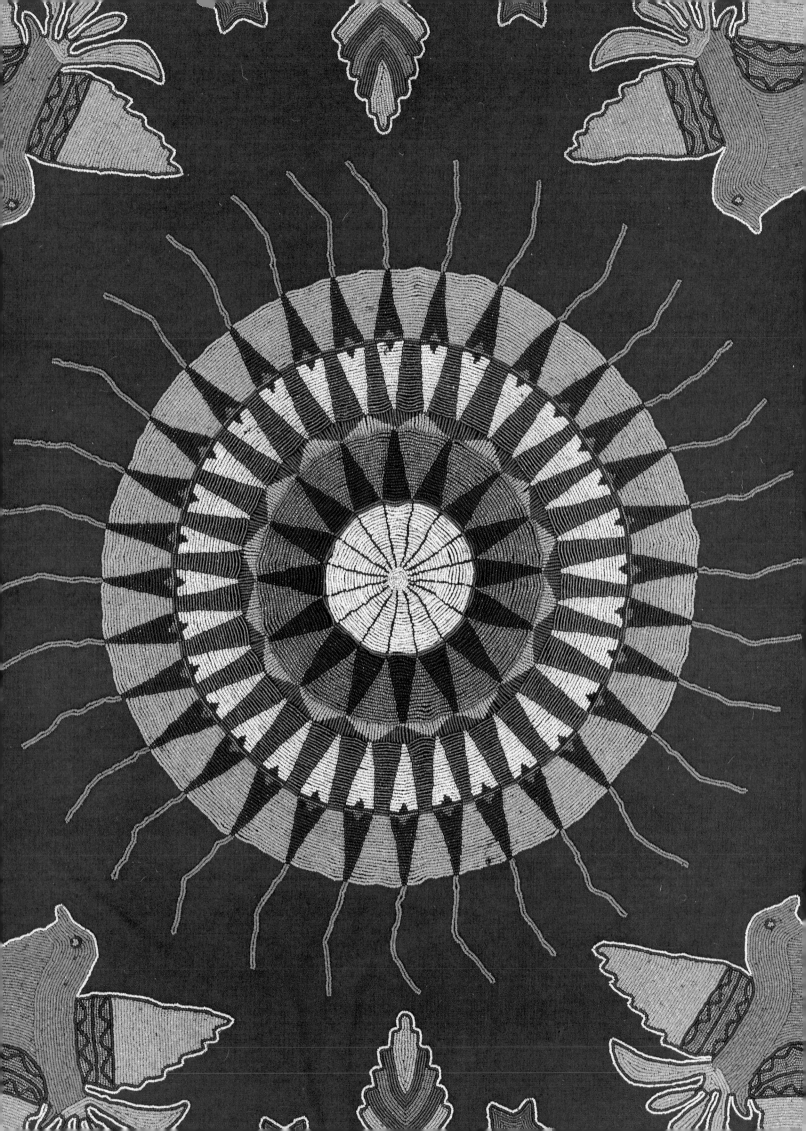

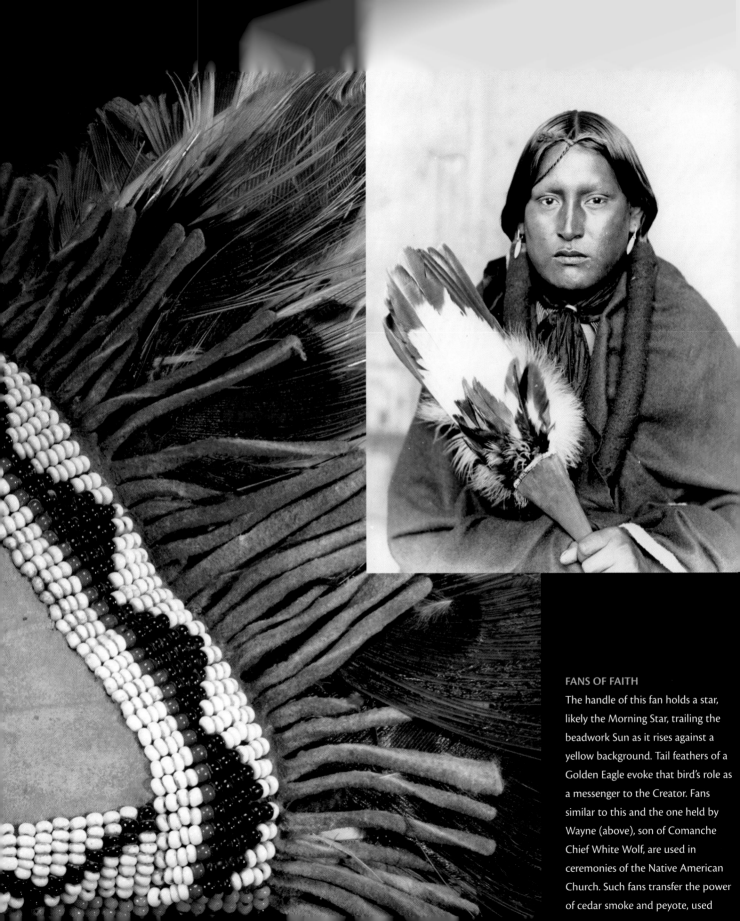

FANS OF FAITH

The handle of this fan holds a star, likely the Morning Star, trailing the beadwork Sun as it rises against a yellow background. Tail feathers of a Golden Eagle evoke that bird's role as a messenger to the Creator. Fans similar to this and the one held by Wayne (above), son of Comanche Chief White Wolf, are used in ceremonies of the Native American Church. Such fans transfer the power of cedar smoke and peyote, used

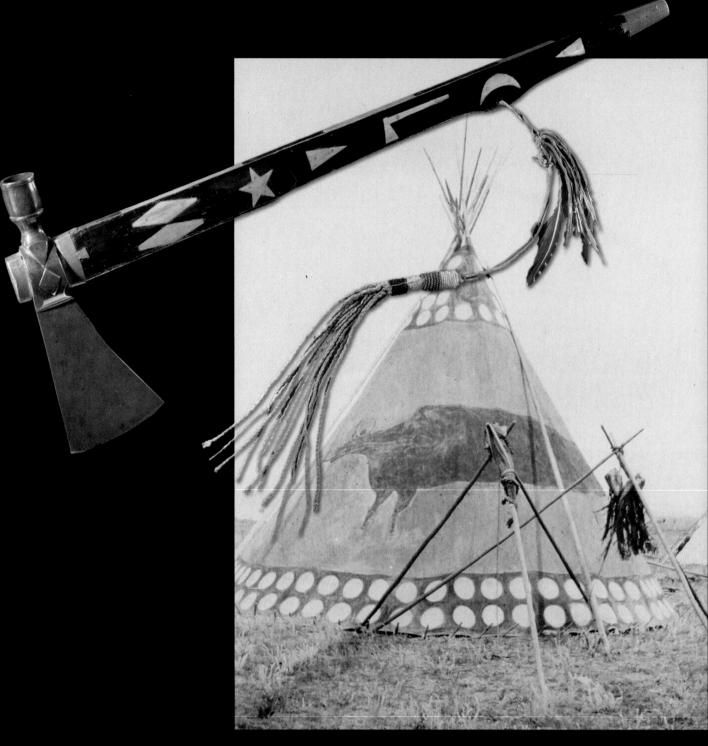

CELESTIAL SIGNS

Native spirituality, architecture, art, and daily objects frequently resonated with the people's view of the cosmos, its deities, and their stories. The pipe tomahawk (above) belonged to the notable Sac and Fox leade Chief Keokuk (Watchful Fox). With its moon, star, and hatchet glyphs, it was more a ceremonial object and symbol of authority than a weapon. Stars encircle the base and top of a Blackfeet tipi (background), and a painted buffalo gallops between them. Designs for such tipis often arose in dreams or visions that connected the owner to the world beyond. The center beadwork of an Absaroke (Crow) horse ornament (opposite) features a Morning Star design. Among the Absaroke people, stars and stories about stars were used to describe the origins of religious objects, as is the case with the tale of the twins Starboy and Earthboy. When Starboy came down from a mountain with tobacco his father had given him, he met Earthboy, who said tha he had been given a pipe. The brothers agreed to settle their differences and smoked together. They parted ways, each taking some of the people with them. Though divided, the people did not become enemies for

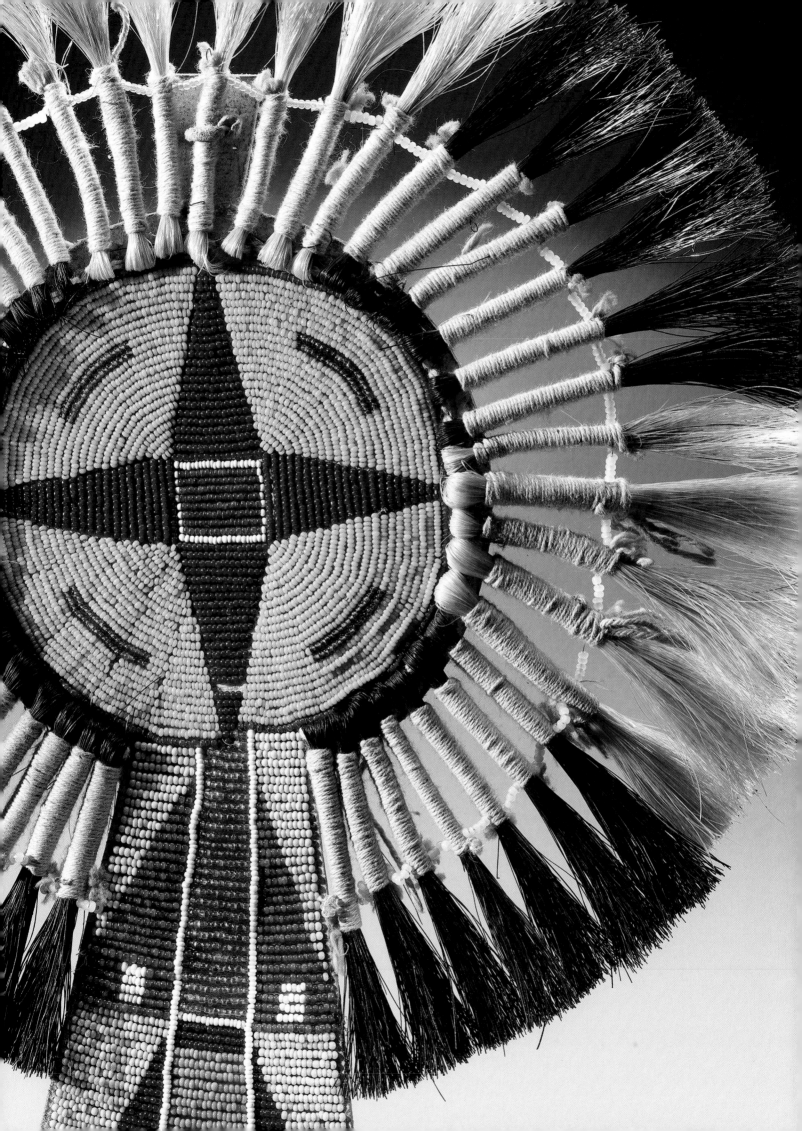

Carriers of the Dream Wheel

By N. Scott Momaday

This is the Wheel of Dreams
Which is carried on their voices,
By means of which their voices turn
And center upon being.
It encircles the First World,
This powerful wheel.
They shape their songs upon the wheel
And spin the names of the earth and sky,
The aboriginal names.
They are old men, or men
Who are old in their voices,
And they carry the wheel among the camps,
Saying: Come, come,
Let us tell the old stories,
Let us sing the sacred songs.

DESIGNS OF TIME

A wood figure from the Shipibo people of Amazonian Peru is sometimes known as a *Joni Santo*, or saint, although such objects predate Christian influence. The geometric designs reflect two periods. The serpentine motif on the figure's legs refers to an ancient time when the Shipibo were taught by the giant anaconda, *Ronin Ehua*, which encircles the world. The Shipibo say they received the cross motifs from the Inka, some of whom fled as refugees to the lowlands to escape the advancing Spanish. Today's Shipibo execute intricate designs in ceramics and textiles.

SHIPIBO BALSA WOOD FIGURE, CA. 1960. RIO CALLERIA, UCAYALI, PERU. HEIGHT 50.8 CM. 23/1613

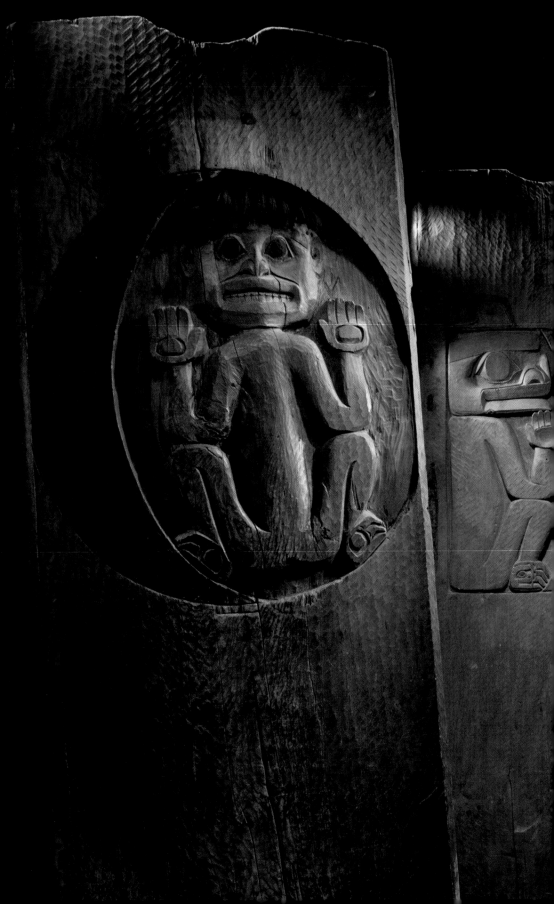

HOUSE SPIRITS

Native peoples of the Northwest Coast built large structures with interior house posts supporting overhead beams (below). The Tlingit posts (opposite) feature carvings of moons with human and possibly wolf figures. The figures in the two outer posts perhaps refer to a story about a boy who, when he went looking for water, was snatched up to the moon. These four posts were moved from one location to another and yet another. In each place the structure they supported was called the "Moon House."

TLINGIT CARVED AND PAINTED WOOD HOUSE POSTS, EARLY 19TH C. HEIGHTS 241.3 TO 246.4. 17/8012, 17/8013, 17/8014, 17/8015

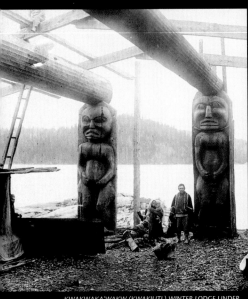

KWAKWA̱KA'WAKW (KWAKIUTL) WINTER LODGE UNDER CONSTRUCTION, GILFORD ISLAND, BRITISH COLUMBIA, 1900.

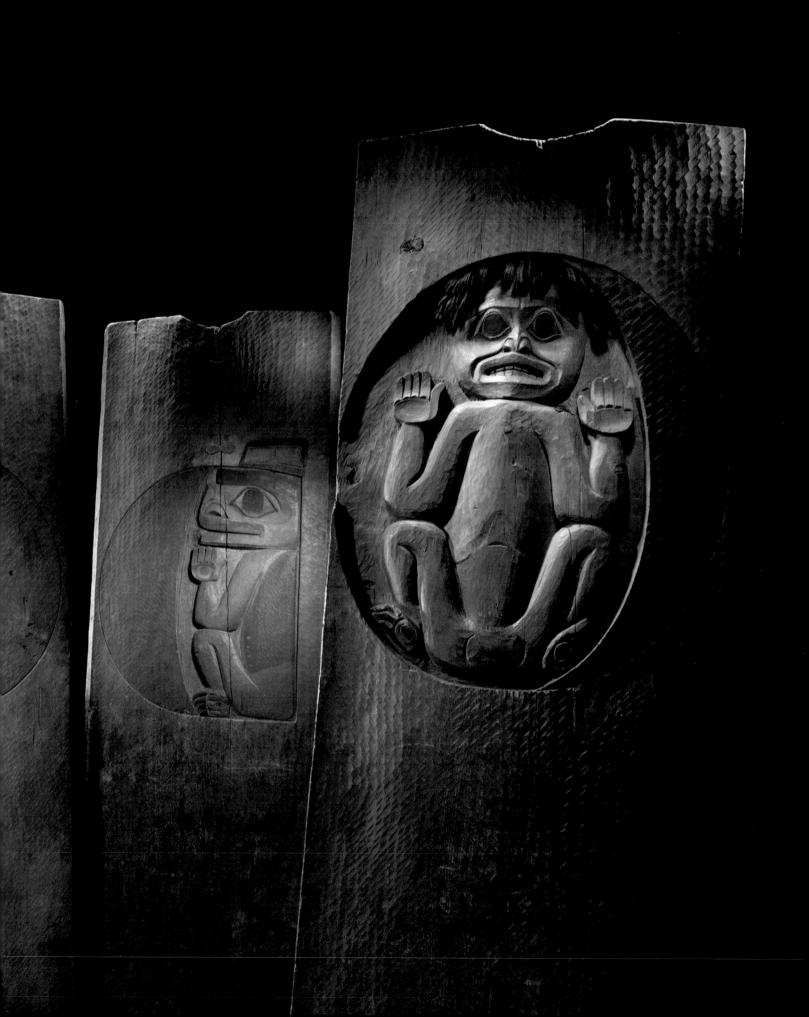

Animal Powers

Native peoples stand in close relationship to the animals who share their lands. In addition to providing humans with the materials for food and items of daily life, animals possess spiritual power and play an integral role in religious belief. Animals from sky, sea, and land participated in the creation of the world and human life, and appear in dreams as emissaries of spiritual power. To the Tlingit of the Northwest Coast, for example, animals are relatives sharing the same past and are represented on ceremonial regalia, dwellings, and household objects. The wooden dish depicting Brown Bear on page 103 embodies this richness of meaning. As a dish, it functions as a utilitarian object, a means of providing food to honored guests. As an embodiment of Brown Bear, it evokes the owner's distinguished clan history and noble ancestors, and important sacred ties to the spiritual world of the past and present.

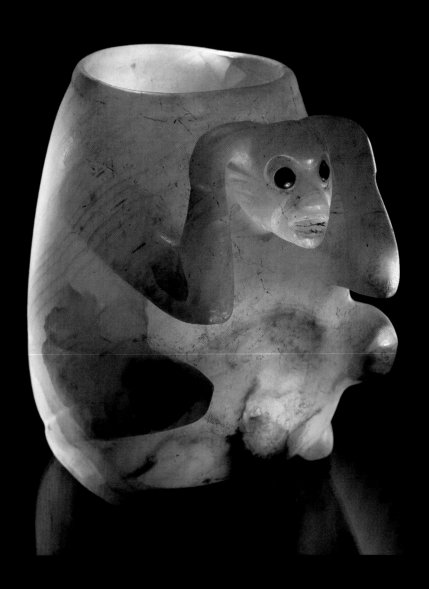

FROM THE ARK

Monkeys have appeared on stone and ceramic vessels in Mesoamerica for some 3,200 years, although this alabaster example (above) dates to the 14th or 15th century. The exterior was carved first; then the inside was hollowed. The eye sockets are inlaid with carefully crafted obsidian discs. The meaning of the monkey in the vessel may refer to a failed creation prior to the advent of true humans, or perhaps it alludes to the playful character of the patron deities of artisans. Among Nahuatl-speaking peoples, the monkey was the avatar of the God Xochipilli, patron of clowns and entertainers at feasts. Monkeys take their place with other animals (opposite) in a detail from a remarkable 18th-century weaving done in the Lake Titicaca basin, where the people were famous for their skill as weavers then as now. The scene is a Native version of the Noah's Ark story with animals from the Andean region and surrounding ecological areas.

MONKEY JAR, CA. A.D. 1300–1521. FOUND AT ISLA DE SACRIFICIOS, VERACRUZ, MEXICO. ALABASTER, 18.3 X 15.3 X 13.6 CM. 16/3371
INKA MANTA, PROBABLY LATE 18TH CENTURY. WOOL, 118.9 X 109.5 C. 5/3773

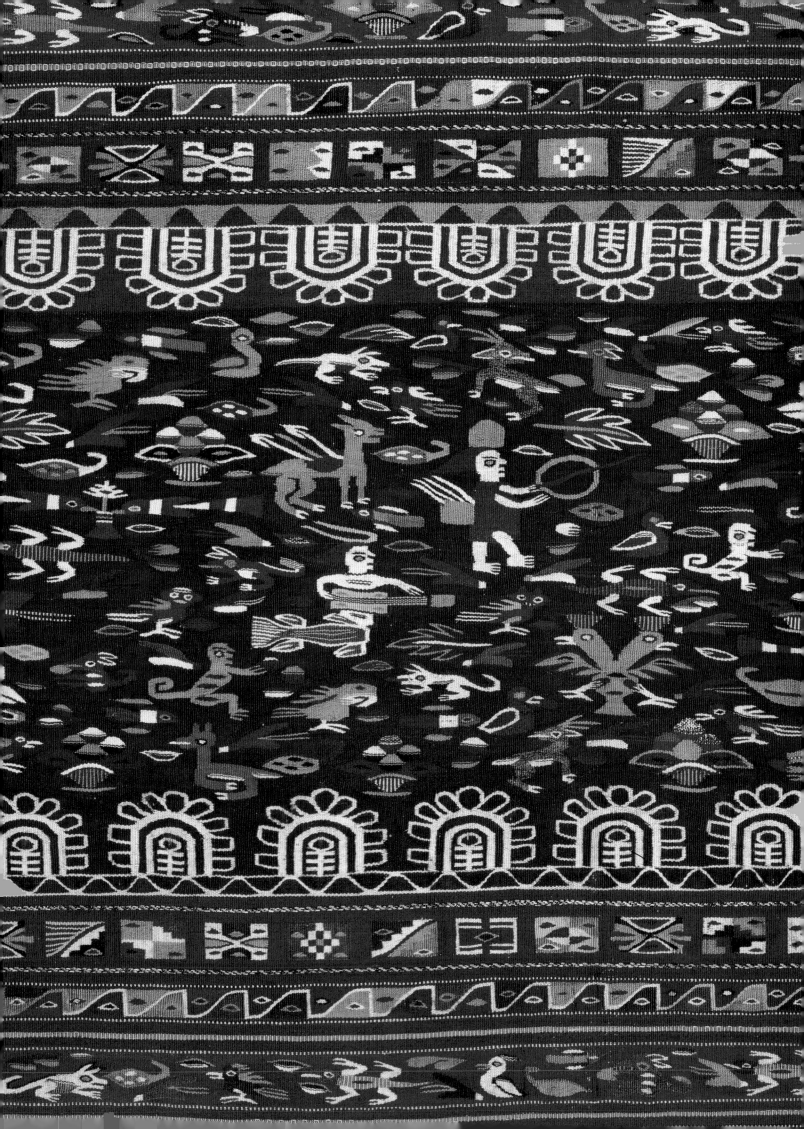

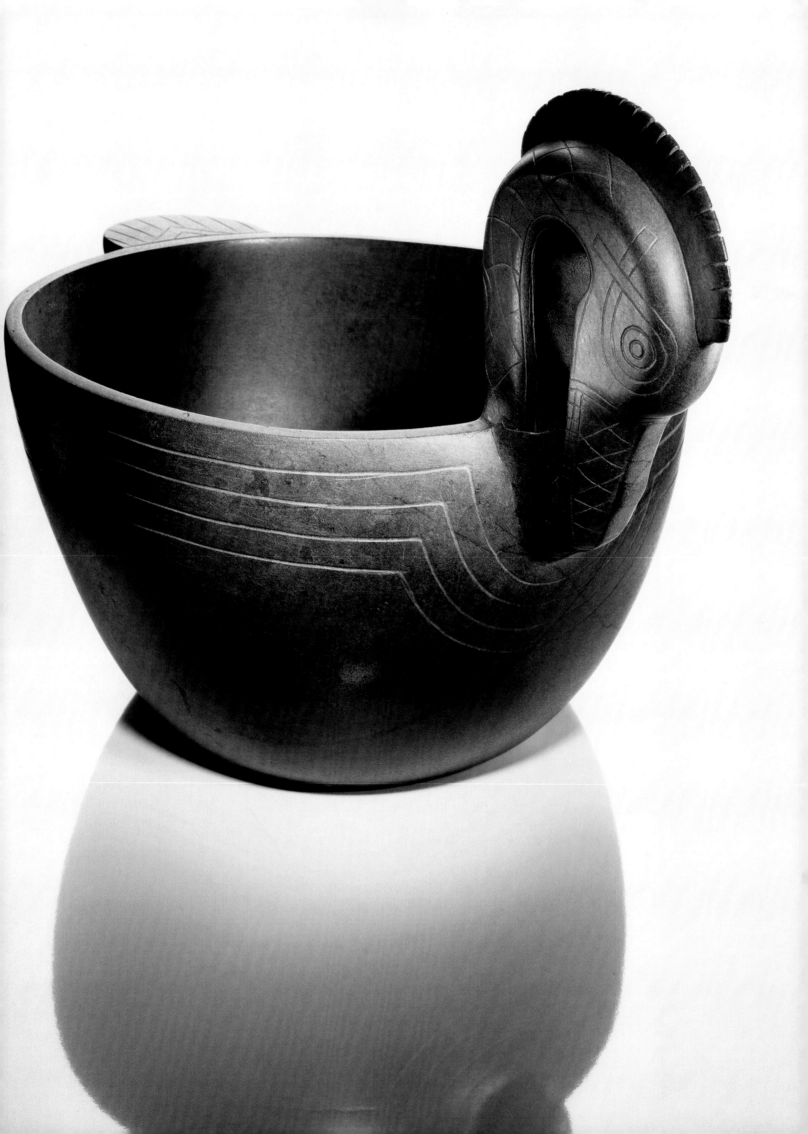

USE AND GRACE

Carved from diorite, a crystalline igneous rock, a bowl with a figure of a monstrous, bird-headed serpent (opposite) is a masterpiece of design and craftsmanship. Other objects from the powerful, sophisticated Native American culture that once flourished along the Mississippi Valley embody eagles, falcons, deer, rabbits, raccoons, beavers, frogs, and fish, among other creatures. For the Tlingit people, animals of the Alaskan forest are close relatives sharing the same past. They are represented on ceremonial clothing, house decorations, and dishes served to honored guests during potlatch feasts. The wooden dish depicting Brown Bear (below) might have been filled with savory dried salmon dressed with seal oil and passed around for the enjoyment of all. The sides of the dish are made from a single piece of wood, steamed and bent at the corners and then attached to a separate base. Brown Bear is both utilitarian and symbolic as it gives homage to the owner's noble ancestors, distinguished family history, and sacred ties to the worlds of past and present.

MIDDLE MISSISSIPPIAN MONSTER EFFIGY BOWL, A.D. 1250–1500. ALABAMA. DIORITE, 29 X 40 CM. 16/5232

CHILKAT TLINGIT BENTWOOD DISH REPRESENTING BROWN BEAR, CA. 1850. KLUKWAN, ALASKA. WOOD, SINEW, LENGTH 34 CM. 9/7847

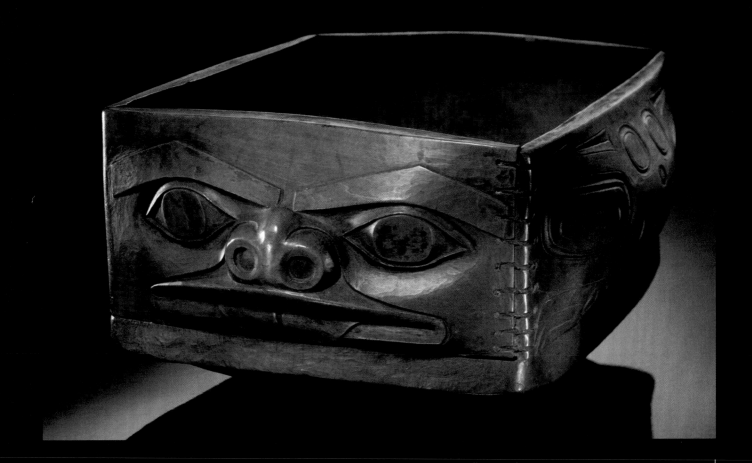

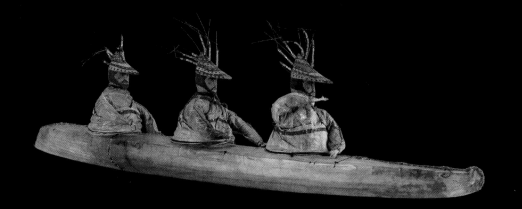

SEA HUNT

Driftwood, when scraped thin, steamed, and bent into a conical shape, was fashioned into hats (opposite) for hunters of otter and other sea mammals along the Bering Sea coast of Alaska and the Aleutian Islands. The overhanging brim cut glare from reflected sunlight, and the beads, sea lion whiskers, painted designs, and carved ivory side plaques called volutes helped give the hat a larger purpose: to honor the animals and invoke spirits that would safely guide the hunters. They ventured out in kayaks and *baidarkas*, one three-man version crafted as a model (above) and the type recorded in an early postcard (below).

HUNTING HAT, EARLY/MID 19TH C. ALEUTIAN ISLANDS. WOOD, SEA LION WHISKERS, IVORY, PAINT, GLASS BEADS, COTTON LASHING, LENGTH 40.6 CM. 14/4869

UNANGAN (ALEUT) MODEL BAIDARKA, CA. 1880. WOOD, SEAL (?) BLADDER SKIN, PAINT, BEADS, SEAL (?) WHISKERS, SINEW, YARN, LENGTH 50 CM. 16/8275

POSTCARD OF ESKIMO MAN IN BAIDARKA. COOK INLET, ALASKA. P07871

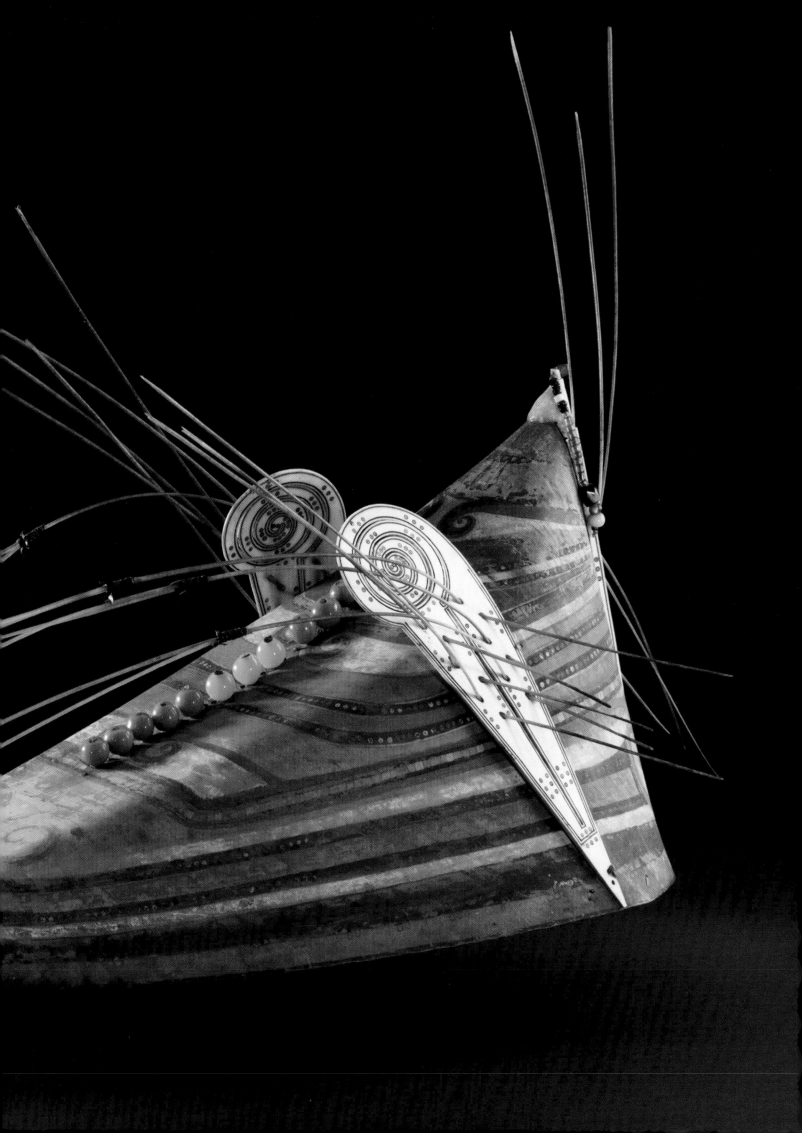

Sacred Feline

By José Montaño

CATS, CATS, CATS

Feline images have long been depicted in Native objects as emblematic of power, grace, speed, stealth, and deity. Of the ceramics on the opposite page, the jaguar with stirrup spout, holding a man in its paws, dates to about 2,000 years ago. Next oldest is in the middle, a censer with a puma at its lip, from about 1,300 years ago. The youngest is the larger vessel with the jutting jaguar head from about 600 years ago. On stylistic grounds, one might expect the turquoise bobcat (above), with its simple, powerful form, to be the oldest. It is the youngest by far, a 1990s work by Navajo artist Herbert Davis.

BOBCAT, CA. 1990, MADE BY HERBERT DAVIS, NAVAJO. NATURAL TURQUOISE, HEIGHT 7.9 CM. INDIAN ARTS AND CRAFTS BOARD COLLECTION, DEPARTMENT OF THE INTERIOR, AT THE NATIONAL MUSEUM OF THE AMERICAN INDIAN, SMITHSONIAN INSTITUTION. 25/6125

MOCHE STIRRUP SPOUT VESSEL OF CROUCHING JAGUAR HOLDING A MAN, 200 B.C.–A.D. 100. PERU. POTTERY, PAINT, HEIGHT 18.4 CM. 5/1888

TIWANAKU CENSER WITH PUMA SHAPE, A.D. 600–900. BOLIVIA. POTTERY, PAINT, HEIGHT 21.5 CM. 20/6314

NICOYA JAGUAR EFFIGY VESSEL, A.D. 1220–1550. COSTA RICA. POTTERY, PAINT, HEIGHT 35.6 CM. 19/4896

A ccording to oral traditions of the *Qulla* (one of several Aymara-speaking groups), a big feline with a long fire tail lives in the core of the Earth. During every new moon, this cat emerges from the bottom of Lake Titikaka to nibble at the lunar sphere. To prevent it from completely devouring the moon, the people beat drums in the night and sling rocks at the moon. Thus the moon is able to grow again. In another story, the sacred feline emerges from Lake Titikaka and is transforms into a flaming serpent with a fish tail. It symbolizes both water and fire, and also represents the dual composition of the Earth, the inside and outside. The sacred feline is a powerful messenger in this universe between the world above and the world below.

Two large cats of striking appearance — the puma and the jaguar — play a significant role in Central and South American ceremonies. Native peoples in the "high plateau" region of Bolivia have a special spiritual and cosmological relationship with pumas and jaguars. In the Andes Lake Titikaka has been considered sacred from time immemorial. *Titi* means puma in Aymara. *Kaka (or qaqa)* has two meanings; depending on the usage, it can refer to the color of the puma, or it can refer to a shelter. *Titikaka* means "Shelter of the Puma."

Because of their importance in our cosmology, the sacred felines are depicted in a wide range of pre- and post-Hispanic Andean ceremonial artifacts, including stonework, textiles, metalwork, bone, wood, and ceramics. In the Altiplano village of Umala, some Bolivian musicians wear ceremonial clothing that refers directly to the sacred felines — a kind of sleeveless yoke, rather like a short, stiff poncho, called a *qhawa* (pronounced *ka' wa*) Some qhawas are made of a thin sheet of silver while others are made of jaguar-skin. This outfit is used in August ceremonies in honor of the moon. For us, these artifacts are not only art but utilitarian objects that reflect our faith and our vision of the cosmos as well as our daily lives. The feline is a ubiquitous symbol in our political, religious, and astronomic systems and carries many meanings: night, fire, power, and hierarchy. The feline is also a metaphoric representation of female elements such as water, the moon, and creation.

In the Andean universe, there is a hierarchy of animals. It begins in the sky and continues to the Earth and under the Earth. Condors and felines occupy the top of the hierarchy, and they are considered the closest beings to the Creator. The condor is thought to be the highest and most powerful sacred animal in the Andes, because this great bird is the bearer of the light of the sun and moon. We pattern our political system on the example of animal hierarchy. Our chiefs are called *mallku*. The condor is called *mallku kunturi. Mallku* means authority or power, *kunturi* means condor. Condors and felines, being close to the Creator, are intermediaries between people and the Creator.

We have our own way of seeing the world, and this universe is called *Pacha,* which literally means both "time" and "space." It consists of three elements: *Alax Pacha* (the sky), *Aka Pacha* (the surface of the Earth), and *Manqha Pacha* (the underground). Each of these areas is inhabited by living beings that are intimately related to the people. Alax Pacha is the sky and the community of stars — the Milky Way. The Alax Pacha also exists in a reciprocal relationship with the Aka Pacha, with its people and animals. Productivity depends on these harmonious relationships. Aka Pacha is the atmosphere; Mother Earth and sacred places exist inside this atmosphere. This is where humans live, along with plants and animals, in a reciprocal relationship with Mother Earth and the protectors of sacred places called *Uywiris*. The Manqha Pacha is the place where the spirits of the ancestors live, inside or underneath the Earth. It includes the depths of the ocean and bottom of lakes.

In the Tiwanaku-style *uywir chua (incensario* or censer), displayed on the opposite page, we can see both a sculptural puma and an abstraction of a painted condor. We use the uywir chua in our prayer and as a *luqasiñ chuwa,* a plate for offering something to the protectors. During the ceremonies, it is used to burn offerings that include incense, copal, and aromatic plants. The smoke from burning the offerings is prayed over, to infuse it with our prayers, hopes, and messages. As it expands and moves outward to the three segments of our universe, Mallku Kunturi and Puma carry our prayers to the Creator.

Honoring
the Universe

Ritual drinking cups known as *qeros* have been important symbolically for millennia in the Andean region. At the time of the Inka Empire (ca. A.D. 1470-1532), qeros played a central role in the Inka conquest and in sociopolitical interaction with non-Inka people. Always made in pairs, they reflect the significance of duality in Andean thought. Pachamama (Mother Earth) and Apu (Father Mountain) are the owners of everything on Earth in pairs, including mountains, rivers, humans, animals, and spirits. After the Spanish conquest, qero manufacture and use asserted indigenous identity despite repression of Native culture. Andean artisans developed a new, European-influenced figurative style that drew upon and transformed not only ancient iconography but also indigenous materials and techniques, attaining new forms of indigenous communication. Triumphing over colonial rule and modern Western civilization, the qero tradition continues to honor the Native universe and express a profound pattern of relatedness.

DUALITY AND DOGMA

The inlaid wooden *qeros* illustrated above (and detail of one, opposite) were made during the colonial era (A.D. 1532 to 1821), and the two plainer examples are from the earlier Inka period (ca. A.D. 1470 to 1532). Qeros were always made in pairs as vessels for *chicha* (maize beer) used in social and religious ceremonies. They symbolize concepts of duality essential to Quechua-speaking peoples: female and male, negative and positive, and upper and lower. One qero of the pair is "male," and its mate is "female." In ceremonial arrangement, the male qero would be placed on the right and the female qero on the left. A drawing by Felipe Guaman Poma de Ayala, a Native Andean who served in the Spanish colonial administration (right) shows "The Fifth Inka, Capac

Yupanqui Inga, [who] ruled a kindom that extended to the province of the Aymara and Quichiua." The Inka ruler is depicted holding a qero, ritually drinking with an Inka deity to honor the Sun God. However, the artist, a convert to Roman Catholicism, has drawn the deity to represent a devil in the Christian concept of that era. Such misunderstanding of religious dogma was to cause endless grief for Native Andeans.

INKA AND COLONIAL PERIOD QEROS, CA. A.D. 1470 TO 1821. WOOD, PLANT RESIN-BASED INLAY, ORGANIC DYES, MINERAL PIGMENTS, HEIGHTS 14.2 TO 24.1 CM. 6/5838, 10/5635, 10/5637, 10/5858, 15/2412, 15/2413, 15/4548, 15/8338, 15/9411, 16/3605, 16/9708, 17/5445, 17/8956, 21/6917, AND 21/7453

DRAWING BY FELIPE GUAMAN POMA DE AYALA, FROM EL PRIMER NUEVA CORÓNICA Y BUEN GOBIERNO (CA. 1615).

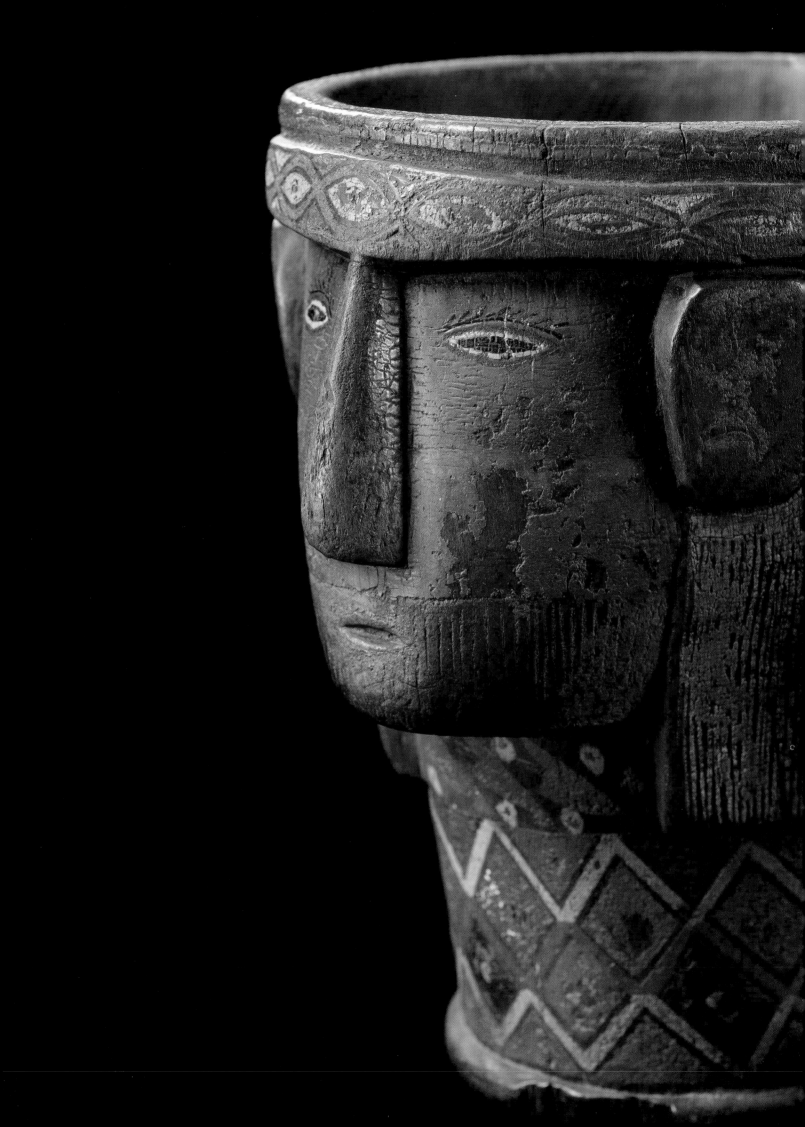

SEPARATED TWINS

During the pre-Hispanic and colonial periods in the Andean region, ritual drinking cups or *qeros*, such as the two at right, were always made and used in pairs. They were passed down together through generations as heirlooms. However, as they entered the commercial art and museum collection markets of the early 20th century, the pairs were most often split apart, and it is now rare to find intact pairs. Although the National Museum of the American Indian has one of the largest collections of qeros outside Peru, the two illustrated here are among only a few examples that could possibly be considered pairs. They may be so, or they may be from the same workshop but not true pairs. Sadly, the very vessels that symbolized unity through duality can rarely be reunited.

COLONIAL QEROS, CA 17TH–18TH C. WOOD, PLANT RESIN-BASED INLAY, ORGANIC DYES, MINERAL PIGMENTS, 20 X 17 CM (LEFT), 21 X 17 CM (RIGHT). 21/6920, 19/0496

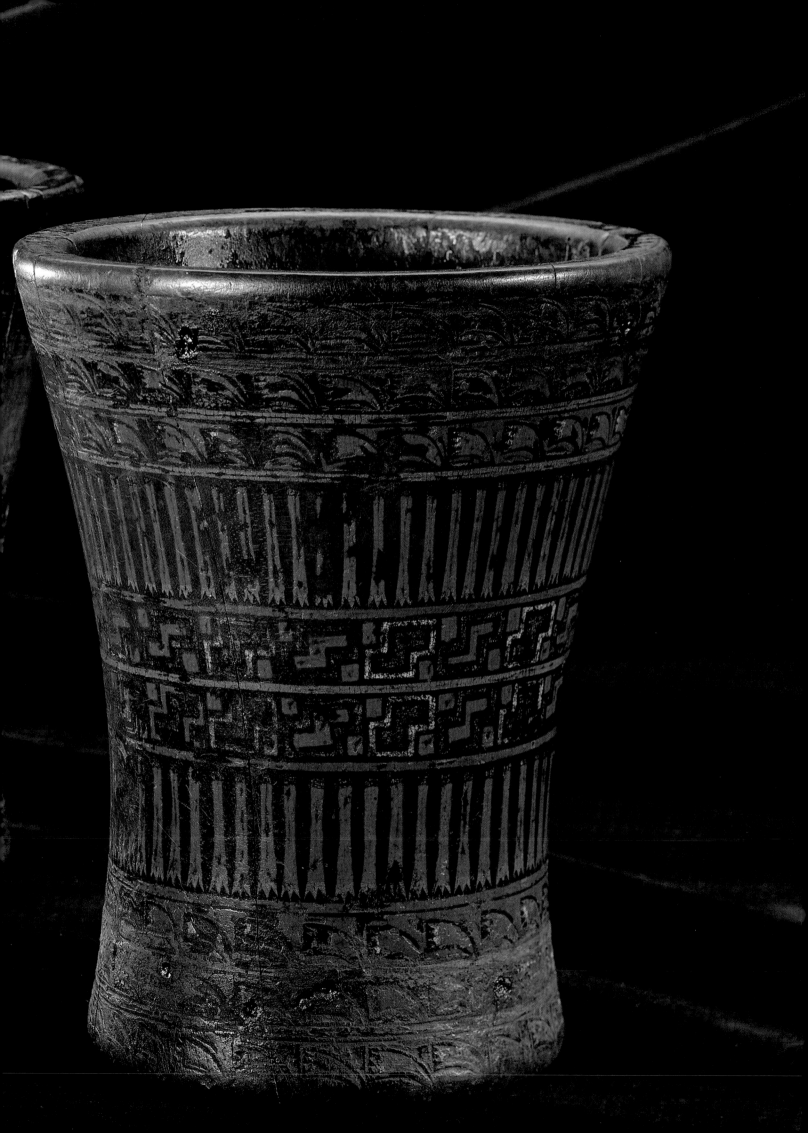

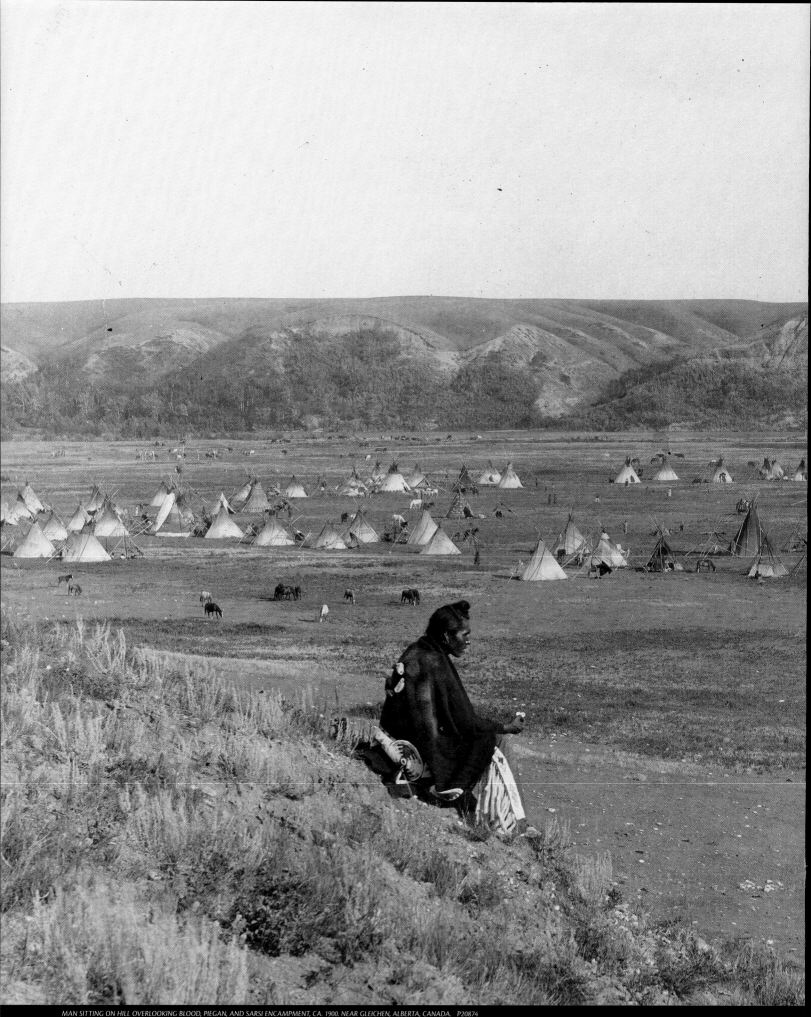

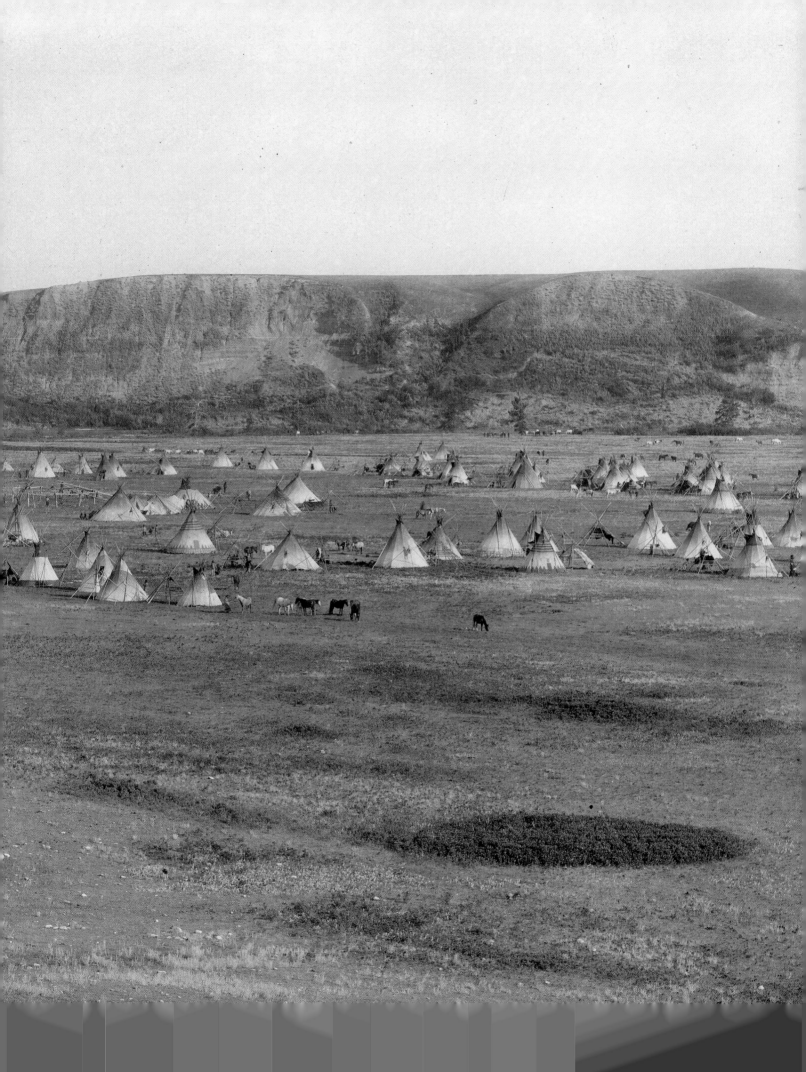

I N NOVEMBER 1876, GENERAL OLIVER O. HOWARD, U.S. MILITARY COMMANDER of the Department of the Columbia, met with Nez Perce leaders at Fort Lapwai in what is now the state of Idaho. He ordered the Nimi'ipuu, as the people called themselves, to abandon the beautiful mountains, valleys, and rivers of their forefathers, but they refused. The Nimi'ipuu would not give up any more of the land that held the bones of their ancestors. Howard met with them again in May 1877, and the venerated holy man Toohoolhoolzote spoke for them. Standing nearly six feet tall and with a deep, guttural voice, Toohoolhoolzote told Howard through an interpreter that he had "heard of a bargain, a trade between some of these Indians and the white men concerning their land." In 1863 a small number of Nez Perce, including Chief Lawyer and his followers, agreed to sell the land and move to a smaller reservation. Other Nez Perce called this the "Thief Treaty" and refused to obey it. Meanwhile, thousands of gold miners had flooded onto Nez Perce lands, and the U.S. government's solution was to propose shrinking the Nez Perce homeland to one-tenth its original size. The situation became more serious after a band of Lakota, Cheyenne, and Arapaho warriors wiped out Lt. Colonel George A. Custer's entire command in 1876, and the government ordered the Nez Perce tribe to move or face utter devastation.

Toohoolhoolzote informed General Howard in 1877 that neither he nor any of the "non-treaty" Nez Perce had agreed to the 1863 treaty and would not abide by it, adding: "I belong to the land out of which I came." For hours Toohoolhoolzote reasoned with General Howard, explaining the land's sacred nature, what the Nez Perce called the "chieftainship of the Earth." Again and again, Toohoolhoolzote reiterated the Nez Perce attachment to the Earth—until Howard exploded: "Twenty times over you repeat that the Earth is your mother, and about the chieftainship from the Earth. Let us hear it no more, but come to business at once." Toohoolhoolzote was unmoved:

IN MUT TOO YAH LAT LAT (THUNDER ROLLING OVER THE MOUNTAINS, OR CHIEF JOSEPH) WALLOWA BAND OF NEZ PERCE, PHOTO BY FRANK A. RINEHART (?). P00384

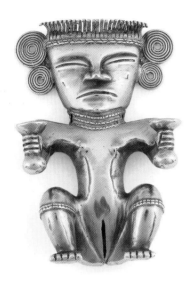

GLEAMING PLUNDER

The figures on this page and on the facing page were cast in pre-Columbian times. Native gold was worked into many elaborate forms and displays, lavished on palaces, adorned on priests, and traded through extensive networks. It symbolized great power and spiritual wealth. In the Americas, a strong connection was formed between gold and the sun. Ceremonial gold pieces were displayed outdoors to absorb and radiate the sun's energy. Spaniards hastily melted most of the pieces into ingots, a few still bearing faint imprints of the original figurines, shipped them home, and financed what became the most powerful of European empires.

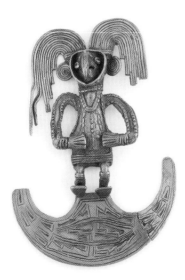

"What person pretends to divide the land, and put me on it?" Howard exclaimed that he was that very man and would execute his orders. Toohoolhoolzote remarked that Howard was "trifling with the law of the Earth" and concluded that other "Indians may do what they like, but I am not going to the reservation." Howard then ordered Captain David Perry to detain Toohoolhoolzote, at which point the holy man asked if Howard meant to "scare me with reference to my body?" Howard said that his body would be left with Captain Perry, who forced the Nez Perce elder into jail temporarily. Then, one by one, General Howard demanded that the leaders, including Chief Joseph, comply with his order to move to the reservation. Each one responded reluctantly that he would.[1] Nonetheless, circumstances intervened and war resulted.

Years later, Chief Joseph recalled this moment, saying: "We were like deer. They were like grizzly bears." He declared that "The Creative Power, when he made the Earth, made no marks, no lines of division or separation on it," and the Earth was "too sacred to be valued by or sold for silver or gold."[2] These words still resonate among our peoples.

CIRCULAR AND LINEAR TIME

Wyandot historian Georges Sioui once explained that major differences between Native Americans and Europeans lie in the ways people think, whether their processes are linear or circular.[3] Toohoolhoolzote's encounter with General Howard vividly illustrates the difference between Native and non-Native concepts of man's relationship to the land. Understanding certain elements of these two distinct cultures helps us understand their conflicts.

Formal education in most nations of the Western Hemisphere has origins in traditions that respect a linear approach, which emphasizes a sequential presentation of events or ideas from a European perspective, glorifying, for instance, the "Age of Discovery" as a positive era in world history. When Prince Henry the Navigator sent sailing ships down the coast of West Africa, man's knowledge of the world was expanded and markets were opened for silks and spices. We usually do not hear that Europeans also spread racial and religious war to West Africa, which led to large-scale enslavement of the Native peoples of Africa. Through linear history, we learn about Christopher Columbus's significant voyage in 1492 and the subsequent introduction of European culture to Native America, without dwelling on the death and destruction brought by Europeans to indigenous peoples of the Western Hemisphere.

In contrast, for Native nations of the Americas, who developed their educational system through oral tradition, contemporary events, and past experiences form a great circle that greatly influences our present lives. The circular manner of perceiving past and present, rather than seeing one event simply follow another, is most important as a way to think about Native American history.

The Americas prior to 1492 were certainly no utopia, for Indian groups fought each other and vented their prejudices. Some Native nations had centralized governments with authoritarian leaders, but the vast majority of tribes and bands were autonomous groups that tended to be politically fluid. Tribal elders gave power and allegiance to spiritual, civil, and military leaders, and the Indians themselves respected individuals and families who shared generously with each other, which enhanced their social standing. Many groups believed in private ownership of property, but they did not buy and sell land like Europeans. Indians also valued trade, but the vast majority of tribes, with notable exceptions, did not promote market economies or nation-states. Agriculture developed throughout much of Native

America, but usually it did not result in surpluses for export.

The European invasion and colonization of America was catastrophic for Native Americans, with multitudes dying from disease, war, starvation, and exposure. White expansion left thousands of Indian people homeless and hopeless and brought chaos and anomie. In a variety of ways Native Americans acted to preserve their cultures, protect themselves, and defend their lands, but events flowing from contact often overwhelmed them. All Native peoples learned to contend with conflict, resistance, and survival—what were to become central themes of our history.

NATIVE PLACES

American Indian history is a subject of place and the relationships of humans to their community, which also includes trees, rivers, mountains, valleys, and other elements of the natural world. Important places to Indian people include the soil that holds the remains of ancestors and sites where our forefathers prayed, danced, gardened, gathered, hunted, fished, and told stories. Significant places also include holy sites where unseen beings and forces dwell and work their influence on the living.

Choctaw people of Mississippi and Oklahoma have many sacred places, but none is as holy as Nanih Waiya in present-day Mississippi. Choctaws share a story about their people migrating across the American West to Nanih Waiya. Each night of their journey, when they settled down to rest, their leader stuck a sacred staff into the ground. Each morning the staff would be leaning in a particular direction, and the Choctaw set off in that direction. For several generations the Choctaw traveled in a southeasterly direction, and over the years many people died. Out of respect for the dead, the Choctaw carried their bones with them so that they could be buried at their final destination—the place where the Creator wanted the Choctaw to reside.

Like other American Indians, Choctaw considered their homelands and their every natural element to be sacred. Families lived in particular areas, and husbands often moved in with their wives' families, forming relationships with new people and places. Over years, Choctaw lands became filled with spirit and story. Like everyone, the Choctaw had conflicts among themselves and with others. Still, within the boundaries of their traditional lands, Choctaw and other tribes usually lived in harmony with their environment, the unseen powers of the land, and the spirits of the dead. From time to time, other Indians invaded their lands, causing conflict and war, but by far the most devastating incursions followed the arrival of Europeans.[4]

INVASION

In 1492, when Christopher Columbus first encountered Taíno people on the island of San Salvador (modern Watlings Island), Native Americans throughout the Caribbean and on the mainland soon were forced to deal with *conquistadores* bent on claiming their lands and resources for the Kingdom of Spain. Conquistadors did not appreciate Native culture or the objects the people made, unless they were of precious materials. Myriad gold and silver art objects of Native America were seized and melted down to enrich the Spanish crown.

Although greeted kindly by Native peoples of the Caribbean, conquistadors repaid the courtesy with murder, rape, and pillage when they encountered resistance. A Taíno leader named Hatuey refused to bow to the Spaniards and their religion, so they were prepared to burn him at the stake. Before lighting the fire,

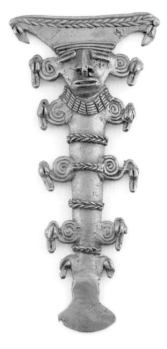

GOLD FIGURE WITH HUMAN HEAD FROM THE EAST BANK OF THE SINU RIVER, COLOMBIA. 5/2846

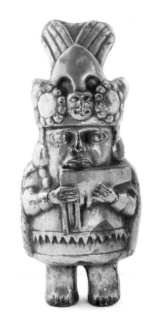

MOCHE SILVER PANPIPE PLAYER, CA A.D 100–600. CASMA, PERU. 18/589

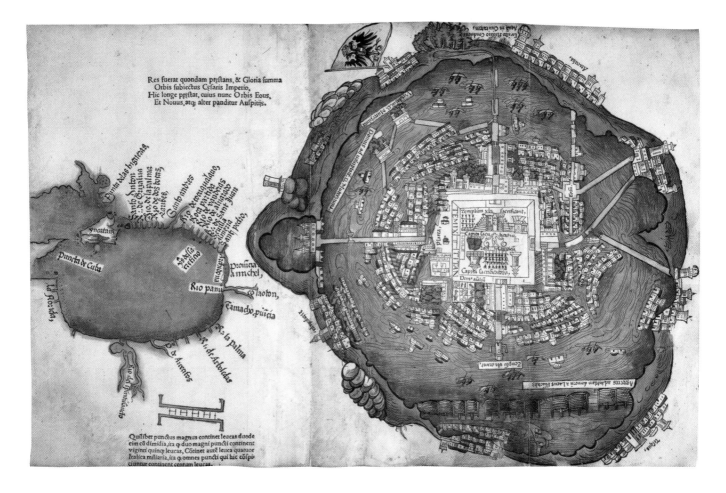

CHARTS OF CONQUEST

Published in a book on the conquest of Mexico published by Friedrich Peypus in Nuremberg in 1524, the hand-tinted woodcut map of Tenochtitlán (Mexico City) shows the Aztec capital as an island connected by four major causeways, with an outlying fortress. Hernan Cortés, Spanish conqueror of Mexico, had been greatly impressed by the city, and the map is based on a drawing reportedly made at his request. The smaller map is of the Gulf of Mexico (with south at the top). Prominent are the western end of Cuba (above "La Florida"), the Yucatan Peninsula, and the large river at the bottom, marked "Rio del Spiritusancto," now known as the Mississippi River.

a Spanish priest offered to baptize him so he might go to heaven. Hatuey then inquired whether the priest would be in heaven, too, since he was a Christian. When the reply was yes, the Taíno leader refused the baptism. His example of defiance and resistance persisted long after the fifteenth century and contributed much to the survival of the Taíno and other Native nations.

FORCES OF CHANGE

By 1492, remarkable Native civilizations already existed. The political, economic, and military federation of Quechua-speaking peoples of Peru and Ecuador had resulted in a fabulous empire ruled by a Sapa Inka. The Maya, Mexica (Aztec), Mixtec, and others in Mexico had organized strong communities on a large scale and had ruled huge geographical areas, fighting adversaries while strengthening themselves. Tenochtitlán (Mexico City), which Spanish historian Bernal Díaz del Castillo described as having "palaces magnificently built of stone, and the timber . . . with spacious courts and apartments . . . gardens . . . beautiful and aromatic plants . . . and a lake of the clearest water," had a population of approximately three hundred thousand—larger than that of Paris, London, or Madrid. Aztec skill in architecture had created magnificent temples, dams, and aqueducts. Irrigated fields of corn flourished. Native artisans crafted intricate art objects of stone, feathers, gold, and silver.[5]

Hispañola (the island now Haiti and the Dominican Republic) became the hub of the Spanish empire in the Americas, and from there Spain sent expeditions in many directions to claim the land, make subjects of the Native Americans, and spread Christianity. Everywhere the Spanish went, they inadvertently infected Native people with smallpox, influenza, measles, and other ordinary European diseases, exacting a death toll far greater than what Europe suffered during the

Black Death. Smallpox contributed greatly to the Spanish defeat of powerful Native American cultures, including the Aztec, who controlled the region surrounding Mexico City and fought the Spanish from 1519 to 1521. "It...spread over the people as great destruction," wrote one Aztec of the devastating outbreak of disease: "Covered, mantled with pustules, very many people died of them."[6] Attacking with horses, metal armor, and superior weaponry, the Spanish devastated Indian people already staggered by disease. The powerful Aztec empire succumbed, but its people survived and continue to be an integral element of Mexican culture.[7]

Rivalry and conflict among Native groups often accelerated with the arrival of Europeans. Native nations allied themselves with one group of Europeans against another, or other Indians, seeking advantage and trading for weapons and horses they could use against their Native enemies. The Spanish forced captives into slavery, but American Indians everywhere resisted. Although some Native peoples had themselves taken captives and enslaved other Indians, European slavery created a whole new form and degree of human misery. Europeans believed themselves superior to Native Americans and justified their exploitation by deeming Indians infidels and savages. Wherever the Spanish resettled Indian lands and established their own institutions, some Indians fought them while others adapted to the new cultures in various ways. In California, a master basket-maker among the Chumash incorporated the image of a Spanish coin into her art, adapting a traditional art form in a way that reflected cultural change within her community. Another Native woman chose to resist the Spanish at Mission Santa Barbara. Dreaming of Chupu (Earth Mother Deity), she received instructions to reject Catholicism and return to Native culture. When a two-tailed comet streaked across the sky, the Chumash rebelled against the Spanish, and for a time, controlled much of their traditional territory. These women reacted in different ways to the arrival of foreigners in their homeland.[8]

Spain claimed a huge portion of North America, all of Central America, and most of South America, while Portugal claimed Brazil. These two Catholic nations also claimed dominion over their "Christianized" Native peoples, colonizing the Western Hemisphere uncontested until 1607, when England planted its first permanent settlement at Jamestown. Later, the French, Dutch, Swiss, and Russians colonized parts of North America, attempting to expand their national interests, particularly in trade. With market economies that fed on raw materials, European nations exploited the land, natural resources, and labor of Native Americans for profit.

INDIANS AND ENGLISH COLONISTS

By the time England established its first successful colony, many Native Americans along the Atlantic coast had been trading with Europeans for manufactured goods such as pots, knives, fishhooks, beads, cloth, and metal. However, the colony at Jamestown ushered in a new era, for Indians now had to contend with a foreign power eager to expand its economic sway. Pamunkey Chief Powhatan led a confederacy of Native Americans in the Chesapeake Bay area and dealt cautiously with the English, but during the hard winter of 1607–08, the Pamunkey saved the colonists from starvation and exposure.

The Pamunkey are best known for Powhatan's daughter, Pocahontas, who allegedly saved the life of Captain John Smith and ultimately married the tobacco

CHANGE AND INTERCHANGE

A presentation tray by a Chumash woman near Santa Barbara, California, was made in the mid-1820s under commission from Spanish officials in Monterey, the colonial capital nearly 250 miles distant. Evidently, the repute of the Chumash basket-makers had spread broadly. The tray incorporates a Spanish coin motif into a traditional, and exceptional, craft and reflects cultural interplay traveling in both directions. The officials valued the maker's art and craft; the maker adapted the officials' symbol of value in an extraordinary Chumash basket.

PRESENTATION TRAY, CA 1825. MADE BY JUANA BASILIA SITMELELENE (1780–1838), CHUMASH. BUNDLE-COILED OF JUNCUS STEMS WITH NATURAL AND DYED JUNCUS STITCHES, DIAM. 48 CM. 23/132

Hazianle Cada Año en Tierras de Regadío Semen|teras de estas quatro Callas.

Algodon.

Maiz.

Calabazas.

Axi.

TRIBUTE

A rare record of tribute paid by Native people to Spanish overlords was tallied in two ways, as a written manuscript and as a pictographic account shown at left. It appears to be an 18th-century copy of a 16th-century drawing from the Mexican region of Tepexi de la Seda, a center for silk weaving, where silkworms had been imported from Asia shortly after the Conquest. Important lords who exacted the tribute are pictured, as are items that were given over to them, including slaves, gold, precious stones, fine feathers, textiles, clothing, cacao, chickens, sandals, woven chairs, rattles, gourd vessels, bowls, pots, and pitchers—a grander assembly but similar to the items from the National Museum of the American Indian collection gathered in the photograph at right. A detail from the painting (above) depicts some of the principal crops grown by the Native people of the region: cotton, corn, squash, and hot peppers.

PAINTED TRIBUTE RECORD OF TEPEXI DE LA SEDA, 18TH C. COPY OF CA. 16TH C. ORIGINAL. PUEBLA, MEXICO. PARCHMENT, 61.5 X 58 CM . 8/6682

HOLY BOOK COVERS

As Sioux people were settled on reservations, Christian denominations were assigned to establish mission schools among them. Episcopalians established schools at the Oglala (Pine Ridge) and Sicangu (Rosebud) reservations, later followed by Jesuit missionaries also known as the Black Robes. Bibles and hymnals were decorated by Sioux people with dyed porcupine quills in the traditional manner. The hymnals opposite have the words *"Wakan Cekiye Odowan"* (Holy Prayer Hymnal) worked in porcupine quills. The bible is decorated with small glass beads, which were introduced by traders and eventually replaced quills.

SIOUX HYMNALS DECORATED WITH PORCUPINE QUILLS, CA. 1900. 23/8300 AND 25/3885
SIOUX BIBLE DECORATED WITH GLASS BEADS, CA. 1920S. 23/6809

promoter John Rolfe. She served as a cultural broker for several years, but after her marriage supported English investment in the Virginia Company and her husband's agricultural enterprise. While the Spanish found gold and silver, the English utilized abundant Indian crops of corn, tobacco, pumpkins, cranberries, and tomatoes to bring a market economy to Virginia and other colonies. Tobacco eventually exhausted the soil, and this encouraged the English to expand deeper into Native America. As tobacco farming grew, it required additional labor, so in 1619 the English brought the first Africans to Virginia to work the land. During the colonial era, Indians and Africans forged trade and familial connections that continue to this day. Africans and Indians also shared in the ill effects of Puritan covenant theology that developed out of Christianity, particularly the Calvinism of Massachusetts Bay.

In 1620, Pilgrims arrived at Plymouth, the site of a former Patuxet village that had been destroyed by European disease. Like the colonists at Jamestown, Pilgrims suffered a starving time, but in the spring of 1621 two Native Americans named Tisquantum and Samoset saved the English from hostilities, hunger, and exposure, working as intermediaries and teaching settlers to plant corn, squash, and beans. They also showed them prime areas to fish, hunt, and gather.

Although Pilgrims celebrated their first harvest with their Wampanoag neighbors, the two peoples settled into an uneasy association that alternated between coexistence and friendship. In 1630, however, Puritans arrived in Massachusetts Bay and soon challenged all the tribes of New England. Puritans experienced no starving time, and they took this as an affirmation of God's love for them and their work to establish a "City upon a Hill," a pure, just, and godly community for the world to witness. The Puritan colonies prospered from the beginning and grew quickly, while Native American populations declined rapidly from various European diseases. To the Puritans, God acted against Native Americans by sending plagues among them, clearing the land of "heathens" and "savages." Puritans expanded their towns into the forests, taking over Indian villages, gardens, and hunting grounds—lands already cleared of thick woods. The issue of land ownership emerged as a major theme throughout the Western Hemisphere, but other problems also developed.[9]

One underlying tension between Native and non-Native peoples resulted from their separate worldviews of religion. Many Europeans believed that Satan was an active agent on Earth, corrupting humans and leading them away from God. They often swore that Satan worked his evil through Indians. Many equated "primitive" Native American ceremonies with Devil worship. Such an attitude made it easier for some colonists to justify forcefully removing Native Americans from their lands. This was certainly the case for those who feared the Wampanoag, Pequot, Narragansett, Abenaki, and Massachusett. Puritans believed that Native Americans were outside the covenant that God had established with his chosen people, the Christians.

In Virginia and Massachusetts, Native Americans resisted encroachment by English settlers, often fighting to prevent their physical, spiritual, and economic expansion. When under Opechancanough the Powhatan Confederacy attempted to destroy the English settlements in 1622, Parliament offered Virginia support by naming it a crown colony. And when the Pequot refused to surrender their lands in 1637, whites attacked Indian fortifications on the Mystic River and killed between 400 and 700 men, women, and children. In the Old Testament, King David had killed many "wicked" people, so Puritans and Pilgrims believed they had the same right. The Pequot War was followed with a reservation system that forced Indians into prescribed areas where white magistrates dictated policies, including forced

introduction to Christianity and elements of English "civilization." Puritans ordered these "Praying Indians" not to use firearms or alcohol and to have no contact with Indians outside the reservations. Many Christian nations shared the Puritan philosophy that non-Christian "barbarians" had no standing in God's eyes and used this rationale to subject Indian people.

EXPANSION

Despite the tensions between Christians and Indians, some Native Americans gravitated to Christianity and formed their own congregations. Still other Christian Indians remained troubled over land issues. English settlers, among them many devout Christians, continued to overrun Indian lands, igniting conflicts that ultimately led to the loss of more Native lands. The process begun in the colonial era continued through America's Revolutionary and Early National periods. In spite of efforts by some government officials to stop the theft of Indian lands, settlers ignored Indian rights and acted independently. As a way of extinguishing Indian title to lands, the new American republic created the first national treaties at Fort Stanwix, Fort MacIntosh, and Fort Hopewell with the Iroquois, Lenape (Delaware), Shawnee, Wyandot, Ottawa, Cherokee, and other Native nations. Numerous other treaties followed, forming a nation-to-nation relationship that recognized Indian sovereignty. But, unfortunately, the United States also used this process to invalidate treaties not to their liking. During the 1790s, the Wyandot, Ottawa, Shawnee, Lenape, Seneca, Anishinaabe (Ojibwe), Miami, Potawatomi, and other tribes from Ohio, New York, Pennsylvania, Indiana, Michigan, and Canada fought three important battles against the United States,

winning the first two and losing the Battle of Fallen Timbers in 1794. That battle and the subsequent Treaty of Greenville forced a number of tribes to cede thousands of acres to the United States and move west. These events in Ohio stung all the tribes of the Old Northwest and the South, where Americans were crossing into Kentucky and Tennessee, resulting in anger and hatred among many.

SPIRITUAL RESPONSE TO RESETTLEMENT

Native nations throughout the Western Hemisphere looked to their spiritual leaders for help in dealing with the calamities that came with the European invasion. For many tribes in North America who had looked to the French as their closest ally, the end of the Seven Years War brought another blow. Once British and American forces defeated the French, Indians lost their support and faced an uncertain future with British agents, soldiers, and settlers. In Ohio, a Lenape holy man named Neolin preached that the Master of Life wanted his children to return to Native foods, technologies, and spiritual beliefs. He urged all Indian people to stand united against the British and Americans. Ottawa Chief Pontiac used Neolin's teachings to unify Indians, and for a time had his way, holding back the westward movement. Ultimately, neither Neolin nor Pontiac could turn the tide of American migration onto Indian lands.

In response to the chaos brought about by the American Revolution and its aftermath, some Native people in the middle colonies and Canada followed the teachings of other spiritual leaders, notably Handsome Lake, the Seneca prophet. Onondaga elder Irving Powless says, "Two centuries ago the Creator saw that we were wandering from our ways because of the changes the White Man had brought." As a result, the Master of Life "sent us a Message through a chief named Handsome Lake" who led the people "back into the Creator's path." Handsome Lake experienced his first revelations in 1799, when spirit helpers taking human form directed him to tell Indians to hold onto ancestral values while living in peace with whites. Handsome Lake and his followers traveled extensively among the Haudenosaunee (Iroquois)—Mohawk, Onondaga, Cayuga, Oneida, Seneca, and Tuscarora—of Ontario, New York, and Pennsylvania. He preached the *Gaiwiio*, or Good Word, of Handsome Lake, which decried the use of whiskey, witchcraft, love medicines, and abortion/sterility medicines. He urged the people to embrace their families and communities, and many were transformed by his message. The teachings of Handsome Lake are still shared in the longhouses of the Haudenosaunee.[10]

In early nineteenth-century Ohio, a Shawnee named Lalawethika had a vision in which the Creator told him to preach the revitalization of Native nations. After this he changed his name to Tenskwatawa, "The Open Door." The prophet's message mirrored that of Handsome Lake in some ways, and he urged Indian people to unite in one mind and do each other no harm. He preached against the use of alcohol, witchcraft, and violence among themselves, and he taught the people not to dress like whites or eat their foods. Tenskwatawa urged his followers to come together and destroy the Long Knives. Thousands of Indians clamored to hear the prophet speak and eagerly joined his pan-Indian movement against the United States. At first his brother, Tecumseh, did not accept Tenskwatawa as a prophet, but eventually this experienced war leader used his brother's religious movement to form a military and political confederacy among the diverse tribes of the Great Lakes region. Tecumseh's Indian confederacy fired the imaginations of many Native peoples in the Old Northwest, but he failed to find followers among most of the Southern tribes. Tecumseh often asked: "Where today are the Pequot? Where are the Narragansett, the Mohican, the Pocanet, and other powerful tribes of our

TOKEN OF ALLIANCE

TOKEN OF ALLIANCE

Gift for a comrade in the War of 1812, a pipe tomahawk (opposite) was presented by a British officer to the warrior leader of the Shawnee and inscribed: "To Chief Tecumseh From Col Proctor MDCCCXII." Proctor commanded Fort Malden on the East Bank of the Detroit River, headquarters of British forces in southwestern Upper Canada and a bastion against American invasion northward. Tecumseh's aim was to lead an Indian confederacy against American expansion westward. In this, he had notable success but was killed at the 1813 Battle of the Thames, after which most Indian armed resistance east of the Mississippi River crumbled.

PIPE TOMAHAWK. WOOD AND METAL, LENGTH 66 CM. 17/6249

people?" He answered that they had "vanished before the avarice and oppression of the white man, as snow before the summer sun." Tecumseh saw no future in negotiating with whites, so he proclaimed: "Let the white race perish. They seize your land, they corrupt your women, they trample on the ashes of your dead!" He raised his tomahawk against the Long Knives, striking terror into the hearts of thousands of settlers.

During the War of 1812, Tecumseh fought alongside many Native warriors and British soldiers against Americans in Ohio, Indiana, Michigan, and Illinois. Tecumseh fought head-to-head against General William Henry Harrison until September 1813 when Harrison's troops bore down on the Indians and their British allies. Tecumseh told British Colonel Henry Proctor (a tomahawk inscribed to the famous warrior from Colonel Proctor is pictured at right), "As for us, our lives are in the hands of the Great Spirit. We are determined to defend our lands, and if it be his will we wish to leave our bones upon them." On October 5, 1813, Tecumseh made his last stand, heroically fighting against the Americans. The Battle of the Thames ended most of the armed resistance of American Indians east of the Mississippi River, but not their memory of homes lost in the Eastern Woodlands. Even now, Indians recall Tecumseh's words: "Sell a country! Why not sell the air, the clouds, the Great Sea, as well as the Earth?"[11]

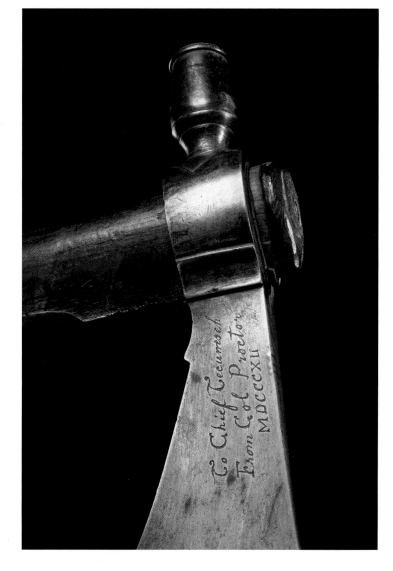

RESISTANCE AND REMOVAL

Tecumseh could not stop the juggernaut of American expansion against the embattled tribes. In fact, his death at the Battle of the Thames opened for them a whole new era of unbridled aggression and forced removal. White Americans called this the "Era of Good Feelings," but Indians watched in horror as whites built the Erie Canal, opened national roads, introduced steamboats and railroads, and added new states to the Union. And white settlers began to demand the forced removal of thousands of American Indians from the eastern seaboard of the United States. They wanted them resettled west of the Mississippi River.

To some extent, all of the presidents from Thomas Jefferson to John Quincy Adams supported the "voluntary" removal of Indians. In the late 1820s, however, Andrew Jackson, the old Indian fighter and hero of the Battle of New Orleans, campaigned for president on a platform of forced removal and westward expansion. Reflecting the views of his own state of Tennessee and others in the West, he demanded the forced removal of the eastern tribes to "Indian Territory," or present-day Kansas and Oklahoma. Although some Americans opposed removal, Congress passed a bill in 1830 that committed the United States to moving Native nations west as quickly and cheaply as possible.

Governments of the United States, Canada, Mexico, and all of the countries of Latin America forced indigenous populations out of their homelands, and this

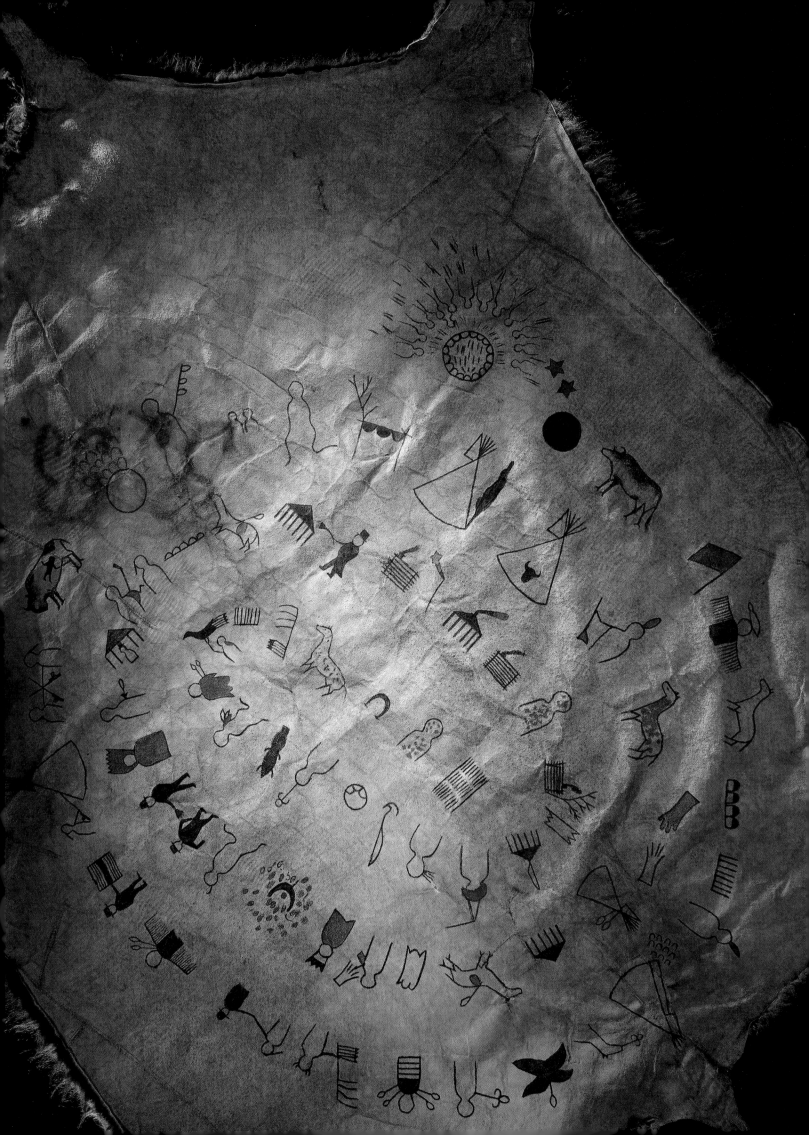

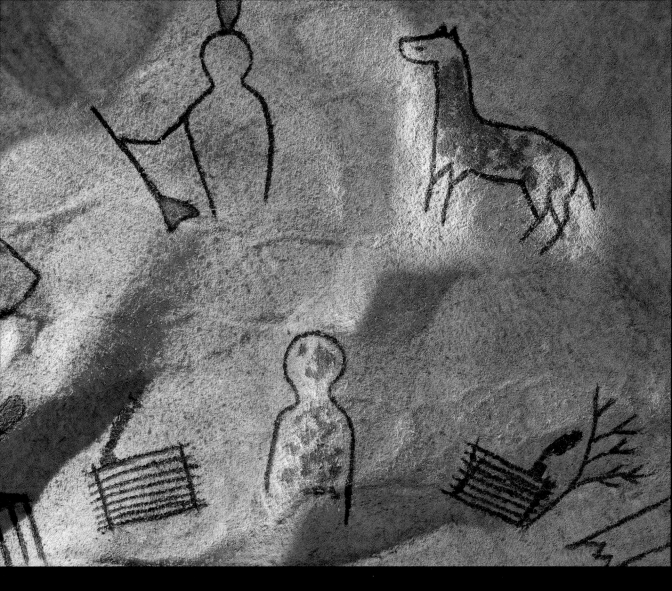

RECORDING HISTORY

This *waniyetu wowapi*, or winter count, is attributed to Lone Dog, a member of the Yanktonai band of Dakota. Winter counts have been used by the Dakota both to record the history of particular bands and to teach that history. During the winter months, elders of each band would gather to decide which event since the previous winter was most significant. Then the historian of the band would conceive a figure to represent that event, drawing it on the buffalo hide next to the most recent one. For example, the spotted silhouetted figure in the detail above references the year 1818–19, when measles devastated the Yanktonai. The entire winter count spans a period of seventy-one years beginning with the winter of 1800–01. Each figure brought to mind a specific event, and it was also a part of the larger narrative of the band's history. In this way the elders could teach younger members the events that stretched back beyond living memory. In so doing, the younger ones were steeped in their past and in their sense of responsibility for the future.

DAKOTA BUFFALO ROBE. PAINTED HIDE, 259 X 207 CM. 1/617

1838

Apache with shrivelled leg fell from mule opposite Snake town, on Gila River. Pima shot him and two Pima women then clubbed him to death.

1839

Many white people, soldiers, cannon wagons & horses crossed the Pima country near Sacaton & camped at Maricopa, then went west along the Gila.

1894

Pima woman murdered in Phoenix

Maricopa man sang at Wilsostown one night.

Santa Fe R. R. built into Phoenix from Prescott.

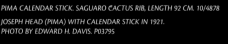

PIMA CALENDAR STICK. SAGUARO CACTUS RIB, LENGTH 92 CM. 10/4878

JOSEPH HEAD (PIMA) WITH CALENDAR STICK IN 1921.
PHOTO BY EDWARD H. DAVIS. P03795

CALENDAR STICK

Long, narrow sticks, notched with straight lines, carved, and painted with symbols, were used by the Maricopa, Pima, and Tohono O'odham as reminders of significant events. Long, straight lines represent summers; the peaceful ones are left unpainted. Short, black notches mark raids, battles, or deaths. The stick shown here, collected from its second and last Pima owner/maker, Joseph Head (right), records events from 1833 to 1921, beginning with a famous meteor shower, and includes numerous notations of Apache raids on Pimas and Pima raids on Apaches. Also recorded are the coming of white people, including soldiers with cannons, intertribal races, and the building of railroads (ladderlike detail at left). Museum catalogue cards (left) preserve the collector's field notes about the events represented on the stick.

process continues to this day. While the United States officially sanctioned Indian removal, settlers and government officials took things into their own hands and forced multitudes of Indian people from their homes, often killing them outright in the process. Although some Wyandot of Ohio and Michigan had sided with Tecumseh, most had lived peacefully on the Grand Reserve of Ohio or near Detroit after the War of 1812. The Ohio Wyandot became productive farmers but continued to fish, hunt, and gather. They remained peaceful when non-Native settlers moved into the region, even though the settlers put pressure on them to move west to Indian Territory. Wyandot leaders worried that the United States would dissolve the Grand Reserve and leave the people landless. Reluctantly, some agreed to move, while others fled to Ontario, Michigan, Indiana, or the woods of Ohio.

By the middle of the nineteenth century, removal, reserves, treaties, trade, and war had become hallmarks of American Indian policy and remained so for most of the century. As the United States pushed many Eastern tribes into present-day Iowa, Kansas, and Oklahoma, the Native nations reestablished themselves and coped with social anomie, diseases, hostility from tribes living in the Plains, and new environments. Choctaw historian Donna Akers has pointed out that the removal of her people from Mississippi to Indian Territory placed all Choctaw in jeopardy, because the government forced them to move toward the Land of the Dead, which they believed was in the West. The spirits of the newly dead traveled close to the Earth in a westerly direction and had power to do humans harm. When the Choctaw faced starvation, cholera, outlawry, and communal tumult, many elders attributed this to their being forced into the path of souls traveling westward.[12] What was true for the Choctaw was true for other Indians from the East who shared such beliefs and attempted to understand the changes within their world from a Native perspective.

INDIAN PEOPLES AND MANIFEST DESTINY

The end of the Civil War fostered even greater expansion into remote regions, not only California and the Northwest but also the Great Plains, Rocky Mountains, and Canada. Non-Native settlers encouraged American agriculture and manufacturing to fulfill the Manifest Destiny of their new nation. Yet that concept could be applied to many non-Native nations of the Western Hemisphere. Indeed, expansionism characterized the movement of Spanish-speaking people throughout Latin America and of Portuguese speakers in Brazil. The various new countries of the Americas did not experience a simple "Westward Movement" but a flood of non-Natives in every direction, penetrating much of Indian Country and forever changing the Native universe. Meriwether Lewis, William Clark, and other American explorers led the way, introducing the public to vast regions and their riches in land and resources.

British trader and adventurer David Thompson traveled the breadth of North America, claiming land for Britain, just as Lewis and Clark had claimed it for the United States. The same process occurred throughout the Western Hemisphere, as non-Indian peoples and governments claimed millions of acres of Native land without seeking permission of Native nations. On Indian lands claimed by British, Americans, and Russians, non-Native trappers killed fur-bearing animals and sea mammals to sell their pelts, and they helped popularize the riches of the region, encouraging others to follow in their wake. In Latin America, explorers, traders, miners, and soldiers claimed Indian lands and introduced new technologies and manufactured goods for trade with indigenous peoples, who were eager for colorful cloth, metal implements, weapons, beads, and a host of other goods. Merchants and

"STINK TO THE WORLD"

Drawn as a benevolent father figure to miniaturized Indians in a political cartoon, Andrew Jackson was instead sire of many of their sorrows. In 1814, he defeated Creek Indians at the Battle of Horseshoe Bend in what is now Alabama, leading to a treaty in which they ceded 20 million acres. As President in 1830 he signed a bill that led to the removal of the Five Civilized Tribes to "Indian Territory" west of the Mississippi River. Ralph Waldo Emerson had predicted that if Indians were forcibly removed, "the name of this nation ... will stink to the world." Of the 16,000 Cherokees herded from their homelands along the "Trail of Tears," 4,000 died on the way west.

traders changed the lives of Native peoples throughout the Western Hemisphere, often making Indians dependent on their trade goods. Bows, arrows, stone knives, and lances gave way to handguns, rifles, and metal knives. At the same time, the need for handmade pottery and baskets declined as Indians acquired metal pots, pans, and dishes. But trade also resulted in artistic innovations among Native Americans, who enriched their cultures by using manufactured beads, cloth, thread, and metal in their art and everyday objects, creating a beautiful synthesis of the traditional and the new.

Spanish and Portuguese priests introduced Catholicism, and the English offered Anglicanism, Calvinism, Methodism, and a number of other Protestant sects. Russians brought the Orthodox Church to Alaska and Canada, and over the years many Indians throughout the Western Hemisphere became Christians. Others did not. Chief Joseph of the Nez Perce acknowledged that his people had fought over many things in the past, but never religion. In his own time, however, Chief Joseph watched Indian people become divided over religion after missionaries Henry and Eliza Spalding introduced Presbyterianism. Not only were Christians arrayed against non-Christians, but

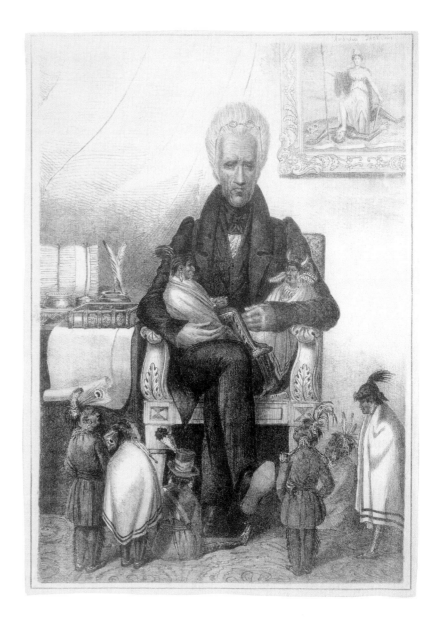

Protestants contested Catholics, and Protestants challenged other Protestants. However, in every part of the Western Hemisphere, there were some Indians who sought refuge in their own religions or rebirths of the old beliefs. Smohalla, Husishusis Kute, Puck Hiya Toot, John Slocum, and other Northwestern religious leaders urged Indians to reject Christianity, Christian values, and materialism. Descendants of these believers are still singing and praying for the healing of the Earth and renewal of Native peoples.

While spiritual changes characterized the history of many Native Americans in the mid-nineteenth century, other events outside their communities significantly affected Indian people. Native Americans then controlled the lands from the Great Lakes and the Mississippi River west to the Pacific Ocean with only pockets of non-Indian inhabitants. In 1846, Britain and the United States negotiated an international boundary and averted a conflict, establishing the forty-ninth parallel as a "border" between their interests. Indian people living near the border may have heard of this deal settled without Native participation, but it meant little to them because they understood that the lands actually belonged to the Anishinaabe, Dakota, Lakota, Nakota, and other Native nations.

Indians living in Northern Mexico and the Southwest from Texas to California also learned of another border issue, this one between the United States and Mexico. Between 1846 and 1848, the United States Army took parts of Mexico,

including what is now California, New Mexico, and Arizona. At the conclusion of this war, the Treaty of Guadalupe Hidalgo brought much of the American Southwest and California into the United States—all without consent from any Indian nations.

Between 1848 and 1870, while the United States consolidated its hold on California and the Southwest, settlers moved into many regions, but particularly California and the Northwest. Many tribes resisted this American invasion. In 1848, a group of Maidu Indians digging a millrace with James Marshall discovered gold at the Native village of Coloma, near Sacramento. News of this discovery brought thousands of miners into California, where until 1850 more than half the miners were Native people. White miners from Oregon resented Native competition and began killing Indians. On the eve of the Gold Rush, more than 100,000 Indians lived in California, but by the 1860s only about 30,000 remained—most of this depopulation from murder and disease. Indian families throughout California still remember the killings. James Rawls has reported that at a community forum in northern California, a Native woman told her family's story of their being hunted down by white men with dogs. When the Indian-hunters drew too close, one family hid their baby in the brush and raced in front of the dogs to lead them away. They ran for their lives, outdistancing the hunters, and by nightfall felt safe enough to return for the child. Early next morning they found their baby—pinned to the ground with a knife driven through the stomach. The woman finished her story with tears streaming down her cheeks. A tall white man standing close by remarked sadly that the woman told the truth. He knew that story, too, because his family had hunted down her family and was responsible for the killing.[13]

Indian peoples throughout the Western Hemisphere not only lost their lives but their homes, lands, and resources. They lost sacred places memorialized in stories, songs, and rituals that tied them to these holy sites. It seemed to many Indians that no matter how much the newcomers took, it was never enough. Government and military officials in Argentina, Chile, Peru, Guatemala, Mexico, Canada, and the United States stood by and allowed non-Indians to take Native lands, because Indians had no "legal" title to their property. In the United States, local militia groups like the Texas Rangers, Mariposa Battalion, and Oregon Volunteers were organized to kill Indians and drive them from their homelands. In the West, the federal government funded wars against the Cahuilla, Chemehuevi, Cupeño, Kumeyaay, Mojave, Quechan, Hupa, Modoc, Yavapai, Apache, Navajo, Ute, Paiute, Comanche, Kiowa, Cheyenne, Lakota, Dakota, Shoshone, Palouse, Nez Perce, Yakama, Cayuse, and numerous other tribes and bands. In San Bernardino County, California, militia forces fighting hostile Chemehuevi turned their guns on peaceful Serrano Indians during a thirty-two-day campaign that resulted in the death of men, women, and children and the forced removal of the Serrano from the mountains of their origins. Still, neither the Serrano nor any other tribe surrendered their sovereignty when they stopped fighting.[14]

The United States and Canada were generally content to designate certain areas as "Indian territory" or "Indian country" until the mid-nineteenth century, when they recognized a small portion of Indian Country as reserves or reservations. Edward Fitzgerald Beale established the first modern reservation at Fort Tejon, California, in the 1850s. He drew on Puritan and Spanish mission precedents to create reservations designed to "civilize" people by forcing them to farm and ranch rather than hunt and gather. Although most California reservations later failed, General James H. Carleton used the model when he created a reservation at Bosque Redondo in New Mexico for Diné people called Mescalero Apache and Navajo. Carleton wanted to "collect them together" on the reservation to "be kind to them;

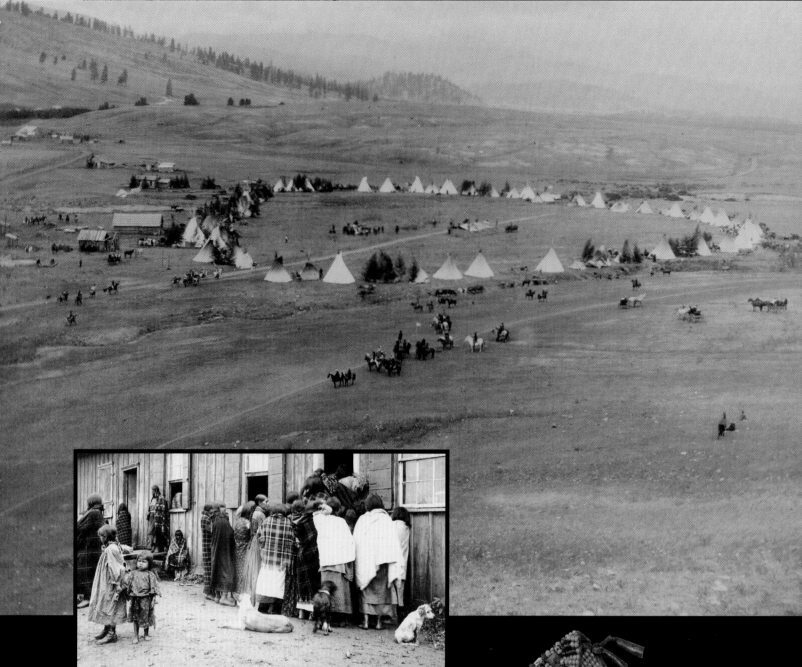

FREEDOM FADES

By the end of the Civil War nearly 20,000 seasoned U.S. Army troops were stationed in forts across the West to protect settlers, gold rushers, surveyors, railroad builders, and assorted others of the onrushing non-Native population. Despite Sioux Chief Red Cloud's success in closing the Bozeman Trail in 1868 and the Sioux, Cheyenne, and Shoshone victory at the Battle of the Little Bighorn in 1876, Indian nations were forced off their extensive free-ranging homelands, onto reservations, and into dependency. By 1870 Kiowa women were lined up to wait for rations (above), and about that same time Blackfeet were assembled (top) to receive government aid. The ration cards issued (right) were, in effect, permits to continue living—though not well, and not free. Even so, the spirit of the people surfaced in ways that were subtly defiant, beautifully subversive. Was a ration card demanded? Then it could be carried in a beaded, leather trimmed pouch (right) that radiated the bearer's pride.

there teach their children how to read and write." He longed to "teach them the truths of Christianity" and "the arts of peace" so that Indians could "acquire new habits, new ideas, and new modes of life."[15]

The reservation, in Carleton's opinion, would render its denizens "a happy and contented people." But this idea clashed with the common feeling that the more Indians killed now, the fewer the government would have to kill later. Carleton

forced his policies on Navajos and Mescaleros and moved them on Long Walks to Bosque Redondo, a windswept plain by the Pecos River in eastern New Mexico. The Mescalero eventually returned to a small portion of their former domain in the Sacramento Mountains of southern New Mexico, and in 1868 the Navajo were permitted to return to a tiny portion of their beloved lands within the sacred mountains that still mark their homeland.[16]

Many Native nations of the Western Hemisphere fought for their freedom, sovereignty, and self-determination, resisting their adversaries through wars and formal agreements. The great leaders Crazy Horse, Geronimo, Kenitpoos, Kamiakin, Quanah, Santanta, and Manuelito guided their people to many victories. Geronimo, who for years led Chiricahua and other Apache against the United States Army, did his utmost to preserve the freedom of his people, but in the end even he surrendered. Along with Naiche, the son of Cochise, Geronimo handed over the warriors' rifles to the bluecoat soldiers and led the Apache into confinement at prisons and reservations far from their homelands. When tribes resisted militarily, the United States sent a never-ending stream of troopers to force them onto reservations. Ultimately the government had its way. Men, women, and children died fighting for their homelands, but by 1890, though Native resistance would never die, most of the fighting had ended.

All across the Western Hemisphere, Indians turned inward to seek help from their Creator. They danced, sang, and prayed for renewed hope. Some elders say this was an Indian victory not foreseen by non-Natives. Holy people—some known only to their own tribes—asked the creative powers of the Native universe for a brighter future in the face of radical cultural changes. Throughout the Indian world, men and women responded in different ways to the chaos within their communities. Some became depressed and sought refuge in drink, but far

more held firmly to the values of their families and their people. Like cultural heroes in ancient stories, the spiritual leaders of Native communities rose to the occasion.

GHOST DANCE AND SURVIVAL

Wovoka, the Ghost Dance prophet, became one of the best known of the holy people. Born among the Northern Paiute who lived on the border of California and Nevada, Wovoka grew up in the spiritual traditions of Tavivo and Wodziwob, both of whom had led a Ghost Dance tradition in the 1870s. Among the people the spirit of the Ghost Dance had remained quiet until January 1, 1889, when Wovoka experienced a major revelation from the Creator, instructing him to tell the people to live peacefully with one another and with whites. Wovoka counseled followers to work hard for the benefit of their people while on Earth and prepare for the day when they would "be reunited with their friends in this other world, where there would be no more death or sickness or old age." The Creator also gave Wovoka a dance to be celebrated for five consecutive days so that the people could "secure this happiness to themselves and hasten the event."[17]

Indians from many different nations conducted Ghost Dances, including Lakota under Chief Big Foot. The federal government wanted to stamp out the provocative aspects of the Ghost Dance on various reservations of the Northern Plains, so agents were instructed to arrest several leaders, including Sitting Bull. Confusion reigned when two Indian policemen arrested the great leader on December 15, 1890, but in the fray Sitting Bull was shot and killed. Fearing for his people's safety, Big Foot led them into the Badlands of South Dakota, where they were surrounded at Wounded Knee Creek by Colonel James W. Forsyth, who set up Hotchkiss guns above the village and ordered the Indians to disarm. The women had erected tipis painted with colorful scenes of days gone by, and among their belongings the people had painted winter counts, skins that depicted historical events important to the Sioux. Few Lakota at Wounded Knee could have anticipated the tragic event about to unfold. An officer tried to take a weapon from Yellow Bird, and when they wrestled, the gun went off, killing the officer. That shot prompted the soldiers to open fire on the villagers. Lakota warrior Black Elk arrived later at Wounded Knee and recorded that "Dead and wounded women and children and little babies were scattered all along there where they had been trying to run away," but the soldiers followed them along the gulch and "murdered them," sometimes in heaps where "they had huddled together." The soldiers killed at least three hundred people, mostly women and children, and the Wounded Knee tragedy has become symbolic of the racial hatred and intolerance of those centuries toward Native American religions.[18]

DIVIDING THE SPOILS: ALLOTMENT

The Ghost Dance religion and the massacre at Wounded Knee occurred at a time when the United States reversed its reservation policy of communal ownership of land by the tribes. Eastern reformers and Western capitalists joined hands in 1887 to support passage of the General Allotment Act, which called for an enrollment of the tribes and a division of reservation lands into individual allotments. Reformers saw allotment as a means of uplifting Indians by giving them a stake in their own homesteads and allowing them the opportunity to become farmers or ranchers. Western cattlemen, land speculators, miners, and oilmen saw allotment as another means of exploiting Indian lands, since excess acreage was to be put up for sale. The

LAST WARRIOR LOOSE

Born Goyathlay, but known by the name given him by Mexican soldiers, early enemies who slaughtered his family, the Chiricahua Apache "Geronimo" (1825–1909) fought the last armed campaign against U.S. forces. After many skirmishes, imprisonment, betrayals, and escapes, in March 1886 Geronimo, opposite (at left with head scarf), parlayed surrender terms with General George Crook (second from right) in the Sierra Madre Mountains of Mexico, saying: "Once I moved about like the wind. Now I surrender to you, and that is all." But he did not surrender for long, and 5,000 soldiers sent to recapture him failed. Finally, a small detachment found him, and he at last gave up to remain with his comrades. He was sent to Florida, then Alabama, and finally and permanently to Fort Sill, Oklahoma. Geronimo was still a prisoner of war even when he rode in the 1905 inaugural parade at the invitation of President Theodore Roosevelt.

GERONIMO AND GENERAL GEORGE CROOK ARRANGE TERMS OF SURRENDER, MARCH 1886. PHOTO BY CAMILLUS S. FLY. P08397
GERONIMO AND HIS SIGNATURE. FORT SILL, OKLAHOMA. P13128

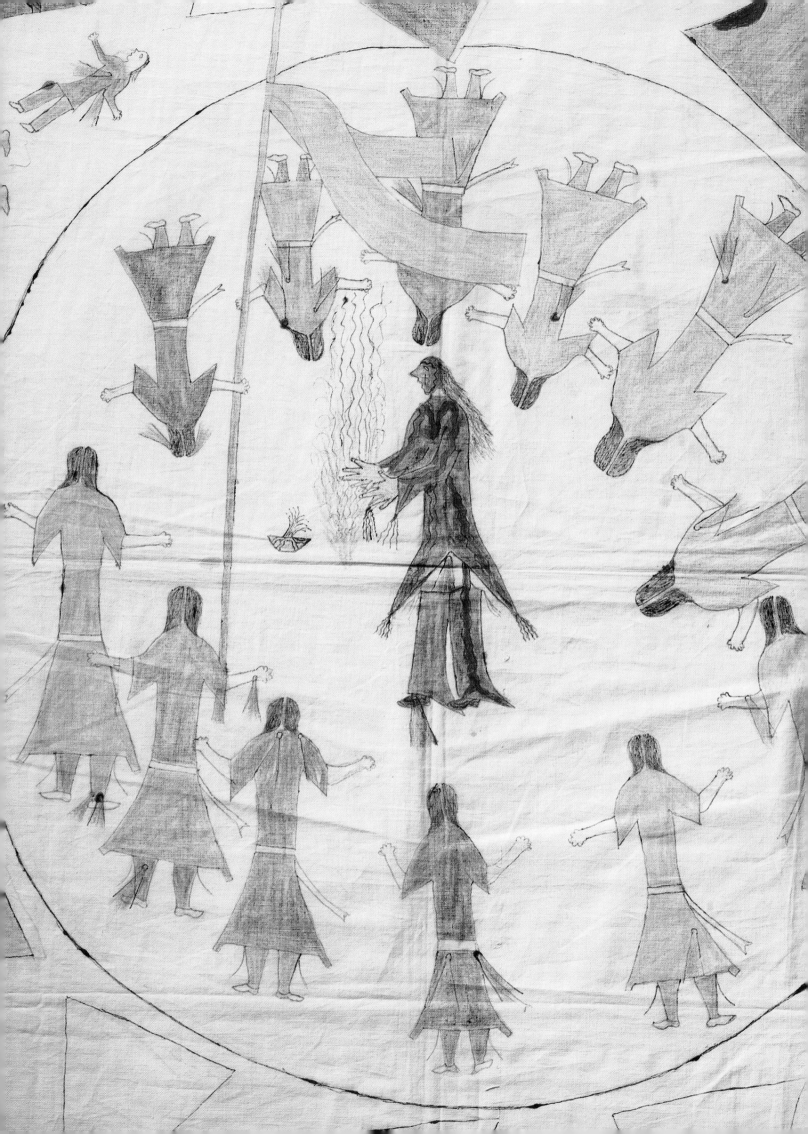

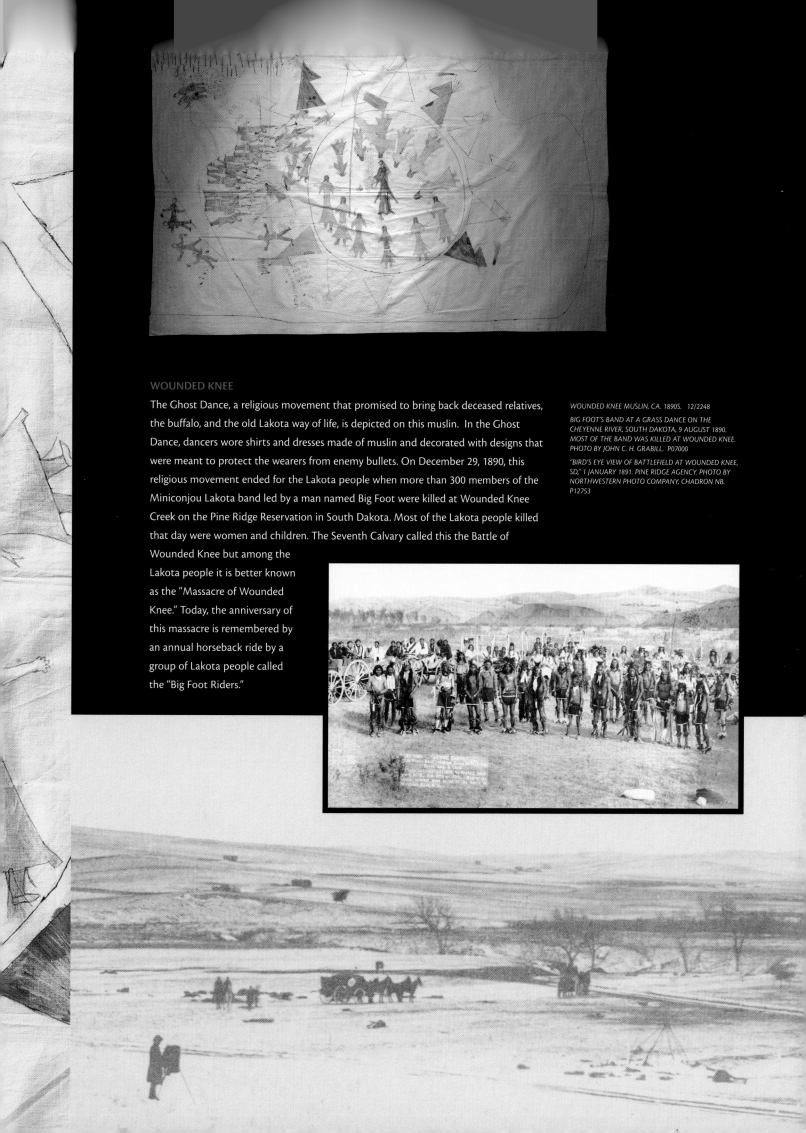

WOUNDED KNEE

The Ghost Dance, a religious movement that promised to bring back deceased relatives, the buffalo, and the old Lakota way of life, is depicted on this muslin. In the Ghost Dance, dancers wore shirts and dresses made of muslin and decorated with designs that were meant to protect the wearers from enemy bullets. On December 29, 1890, this religious movement ended for the Lakota people when more than 300 members of the Miniconjou Lakota band led by a man named Big Foot were killed at Wounded Knee Creek on the Pine Ridge Reservation in South Dakota. Most of the Lakota people killed that day were women and children. The Seventh Calvary called this the Battle of Wounded Knee but among the Lakota people it is better known as the "Massacre of Wounded Knee." Today, the anniversary of this massacre is remembered by an annual horseback ride by a group of Lakota people called the "Big Foot Riders."

WOUNDED KNEE MUSLIN, CA. 1890S. 12/2248

BIG FOOT'S BAND AT A GRASS DANCE ON THE CHEYENNE RIVER, SOUTH DAKOTA, 9 AUGUST 1890. MOST OF THE BAND WAS KILLED AT WOUNDED KNEE. PHOTO BY JOHN C. H. GRABILL. P07000

"BIRD'S EYE VIEW OF BATTLEFIELD AT WOUNDED KNEE, SD," 1 JANUARY 1891. PINE RIDGE AGENCY. PHOTO BY NORTHWESTERN PHOTO COMPANY, CHADRON NB. P12753

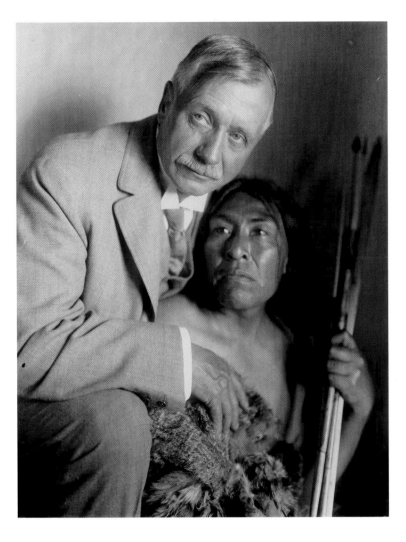

LAST OF THE YAHIS

The Lassen Trail to the California Gold Rush went through the Yahi homeland. Fighting with miners and settlers reduced the tribe to only a few by the 1870s. The last, Ishi, meaning "man" (he refused to say his name), was befriended by two California anthropology professors, who allowed him to live in a San Francisco museum. Ishi became something of a celebrity, giving demonstrations to the visiting public and such scholars as Roland Burrage Dixon of Harvard (above). Ishi died of tuberculosis in 1916 and was cremated, but his brain was first removed. Missing for decades, it was found in a Smithsonian warehouse. In August 2000, Ishi's ashes and brain were interred by representatives of West Coast Native peoples.

ISHI AND ROLAND BURRAGE DIXON, CA 1914, DEPARTMENT OF ANTHROPOLOGY, UNIVERSITY OF CALIFORNIA, SAN FRANCISCO. P07733

government negotiated allotment agreements with select tribes using professional negotiators who were not above threatening the Indians that if they did not agree to allotment they would lose everything. Without legal counsel or the ability to read the agreements, many tribes accepted the allotments. Usually the government divided Indian lands into parcels of 160 acres for adults, eighty acres for older children or young adults, and forty acres per child. In California, allotment agents reduced some Indian land to four or five acres for adults and fewer for children.

The General Allotment Act called for a one-time division of Native American land by formula and the disposition of any excess by sale. As a result, Indians lost more than 100 million acres of land outright and millions of dollars worth of resources that could never be recovered. In the year 1500 Native Americans had controlled about three billion acres in what would become the United States, but by 1887 the tribes held only 150 million acres. By the time the United States repealed the General Allotment Act, Native nations possessed a mere 48 million acres. In sum, American government policies cost Indian tribes nearly all of their estate. They lost most of their reservation lands through general allotment, and many individual allotments became vulnerable to unscrupulous dealings by non-Indians.

When the United States originally passed the General Allotment Act, Indians could not sell their allotment for twenty years, but between 1906 and 1920, secretaries of the Interior and commissioners of Indian Affairs declared over 20,000 Indians "competent," so they could sell their allotment. When Indian families starved because the government had encouraged the destruction of game animals, habitats, and gathering areas, heads of families sold their lands to buy food. Through allotment, the government ripped apart the reservation land bases, and the United States transferred billions of dollars worth of coal, oil, gas, metals, minerals, timber, water, and other resources into the hands of non-Indians. State governments, particularly that of the new state of Oklahoma, passed legislation making it easier for non-Natives to appropriate Indian lands through probate proceedings and guardianships. The United States Forest Service and the National Park Service were granted Indian lands, while ranchers, farmers, municipalities, and counties claimed Indian water.

Huge water projects supported by the national government dammed streams and rivers flowing through Indian reservations, altering the quality of life for Native people through loss of their drinking and irrigation water. Tribes lost their sacred watercourses, like the Colorado River, which the Mojave, Chemehuevi, Quechan, and Cocopa call an artery of the Creator's heart. Water projects stopped the flow of water through the Soboba, Morongo, Cabazon, Torres-Martinez, Augustine, Quechan, La Jolla, Pala, Pauma, and Rincon reservations of Southern California, and the United States has failed to provide adequate water or funds to compensate Indians. The theft of Native water throughout the Western

Hemisphere and the Hawaiian Islands has harmed economic development on Native lands, depriving the people of natural and cultivated food.

The early twentieth century was a bleak time for Indian people. Still, they survived through their own self-determination and spiritual beliefs that continually emphasized rebirth and survival. The government's policy of sending Indian children to boarding schools was heartbreaking for most Indian families, but young people used the individual and collective experiences they gained to resist white control of their lives. They also used their knowledge to fight tuberculosis, pneumonia, whooping cough, and a host of other maladies. In a very real sense, Indian children who were forced into boarding schools often turned the negative experience into positive results, later taking charge of tribal affairs with a better understanding of the English language and the complex workings of the federal government.

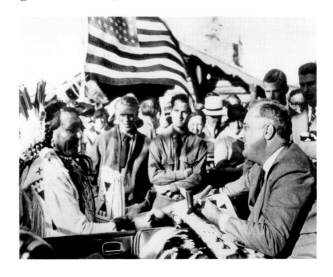

Still, the overall condition of Native Americans in the United States had changed little from the nineteenth century. Indian reformers had expected miracles from the General Allotment Act, but instead people slipped into greater poverty when they lost millions of acres of their land. As a result of worsening conditions, Indian reformers such as Carlos Montezuma, Gertrude Simmons Bonnin (Zitkala-Sa), and others, as well as many non-Native reformers, demanded an investigation into the Office of Indian Affairs and its stewardship of Native peoples. Under pressure, Congress finally acted, and in 1923 hired the Institute for Government Research (now called the Brookings Institution) to investigate the Office of Indian Affairs. Lewis Meriam led a large research team that examined records on several reservations and found that the Office of Indian Affairs had failed in managing health, education, economic development, and general administration among Native Americans throughout the United States. In 1928, Meriam published *The Problem of Indian Administration*, better known as the Meriam Report, which severely criticized the government.[19]

THE INDIAN NEW DEAL

In the United States, the federal government had done virtually nothing to address ill health among Native Americans from 1787 to 1925. In the 1920s, however, after waiting more than one hundred years, Indians received some health care that the government had promised in numerous treaties. Agencies, such as the Yakama Agency of Washington State and the Mission Indian Agency of Southern California, began collecting data critical for an analysis of birth and death rates as well as the tracking of morbidity and mortality. Without such basic information, the government could not target health issues on reservations or convince Congress to authorize funds to address high mortality, particularly of infants, which at the Yakama and Mission agencies was much greater than among the general population. Devastating disease continued to plague Native populations in the twentieth century, particularly tuberculosis and trachoma, and the report linked the health of Native peoples to the grinding poverty of Indian life. National awareness of these and other problems prompted changes in Indian affairs.

In the United States, the Meriam Report directly influenced future reforms initiated by Commissioner of Indian Affairs John Collier in the 1930s. A longtime reformer, Collier initiated an Indian New Deal with great vigor. In addition, Collier

A TURN IN THE ROAD

Kissing babies and visiting Indians had long been sure-fire political stops, as when Franklin D. Roosevelt met Chief Bird Rattler of the Blackfeet in Montana in 1934. But the Indian New Deal brought real changes. John Collier, a harsh critic of Indian policy, was made commissioner of the Bureau of Indian Affairs. The former and failed attempts to turn Indians into red versions of white people and settle them on small individual plots were set aside. Indian culture was to be respected. Economic and political power of tribal councils was increased. New policies were controversial and not universally accepted by Native individuals and groups, but the basic rethinking of the status of Native Americans in the larger America had begun. Today, Chief Bird Rattler's great-grandson, Loren Bird Rattler, works for the National Museum of the American Indian in Washington, D.C.

PRESIDENT FRANKLIN D. ROOSEVELT AND CHIEF BIRD RATTLER, 1934.

used the power of his office to urge agents and superintendents to respect Indian religious beliefs and to treat the "cultural history of Indians" as "equal to that of any non-Indian group." The Indian New Deal also encouraged Indian artists to produce and sell their artwork. To further this and other agendas within Native American communities, Collier and his associates pushed for the passage of a reform bill. In 1934, Congress passed the Wheeler-Howard Act, commonly called the Indian Reorganization Act (IRA). Some tribes supported the measure while others opposed it, especially those who worried that the act would put their allotments in jeopardy. Under the terms of the IRA, tribes could reorganize into tribal councils with constitutions that initiated economic development. The Indian New Deal established Indian preference in hiring at the Bureau of Indian Affairs and a scholarship fund from which Native Americans could apply for aid. These initiatives slowed down or reversed past policies of the United States, and became a watershed in American Indian history.

Still, many Indians and non-Indians criticized Collier's tenure as commissioner of Indian Affairs. Conservatives called his policies communistic and un-American, and many Indians felt that Collier had replaced one form of paternalism with another. Collier worked diligently throughout the 1930s and early 1940s, completing his career by pressuring Congress to set up the Indian Claims Commission in 1946. In Southern California, an intertribal group known as the Mission Indian Federation had fought for years to have their claims against the government addressed. When the Indian Claims Commission finally acted to redress California Indian Claims, the government mailed each enrolled Indian a check for a mere $600. Thousands of Indians in California, especially those in the Los Angeles Basin and San Francisco Bay Area, received no compensation for their losses, because the government did not recognize them as belonging to a federally recognized tribe. Millions of other Indians throughout the Western Hemisphere received nothing for their lands and resources. On the Columbia Plateau, the Yakama, Nez Perce, Umatilla, Palouse, and others were given fifty cents per acre for some of the richest and most productive farmlands and raging rivers that have provided irrigation and electricity to millions of people. When officials offered Palouse elder Mary Jim money for her land, she threw it back at them saying, "Land is not money, and money is not land. I want my Snake River back." Mary Jim's reaction reflects the feelings of many Native people. In the 1970s, the United States Court of Claims offered the Lakota millions of dollars for the theft of the Paha Sapa—the Black Hills. The Lakota never accepted the money, but it remains in a trust account for the people.[20]

WARRIORS FOR THEIR PEOPLE AND THE UNITED STATES

Native Americans love the lands that hold the bones of their ancestors, and many are patriotic toward their national governments. In the United States, Indians have served with distinction in the American Revolution, War of 1812, Mexican War, Civil War, Spanish-American War, both World Wars, and other actions. In 1941, when the Japanese bombed Pearl Harbor, thousands of Native Americans enlisted and many more worked on the home front. They served in every military branch and watched their relatives and friends sacrifice their bodies, minds, and souls for the United States. They fought for their people, and they died for their country.

Navajo elder Teddy Draper, Sr., has said that when the United States entered World War II, hundreds of Diné people—Navajo—rode to agency headquarters with shotguns, rifles, knives, and pitchforks, offering to defend the United States from a Japanese invasion. Draper signed up as one of the first twenty-nine Navajo

Code Talkers, a unique program that began in California shortly after the Japanese attack on Pearl Harbor. Phillip Johnston, an engineer working in Los Angeles who had grown up on the Navajo reservation and spoke Navajo, conceived the idea of creating a secret code based on the Navajo language that the Japanese could not break. With Navajo help, he convinced the Marines to create an elite unit to develop the code and put it into operation. Code Talkers saw action in nearly every major battle in the South Pacific. When Marines on Iwo Jima—including Pima Ira Hayes—raised the American flag on Mount Suribachi, the news left the island in the

Navajo Code. In 1976, former Marine Dillon Story summed up the sentiments of many non-Native soldiers when he said that without the Navajo Code Talkers "a lot more boys would have died taking those islands." Like so many military men and women, Story owed his life to Navajo Code Talkers.[21]

The governments of the United States and Canada had spent millions of dollars to suppress Indian languages, but in a notable historical irony Navajo and others had used a key component of their cultures as Code Talkers to save the lives of thousands of people and contribute to victory. When World War II ended, Native American soldiers, sailors, marines, and airmen returned to the reservations to begin life anew. Those working in defense plants returned home for a new start. They had sacrificed for their country, and they were not willing to settle for the status quo on the reservations. These men and women formed the new leadership of Native nations, and they led our people into an era of greater tribal sovereignty and self-determination. The new leaders had to fight against those eager to assimilate them and to destroy the legal relationship between Indian nations and the nations more recently formed in the Western Hemisphere. Veterans of the World War II era led the fight for a new day for Indian people. They drew on their cultural traditions and brought forward the innate wisdom of our peoples to combat old foes in new ways. They also taught their children the traditional values, taught them respect, and taught them to be strong for their people. The blood of the ancient heroes flowed in their veins, along with the memories of those who had gone before. A spirit surrounded them so they could continue to walk the Earth and make new paths for their children. Our peoples emerged with renewed hope and energy, a wisdom born and nurtured by a Native universe that had faced extermination and had survived.

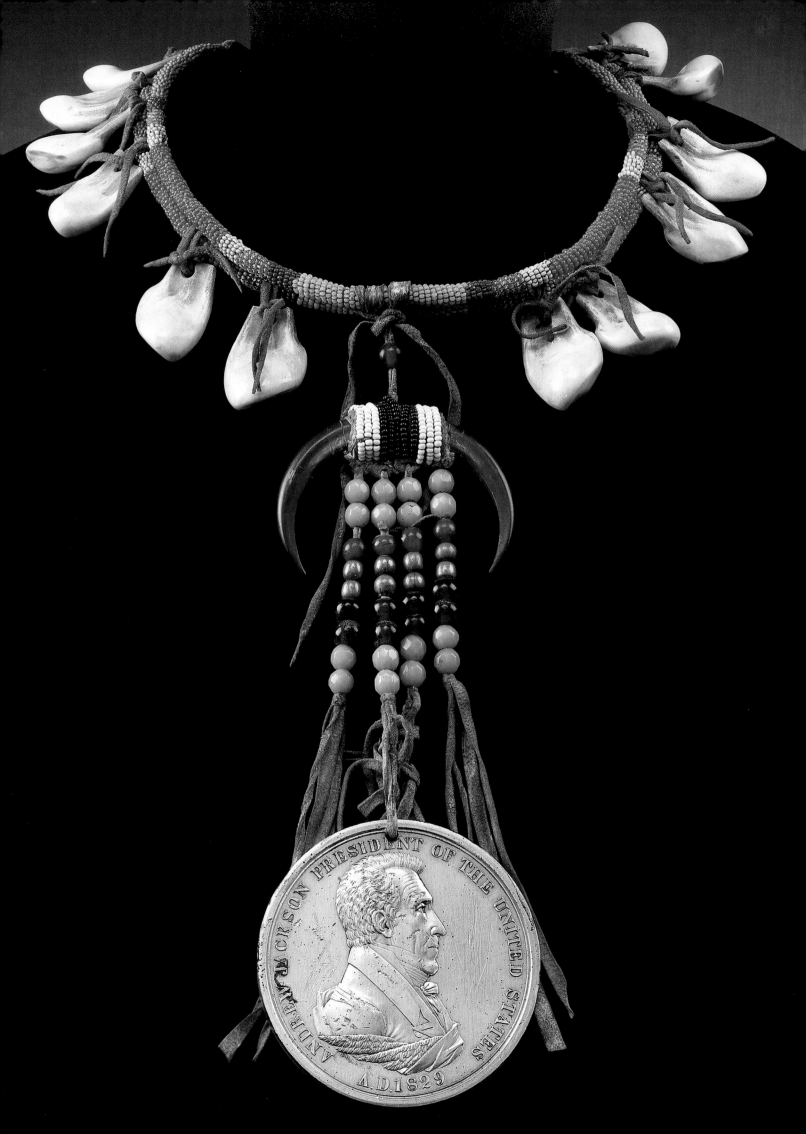

Promises Made, Promises Broken

Vine Deloria, Jr.

For centuries Native peoples of the Western Hemisphere had made agreements or treaties with each other, often marking the event on wampum belts, tanned hides, carved wood, or rocks, and after the arrival of Europeans, they made treaties with them as well. American Indians took their relationships very seriously and expected that promises made would be honored and implemented. However, as time went by, they learned that some nations had few qualms about breaking agreements when they no longer served their objectives.

In this essay, Vine Deloria, Jr., takes us through the history of treaties Britain and the United States made with Native American nations. However, he focuses on the nineteenth century, which saw the creation of hundreds of Indian treaties, typically negotiated by U.S. Indian agents, superintendents, military officers, and special commissioners. Deloria concentrates on treaties made and broken with the nations of the Great Plains, the Northwest, and Indian Territory, but directs particular attention to the removal treaties of President Andrew Jackson and his successors. He also discusses the General Allotment Act of 1887, various decisions of the United States Supreme Court, and the Alaska Native Land Claims Settlement Act. Such government treaties, laws, and decisions have significantly influenced the course of Indian history in the United States, as well as in other nations of the Western Hemisphere. Through hundreds of years of interaction with other governments, Native nations have maintained their tribal sovereignty, asserting their own self-determination whenever possible.

ONG BEFORE EUROPEANS LANDED IN THE AMERICAS, INDIANS HAD been making peace treaties with one another. Uniquely, Indian diplomacy recognized the need to repair damages from prior relationships before embarking on a new agreement. "Wiping away the tears" ensured that no bad feelings would persist. In a feat of peacemaking remarkable in human history, the holy man Deganawidah brought the warring Iroquois nations together to form a strong confederacy. Sioux holy man Matohoshila (Bear Boy) used another ceremony, "the making of relatives," to seal a peace with the Arikara, saying: "He who is our Grandfather and Father has established a relationship with my people the Sioux; it is our duty to make a rite which should extend this relationship to the different people of different nations."[1] Unfortunately, what began as a religious ceremony establishing peace between nations quickly turned into a vehicle for cheap land thefts by the European nations.

From earliest colonial times, the English, French, Dutch, and Spanish all made formal treaties with the nations that occupied this continent. The French envisioned the treaty as a covenant and sought social relations with the Indians, but the Dutch, English, and Spanish used treaties to obtain land cessions. Since most tribes believed that land belonged to the community, not individuals, and did not understand the European concept of "purchase," great confusion ensued. Tribal leaders believed they had given the Europeans permission to use the land; Europeans believed they had received exclusive ownership. In the famous transaction for Manhattan, the Dutch presented gifts to a group of visiting Indians and thereby thought they had purchased the island—a failure of two cultures to communicate. Chief Black Hawk of the Sac spoke for all Indians when he declared in his remarkable autobiography, "What do we know of the manner of the laws and customs of the white people? They might buy our bodies for dissection, and we would touch the goose quill to confirm it, without knowing what we are doing."[2]

COLONIAL ANTECEDENTS

Legend has it that William Penn, the Quaker proprietor of a royal grant encompassing Pennsylvania, always dealt honestly with the Indians. His sons, however, are thought to have committed the first fraud in treaty history by producing a document they claimed had been approved by local Indians to give the Penns all the land a man could walk in a single day. When the Penns sought possession of these lands, they cleared a path into the wilderness and had a skilled athlete run as fast as he could from sunup to sunset, claiming all the lands he covered. This so-called "Walking Purchase" became the archetype of treaty dealings with the Indians.

During colonial times, treaties were negotiated between the large Indian nations and the colonies whose settlements bordered their frontiers. Thus Virginia, Pennsylvania, and New York dealt with the Six Nations; Virginia and North

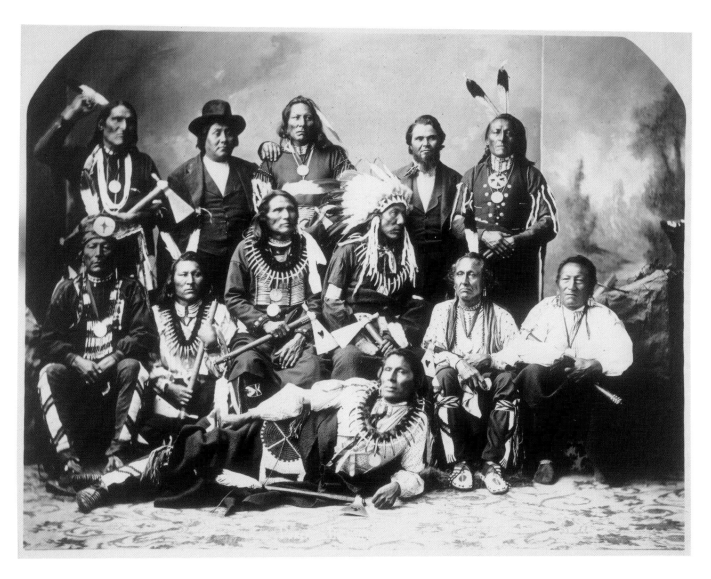

Carolina treated with the Cherokee; and Georgia and South Carolina negotiated with the Creek. The Crown usually appointed the colonial delegates, so that while the treaties were intended to resolve problems on the frontier they also carried out British Imperial policy. At such meetings, held, by traditional Indian custom, with feasting and long speeches, the delegates carefully reviewed each issue so that no misunderstanding of the agreement could later be claimed.

TREATY–MAKING UNDER THE CONTINENTAL CONGRESS

At the beginning of the American Revolution, a meeting was held at Fort Pitt, the westernmost British fort, to explain the nature of the conflict to assembled Indians. The English argued that previous treaties (which included promises to the king *and* the colonies) required that the Indians support the English. The rebellious American representatives, on the other hand, made clear that the colonies sought only Indian neutrality in the war. The conference reached no conclusion, but the following year, at Fort Pitt, the Indians seemed to favor the Americans.

Eventually the Indian nations did take sides in the war, with most of the Six Nations and Ohio tribes favoring the English while the Oneida and Delaware (Lenape) supported the Americans. In the treaty of 1778, the Delaware gave the Americans permission to pass through their lands to attack British posts in the Wabash country. Among its provisions was the promise that after the war the Delaware could organize the Indian nations of the Ohio and apply for statehood to the Continental Congress. Such a promise was made only twice to Indian peoples—

DIPLOMATS DECEIVED

Indian delegations to Washington, D.C., were arranged by federal officials to settle disputes and enter into treaties favorable to the U.S. Its officials also undertook to impress tribal leaders with the government's power, and with the size and scope of American population, institutions, and technology. Delegations brought their own grievances for redress. For instance, the Ponca delegation of 1877 (above) came uninvited to complain that undue attention was being paid to their Sioux enemies. On the Poncas' behalf, even their own resident government agent had cited the tribe's "loyal & good behavior."

PONCA DELEGATION, 14 NOVEMBER 1877. FRONT FROM LEFT: BLACK CROW, BIG ELK, STANDING BEAR, STANDING BUFFALO BULL, WHITE SWAN, SMOKE MAKER. BACK FROM LEFT: BIG SNAKE, BAPTISTE BARNABY, WHITE EAGLE, CHARLES LECLAIRE, THE CHIEF. IN FRONT: HAIRY GRIZZLY BEAR. WASHINGTON, D.C. PHOTO BY WILLIAM HENRY JACKSON. P03413

also to the Cherokee if they would continue their progress toward organizing a state based on the United States model.

During the Revolutionary War, if a state sought an Indian land cession within its boundaries, it could treat by itself, but if the issue involved peace or war, only the Continental Congress could make the treaty. This practice was formalized in the Articles of Confederation and not changed until the adoption of the Constitution. This policy produced many disagreements and enabled New York and Georgia to maintain that they had never agreed to let the federal government negotiate exclusively with the Indians, a subject that would eventually result in the famous Cherokee cases of the 1830s.

TREATY-MAKING IN THE EARLY REPUBLIC

By 1789 the concept that Indian tribes were sovereign nations was so established that, despite many complications, the federal government entered into formal compacts with the Indians. The first of these treaties were primarily pacts of friendship, but following the War of 1812 their main purpose was to acquire land. Indian treaties, considered to have the same force and status as agreements with foreign nations, required the consent of the Senate and ratification by the president. The practice was discontinued in 1871 in part because the House of Representatives wanted more of a say in Indian affairs. Subsequently, "agreements" were made with tribes that became law only after ratification by both House and Senate.

In the heyday of treating with the Indians, the federal government followed traditional principles of international protocol. Amid much pomp and ceremony, commissioners of the United States would formally meet tribal leaders at some convenient location where, after considerable discussion, the parties would sign a solemn document detailing compensations and guarantees. The parties often exchanged gifts affirming continued friendship and loyalty. The most symbolic and significant of these was known as a "peace medal," from the clasped hands of friendship often depicted on the reverse side. Such medals originally were solid silver and bore the likeness of the current president. Indian leaders valued them greatly and were often offended if they failed to receive one.

Following the Revolution, the United States was required to make peace with the Indian nations that had sided with the British. Many of the Six Nations, like

other British sympathizers, left for Canada where the Crown gave them lands. So many departed that they reconstituted their Six Nations Council in Canada. Indians in the South made treaties with the United States within a few years. The Spanish, seeking to protect the Floridas and their profitable trade in deerskins, also made treaties with the Southern Indians. No effort was made to contact some of the Western tribes such as the Sioux and Sac and Fox who had sent small parties of warriors to some of the Western battles.

Indeed, treaty commissioners who later approached the Ohio tribes were careful not to imply that these nations had been conquered, for indeed they had not. Nonetheless, these tribes came under intense pressure to cede their lands because the Proclamation of 1763, which had tried to prevent settlement beyond the watershed of the Appalachians, was now null and void. As the British retreated to Canada, American settlers rushed into the Midwest. Facing an urgent need for land, a commission was sent to the Ohio Indian Confederacy seeking to purchase their holdings on the north bank of the Ohio so that poor Revolutionary War soldiers could have farms and homes. Understanding the plight of the poor in the American colonies, the Indians made a counteroffer:

> We knew that these settlers are poor, or they could never have ventured to live in a country which has been in continual trouble ever since they crossed the Ohio. Divide, therefore, this large sum of money which you have offered us among these people; give to each, also, a proportion of what you say you would give to us annually, over and above this very large sum of money, and we are persuaded they would most readily accept it in lieu of the lands you sold them. If you add, also, the great sums you must expend in raising and paying armies with a view to force us to yield you our country, you will certainly have more than sufficient for the purpose of repaying these settlers for all their labor and their improvements.[3]

Indians approached these discussions under the illusion that the American commissioners were seriously seeking to solve the problem of poverty in their country. Not recognizing the greed for land and the desire to expand the United States, they believed they could help resolve the problems of the new nation by offering sensible suggestions. Many subsequent treaty sessions would feature this

BEADS OF RECORD

Wampum—from the Narragansett word for "white shell beads"—was crafted from shell pieces made uniform in size and drilled for stringing. Loosely strung, wampum became a medium of exchange. For some Iroquois people, strings of wampum are used as condolence gifts and have a sacred or spiritual meaning. When woven into belts, as in the example here, said to commemorate the visit of a Western Chippewa (Ojibwe) chief to Britain's George III, wampum marked important occasions or transactions with European powers. Belts were also given to signify and record agreements between tribes.

WESTERN CHIPPEWA WAMPUM BELT. LENGTH 90.5 CM. 1/4004

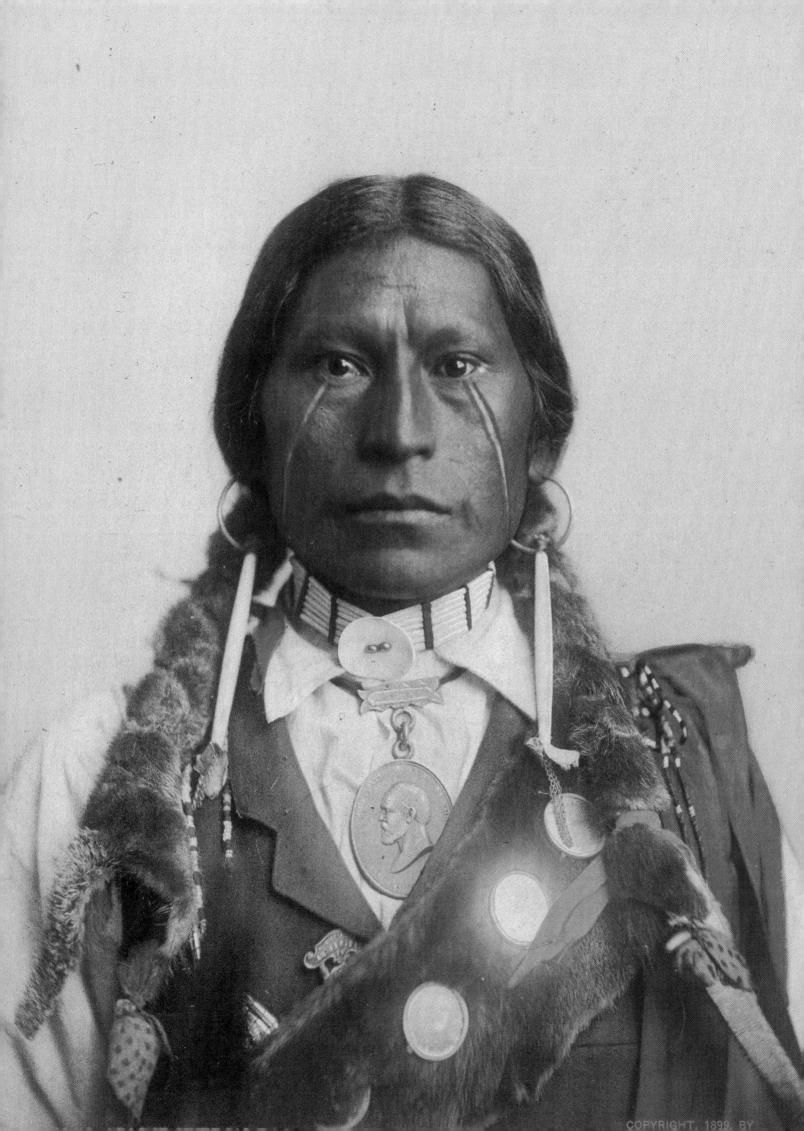

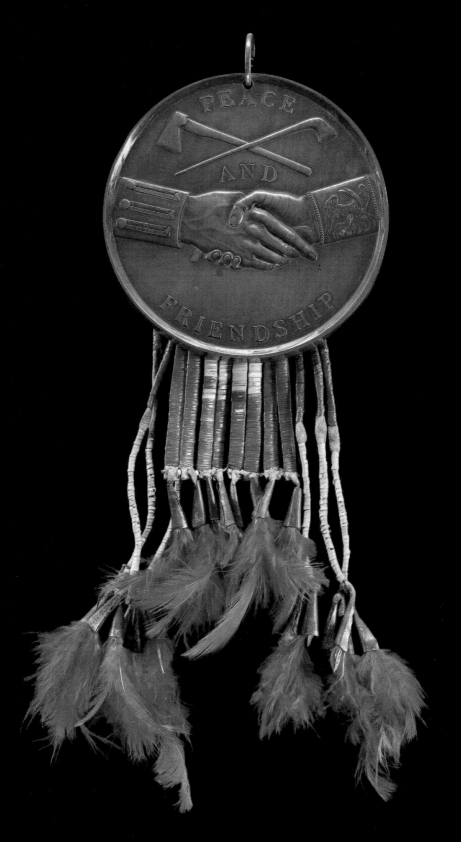

PEACE MEDALS

Following a tradition of striking commemorative medals dating to colonial times, the design of medals for presentation to Native leaders was regularized in style during Thomas Jefferson's administration and continued with little change (except the presidential profile) until 1850, when the image of two hands shaking on the reverse (above) was abandoned. At first, the medals were struck in silver, later in bronze, as in the example above, which has been highlighted with quillwork. At the turn of the 19th century, Apache Chief James A. Garfield (left) posed for a portrait, bearing a peace medal struck during the term of his namesake, James A. Garfield.

THOMAS JEFFERSON PEACE MEDAL. BRONZE, DIAM. 10.2 CM. PORCUPINE QUILLWORK ADDED. 24/1965

APACHE CHIEF JAMES A. GARFIELD. THE DETROIT PHOTOGRAPHIC COMPANY, 1899. P22466

kind of discussion, but gradually, treaty by treaty, the eastern Indians were deprived of their lands, impoverished, and driven beyond the reach of white settlements, each treaty once more promising that this land cession would be the last one asked of them.

THE INDIAN REMOVAL PROGRAM

Most Indian nations sided with the British in the War of 1812 because the British traders were more honest in their dealings and England no longer sought Indian lands for settlement. With the beginning of hostilities, Tecumseh, the great Shawnee warrior, made trips to frontier Indian nations seeking to bring them into a great confederacy that could stop American settlements forever. The large Southern nations, however, regarding themselves as capable of repelling American overtures, rejected Tecumseh's plea, and he was unable to forge the alliance he sought. Nevertheless, he fought for the British and was killed in the Battle of the Thames in 1813. That same winter, Andrew Jackson crushed the Creek at Horseshoe Bend, and eastern Indian resistance to settlement collapsed. A series of new treaties followed that began removing Indians from the lands east of the Mississippi.

The Treaty of Ghent in 1815 required the United States to make peace with those Indian nations that opposed them in the late war. A commission was sent to the remaining Indian nations in the Illinois-Indiana country and an expedition went up the Missouri River to contact remote Indian nations. The purpose was to establish a political relationship that would prevent the Indians, who were already trading with the English Hudson's Bay Company, from forging a partnership with the British.

The large tracts of land of the Ohio Indians had long since been subdivided, so removing the Indians from that area was not difficult; treaties were made with families and small villages in which the people agreed to move to Kansas or Missouri. In the upper areas of the Great Lakes, the people were allowed to remain on small reservations, and once assured that they could preserve their hunting and fishing rights, the Chippewa (Ojibwe), Ottawa, and Potawatomi of Michigan, Indiana, and Wisconsin ceded much of their land holdings. The rights to hunt and fish were kept inviolate—and even in the 1980s and 1990s proved to be as potent as when the treaty was made.

Moving the Southern tribes proved much more difficult. After years of dealings with the federal government, the Cherokee, Choctaw, Chickasaw, and Creek had in place shrewd and competent leaders, many of whom were well educated, English-speaking, and not easily duped or intimidated. One such leader was Pushmataha of the Choctaw, a general in the United States Army who fought side-by-side with Andrew Jackson at the Battle of New Orleans. In 1824 Pushmataha headed a delegation called to Washington, D.C., to rectify the 1820 Treaty of Doak's Stand with the Choctaw. Pressured by Southern planters, the government had persuaded the tribe by threats and large "donations" to Choctaw leaders to exchange a large chunk of their lands in Mississippi for a tract in Arkansas Territory—which later was found to be occupied by five thousand white setters. The government now wanted the Choctaw to sell still more of their Mississippi holdings and exchange the Arkansas land for a larger tract farther west that would belong to the tribe "forever." Pushmataha not only refused to consider selling any more of the tribe's holdings in Mississippi, but he also demanded what the government considered an exorbitant price for the land in Arkansas. "Do you want us to give up farming and become hunters?" Pushmataha asked Secretary of War John C. Calhoun, who was conducting the negotiations. "Take us to the western boundary of Arkansas Territory, and you will take all our valuable land."

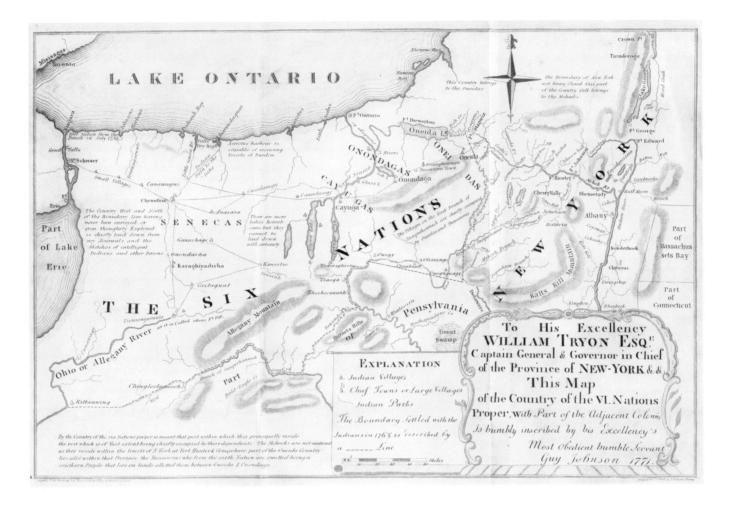

"Good chief," Calhoun responded. "You are contradicting yourself. When we were trying to sell you those lands in 1820 you insisted they were all rocks and hills, and that the waters were only fit to overflow the crops, put out fires, and float canoes. What is the meaning of this great change?"

"I can only say, good father, that I am now imitating the white man. In 1820 we wanted to buy; now we are anxious to sell."[4]

On that occasion the Choctaw left Washington with a remarkably generous arrangement, thanks largely to the fact that one of the tribal delegates was a lawyer. In fact, it was the first, and probably only, instance in which a tribe had legal representation in negotiating a treaty with the federal government.

Pressure upon the so-called Five Civilized Tribes (Cherokee, Chickasaw, Choctaw, Creek, and Seminole) to leave their homelands in the Deep South had begun shortly after the formation of the United States, but it became intense after the War of 1812 as Southern planters cast envious eyes on their huge tracts of prime farmland. Through coercion, bribes, and empty promises, small groups from these tribes were, in fact, persuaded to move beyond the Mississippi even before passage of the notorious Indian Removal Act in 1830.

In 1824, two citizens of Georgia, serving as commissioners for the United States, had negotiated a treaty that called for the Creeks to sell their holdings in the state and move west of the Mississippi. The commissioners claimed the four signatory chiefs represented the entire tribe, but in truth they spoke for only a small faction. The Creeks were so outraged that they killed three of the chiefs who signed the treaty; the fourth only escaped the same fate thanks to his fast horse.

When tribal representatives rushed to Washington to protest the theft of their lands, President John Quincy Adams agreed to let them negotiate a new treaty as long as the result would be the same—the departure of the Creeks from

Georgia. The delegation offered to sell two-thirds of their holdings, but the government stood firm. As the weeks dragged into months, the Creek delegates became desperate. Opothele Yoholo, leader of the delegation, saw no solution short of his own suicide, but fellow delegates foiled the attempt. When President Adams learned of the incident, he authorized the secretary of war to accept the Creek offer, but the concession only delayed the inevitable for a short time.

With passage of the Indian Removal Act in 1830, the pressure on the Five Civilized Tribes to leave their ancestral lands became overpowering as government officials forced them to accept relocation treaties. Once these were signed, the government demanded that the people move immediately, even though the treaties provided for an orderly migration. Army units marched the people westward and naval ships loaded whole villages and rushed them to the western rivers where more than a dozen tribes were unceremoniously dumped with few provisions and no hope for the future. Whether five died or five thousand, the removal program was a nightmare without end, forcing affected tribes to begin life anew in a strange country. The trek and resettlement were horrors for every person who experienced them, and a scar on America's honor.

Indeed, for many of these heartbroken refugees their problems were only beginning, because the United States did not own the western lands it had given them. Indeed, the Osage and Pawnee who already lived there viewed their eastern brethren as legitimate targets of plunder. In one attack, Pawnees killed five Cherokee immigrants and wounded several others. Writing to family still in the East, one Cherokee confided: "At the West there is much war. There is no prospect of peace. What you hear of bloodshed is true."[5]

As a result, government officials scrambled to make treaties with western nations to cede lands upon which the Five Civilized Tribes could settle. Even then, when these immigrant tribes went westward on hunting expeditions, they often encountered hostile Kiowa and Comanche who held sway over vast tracts of land. These tribes had treaty relations with the government of Mexico, not the United States. In 1835, the United States sponsored a large gathering of western Indian nations and sought to make peace so that there would be no more conflicts between the recently arrived eastern Indians and the western or "wild" tribes. Since Mexico did not take offense at this interference, a trail to Santa Fe was guaranteed in this treaty, opening up the Southwest to eventual settlement.

TREATY-MAKING IN THE 1840s AND 1850s

During the 1840s, small parties of Iroquois began to move west. The Oneida sold much of their lands to the state of New York and bought lands in Wisconsin. Other groups moved to the northeasternmost area of present-day Oklahoma. For the first time, the United States had to negotiate treaties with Indian nations to provide land for other Indians. The Winnebago (Ho-Chunk) of Wisconsin were asked to cede their lands and move to Minnesota to settle upon a tract of land between the warring Sioux and Chippewa nations. Living in constant fear from war parties, the Winnebago then asked for another reservation. They accepted a desolate tract on the banks of the Missouri in South Dakota before eventually founding a reservation in northeastern Nebraska.

Oregon was a popular destination for white settlers in

HARD CHANCES

By the time members of the Delaware (Lenape) had signed a 1765 treaty (opposite) with Sir William Johnson, the tribe had been dispossessed from its Delaware River Valley homeland and suffered other losses and indignities at European hands. Centuries later, Winnebago (Ho-Chunk) men (below) came to Washington to complain that treaty commitments were not being honored—and bearing a copy of the treaty to bolster their case.

PORTRAIT OF WINNEBAGO MEN, MARCH 1912.

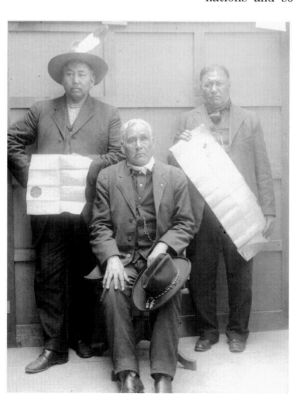

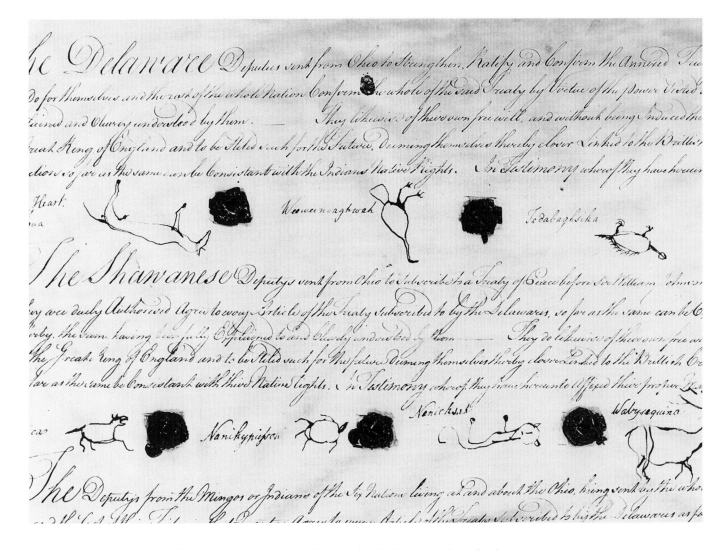

the 1840s, and with the discovery of gold in California in 1849, the rush to both coastal areas became a tidal wave. Conflict between wagon trains heading west and Indians inhabiting the Great Plains was frequent as wagon trains disrupted Indian hunting. To reduce these incidents, the United States called a great conference in September 1851 at Horse Creek near Fort Laramie, long regarded as a major stop on the California/Oregon Trail. An estimated 10,000 Indians attended the meeting.

Cheyenne, Arapaho, Crow, Arikara, Mandan, Assiniboine, Gros Ventre, and Sioux—all colorfully attired in their best clothes—came proudly marching into the encampment. But suddenly tension gripped the camp. On a distant hill was a large band of Shoshone led by the indomitable Chief Washakie. The Sioux and Shoshone had fought a ferocious battle just a short time before, and at the sight of the proud Washakie, the Sioux warriors began singing their war songs and painting their ponies. It took immense diplomacy by D. D. Mitchell and Thomas Fitzpatrick, the American commissioners, to prevent a bloodbath. Mitchell persuaded Washakie and his warriors to go home by promising a special treaty commission just for the Shoshone. The current treaty was concluded rapidly before other tensions developed.

The Horse Creek treaty was a turning point in frontier history. Unveiling a large map, the commissioners asked each Indian nation to delineate its lands. There was much bickering when different groups claimed areas in which they hunted but did not necessarily live. Finally, boundaries were drawn, primarily for the convenience of the United States since there was no way of enforcing compliance. The chiefs were told, however, that if wagon trains were attacked, the government would reduce annuities for the nation where the conflict occurred. After 1946, in the

PHOTOSTAT OF TREATY OF PEACE OF THE DELAWARE NATION, ENTERED INTO BY THEIR DEPUTIES BEFORE SIR WILLIAM JOHNSON, BARONET, HIS MAJESTY'S SOLE AGENT AND SUPERINTENDENT OF INDIAN AFFAIRS IN THE NORTHERN DEPARTMENT OF NORTH AMERICA, 1765. FOLIO 45. P11421

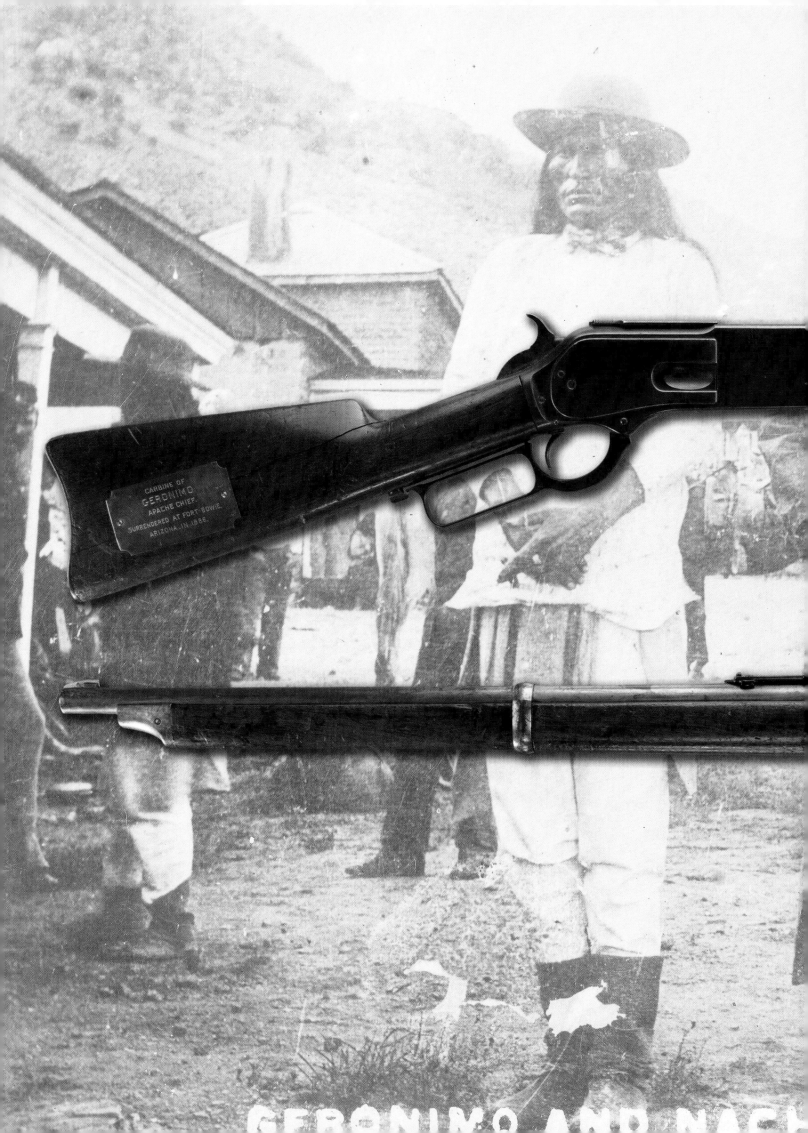

CARBINE OF
GERONIMO
APACHE CHIEF
SURRENDERED AT FORT BOWIE
ARIZONA IN 1886

GERONIMO AND NAC

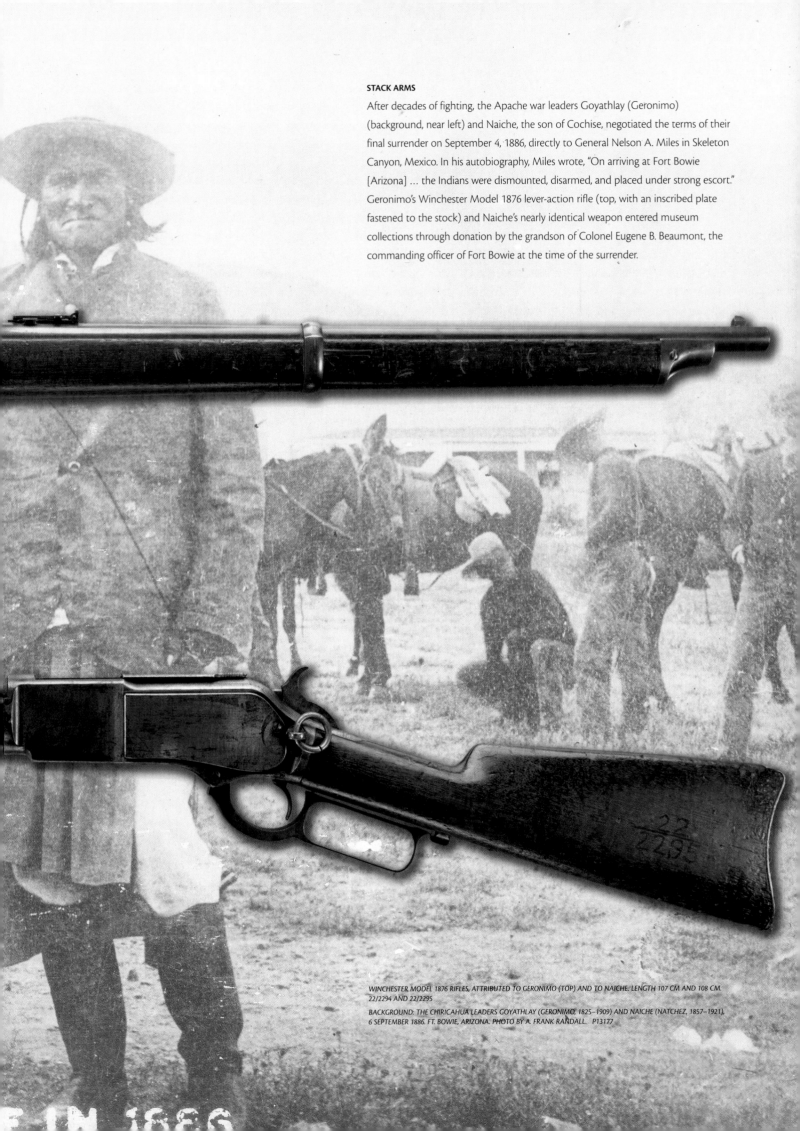

STACK ARMS

After decades of fighting, the Apache war leaders Goyathlay (Geronimo) (background, near left) and Naiche, the son of Cochise, negotiated the terms of their final surrender on September 4, 1886, directly to General Nelson A. Miles in Skeleton Canyon, Mexico. In his autobiography, Miles wrote, "On arriving at Fort Bowie [Arizona] … the Indians were dismounted, disarmed, and placed under strong escort." Geronimo's Winchester Model 1876 lever-action rifle (top, with an inscribed plate fastened to the stock) and Naiche's nearly identical weapon entered museum collections through donation by the grandson of Colonel Eugene B. Beaumont, the commanding officer of Fort Bowie at the time of the surrender.

WINCHESTER MODEL 1876 RIFLES, ATTRIBUTED TO GERONIMO (TOP) AND TO NAICHE. LENGTH 107 CM AND 108 CM. 22/2294 AND 22/2295

BACKGROUND: THE CHIRICAHUA LEADERS GOYATHLAY (GERONIMO, 1825–1909) AND NAICHE (NATCHEZ, 1857–1921), 6 SEPTEMBER 1886. FT. BOWIE, ARIZONA. PHOTO BY A. FRANK RANDALL. P13177

Indian Claims Commission, the government was forced to acknowledge the large occupancy areas designated by the commissioners at this 1851 gathering.

Among other requirements of the treaty was the demand that each tribe designate a head chief with whom the United States would thereafter deal. For the wide-ranging Sioux the idea of one chief was anathema, and they strongly resisted. The commissioners appointed Conquering Bear, a Brulé, as Sioux head chief. Three years later, in the Mormon Cow incident, Conquering Bear tried to resolve a dispute over a lost cow by offering to compensate a Mormon traveler. An inexperienced officer refused the offer and led a small force to the Indian village, intent on reclaiming the cow. The senseless fight that ensued cost the lives of the officer and his entire command as well as that of the chief the United States had appointed.

In 1851, the Eastern Sioux signed two treaties, negotiated by corrupt territorial officials, that ceded parts of central Minnesota and laid the groundwork for a bloody war a decade and a half later. In the Pacific Northwest, Anson Dart was commissioned to secure land titles from Indian nations in the Willamette Valley of Oregon. Although he made several treaties with the valley and coastal nations, none of his treaties was ratified. Three years later, Joel Palmer and Isaac Stevens were authorized to secure treaties with the major Indian nations of Washington and Oregon. Here two cultures began a struggle that has continued to the present day.

Touring this large territory and calling occasional meetings with the Indians of the Northwest, Palmer and Stevens learned that salmon fisheries were the primary source of livelihood for the Indians, who resisted any talk of ceding land and were prepared to fight for their traditional fishing sites, which were scattered along the Columbia River and its tributaries.

Recognizing the Indian attachment to fishing and believing that the white settlers would prefer farming, Stevens visualized a society in which Indians provided fresh seafood to settlers who would produce marketable vegetables. The treaties contained the provision that all "usual and accustomed" fishing sites would be permanently guaranteed to the Indians, and the right to fish "in common" with white citizens anywhere was also guaranteed. Almost immediately after the treaties were ratified and the Indians were urged to go to various new reservations, the territorial government sought to litigate the treaty provisions for fishing, hoping to turn the profitable fishing industry over to white fishermen. But the territorial court ruled in favor of the Indians. Almost every twenty-five years since, either the territory or the state has sought to curtail Indian fishing. In the 1890s three such cases were taken in various parts of the state. The Makah were deprived of their rights to whaling, but in *United States v. Winans* in 1905 the Supreme Court ruled that land cessions in treaties meant that the Indian nation had granted some tracts while refusing to cede others, thereby preserving exclusive fishing rights. In the 1920s and again in the 1940s, further efforts were made to keep the Indians from fishing, but again the courts preserved the Indian rights.

Finally, in the 1960s and '70s, after a great struggle on the Nisqually River at Frank's Landing, a test case was brought by the Justice Department to settle the fishing controversy once and for all. In exhaustive hearings that produced an immense amount of data on Indian fishing practices, the federal courts awarded half the fish in the Pacific Northwest to the tribes with treaty rights. Although the case was argued in Washington State, Oregon and Idaho were also affected. Within a few years, the Indian nations of the Great Lakes area filed suit and were also admitted to have a federally protected treaty right. Of the many provisions in Indian treaties, the fishing rights articles are perhaps the most potent, most litigated, and most carefully observed.

THE CIVIL WAR AND ITS AFTERMATH

With the beginning of the Civil War, the Five Civilized Tribes found themselves in an uncomfortable situation. Many Indians had adopted the economics and mores of the Southern states from which they earlier had been removed, held African slaves and lived on plantations. Their sympathies were with the South, and in 1861, Confederate treaty commissioners met with them and made treaties to ensure their borders. Variations of the popular phrase "as long as the grass shall grow and the rivers run" are found in these treaties. As might be expected, military units were organized among these Indian nations, and some regiments fought with the South in the Battle of Pea Ridge, Arkansas, giving a good account of themselves.

Many Northern sympathizers among the Indians joined the Union forces as individuals, so that within the Five Civilized Tribes there was much conflict, and both sides suffered from intense guerrilla warfare. After Appomattox, although Confederate military units were disbanded, Union generals made treaties with Indian groups and allowed them to march back home as organized military units. In fact, the last Confederate combat unit to surrender was commanded by General Stand Watie of the Cherokee. When these Indian soldiers arrived home, the Cherokee Nation had a big parade, and veterans of the war—in both blue and gray—marched together side by side as fiddlers played old mountain folk tunes, recalling better days when the nations lived in the Appalachian Mountains with the Scotch-Irish.

The Sand Creek massacre of Black Kettle's peaceful Cheyenne in late 1864 set off a frontier war of major proportions involving the Sioux, Cheyenne, and Arapaho. In 1865 Senator James Doolittle conducted an investigation of conditions on the frontier and concluded that major reforms were needed in Indian policy. In 1867 Congress authorized a Peace Commission, and a series of treaties was made with the Kiowa, Comanche, Southern Cheyenne and Southern Arapaho, and Plains Apache in the fall of 1867 at Medicine Lodge, Kansas. The following spring the

SALE OF TEARS

When in the mid-1940s the Fort Berthold Indian Tribal Council sold 155,000 acres of farmland to the United States, Secretary of the Interior Julius A. Krug signed the papers, as Berthold chairman George Gillette wept, saying: "Right now the future does not look so good for us." The three tribes of the reservation, Mandan, Hidatsa, and Arikara, received more than five million dollars, but the land—site of villages and ancestral burials—was inundated to provide flood control for the Missouri River.

commission traveled to Fort Laramie seeking treaties with the Sioux, Northern Cheyenne and Northern Arapaho, Crow, and Shoshone.

Since 1864, the Sioux had effectively closed the Bozeman Trail to Montana gold fields and had wiped out a detachment of soldiers under Captain William J. Fetterman, who was determined to reopen it. Red Cloud refused to sign the treaty unless the government officially closed the Bozeman Trail, abandoned the forts protecting it, and exited the Big Horn Mountains and other hunting grounds. In late April and May, the commission negotiated with those members of the tribes willing to talk with the government. Although the number of signatures approving the treaty increased, the commission was unable to entice Red Cloud and the aggressive Northern Sioux to sign the treaty. Finally, the forts were abandoned, Red Cloud sent his warriors to burn them, and in mid-November he appeared at Laramie and gave his approval to the treaty. One of the commissioners was detached to negotiate with the Navajo, and one was sent to the Shoshone. An Indian agent, W. J. Cullen of Montana, secured the treaty approval of the Gros Ventre, Assiniboine, and Blackfeet, but the treaties were not submitted for ratification because Cullen had arrested two white men for killing an Indian, and the settlers in Montana protested his action.

Meeting at Chicago in January 1869, the commission debated its recommendations to Congress. Since the majority on the commission were military officers, veterans of the Civil War, they argued hard for military control over the Plains tribes. But the civilians had an irrefutable argument: In the campaigns of the summer of 1866 it had cost over a million dollars to kill one Indian—and since there were an estimated 250,000 Indians living on the Great Plains, war might mean public bankruptcy. When the commission sent in its report, the Senate and House of Representatives were engaged in a quarrel over Indian policy that delayed ratification of the treaties.

Promises Made, Promises Broken

In 1870, the Senate Judiciary Committee issued a report stating that the Civil Rights amendments enacted in the 1860s did not affect Indians under tribal jurisdiction, but a year later, Congress agreed to take away the power of the president to recognize Indian tribes as entities capable of making treaties. Yet federal officials still needed a means to deal administratively with the western Indian nations. Congress began to send out commissions to make "agreements" (still called treaties in floor debate) to negotiate land cessions in the territories. By the 1890s, with the power of the General Allotment Act, or Dawes Act, behind them, U.S. Indian inspectors were busy making agreements with tribes to secure their approval to the allotment of their reservations.

Until 1903, Congress faithfully obeyed the provisions of the 1867-68 treaties that required either a two-thirds or three-fourths approval of the adult male members of Indian nations for any land agreement to be valid. With the case of *Lone Wolf v. Hitchcock* (1903), the Supreme Court ruled that Congress could, in an emergency, violate a treaty article. Between 1903 and 1970, Congress sought informal approval of tribal members when considering legislation that would affect their rights or property.

Beginning with the Alaska Native Land Claims Settlement Act, passed in 1971, Congress began to use the format of legislation endorsing or ratifying agreements that had been worked out between Indian nations and state governments. Nearly a hundred such agreements have been made in recent times, including many dealing with gaming, water rights, education, and health services. Many people now understand settlement acts as the modern expression of treaty-making.

More than 900 treaties and agreements were negotiated with Indian nations during the course of settlement. Only 377 were ever ratified and given a legal status. Of these, relatively few were negotiated in what was then the nation's capital—two in New York City, two in Philadelphia, and sixty-five in Washington, D.C.—and most of these involved either important land cessions or significant controversies. Usually unproductive negotiations in the field led government officials to summon tribal leaders to Washington where, under pressure, even the most sophisticated Native leaders would eventually come to terms.

There were many reasons for treaty-making. Peace and land cessions represent the majority of reasons, but there were others. Several treaties created or abolished different forms of government, and a number of treaties were between two Indian nations in which the smaller one purchased citizen membership in the larger tribe. Some treaties were required of the United States as a result of treaties with European nations, such as those that followed the peace with Great Britain after the American Revolution. For a long time Indian nations made treaties with governments other than the United States such as England, Spain, Mexico, and Russia. Strangely, some treaties and agreements were made with railroads, and even with towns and corporations. The scholarly community has yet to fully grasp the scope of diplomatic activity by Indian nations.

The principle of the treaty—mutual agreement and consent by nations of people—has remained a keystone to federal Indian policy. Treaties continue to form the basis of all other federal laws and regulations. Litigation of treaty documents today requires a large staff of people doing prodigious historical research in an effort to determine exactly what the two parties intended when they came together. The spiritual aspect of the treaty, once expressed by such Native concepts as "wiping away the tears" and the "making of relatives" has virtually disappeared, and what remains can probably be found in the assumption that both parties are negotiating in good faith.

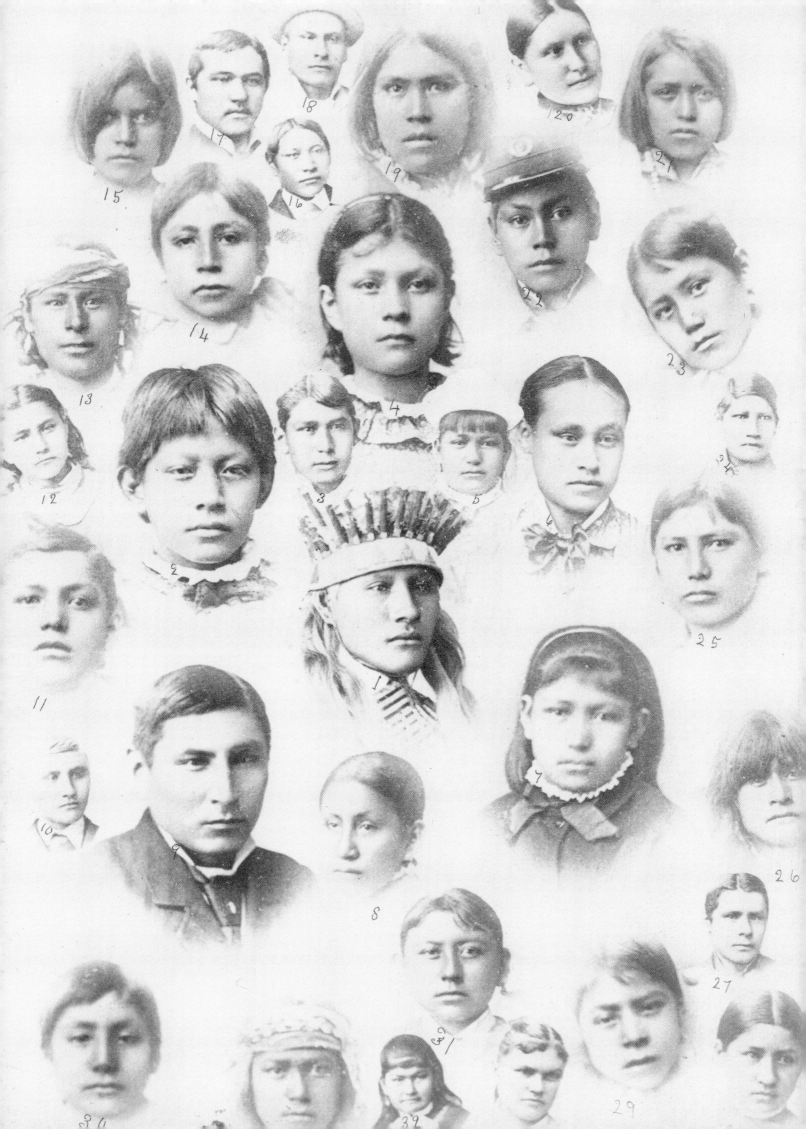

Indian Education, American Education

Brenda J. Child

Change is inevitable, but change among American Indians occurred dramatically and often proved harmful to Native families. After contact, Christian settlers soon established mission schools to share their beliefs with Indian people, particularly the children. The Spanish and Portuguese in Latin America and the French in Canada and the Mississippi River Valley (as well as Latin America) supported Catholic mission schools for Native Americans. The Puritans and other Protestant denominations also engaged Indian children in their mission schools, but off-reservation boarding schools were not created by the United States until 1879, when Lieutenant Richard Henry Pratt founded Carlisle Indian School in Pennsylvania. During the late nineteenth and early twentieth centuries, the United States and Canada organized many boarding or residential schools as a means of separating Indian children from their homes and cultures, so that non-Native staff could "civilize" and Christianize the impressionable young children: "Kill the Indian and save the man." American Indians resisted sending their children to Carlisle, Haskell, Hampton, Sherman, Rapid City, Phoenix, Albuquerque, Santa Fe, Chemawa, Flandreau, St. Boniface, and other schools. Nevertheless, government officials and church leaders in the United States and Canada did send thousands of Native American children to boarding schools that forever changed the lives of Indian people. Ojibwe professor Brenda Child explains that while some children responded well to the school, others ran away or refused to participate in school activities. Some children used the boarding school experience to enrich their lives but still held tenaciously to elements of their Native cultures, including ceremony, song, stories, and language. The effect of boarding schools is still felt within Native communities and remains an important element of Native American history.

MONTAGE OF INDIAN STUDENTS AT THE CARLISLE INDIAN SCHOOL, 1881. CARLISLE, PENNSYLVANIA. PHOTO BY JOHN N. CHOATE. GENERAL NELSON A. MILES COLLECTION. P06946

"HEN I WAS YOUNG EVERYTHING WAS VERY SYSTEMATIC," EX-plained Nodinens, a seventy-four-year-old Mille Lacs Ojibwe woman early in the twentieth century. "I, as the oldest daughter, boiled basswood bark, and made cord, and Grandmother made the bone needles that we would use in weaving the mats. When the rushes were ready, we laid a cord on the ground and measured the right length for the mats. My mother knew just how long they should be to go around the wigwam, and we made five long ones, four of the middle size, and two small ones." Nodinens's labors were proficient, precise, and substantial, but shared with other family members. Nodinens's grandmother "directed everything." Her father "was a good hunter and sometimes killed two deer in a day." Nodinens recalled that the fall season began when her father carved an annual counting stick for keeping track of the days and months, and ended when her mother "put away the wild rice, maple sugar, and other food that we would need during the winter." Only then could the family feel secure as the ice began to freeze on Lake Mille Lacs, ushering in a new sequence of work as they "started for the game field," their winter landscape among relatives.[1]

For generations, Ojibwe people in the western Great Lakes lived the seasonal round described by the elderly Nodinens to Minnesota ethnologist Frances Densmore, each year moving to hunt, gather, farm, and fish in a "systematic" way of life. In dozens of dynamic, flourishing Ojibwe communities like those around Mille Lacs, the family was fundamentally responsible for passing on culture across the generations. Elders, parents, aunts, and uncles taught young people through oral tradition and by example. Children learned from their elders while the family gathered wild rice, tapped maple trees, hunted and fished. It was an informal but demanding education. Within each community, every family member had an essential role to play in the education of young people. Elders brought experience, tradition, and vision, and children contributed energy and spirit to this orderly world. The early autumn wild rice harvest was a model of intergenerational cooperation and learning, as men hunted waterfowl, women harvested rice, and the young and elderly assisted in the labor-intensive process of getting the grain from boat to soup bowl. Rice chiefs and tightly structured committees composed of both men and women enforced proper procedures for the harvest, sometimes negotiating with other Ojibwe communities to ensure access to lakes, simultaneously creating ties of reciprocity and friendship. Each season brought new opportunities for learning.

MISSIONARY SCHOOLS IN INDIAN COUNTRY

By the 1870s, many American Indians had come to know about the Western style of formal education. For many years Catholic and Protestant missionaries had operated schools in the heart of Indian Country, and governments had sponsored some schools among Indian peoples both on and off reservations and reserves. In

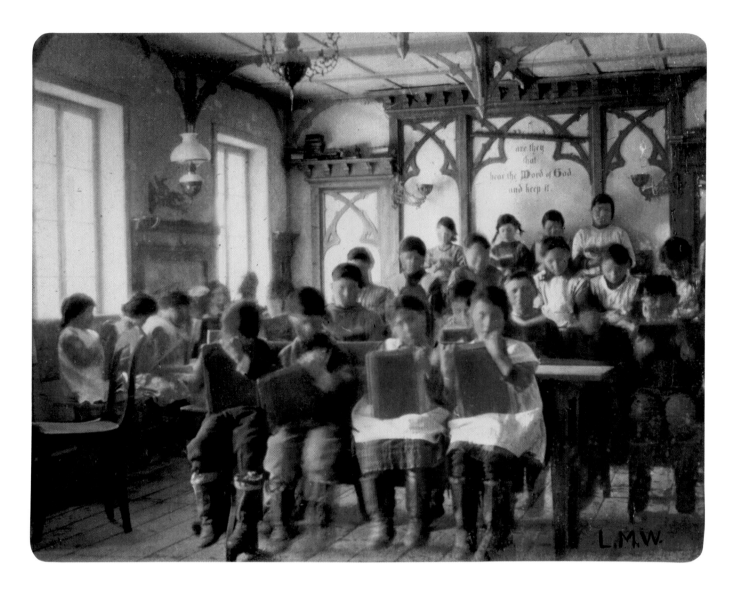

the Great Lakes, some children had attended missionary day schools, where young Ojibwe remained within families to take part in the seasonal round. By attending day schools, children could join their families at rice camps in the fall or in the sugar bush each spring. Students had to master the foreign-sounding English language for the classroom, but the comforts of home and familiar friends allowed them to keep hold of family and cultural traditions. Children were often bilingual in rural reservation settings, and their experiences with school lacked the isolation, heartbreak, and drama associated with many boarding school experiences.

One former day-school student, Thomas, recalled fairly pleasant childhood memories of his introduction to American education. Thomas attended school near his home, and it was close enough to be reached even when the midwestern weather turned harsh and stormy. He remembered, "the same routine was taken each and every day, calling roll, group singing, and other things before regular classes had begun. School went on the duration of the winter months. My father would help me to school, and received me at the end of the day in the schoolyard."[2]

Students in reservation-based day schools rarely mentioned trauma, but left rather ordinary, predictable early recollections of school. It was common for Indian students, a rural population at the turn of the century, to patch together an education in several schools. Off-reservation boarding schools, which were the hallmark of Indian education for fifty years in the United States, would dramatically alter the narrative of Indian experiences with American education.

SUNDAY BEST

Settler and Inuit children attended Sunday school together in the Moravian Church at Makkovik, a community established by missionaries on the Labrador coast in 1896. Unlike many others elsewhere, Moravian missionaries and families learned the Native language, in this case Inuktitut. Missionaries provided basic medical care and established elementary schools, one for settler children and one for Inuit children, until the 1950s.

TINTED LANTERN SLIDE OF SUNDAY SCHOOL WITH INUIT AND SETTLER CHILDREN AT THE MORAVIAN CHURCH AT MAKKOVIK, KAIPOKOK BAY, LABRADOR, CANADA. PHOTO BY M. A. ROWE. LEUMAN M. WAUGH DDS COLLECTION. L02274

The Ojibwe seasonal economy, like so many time-honored indigenous practices across the North American continent, was a source of tension between tribes and state and national governments. Scholar Thomas Vennum, Jr., has stated, "truancy, a direct result of population movements, emerged as a contributing factor to the creation of Indian boarding schools."[3] Residential boarding schools, the creature of policymakers and reformers committed to cultural assimilation and land allotment of reservations, appeared to some Americans a solution to long-standing "problems" in Indian Country.

CIVILIZING THROUGH BOARDING SCHOOLS

In 1879, Congress appropriated funds for the first federal Indian boarding school in the United States, to be situated at the old army barracks in Carlisle, Pennsylvania. Lieutenant Richard Henry Pratt, a military officer turned Indian educator, urged Congress to appropriate funds to support off-reservation boarding schools with the goal of destroying Indian culture and assimilating Indians into the great melting pot of late nineteenth-century America. The Carlisle Indian Industrial School served as the blueprint for an Indian residential school system. The systematic education that Nodinens experienced during her childhood among Ojibwe relatives in the wild rice lakes and forests of central Minnesota was in jeopardy as Indians lost access to environments that supported the traditional economy. Children, assigned to distant, off-reservation boarding schools far from the encouragement and inspiration of mothers, fathers, and the extended family and community, had fewer and fewer occasions for an Indian education.

The lives of American Indian children changed forever in the late nineteenth century when the United States and Canada began a system of compulsory education that forced young people from their homes and traditional ways of education. For the first time in history, the inviolability of Ojibwe families had been breached. Ojibwe students joined Lakota, Pawnee, Kiowa, Oneida, and other Indian youth at Carlisle in Pennsylvania, Haskell in Lawrence, Kansas, and at two dozen, freshly built residential schools. At these boarding schools, administrators, teachers, disciplinarians, and others worked to destroy Indian languages, religions, and ways of life. The government used the boarding school as a means of physically separating children from their parents, grandparents, and communities and sought to use the school experience to supplant traditional Native values and culture with those of the dominant, American society. To nineteenth-century Christian reformers and Washington politicians, the institution represented the humanity and goodwill of the United States government toward the Native inhabitants of the country—a cheerful beacon in the long, gloomy campaign to transform Indians into more harmonious, cooperative neighbors. Little consideration was given to how American Indians might receive this turn in policy, and for their part, few Indian families had ever considered relinquishing children to government authorities for education or any other purpose.

Indian communities did not readily embrace the system of compulsory education forced on them by the federal government. Among the Hopi, for example, some parents hid their children from government agents, soldiers, and missionaries in remote areas, far from their homes on the mesa tops. Rather than surrender Hopi children to government schools, Chief Lomahongewma and eighteen Hopi men chose incarceration in the federal penitentiary at Alcatraz Island near San Francisco, California, in 1895. Hopis have never forgotten this transgression against their sovereignty or the theft of their children by the United States. The Hopi incident was only one of many violations of Native society in the name of assimilation through boarding schools.

American Indian communities opposed boarding schools for good reason. Indian elders feared that children forced to attend boarding schools might grow distant from their cultural and kinship ties. Furthermore, they worried that Native children might grow up accepting new values that focused on materialism rather than generosity. But at the center of it all, relatives did not want to lose their children to a foreign institution often located hundreds of miles from home, where they could not raise and love their children on a daily basis

American Indians gradually incorporated sending children to school as part of their autumnal rituals, but ricing and other economic traditions deeply rooted in Indian lifeways were fodder for complaint by education officials. Authorities always hoped for more cooperation from families or local reservation agents than they received. When voluntary efforts failed, officials in Canada and the United States rounded up thousands of children of all ages, taking them to boarding schools throughout both countries. Scores of students who did cooperate failed to arrive on time, and school superintendents seriously debated shifting the opening of the school year to October because of high rates of absenteeism during the harvest season. As one exasperated superintendent wrote to a colleague in 1908, "You know as well as I do that Indians are never ready to start school in the fall of the year, they wanted to pick berries, make hay, pick rice, etc., before they are ready to come, which is usually about the time cold weather starts and they need better clothing and more food."

Boarding schools were funded on a per capita basis, and officials counted on large September enrollments for reports to Washington. Children who followed tribal tradition or contributed to a family income challenged the mission of methodical government bureaucrats. Still, student populations grew steadily at the turn of the century, and schools branched out to accommodate students from nearly every tribal nation in the United States and Canada. Reformers, politicians, and education officials continuously promoted the idea that residential schools would transform a new generation of Indians into model citizens and workers.

AMERICAN EDUCATION

Nearly thirty years after Carlisle opened, Commissioner of Indian Affairs Francis Leupp remained committed to education for civilization. In a keynote speech to a conference of educators in 1907, the commissioner used metaphor to explain the role of Indian education in American civilization. Leupp reflected, "I have often likened the Indian to a tadpole, which is born in the water with a tail, but without legs. We cannot make its legs grow any faster by chopping off its tail—nature in her own

SAVE A DANCE?

Not everything about Native education was grim. Oscar Howe (Mazuha Hokshina), a Yanktonai Sioux, captured an elegant moment in his painting, perhaps a woman showing her dance card during a prom. Born on the Crow Creek Indian Reservation in South Dakota, Howe attended the Pierre Indian School, a government boarding school, and went on to become a professor of art at Dakota Wesleyan University and, later, at the University of South Dakota.

OSCAR HOWE (YANKTONAI SIOUX, 1915–1983), THE COLLEGE INDIAN, 1949. WATERCOLOR AND INK ON PAPER, 30.1 X 45.2 CM. 24/9059

BOARDED UP

Three girls and three boys photographed at the Ft. Yuma boarding school generations ago may have been frightened, homesick, and hungry. At boarding schools, Indian children were dressed in uniforms and their hair was cut short. They were not allowed to speak their own language, enjoy the familiar ways of their own culture, or see their families for long stretches of time. They were taught to act, recite, and become Indian versions of white children. Native children learned useful academic and survival skills, but the price was high, and the policy failed.

THREE YUMA SCHOOLGIRLS, LATE 19TH C. FORT YUMA, ARIZONA. N35364 ; THREE YUMA SCHOOLBOYS, LATE 19TH C. FORT YUMA, ARIZONA. N35365

good time, will attend to that. When the tadpole develops legs, and it is able to hop about on the land as a frog, its tail drops off of itself. So the Indian will voluntarily drop his racial oddities as he becomes more and more of our common body politic, and learns to breathe the atmosphere of our civilization as his own." The boarding school agenda remained formidable during Leupp's tenure in office.[4]

Politicians and reformers involved in Indian policymaking and education left extensive public records of their ideas and actions during the boarding school era. Views on the boarding school experience from Indian students and families, though strongly held, require more labor to locate. Scholar K. Tsianina Lomawaima interviewed alumni from the 1920s and 1930s to write an oral history of the Chilocco School in Oklahoma. The stories from alumni revealed a multifaceted "story of Indian students—loyal to each other, linked as family, and subversive in their resistance." Chilocco students were creative and resilient, found ways to maintain their tribal identity despite constant surveillance, and forged intense bonds with classmates during the years away from kin. Lomawaima's father, Curtis Carr, a student at Chilocco during the 1930s, recalled the warmth and camaraderie of other students and the Chilocco practice of stealing away from campus for socialization along the creek banks near school. He reminisced about "stomp dances out at night," and "little tom-toms" made from tin cans, and other "things I remember with great fondness."[5]

An amazing treasure chest of Native American letters, including a sample taken from the early decades of the Flandreau Indian School, is part of the written legacy of government boarding schools. Flandreau was founded in eastern South Dakota in 1893 and was primarily for students from the upper Midwest, especially Ojibwe and Dakota, though Lakota, Oneida, and other tribal youth were sometimes enrolled. Today the school lives on as the oldest, continuously operating boarding school in the United States, though cultural assimilation is not part of its present-day charge. Letters recovered from dusty boxes in government archives illuminate some of the ambiguities of the boarding school era.

STUDENT VIEWS OF BOARDING SCHOOL

A child's arrival at boarding school could be both traumatic and exciting. Nearly all suffered from homesickness. Boarding school students ranged in age—some as young as five, but most were twelve years and older. Vernie, who wrote to enroll at Flandreau in 1913, was a sixteen-year-old boy of Stockbridge ancestry from Gresham, Wisconsin. Concerned about transportation to the school, he wrote the superintendent, asking "if you pay the fare out there for children" or "whether a matron comes after them." He also asked the superintendent for more information about the school, and like so many students, expressed a genuine interest in formal education.

Enrollment letters arrived at boarding schools from parents, guardians, agency officials, and students themselves. In a number of letters associated with Flandreau Indian Boarding School, students asked permission to return to *their* school. Emma's letter, written in 1913, illustrates an important fact about Indian boarding schools. Her father, a widower, was ill, and children who faced family instability often attended government boarding schools. Widowed mothers and fathers looked to boarding schools during difficult times. Emma wrote in September 1913, "I would like to know if you can save me a place for I would like to come back to school. I was in the Junior Grade last year and I passed, so I am to be in the Senior grade, so I would like to come back, but my father is very sick and the doctor don't know if he will pull through or not so, I don't know when I can come back. I want to

come back so bad, but I hate to leave my father for there is no one to take care of him but my brother, as we have no mother. Please keep a place vacant for me, as I am going to return as soon as he gets better."

In similar fashion, Fannie wrote to the superintendent at Flandreau to tell him that she "would like to come back to school." She told him that her mother could take her as far as Mitchell, South Dakota, but she hoped that he would mail her a train ticket so that she could travel the remainder of the way to school. Fannie explained that one of the reasons she wished to return to school was that when she "came back home I sure was lonesome." She had missed her classmates.

Many orphans resided in the schools, for reservation superintendents sometimes sent children to boarding school after the death of a parent or guardian. An urgent letter arrived at Flandreau in the fall of 1926 asking, "Please take these two children by all means. Their grandfather died a week ago and left them homeless." Some students, like Napolaen, and the enthusiastic George, appeared to have their own plans for what they would pursue and gain through a boarding school education. Napolaen wrote from his reservation in South Dakota in 1913, "I will come back to School myself and I want you to give me back my trade of Harness making as I want to finish that trade. Please be sure and keep a place vacant for me." That same year, another student could hardly contain his excitement about Flandreau. "I played in band for two or three years and I am just in fifth grade," wrote George to the school superintendent. "I have looked over all the non-reservation schools but I don't think I can go anywheres but to come over to your Flandreau Indian School as I thoughts this School will give me the little more education so that I can make an honest living when I get out." George learned about Flandreau from other Indian boys who attended the South Dakota school, and wished to join his friends as soon as possible. He concluded, "The very first thing I want to do when I get over there is to join the band." In some cases, students and parents began to feel boarding schools provided opportunities and advantages for children, families, and their communities.

The letter from George to the superintendent at Flandreau suggested he wanted to attend the school in part because of his interest in music. Other students wanted to learn a trade, be with friends and relatives, move into a stable living environment, escape family responsibilities, or join the drama club. Some wanted to participate in sports programs. Allan Houser, the great Apache artist, revealed that boxing lured him to boarding school. At first superintendents were reluctant to allow children to engage in competitive sports, but soon they learned that sports could garner public interest in the schools and raise money. Indian children wanted to participate in sports, particularly after the international success of Native athletes such as Olympic gold medalist Jim Thorpe, silver medalist Lewis Tewanima, and Baseball Hall of Fame pitcher Charles Albert Bende. Scholar John Bloom has pointed out that male and female students interested in athletics saw sports at boarding schools as a way of expressing pride in being Indian.

The curriculum focus for both boys and girls was to learn a useful trade. Students were taught the "three Rs," but school officials never intended for Indians to focus primarily on academics. They developed the institutions as trade schools, encouraging students to take advantage of outing programs where they worked in nearby white, middle-class communities as maids, cooks, childcare attendants, or ranch and farm hands. Students often grew tired of institutional life and hated boarding school so much that they ran away. Throughout Canada and the United States, lonely and homesick children braved the outside world to escape boarding schools. In 1909, traveling from Rapid City Indian School to Pine Ridge Reservation in South Dakota, two Lakota boys spent nine days in a winter storm before they were found. The boys suffered severely from frostbite and had to have their legs amputated below the knee. And a year later, two other runaways lost their lives when they fell asleep on tracks and a train ran over them.[6]

In 1913, Mrs. Elm, an Oneida mother, wrote the superintendent of Flandreau announcing that her son, Lewis, had run away and would do so again if the government forced him to return: "He will not stay, if he went back." Mrs. Elm confessed that she "would like to have him go to school there, yet I cannot stand to be worry about him all the time not knowing where he is." In fact, Mrs. Elm added, "I have been almost ill from the fact that I have worried to much about my children." She opposed sending him back to Flandreau and wanted "him to go to school in Green Bay at my expense."

In another letter to Flandreau Indian School, Mrs. Young wrote in 1916 that her daughter, Grace, ran away for "the first time," but she assured the superintendent, "When she goes to school I'd tell her not to run away but to leave a good name during her school time." On the other hand, in 1927 when Mrs. Brooks learned that her "daughter Rose ran away from school," she felt that "the best thing to do is send her home because she will only try it again." Concerned about Rose's safety, Mrs. Brooks wrote, "What I am worry about she might get hurt." Students who ran away from school often went directly home, so families were able to spend time together and circumvent harsh boarding school policies of separation.

Boarding school letters reveal the institution's legendary dark side as students and their families express unhappiness about aspects of residential school life. The historical record shows they were justified in their complaints. School administrators were sometimes callous about the welfare and health of their young charges, and school curriculums emphasized tedious student labor over academic accomplishment and vocational skill. Sadly, inadequate food, overcrowding, poor medical

ON CANADA'S PLAINS

Following the concept of "the Bible and the plow," the Qu'Appelle Industrial School was established in what is now Lebret in southern Saskatchewan by a Catholic missionary order in 1883. In 1885 its director Father Joseph Hugonard and his students (opposite) looked over a treeless landscape to the substantial school building. During the residential school's first seven years—a time of rampant tuberculosis—fifty students died. Ignoring the government policy of English-only education, Fr. Hugonard (said to have been called "the black dress which speaks to God in a book" by Sitting Bull) taught his students written Cree and introduced a Cree-English primer. The school and two others like it closed in the 1920s.

DIRECTOR AND STUDENTS OVERLOOKING QU'APPELLE INDUSTRIAL SCHOOL AT WHAT IS NOW LEBRET, SASKATCHEWAN, 1885.

care, racism, and harsh punishment were the basic ingredients of the boarding school diet. Parents who wrote to boarding school officials asking that children return home because of an urgent situation, or simply to visit their families, were at the mercy of capricious bureaucrats who had the authority to deny such requests. Separation took a heavy toll on children and their families.

Mrs. Cadotte expressed concern in a letter to Flandreau in October 1913, when she learned that her son, Charlie, had run away. "I was very much grieved to hear this and wish to know if you have had any news of him yet or if you know why he should wish to runaway." Charlie had told his mother that he was "very much dissatisfied and he has seemed in that mood too I think ever since he learned that Mr. Finley would be at the school again this year." Finley, a teacher, had been "very hard on him" and wanted Charlie to do farmwork rather than learn a trade as the boy had always wanted. Mrs. Cadotte explained to the superintendent that she could "do so much more with Charlie by talking to him in the right way" than by means of punishment. She warned that if the teacher hurt Charlie "in any way I just feel like settling with Mr. Finley myself." She continued, "I cannot help but think there must have been something that was very hard for him to do or he would not have run away."

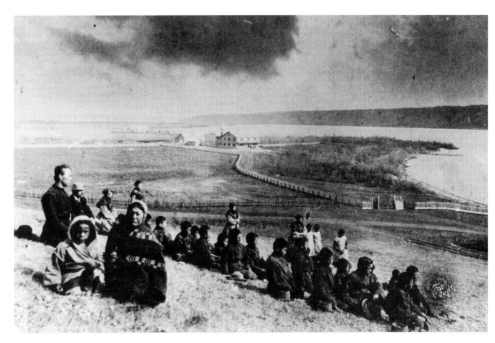

In 1942, a Meskwaki boy arrived at an important decision, and vowed never to return to school. As this child's letter indicates, Indian resistance to government boarding school was prompt and relentless, easily outlasting the designs of federal policymakers. At the end of a summer at home, Gaston wrote to his former superintendent, "I am answering your letter about school and I am sorry to say that I am not coming back, but that's it, I am not coming back."

Gaston's letter illustrates a central theme of the boarding school experience, an abiding tradition of resistance. Letters in the government archives document Gaston's travails. He was an unhappy student who more than once wrote to his mother asking her to have him released. His only pleasure was the drum group he formed with classmates. Gaston attended school in the relatively broadminded early 1940s, and this was not an activity repressed or frowned upon, but rather he gained recognition for participating in a radio program that showcased his songs. Gaston was spirited and gutsy, and in refusing to bend to the ethos of Flandreau, he followed in the footsteps of countless boarding school students.

The atmosphere of boarding schools invited resistance. Students endured prolonged absences from family, rigid regulations for home visits, strict rules of behavior, and a repressive segregation of male and female students. Boarding school culture enforced the principles of a patriarchal government bureaucracy, along with its mission of detribalization and cultural assimilation. It should come as no surprise that students became fed up. When students reached a boiling point, some took action. At one Indian boarding school, Haskell Institute, a full-scale mutiny was

planned and executed by the student body in 1919. Violence, threats, and damage to school property were the end result of a short-lived episode. The guilty students were expelled and nothing changed.

Rebellions were not routine events. What scholar James C. Scott has referred to as "everyday forms of resistance" best describes how students negotiated daily struggles. The "ordinary weapons of relatively powerless groups: foot dragging, dissimulation, false compliance, pilfering, feigned ignorance, slander,

arson, sabotage," each had a place in the boarding school arsenal.[7] Children, humanity's experts at testing the upper limits of the adult psyche, defended their interests with creativity, nuance, and resolve. The results were a mixed blessing. Ojibwe scholar Basil Johnston's touching and humorous memoir of his experience at a Canadian residential school during the 1930s, *Indian School Days*, provides many examples of how students confronted authority, in this case Jesuit teachers and administrators. He shows that most acts of rebellion were spontaneous, a personal form of self-help, while others required planning or coordination by students. Running away, playing pranks on teachers, or stealing food and having potato fights during kitchen duty, not to mention other less obvious, irreverent behavior, provided an outlet for a stockpile of negative emotions and frustration. Johnston's stories confirm that student resistance could be measured in degrees: "In the recreation hall downstairs the boys either stood around in knots or sat slouched on the top board that served as a bench as well as a lid for the boxes that were built into the wall. But as I was to learn later, the boys were not really waiting in the commonly understood sense of the word wait. Though they may have appeared to be waiting, the boys were in reality exercising a form of quiet disobedience directed against bells, priests, school and, in the abstract, all authority, civil and religious." Johnston explained, "Since the boys could not openly defy authority either by walking out of the school and marching north or south on Highway 17 or by flatly refusing to follow an order, they turned to the only means available to them: passive resistance, which took the form of dawdling."[8]

Resistance has a prominent place in nearly every study of the boarding school experience. Scholar David Wallace Adams found that Native Americans in the West interfered with police attempts to gather students for school, and the Indian Office in Washington considered boarding school arson a serious problem.[9] School officials labeled students who ran away from school "deserters," like soldiers AWOL from the military. Students were locked in campus jails to prevent escape when they were judged likely to flee and were often jailed upon return to school as punishment. The sentence was harsh, but time after time students ran away from school. Most often they ran home to the solace of family and tribe, but in many cases they were loose in the countryside, and school officials had to write parents that the whereabouts of their children were unknown. Stories of runaways figure prominently in boarding school letters.

A New Beginning in Indian Education

In the 1930s, Indian students began to have alternatives to boarding school. Johnson-O'Malley funds provided local school districts with money for the additional costs of schooling American Indian children. Still, some students continued to enroll at Indian boarding schools for years to come because of the security of the

all-Indian environment, especially for those who experienced racial discrimination at predominantly white public schools. Melvin, a boy from northern Minnesota, yearned for the refuge of his Indian classmates at Flandreau after a bad experience in public school in the early 1940s. "I am the only Indian boy there and all the kids look down on me, probably you would understand better if I were to tell you all," wrote the desperate student to Flandreau's superintendent, asking to enroll in boarding school in the middle of the year in 1941.

By the 1930s, a new team of reformers had emerged in American political life who attacked the boarding school institution as obsolete and culturally damaging to Indians, since it interfered with a normal family life, a position that echoed the complaints of several generations of boarding school alumni and their families. New Deal reformers, who dared to imagine that tribal life had a place in American society, challenged the concept of a segregated system of Indian schools as they advocated, alongside Indian families, the sensible alternative of public school education. But for a terrible half-century, boarding schools stood as an important symbol in the United States, despite few successes. To nineteenth-century Christian reformers and Washington politicians, the institution represented the humanity and goodwill of the United States government toward the Native inhabitants of the country.

Hearing from boarding school students and their families who lived and recorded something of their experiences decades ago is extraordinary, and these eloquent, Indian voices are powerful testimony to the troubled history of the boarding school era. The official paper records, mostly letters left in government archives, are significant documents that represent a kaleidoscope of student emotions and opinion. Some students loved school while others rebelled. Most students languished in homesickness while a number of their peers felt liberated from the watchful gaze of parents. Hundreds of students died of contagious diseases like tuberculosis only to be buried in school cemeteries, while the majority grew and thrived. It is not easy to explain why many children cherished and identified with their schools as their own classmates succumbed to unbearable sadness and despair. The boarding school experience was carried out in public but had an intensely private dimension.

Letters from parents across Indian Country show that they stayed in touch with their children at boarding schools and looked after their health and well-being, though from a distance. When students graduated, parents often expressed great joy. A Wisconsin Oneida wrote to Flandreau, "I am very thankful to you people for all good you have taught my daughter while she was in school and that she is a graduate girl now. I am proud of her. I am sorry I can't be there on the Graduating exercise oh I would like to have been there. When will you send the Oneidas home?"

While some boarding school alumni scattered to faraway places, most returned to their homes and loved ones. John Rogers was twelve years old when the train brought him home to a family reunion with parents and siblings on the White Earth Ojibwe Reservation in Minnesota. Rogers recalled this significant time in his life. "During the days that followed we had a happy time getting acquainted after those long years of separation. Mother kept saying what a big help I was going to be. She asked whether I would be happy gathering birch bark, tobacco, and wood? While we sat around the fire talking and planning, Mother told my oldest sister to explain that she wanted us to be called by our Indian names. She insisted that we start at once to use them. My own Indian name, Way Quah, meant 'dawn of day' and at school I was known as John." At home in the wild rice stands and pine forests of northern Minnesota, Way Quah resumed his Ojibwe education.[10]

LEARNING UNBOUND

The course of Indian education might be likened to bookends (opposite), which were probably carved at the Haskell Indian School before it became a university. Whatever kind of learning, courses of study, degrees, and opportunities may now be offered to Native students, it is they, their teachers, and their sense of their long trials and longer traditions that support the ventures and hold them in place.

PAIR OF WOODEN BOOKENDS. PROBABLY MADE BY A HASKELL INDIAN SCHOOL STUDENT, LAWRENCE, KANSAS. 25/2220

Season of Struggle

Paul Chaat Smith

Asserting tribal sovereignty throughout their history, many American Indian nations found it difficult to do so forcefully while surviving dreadful diseases, prolonged wars, forced removals, and adjustment to new environments. And in the twentieth century, as they began to recover from earlier cultural ravages, they faced a worldwide depression in the 1930s and the Second World War in the 1940s. Throughout the Western Hemisphere, countless Native peoples served in the military during the war, and when they returned home refused to accept their status ante bellum. They had contributed, soldiers and civilians alike, to the defeat of the Axis powers, and they asserted their rights as free people to receive benefits for their tribes and Indian people in general. Working through new organizations such as the National Congress of American Indians in the United States, they laid the groundwork for the next generation of Indian activists, who challenged the federal government during the presidency of Richard Nixon. Commanche scholar Paul Chaat Smith, himself an activist, sets the stage here for the Indian occupation of Alcatraz Island in 1969 and subsequent events in the era of Red Power. He introduces us to the American Indian Movement (AIM) and the Trail of Broken Treaties of 1972. And in 1973 when members of AIM took over the Custer County Courthouse in South Dakota and then moved the protest to Wounded Knee, Smith subsequently joined them in the Wounded Knee Legal Defense/Offense Committee, working with AIM for five years. His essay provides firsthand insight from one former activist who looks back on events of the 1970s that forever changed Indian people. Today during the age of American Indian sovereignty, Native Americans owe gratitude to activist leaders who demanded self-determination for all Native people. Their voices still ring and influence the course of the Native universe.

ANDY WARHOL (1930–1987), PORTRAIT OF RUSSELL MEANS, 1977. ACRYLIC AND SILKSCREEN ON CANVAS, 213.4 X 178.5 CM. 25/3999

It is necessary that,
with great urgency, we all speak well and listen well.
We, you and I, must remember everything.
We must especially remember those things we never knew.

— JIMMIE DURHAM
(Cherokee)

ALL HISTORIES HAVE A HISTORY THEMSELVES, AND ONE IS INCOMplete without the other.

History promises to explain why things are, and how they came to be this way, and teases us by suggesting that if only we possessed the secret knowledge, the hidden insight, the relevant lessons drawn from yesterday's events, we could perhaps master the present. A history is always about who is telling the stories, and to whom the storyteller is speaking, and how both understand their present circumstances.

Because this history is about Indians (a word that exists only with the idea of the discovery that created the modern world), the story of its creation could begin almost anywhere and with anyone: a sunrise at Chichén Itzá a thousand years ago, the floor of the London Stock Exchange last week, or a press conference in Los Angeles in 1962.

That press conference is one of the most famous in American political history. Two years after losing to JFK, Richard Nixon ran for the California statehouse and lost badly. A furious Nixon blamed reporters for his defeat: "You won't have Dick Nixon to kick around anymore, because, gentlemen, this is my last press conference." *Time* magazine declared his career over. Journalists eagerly wrote his political obituary.

But was it true? Richard Nixon out of politics? It was a landscape difficult to imagine: American politics without Nixon was like Las Vegas without casinos, or Detroit without cars. For a while, it seemed Nixon really had retired from public life. He moved to New York, a place where he had no political future even before he was "dead," and joined a law firm where he represented Pepsi-Cola. Even his enemies, forever suspicious (and yet forever surprised nonetheless), breathed easier. With Nixon, however, things were rarely what they seemed, and his Manhattan exile would become the staging ground for one of the most remarkable comebacks in American politics. Six years after that last press conference, he won the presidency, and four years later carried forty-nine states in one of the greatest landslides in American history.

Soon after moving into the White House in 1969 Nixon offered an olive branch to his enemies in the fourth estate and ordered that the White House Swimming Pool be covered over to create a more spacious area for the press. This was, after all, a New Nixon, less partisan, more statesmanlike, a Nixon willing to let bygones be bygones. He and the press would start over, and to show his good intentions the president sacrificed the pool built by Franklin Roosevelt, so that his new friends could move into a luxurious clubhouse built especially for them.

In those early months of the new Administration, when anything seemed possible, even friendly relations with the Eastern press, Nixon's team shopped for a minority group that could be theirs. The country was a bitter and divided place, with race riots in the summer and massive antiwar demonstrations in the fall. Nixon campaigned on a pledge to end the Vietnam War and, as he said, "bring us together." If he ended the war, presumably the demonstrations would end as well. But blacks were hostile to Nixon and probably always would be. He had to bring together more

RED RISING

Indian activist Russell Means turned Pop idol (p. 174) or sea-lion-intestine-gowned doll titled *My Love, Miss Liberty* were bursts in an explosion of Native celebrity, rebellion, art, and power that rocketed across America from the 1960s onward.

ROSALIE PANIYAK (CUP'IK ESKIMO), MY LOVE, MISS LIBERTY, 1987. SEA LION INTESTINE OVERDRESS, PRINTED FABRIC, FUR, SEAL HIDE, WOOD, BLUE GLASS MARBLES, HEIGHT 84 CM. INDIAN ARTS AND CRAFTS BOARD COLLECTION, DEPARTMENT OF THE INTERIOR, AT THE NATIONAL MUSEUM OF THE AMERICAN INDIAN, SMITHSONIAN INSTITUTION. 25/5563

than white people. The solution: Indians. Not much was known about them; they were fresh and interesting (for example, did you know that thousands of them now lived in cities?), and the president's domestic policy wizards saw opportunities to simultaneously improve the lives of Indians and the image of their boss.

The historical record does not show Nixon to be personally invested in his Indian policy. He delegated, rarely inquiring about how things were going at the Bureau of Indian Affairs or if the Cheyenne were feeling any better about their prospects. After all, there was Vietnam, China, détente with the Soviet Union to contend with. Still, the historical record does show Nixon was profoundly influenced by one Indian: his football coach at Whittier High School, a Luiseño man known as Chief Wallace Newman. "I think that I admired him more and learned more from him than from any man I have ever known aside from my father." Coach Newman taught his players two fundamental lessons: the importance of striving and the importance of winning. "He inspired in us the idea that if we worked hard enough and played hard enough, we could beat anybody."[1] Nixon knew early on he was neither a gifted athlete nor a gifted student; he could only make the team through a superior work ethic and a refusal to ever, ever give up, to ever quit. It is both highly speculative and irresistible to quote Nixon on Newman when discussing Nixon on Indians, just as studies on Nixon and Vietnam rarely fail to point out Nixon's mother was a devout Quaker. (And if Quakers are renowned for their pacifism, they also are only slightly less celebrated for their friendly relations with Indians.)

Nixon himself may have cared nothing for Indians. Yet Indians cared about him. Today his Administration is widely regarded as one of the most pro-Indian of the twentieth century, one that reversed the hated termination of federal reservations, restored Indian lands to tribes, and ushered in a new era of self-determination. Nixon's White House actually took Indians seriously and engaged Indian policy at the highest levels, and for that is remembered fondly by many Indians

even now. Which is surprising, given that in the days and nights before Nixon's greatest political triumph, his landslide reelection in 1972, hundreds of angry Indians very nearly blew up the Bureau of Indian Affairs building, just six blocks from the Executive Mansion.

Nixon's five years as president coincided almost perfectly with a firestorm of Indian rage that seemed to come out of nowhere and turned Indian Country upside down. The selection of Indians as the Administration's model minority played a major, though unintended, role in making this happen. In November 1969, a few dozen college students broke into a federal facility in California. It was technically a protest, but by the standards of the day just barely. A few weeks earlier, a quarter of a million marched in Washington against the war. Yet because the college students in California were Indians, and

Indians were Nixon's chosen minority, this trespassing case attracted the attention of senior White House staff, and instead of being arrested, the Indians found themselves negotiating with representatives of the president of the United States. The federal facility was the abandoned maximum security prison called Alcatraz, and once the White House sent negotiators the publicity stunt became a matter of state, and all the ingredients were in place for a radically new Indian movement.

For the activists, Alcatraz was not a case of trespassing but occupation, or reoccupation. The students called themselves Indians of All Tribes and the rocky island reclaimed Indian territory. For the next three and a half years, Indians occupied missile sites, tribal governments, bridges, and parks in a dozen states. Thousands took part, and unlike the other movements of the day, this one involved the very young and the very old, and all ages in between. Except for Alcatraz, college students never again led; if the white population that most fervently supported Nixon were the regular, gainfully employed, law-abiding folks known as "Middle Americans," the American Indian Movement (which came to be known as AIM) was led by former Honeywell executives (Dennis Banks) and accountants (Russell Means)—older guys long out of school that one might call Middle Native Americans. They understood perfectly the poetics, risks, and rewards of political theater in the age of television, and mounted successful productions again and again. But they could never have done it alone. Without the drama of a White House envoy at Alcatraz, that takeover would have been a mildly interesting one-day story. With it, the occupation lasted nineteen months and won press coverage around the world.

In the fall of 1972 a tougher Indian movement, seasoned and battle-tested, weary but determined, rolled into Washington. The caravan was named the Trail of Broken Treaties and had started from the West Coast months earlier. Along the way the caravan stopped at reservations, and activists spoke about the reasons for their journey. They believed an urgent need existed for a national demonstration that told the federal government Indian treaties were not a dead letter but binding agreements that must form the basis for a new relationship with the United States. They found enough support to keep going, and in the first week of November arrived in the capital.

It was a disaster from the start; a chaotic result of bad planning, mixed signals, and paranoia on all sides, and came very close to being a full-scale catastrophe. The promised housing arrangements were inadequate or nonexistent, and the exhausted Indians gathered at the one place they believed could not turn them away: the Bureau of Indian Affairs. Days of negotiations to find suitable housing ultimately failed, and the colonial headquarters was transformed into a rebel fort. A tipi looked out on Constitution Avenue, and a banner announced the building's new name: Native American Embassy. Inside files were trashed and dumped into the street below. SWAT teams readied for an assault, and above them furious Indians in war paint slapped together gasoline bombs, hoping they knew what they were doing, and hoping even more they wouldn't have to use them. Weapons were a makeshift affair: AIM warriors guarded the embassy entrance with armchair clubs and bows and arrows ripped from display cases. There was so much gasoline in the building, most of it in Molotov cocktails, that you could smell it from the street. Disaster was finally averted, thanks to high-level talks by Nixon's Indian troubleshooters and $66,000 in travel money provided by the federal government. The building survived, barely. A *Washington Post* headline a few weeks later read, "Damage to BIA third heaviest ever in U.S."—meaning damage to government property. The first was the British sacking of Washington in 1814; the second was the San Francisco earthquake of 1906.

In the months following the BIA takeover, the Bureau's considerable art collection turned up in Indian homes across the land. Most people who took part in the Trail of Broken Treaties felt Washington, D.C., was no place for the art of Indian people, and saw nothing wrong with taking the cultural treasures of their people. These were acts of liberation, not theft.

It was a disaster for Nixon's Indian crisis managers, who stood accused of coddling the militants by critics on the right, and a public relations fiasco for Indians as

well. They had failed to appreciate that the final days of a presidential campaign was the worst possible time for a demonstration in Washington. It never became a national story, and the stories that were written focused on vandalism, not treaties. AIM had looked bad before (to call AIM disorganized was merely an observation, not a criticism), but never quite this bad. Warriors who days earlier shouted to reporters that they stood ready to die for their people stood patiently in line the morning after Nixon's reelection, waiting for their gas money to be counted out for the drive home. AIM's many enemies, within the Indian world and without, hoped this humiliating defeat signaled the end of this crazy season of occupations.

Four months later AIM and Oglala Lakota activists seized the village of Wounded Knee. It was an electrifying event, and AIM's warriors looked anything but defeated as they faced federal marshals with M16s across a thousand yards of frozen South Dakota prairie. Armored personnel carriers moved into position and Phantom jets zoomed overhead. Television networks hired Lear jets to ferry to Chicago film of the warriors and the jets so it could lead the evening news. In the last days of February 1973, Indians were the biggest story in the country. Indians (*Indians!*) were banner headlines on the front page of the *New York Times*, above the fold. It was the first time that had been true in nearly a hundred years; it would never happen again, not once, during the remaining years of the twentieth century.

The siege at Wounded Knee lasted for ten weeks, and after the first few days rarely made the newspapers. It ended with no clear winners and many losers, among them two dead Indians, a paralyzed U.S. marshal, and a small village where dozens lived destroyed. AIM never recovered, and the federal government spent millions prosecuting every single person they could find who participated in the occupation. Hundreds were charged. The trials spanned two years and took place in three states.

Meanwhile, back at the White House, the swimming pool gambit had failed

November 1969: Dozens of Indians, mostly college students calling themselves "Indians of All Tribes," occupy the former federal prison on Alcatraz Island, San Francisco Bay. With a new kind of sign language (right) they change "United States Property" to "United Indian Property."

November 1972: Having begun in July, a caravan of Indians following the "Trail of Broken Treaties" with a list of grievances occupies offices of the Bureau of Indian Affairs in Washington, D.C. In a symbolic gesture, demonstrators display an American flag upside-down (above), a traditional way to register distress and call for assistance.

February 10, 1973: Some 200 AIM members and sympathizers gather at the courthouse in Custer, South Dakota, to protest that the fatal knifing of an Indian would be prosecuted as a manslaughter case, not a murder. Debate ends as a riot and arrests in a snowstorm (opposite). Seventeen days later, the occupation of Wounded Knee begins.

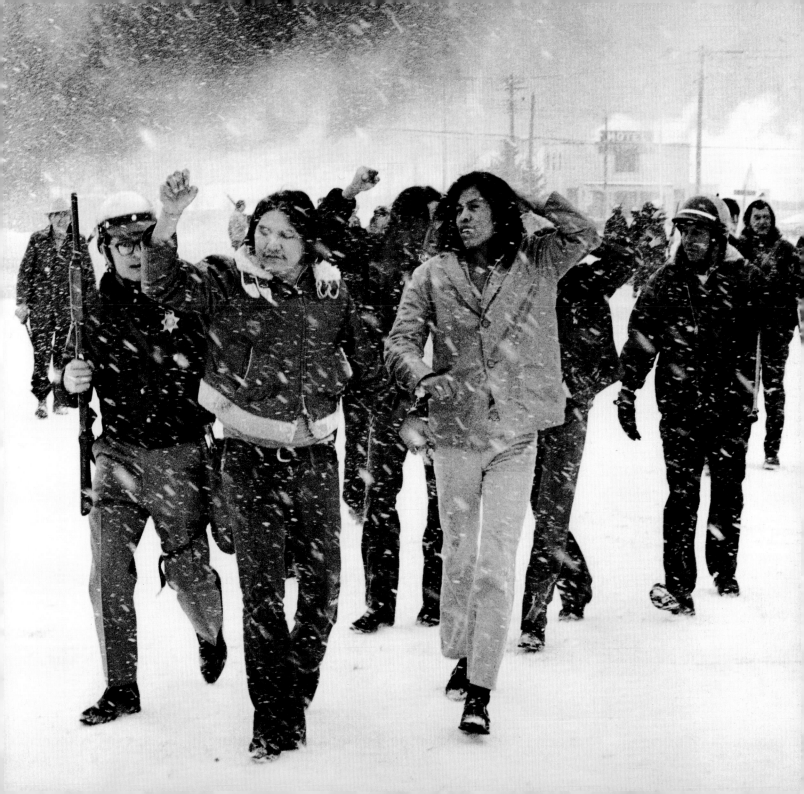

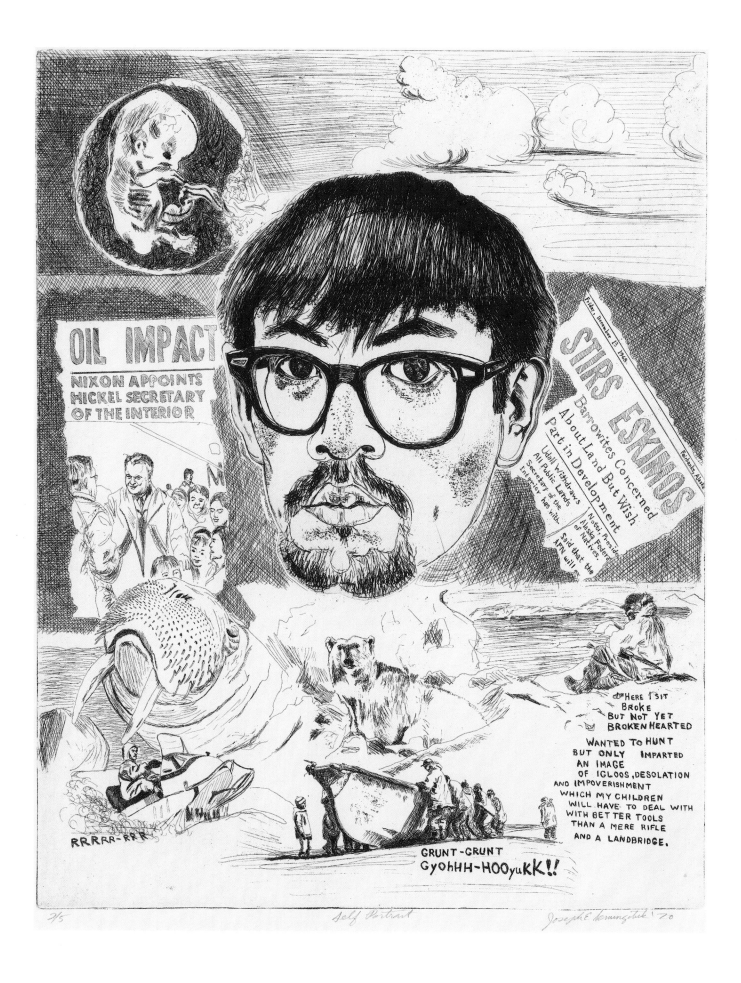

right along with the Indian model minority strategy. The new White House press-room hosted the most contentious press conferences in the history of the Republic. At one, Nixon announced he was "not a crook." In back rooms, Nixon made lists of enemies that included no Indians but many journalists. Many people disagreed with their president and felt Nixon was a crook, and as the Watergate break-in slowly turned into a constitutional crisis, their number increased. Nixon, it appeared, had given up his swimming pool so that his traditional enemies could attack him in comfort. In August 1974, Nixon resigned the presidency. Ironically, although his Indian policy may have been as expediently conceived as his swimming pool diplomacy, its results were as profound as they were unexpected.

A few weeks before Christmas in 1974, a curious proceeding was underway in federal court in Lincoln, Nebraska. Historians, legal experts, and Sioux elders presented testimony arguing that the Wounded Knee charges should be tossed because the 1868 Fort Laramie Treaty was still valid, and federal presence on the Great Sioux Nation was illegal. The judge made clear he found this of doubtful relevance; he indulged the hearing while all but promising to ignore it. AIM spiritual leader and medicine man Leonard Crow Dog, his father Henry Crow Dog, and a dozen other Lakota traditionals sat in the jury box and posed for a photograph. It captured exactly the moral authority and weight of evidence the Sioux brought to bear during the hearing. Judge Warren Urbom denied their request to dismiss charges, but his lengthy, emotional ruling made it sound like the Indians lost on a technicality and not on the merits of the case. "It cannot be denied that official policy of the United States until at least the late nineteenth century was impelled by a resolute will to control substantial territory for its westward-moving people. Whatever obstructed the movement, including the Indians, was to be—and was—shoved aside, dominated, or destroyed. Wars, disease, treaties pocked by duplicity, and decimation of the buffalo by whites drove the Sioux to reservations, shriveled their population and disemboweled their corporate body. It is an ugly history. White Americans may retch at the recollection of it."[2]

Leonard Crow Dog told the court: "We are the evidence of the Western Hemisphere."[3] His evidence is far grander than treaties between the Sioux and the United States. Crow Dog speaks of the Western Hemisphere as an Indian place—every bit of it, even the White House itself—a place thoroughly occupied for a very long time, a place whose discovery by Europeans created the world we live in today, a place we can't truly know until we dig deeper and look harder, until, finally, we examine the evidence.

I was a high school student during those years, living in a middle-class suburb of Washington, D.C., and somehow these events seemed to speak to me directly. My bedroom window featured a RED POWER bumper sticker advertising defiance and solidarity with my brothers and sisters in the struggle. In 1974, at the tender, stupid age of nineteen I joined the Wounded Knee Legal Defense/Offense Committee in Sioux Falls, South Dakota. For the next five years AIM became the center of my life.

It was a bit like being a late arrival at Woodstock—the original that is, not the copy—and hearing ten minutes of the final set on the last day. All the best moments I heard about secondhand, and, during my tenure in South Dakota, instead of militants facing armored personnel carriers with shotguns and .22s, I watched dozens of AIM people face trial and many of them go to prison. I came expecting to see barricades stormed. Instead I had a front-row seat to the messy aftermath of an inspired, disorganized movement, crushed by government infiltration and legal prosecutions, a task made easier by the movement's own mistakes and shortcomings.

As a high school student, Fritz Scholder studied under Oscar Howe (see p. 165) and continued to study, paint, and exhibit, gaining a worldwide reputation, honorary degrees, and status as a major influence for a generation of Native American artists. In *The American Indian* from 1970 (facing page), the United States flag motif is a banner, a blanket, or perhaps an entire garment, wrapping an Indian who is laughing—at what? Should this be taken as an emblem of patriotism? Of protest? As an ironic twist? Or as all three at once, each doubling back on the others in a visual dance of intertwined meanings?

FRITZ SCHOLDER (LUISEÑO, B. 1937), THE AMERICAN INDIAN, 1970. OIL ON CANVAS, 153 X 107.4 CM. INDIAN ARTS AND CRAFTS BOARD COLLECTION, DEPARTMENT OF THE INTERIOR, AT THE NATIONAL MUSEUM OF THE AMERICAN INDIAN, SMITHSONIAN INSTITUTION. 26/1056

American Indians had seized the attention of the nation and the world for a brief and exhilarating period with a series of political actions at times audacious, amusing, heroic, and brilliant. Indians were prouder and more visible, and our tribal leaders emboldened. A politics based on symbols and media highlighted the problems theatrically, but AIM failed to make a compelling case for its own vision of change. Some fifteen years after AIM's glory days, Jerry Wilkinson, then executive director of the National Indian Youth Council, contrasted the movement's lack of clear goals with the success of the Civil Rights movement in winning passage of voting rights legislation. "It did not create a tradition of people relentlessly, ceaselessly, and uncompromisingly pursuing a long-range goal," he said. "There were plenty of manifestoes with plenty of demands but . . . it was generally more important to throw these [demands] in somebody's face than to get them to act on it." Wilkinson argued that the movement also suffered from anti-intellectualism: "Everybody was for sovereignty, the Indian way, and traditional religion, but there were as many ideas about what these things were as there were people involved. Anyone raising questions about these things was highly suspect."[4] The movement also cared nothing about its own history, and has paid dearly for this inattention. The key architects of modern Indian activism—Mel Thom, Clyde Warrior, Richard Oakes—are virtually unknown even to present-day Indian activists. The continuing fame of Russell Means may have more to do with his Hollywood acting career than his bold leadership of the American Indian Movement.

I ponder these questions now from the vantage point of the Smithsonian's National Museum of the American Indian, with its centerpiece building situated on what was the last open space on the National Mall. This might be the most amazing piece of earth in America. From above, the Mall is like a jigsaw puzzle. There is Washington, the father of the country, and Lincoln, who saved it. A great art museum to rival any in Europe on one side, a vast warehouse of the American rockets that conquered space on the other. It is America at its best, a country big enough and reflective enough and generous enough to not only acknowledge a fiasco like Vietnam but to remember it with the stunning black granite walls of the Vietnam Veterans Memorial. African slave labor built the Capitol Dome yet it signals freedom and hope in spite of that, or perhaps because of it. The Mall is a fabulously weird theme park of the country's idea of itself over the last few centuries, a boulevard of broken dreams, liberation, and astonishing achievement. The planet's smart money is still betting Lincoln was right, that this is Man's last best hope, and is there better proof of America's outrageous ability to change (and not change) than this new palace carved from Indian rock and dedicated to the preposterous, wonderful, and breathtakingly ambitious task of telling the stories of Native peoples from throughout the hemisphere and throughout time?

Certainly the firestorm of anger and protest at the end of the 1960s and the beginning of the 1970s shaped a generation of American Indian thought on culture, political action, and identity. The flamboyant, resourceful, and foolish movement I knew was a story of people making history instead of the sad recitation of victims and government misconduct. This was a season of struggle in which Indians found a way to be more than a footnote and to force fundamental reassessments of what it meant to be Indian, of American history, of each other, and of their communities. The legacy of that failed revolution is the inheritance of Indian intellectuals and activists today, a legacy that has only begun to be explored with any depth. Those forty-two months that began over three decades ago still cast long shadows over Indian Country, and in the light and dark of those shadows are lessons for the present, some bitter and painful, some inspiring and instructive; all worth knowing.

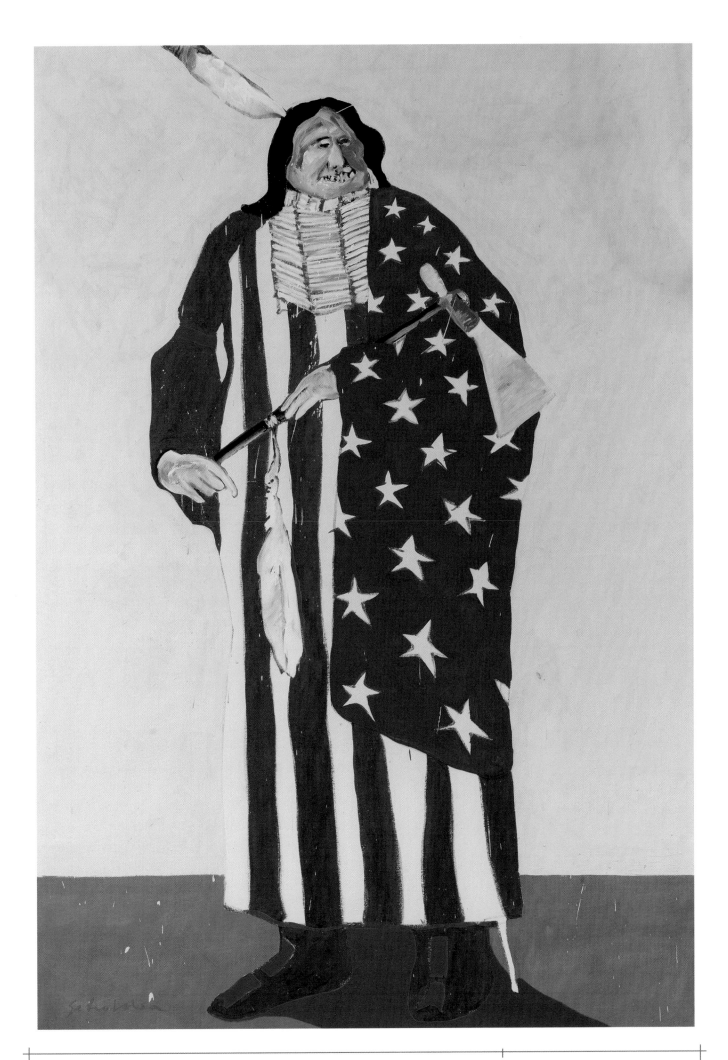

Indians of All Nations: The Alcatraz Proclamation

to the Great White Father and his People, 1969

In November 1969, a diverse group of Native Americans led by activist Richard Oakes took over Alcatraz, a small island in San Francisco Bay that had been the site of a federal prison from 1934 until 1963. They publicized their takeover by issuing a proclamation, replete with satirical humor and allusions to past events in Native history, that stated their demands, grievances, and goals. The occupation of Alcatraz—nicknamed "The Rock"—lasted nineteen months and inspired Indian protests throughout the nation.

PROTESTORS IN A MULTI-LEVELED CELLBLOCK ON ALCATRAZ. PHOTO BY ART KANE. P28162

Fellow citizens, we are asking you to join with us in our attempt to better the lives of all Indian people.

We are on Alcatraz Island to make known to the world that we have a right to use our land for our own benefit.

In a proclamation of November 20, 1969, we told the government of the United States that we are here "to create a meaningful use for our Great Spirit's Land."

We, the native Americans, reclaim the land known as Alcatraz Island in the name of all American Indians by right of discovery.

We wish to be fair and honorable in our dealings with the Caucasian inhabitants of this land, and hereby offer the following treaty:

We will purchase said Alcatraz Island for twenty-four dollars in glass beads and red cloth, a precedent set by the white man's purchase of a similar island 300 years ago. We know that $24 in trade goods for these 16 acres is more than what was paid when Manhattan Island was sold, but we know that land values have risen over the years. Our offer of $1.24 per acre is greater than the $0.47 per acre the white men are now paying the California Indians for their lands.

We will give to the inhabitants of this island a portion of the land for their own to be held in trust . . . by the Bureau of Caucasian Affairs . . . in perpetuity—for as long as the sun shall rise and the rivers go down to the sea. We will further guide the inhabitants in the proper way of living. We will offer them our religion, our education, our life-ways in order to help them achieve our level of civilization and thus raise them and all their white brothers up from their savage and unhappy state. We offer this treaty in good faith and wish to be fair and honorable in our dealings with all white men.

We feel that this so-called Alcatraz Island is more than suitable for an Indian reservation, as determined by the white man's own standards. By this, we mean that this place resembles most Indian reservations in that:

1. It is isolated from modern facilities, and without adequate means of transportation.

2. It has no fresh running water.

3. It has inadequate sanitation facilities.

4. There are no oil or mineral rights.

5. There is no industry and so unemployment is very great.

6. There are no health-care facilities.

7. The soil is rocky and nonproductive, and the land does not support game.

8. There are no educational facilities.

9. The population has always exceeded the land base.

10. The population has always been held as prisoners and kept dependent upon others.

Further, it would be fitting and symbolic that ships from all over the world, entering the Golden Gate, would first see Indian land, and thus be reminded of the true history of this nation. This tiny island would be a symbol of the great lands once ruled by free and noble Indians.

What use will we make of this land?

Since the San Francisco Indian Center burned down, there is no place for Indians to assemble and carry on tribal life here in the white man's city. Therefore, we plan to develop on this island several Indian institutions:

1. A Center for Native American Studies will be developed, which will educate them to the skills and knowledge relevant to improve the lives and spirits of all Indian peoples. Attached to this center will be travelling universities, managed by Indians, which will go to the Indian Reservations, learning those necessary and relevant materials now about.

2. An American Indian Spiritual Center, which will practice our ancient tribal religious and sacred healing ceremonies. Our cultural arts will be featured and our young people trained in music, dance, and healing rituals.

3. An Indian Center of Ecology, which will train and support our young people in scientific research and

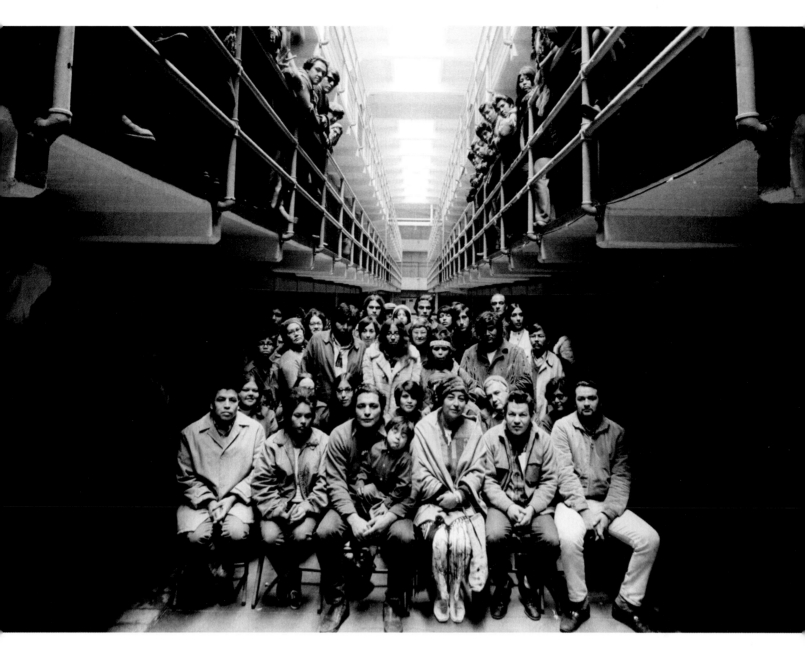

practice to restore our lands and waters to their pure and natural state. We will work to de-pollute the air and waters of the Bay Area. We will seek to restore fish and animal life to the area and to revitalize sea-life which has been threatened by the white man's way. We will set up facilities to desalt sea water for human benefit.

4. A Great Indian Training School will be developed to teach our people how to make a living in the world, improve our standard of living, and to end hunger and unemployment among all our people. This training school will include a center for Indian arts and crafts, and an Indian restaurant serving native foods, which will restore Indian culinary arts. This center will display Indian arts and offer Indian foods to the public, so that all may know of the beauty and spirit of the traditional Indian ways.

5. Some of the present buildings will be taken over to develop an American Indian museum which will depict our native food and other cultural contributions we have given to the world. Another part of the museum will present some of the things the white man has given to the Indians in return for the land and life he took: disease, alcohol, poverty, and cultural decimation (as symbolized by old tin cans, barbed wire, rubber tires, plastic containers, etc.). Part of the museum will remain a dungeon to symbolize both those Indian captives who were incarcerated for challenging white authority and those who were imprisoned on reservations. The museum will show the noble and tragic events of Indian history, including the broken treaties, the documentary of the Trail of Tears, the Massacre of Wounded Knee, as well as the victory over Yellow-Hair Custer and his army.

In the name of all Indians, therefore, we reclaim this island for our Indian nations, for all these reasons. We feel this claim is just and proper, and that this land should rightfully be granted to us as long as the rivers run and the sun shall shine.

We hold the rock!

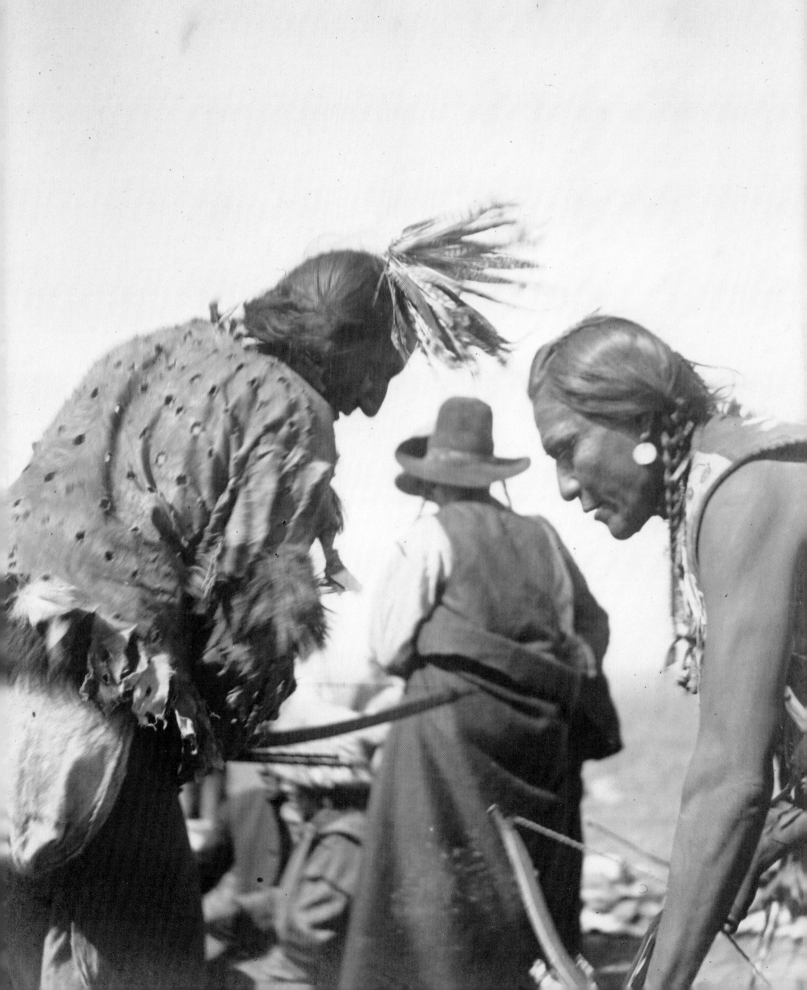

Objects—whether they be elaborately feathered, carved, beaded, and painted ceremonial symbols, or the strikingly designed shirt of a famous leader such as Crazy Horse, or a wonderfully simple creation such as the "cactus boot" canteen on this page—speak of the lived historical experience of Native peoples throughout the Americas. A cactus boot occurs when a bird drills into a Saguaro cactus and the plant forms a scab to protect itself. After the cactus dies and dries up, the "boot" remains. Resourceful and long-practiced at living in the harsh environment of the Sonoran desert, the Tohono O'odham utilized this natural phenomenon to create water containers. Young men carried such canteens on Salt Pilgrimages from their inland villages in what is now Arizona to the Gulf of California. There they harvested salt, made offerings to the ocean, and sought visions. The journey could transform a young man's life—not only because of the spiritual teachings he learned from elders along the way, but also because of the life-defining

vision he might receive when he first stood before the ocean. As invasion by Europeans brought accelerating and irreversible changes to the lives of Native Americans throughout the hemisphere, the people struggled to carry their cultures forward despite lives fraught with chaos, displacement, and poverty. Native makers continued to create beautiful things and appropriated new materials to their own uses. Their exquisite creations are linked to the stories of the people and carry cultural and spiritual meaning in addition to aesthetic power.

TWO BLACKFEET MEN IN TRADITIONAL CLOTHING. MONTANA. MARY ROBERTS RINEHART COLLECTION. P20730
TOHONO O'ODHAM "CACTUS BOOT" CANTEEN, CA. 1910–20. SAGUARO CACTUS AND AGAVE FIBER, HEIGHT 12.6 CM. 8/9757

OUR PEOPLES
PORTFOLIO

Ceremonial Nations

Through ceremony, with its profound and complex ritual process, Native peoples from the Arctic to the tip of South America celebrate and renew their reciprocal relationship with a world that is seen as alive and sacred, and give thanks to the creative powers. In the ceremonial space, dancers, drummers, singers, and speakers reenact ancient stories and summon ancestral spirits. The Sun Dance, the preeminent religious ceremony of Plains tribes, has as its cynosure a circular lodge that represents the cosmos in miniature. With the sound of an eagle-bone whistle, the rhythm of the drum, and the singing of prayers, the sacred drama re-creates the world and recognizes the necessity for participants to give of themselves to maintain the great, intertwined cycle of life. Despite attempts at suppression and outright banning of Native ceremonies by the U.S., Canadian, and other governments, such cultural expressions survived, and ceremonial life has been reinvigorated in recent years.

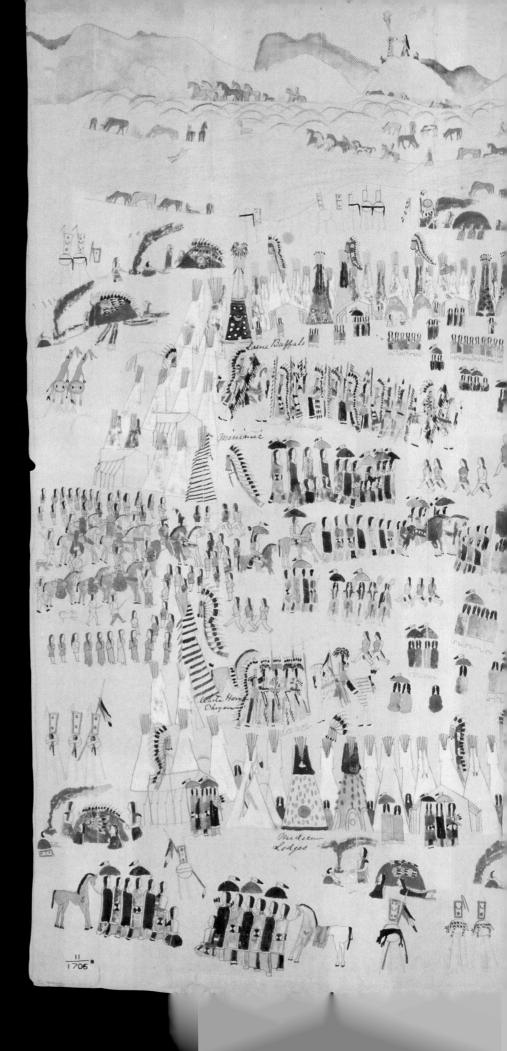

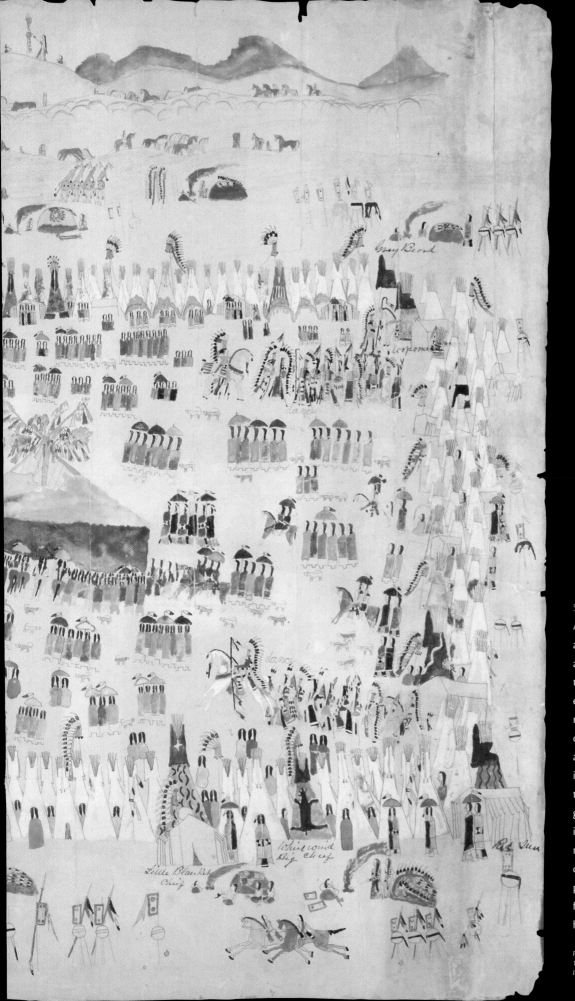

SUN DANCE

A multitude of figures and objects are arrayed across a painting representing a summer Sun Dance encampment of the Cheyenne nation. Bands of the entire tribe gather for reunion and religious observance of the Sun Dance or Medicine Lodge Ceremony. The actions of several days are compressed into the one scene; people arrive from the left at the same time people gather around the large sacred lodge in the middle to watch offerings being made at this most important of all observances. In the distance hunting parties stalk game, horses graze, and further offerings are made in the blue hills on the horizon.

PROBABLY LITTLE CHIEF (SOUTHERN CHEYENNE, 1854–1923), SUN DANCE ENCAMPMENT. WATERCOLOR, INK, AND PENCIL ON PAPER, 59.5 X 65.8 CM. 11/1706

This Land Belongs to Us

(ca. 1882)

*By Tatanka Yotanka
(Sitting Bull)*

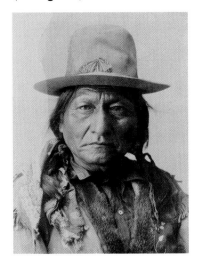

Sitting Bull (above) made these statements (right) to journalist James Creel in 1882. The Lakota chief was a notable spiritual leader, especially at the Sun Dance before the Battle of the Little Big Horn, and the shape of his medicine drum (opposite) is unique in that Lakota people made circular drums.

TATANKA YOTANKA (SITTING BULL, 1831?–1890), HUNKPAPA LAKOTA, 1882. GENERAL NELSON A. MILES COLLECTION. PHOTO BY WILLIAM R. CROSS. P06911

HUNKPAPA LAKOTA MEDICINE DRUM, BELONGED TO TATANKA YOTANKA. HIDE, HORN, WOOD, PAINT, 59 X 49 X 7 CM. 23/2202

This land belongs to us, for the Great Spirit gave it to us when he put us here. We were free to come and go, and to live in our own way. But white men, who belong to another land, have come upon us, and are forcing us to live according to their ideas. That is an injustice; we have never dreamed of making white men live as we live.

White men like to dig in the ground for their food. My people prefer to hunt the buffalo as their fathers did. White men like to stay in one place. My people want to move their tipis here and there to the different hunting grounds. The life of white men is slavery. They are prisoners in towns or farms. The life my people want is a life of freedom. I have seen nothing that a white man has, houses or railways or clothing or food, that is as good as the right to move in the open country, and live in our own fashion. Why has our blood been shed by your soldiers?

[*Sitting Bull drew a square on the ground with his thumbnail.*]

There! Your soldiers made a mark like that in our country, and said that we must live there. They fed us well, and sent their doctors to heal our sick. They said that we should live without having to work. But they told us that we must go only so far in this direction, and only so far in that direction. They gave us meat, but they took away our liberty. The white men had many things that we wanted, but we could see that they did not have the one thing we liked best—freedom. I would rather live in a tipi and go without meat when game is scarce than give up my privileges as a free Indian, even though I could have all that white men have. We marched across the lines of our reservation, and the soldiers followed us. They attacked our village, and we killed them all. What would you do if your home was attacked? You would stand up like a brave man and defend it. That is our story. I have spoken.

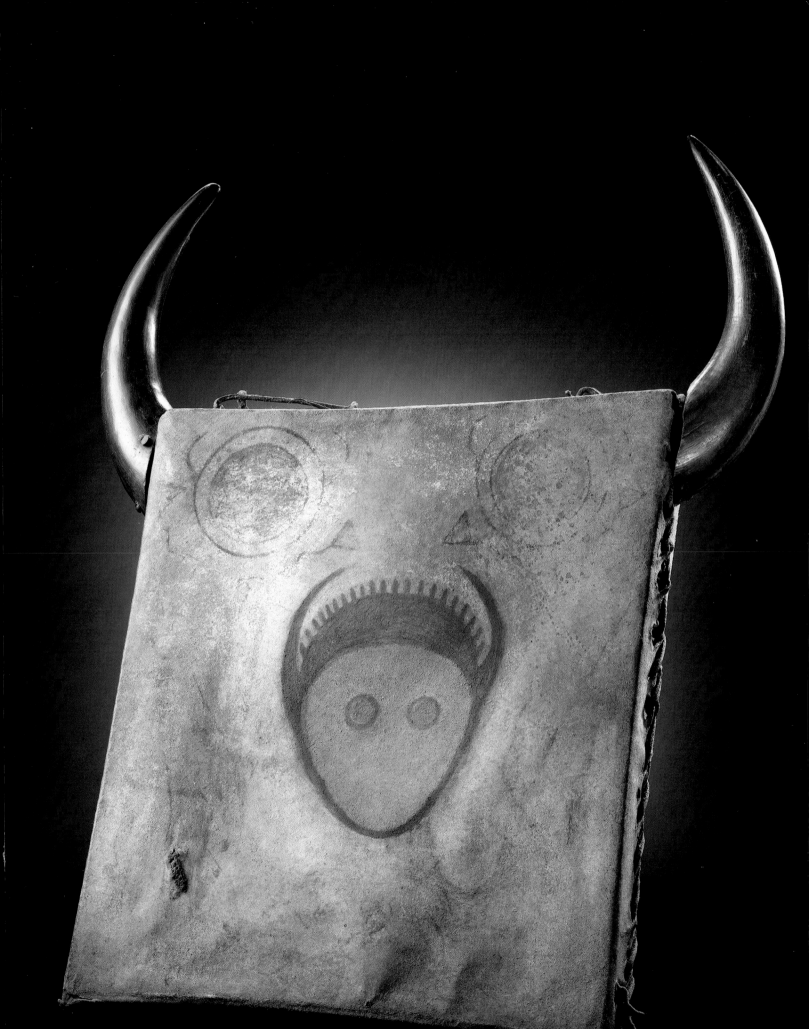

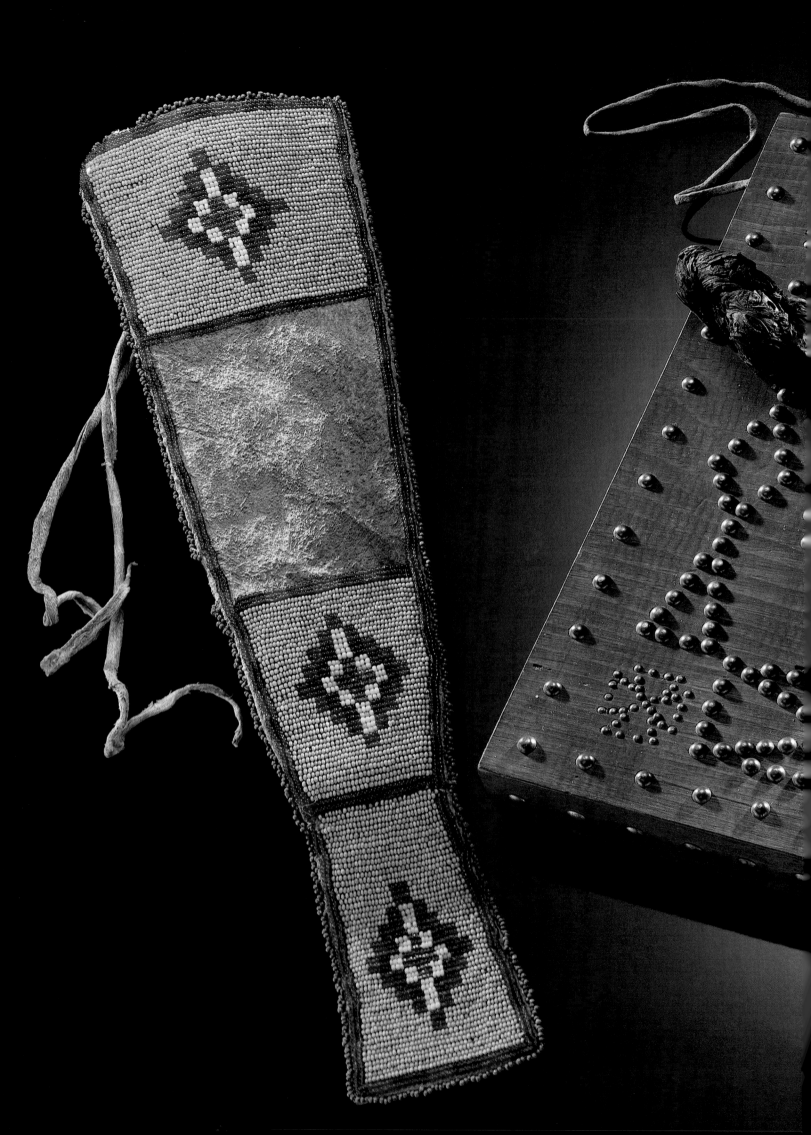

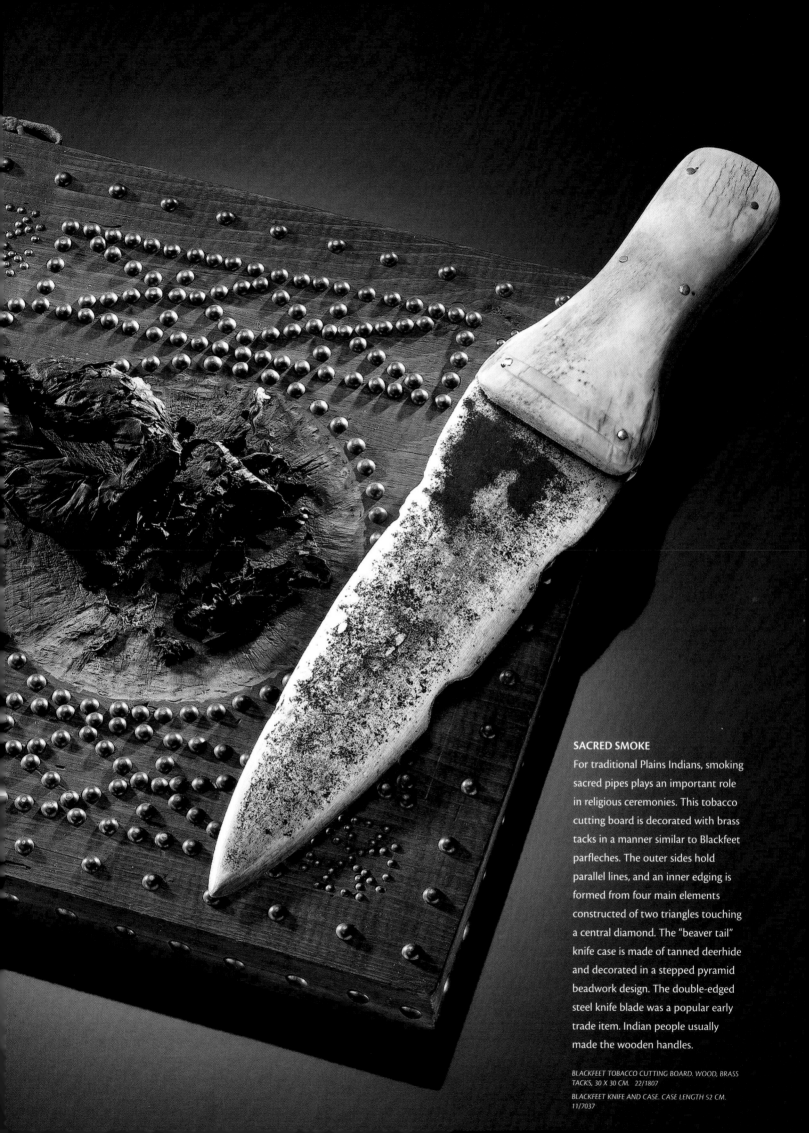

SACRED SMOKE

For traditional Plains Indians, smoking sacred pipes plays an important role in religious ceremonies. This tobacco cutting board is decorated with brass tacks in a manner similar to Blackfeet parfleches. The outer sides hold parallel lines, and an inner edging is formed from four main elements constructed of two triangles touching a central diamond. The "beaver tail" knife case is made of tanned deerhide and decorated in a stepped pyramid beadwork design. The double-edged steel knife blade was a popular early trade item. Indian people usually made the wooden handles.

BLACKFEET TOBACCO CUTTING BOARD. WOOD, BRASS TACKS, 30 X 30 CM. 22/1807
BLACKFEET KNIFE AND CASE. CASE LENGTH 52 CM. 11/7037

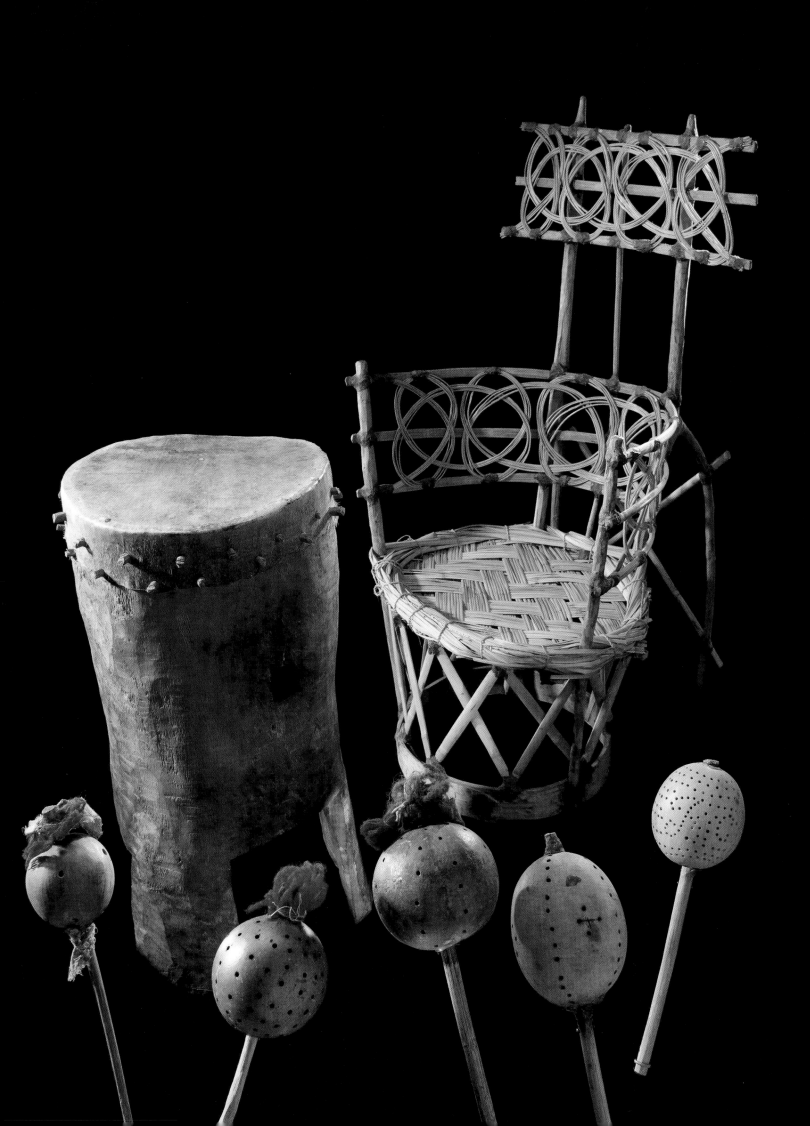

WIXARIKA (HUICHOL), UWENI (SHAMAN'S CHAIR), TEPU (DRUM), XAWERI (VIOLIN), KANARI (GUITAR), AND KAITSA (RATTLES), CA. 1930. FIBER, BAMBOO, WOOD, SKIN, GOURD, WOOL YARN. 11/9699, 19/5550, 11/9723, 11/9724, 19/5404, 19/5570, 19/7831, 19/7834, AND 19/7835

WIXARIKA NIERIKA (YARN PAINTING), CA. 1965. MADE BY TUTUKILA CARRILLO, SANTA CATARINA CUEXCOMATITAN (TUAPURIE). WOOL YARN, PLYWOOD, BEESWAX, 30 X 30 CM. 26/2627

WIXARIKA MUSICIANS AT CORN FIESTA, 1937. EL LIMON, NAYARIT, MEXICO. PHOTO BY DONALD B. CORDRY. P13395

PILGRIMS' PROGRESS

When harvest time begins, the Wixarika (Huichol) of Mexico celebrate the *Tatei Neixa* or Festival of the Drum. A shaman sits in his barrel-shaped chair beating a drum all day and night, and singing of an imagined pilgrimage to Wirikuta, the main sacred site to the east. Behind him, musicians play violin and guitar. Children with painted faces shake rattles during the day, and only when they have participated five times in this ceremony will they be able to take part in a real pilgrimage. Square yarn paintings depicting symbols of Wixarika mythology or rituals evolved from small round versions that were sometimes carried along and left as offerings on pilgrimages.

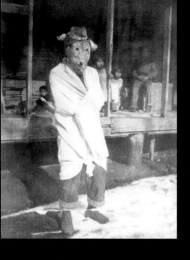

BOOGER MASK

Many Cherokee traditional dances, most notably animal and Booger dances, require masks. Animal dance masks were typically made from wood. Masks for the Booger Dance, intended to drive away evil spirits, are most often made from gourds. This hornet nest mask, which is a Booger mask, may have been hastily made and used to ward off illness. Hornet nests, used to store eggs, were once common items in Cherokee homes. Traditional Cherokee dancing was nearly extinct when, in 1984, the Eastern Band of Cherokee Indians of North Carolina and the Cherokee Nation of Oklahoma met in council for the first time in 150 years. To mark the momentousness of the occasion, organizers invited a Cherokee elder to gather together a group of dancers to perform publicly, thereby renewing an almost lost art form.

CHEROKEE DANCER WEARING HORNET NEST MASK, 1935. NORTH CAROLINA. PHOTO BY FRANK G. SPECK. P11932
CHEROKEE HORNET NEST MASK, CA. 1935. NORTH CAROLINA. 21 X 26 X 43 CM. 18/9353

CALLING FOR THE RAIN

In the Sonoran desert of the American Southwest, rain is critical for survival. The Tohono O'odham perform a ceremony each July to solicit moisture for newly planted corn, beans, and squash. The ceremony involves the ritualized fermenting, sharing, and drinking of wine made from the fruit of the saguaro cactus, gathered with the help of a long pole (right). Elders mix the fruit's syrup with water and ferment the liquor in clay ollas (above). As that is done, medicine songs are sung in a prescribed order for two nights, and each night the medicine people beckon rain. Oratory is also an important component of this ceremony.

TOHONO O'ODHAM CLAY OLLAS, CA. 1910–20. HEIGHT 62 CM AND 41 CM. 8/9723 AND 8/9707
MAN GATHERING SAGUARO FRUIT, 1919. BLACKWATER, ARIZONA. PHOTO BY EDWARD H. DAVIS. P00366

Warrior Traditions

Many tribes have a strong warrior tradition. Ancient warrior societies defended the land and protected their people's way of life. Kiowa writer N. Scott Momaday explains that in his ancestral Plains culture, a warrior exemplified principles of bravery, fortitude, generosity, and virtue. "Those principles have been extremely important to me," he says. "I would like to live my life according to those four things." Many Native Americans have served the United States in the armed forces, from scouts who fought alongside George Washington in the American Revolution to Hopi tribal member Lori Ann Piestewa, who gave her life in the Iraq War. Veterans—both men and women—hold a place of honor among many Native peoples. Warrior traditions find new expression in contemporary society as Native peoples fight for jobs, rights, and lost lands on many battlefields, including the workplace, state legislatures, courts, and the U.S. Department of the Interior.

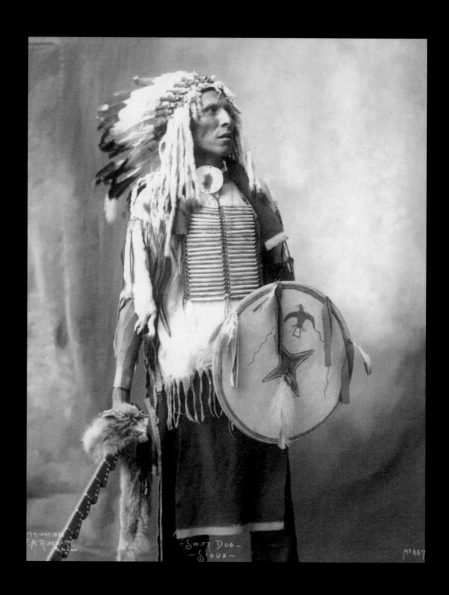

EMBLEMS OF COURAGE

A Plains Indian warrior did not own an eagle feather war bonnet such as that worn by Lakota warrior Swift Dog (above) unless he merited it. Each feather on a war bonnet told a story as to how it was earned—in battle. Plains Indian warriors made their shields according to their personal medicine. Feathers on this model of a Kiowa warrior's shield and cover (right) are from crows and sparrow hawks (kestrels). The attributes of those birds were sought by Kiowa warriors. Crows are intelligent and strong, and warn Kiowa people when danger approaches. Sparrow hawks are fast and hunt so low to the ground that they can attack their prey without being seen from a distance.

SWIFT DOG (LAKOTA), 1898. PHOTO BY FRANK A. RINEHART OR ADOLPH F. MUHR. P09873

KIOWA SHIELD AND COVER. COLLECTED IN 1910. RAWHIDE, BUCKSKIN, CROW AND SPARROW HAWK FEATHERS, RED WOOL TRADE CLOTH, HORSEHAIR, PIGMENT, 87.7 X 62.5 X 11.5 CM. 2/8376

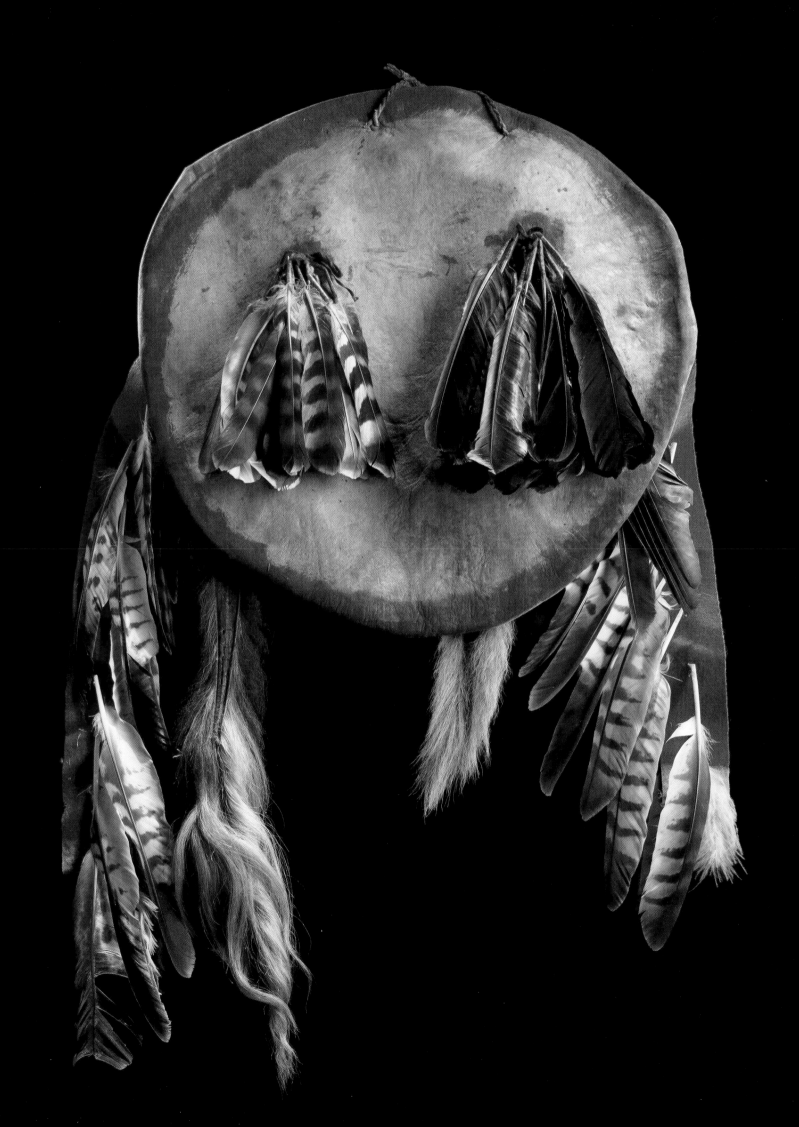

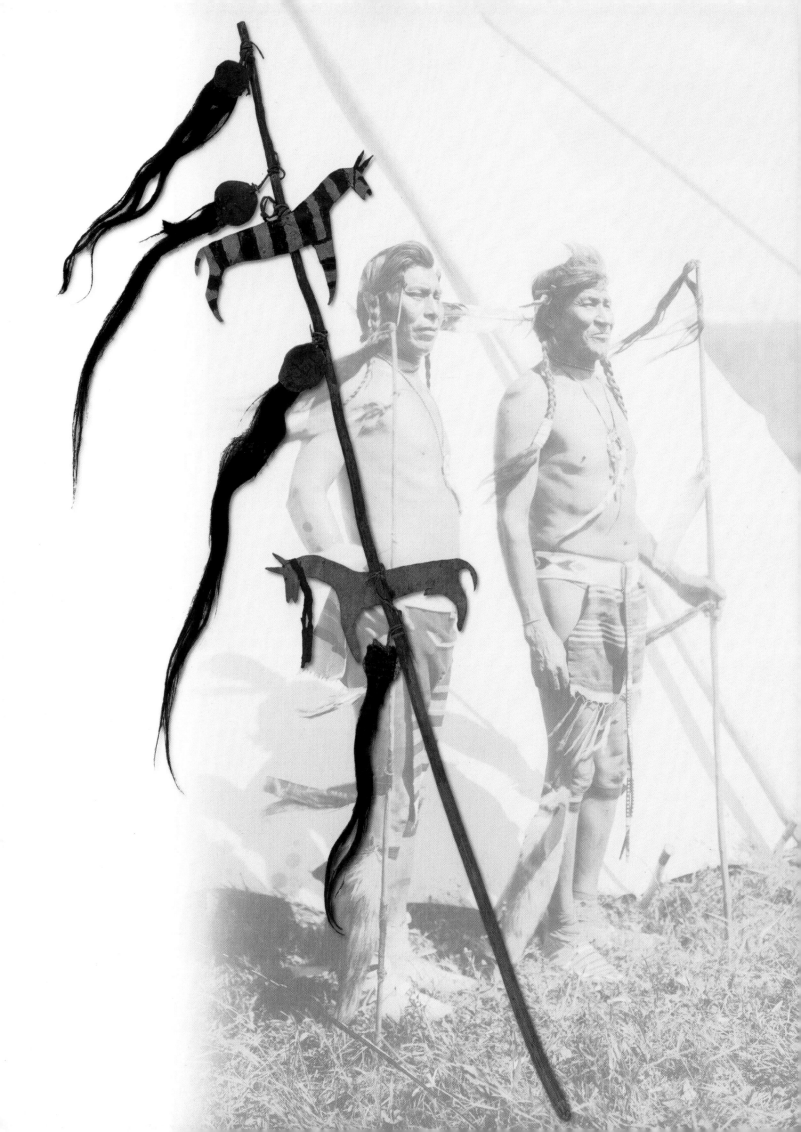

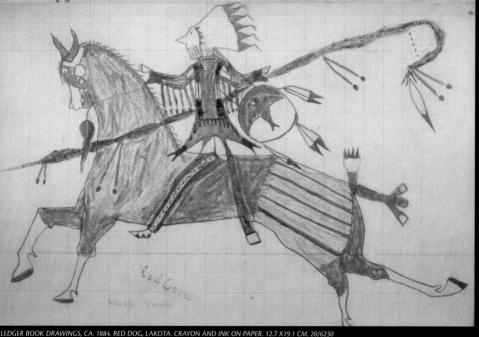

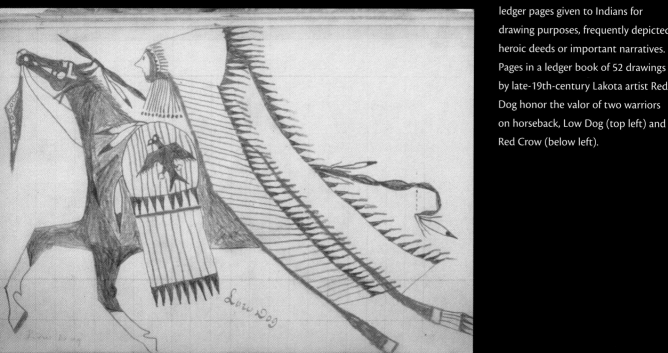

MOUNTED HONOR

A profound agent of change for American Indians was the accidental gift of horses descended from mounts of Spanish colonial soldiers. Blackfeet men (opposite, background) celebrated horses with special societies, gatherings, dances, and songs. They carried staffs such as the one opposite, which is decorated with horse cutouts representing animals the owner had ridden in battle, and symbolic "scalps" made of horsehair. The staffs could be used as coup sticks. To gain honor in battle, a warrior might ride up to an enemy and touch him with his coup stick, not necessarily killing or even wounding him. Indian ledger art, so named because it was often drawn on ledger pages given to Indians for drawing purposes, frequently depicted heroic deeds or important narratives. Pages in a ledger book of 52 drawings by late-19th-century Lakota artist Red Dog honor the valor of two warriors on horseback, Low Dog (top left) and Red Crow (below left).

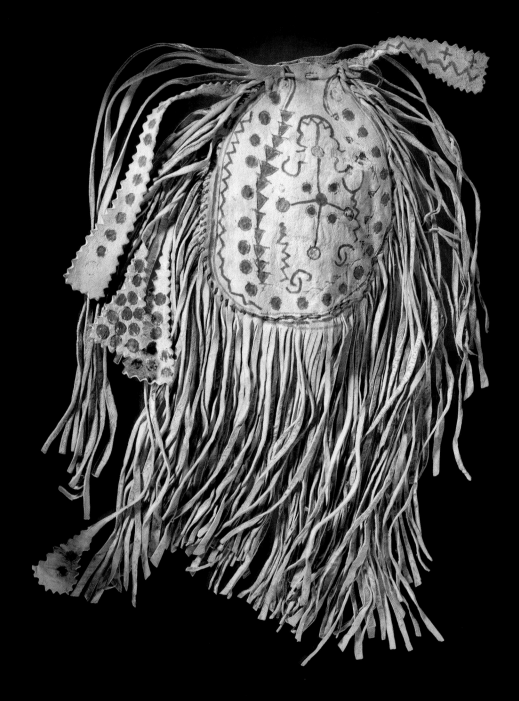

GARMENTS OF GREATNESS

Celebrated leaders are remembered for their deeds, both warlike and peacemaking, and some of their personal possessions remain. The pouch (above) bears wide serrated tabs—classic decorative elements found on Apache examples. It is said to have belonged to Geronimo. While no image of Crazy Horse, no photograph or artwork, has ever been found, his shirt (right) still carries a powerful aura of the renowned Lakota leader who held the high title of a councilor called a "shirtwearer."

GERONIMO'S DRAWSTRING POUCH, CA 1880S. CHIRICAHUA APACHE. DEER HIDE, PIGMENT, LENGTH 56 CM. 23/3101
CRAZY HORSE'S SHIRT. OGLALA LAKOTA. HIDE WITH PAINT, SCALP LOCKS, AND WOODPECKER FEATHERS, LENGTH 84 CM. 16/1351

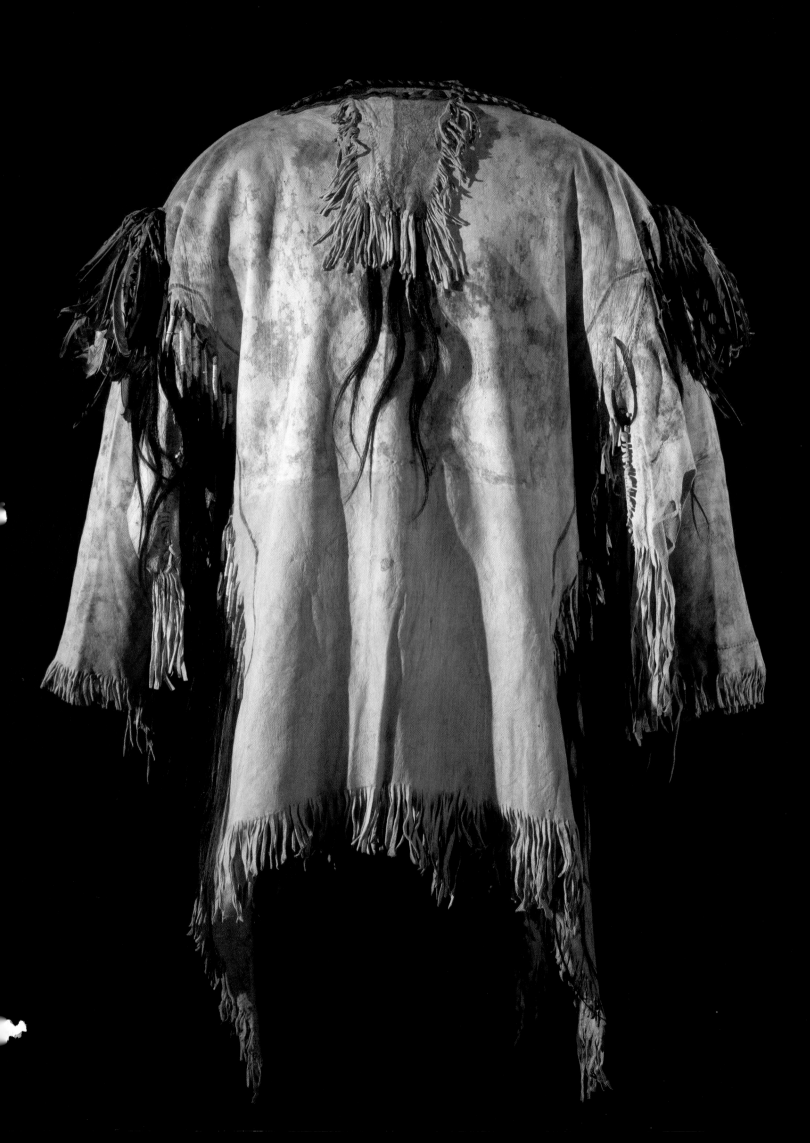

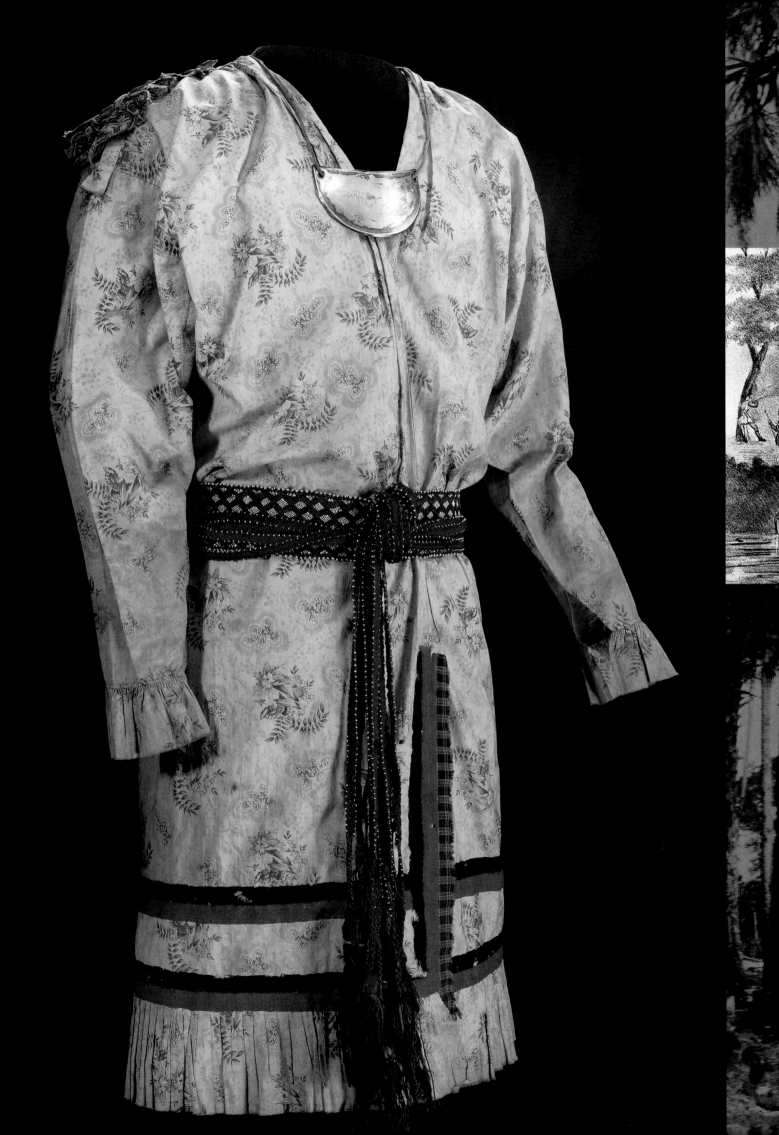

FIGHTING BACK

Seminoles, for the most part, spent the greater part of the 19th century opposing and fighting the removal policy of the U.S. government. The period lasting from 1817 until 1858 is known as the Seminole Wars. The Second and Third Seminole Wars were

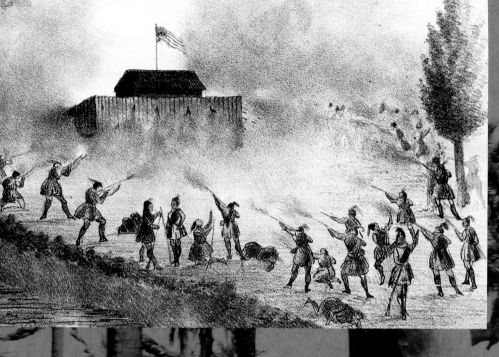

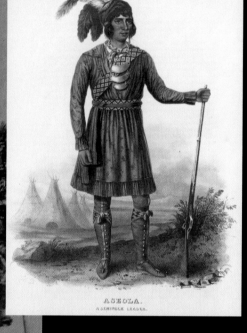

OSCEOLA.
A SEMINOLE LEADER.

fought directly over removal: Seminoles were resisting their removal from Florida to Indian Territory (present-day Oklahoma). Osceola emerged as a major leader during the Second Seminole War. His full-length portrait, in which he wears a long shirt strikingly similar to the rare example in the NMAI collection (opposite), was painted by George Catlin. Later engravings were based upon that painting. Also during the Second Seminole War, Seminoles laid siege to an Army blockhouse (left) for 48 days. At the close of the Seminole Wars, fewer than 300 Seminoles, possibly only 200, remained in Florida, living deep in the Everglades. They cleared land for small fields by girdling trees (background).

COLOR ENGRAVING OF OSCEOLA FROM MCKENNEY AND HALL'S HISTORY OF THE INDIAN TRIBES OF NORTH AMERICA. PHILADELPHIA: 1837–44. P27784

SEMINOLE CHINTZ LONG SHIRT, CA. 1830S. 13/5085

SEMINOLE SILVER GORGET, CA. 1780. 24/1225

SEMINOLE WOVEN BELT, CA. 1830S. 20/8060

SEMINOLE ATTACK ON A FEDERAL MILITARY POST DURING THE SECOND SEMINOLE WAR.

SEMINOLE CORNFIELD WITH GIRDLED TREES, 1908. FLORIDA. PHOTO BY MARK R. HARRINGTON. P12235

The Native Aesthetic

A rich tradition of creativity manifests both tribal and personal identity in the objects that Indian people fashion. Diverse Native cultures have produced varied treasures, including intricate and massive carvings from the Northwest Coast of North America; elegantly painted and beaded hides and garments from the North American Plains; pottery and basketry from the southwestern United States; textiles and gold from the Andean cultures; elaborate featherwork from Amazonia; and paintings by contemporary Native American artists. With a powerful sense of design and form, Native art is a dynamic force that allows individual and community vision to evolve and thrive. Indian artists, for example, became renowned for their beadwork after European trade introduced glass beads. Designs once fashioned with quills or paint now embodied community identity and personal innovations in shimmering beaded patterns. Carriers of knowledge and expressions of beauty, the objects created by our forebears helped keep our cultures alive and continue to strengthen and inspire us today.

QUILL CRAFT

Porcupine quills were long and widely used for decoration by many Native groups of North America. Although quillwork was largely replaced by designs employing glass beads introduced by fur traders, the tradition has been kept alive. The Anishinaabe (Ojibwe, also known as Chippewa) continued to use quills, birchbark, and sweet grass gathered from their environment to make objects for personal use and commercial sale. By stacking quills, interweaving them into elaborate patterns, and complementing natural colors with commercial dyes, the makers have enriched their creations in color and expressiveness (right and detail above).

CHIPPEWA (OJIBWE) QUILLED BIRCHBARK OBJECTS FROM THE NMAI COLLECTION. 12/9890, 13/7212, 24/4331, 14/5537, 16/2569, AND 2/9519

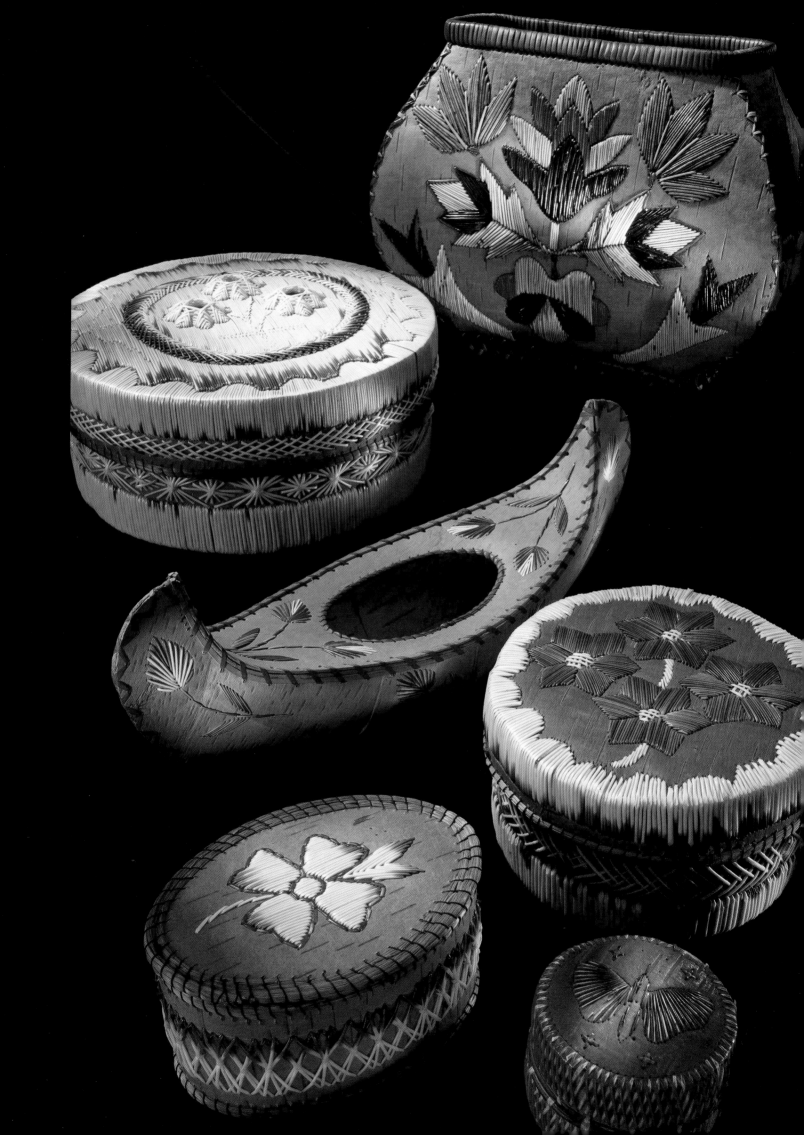

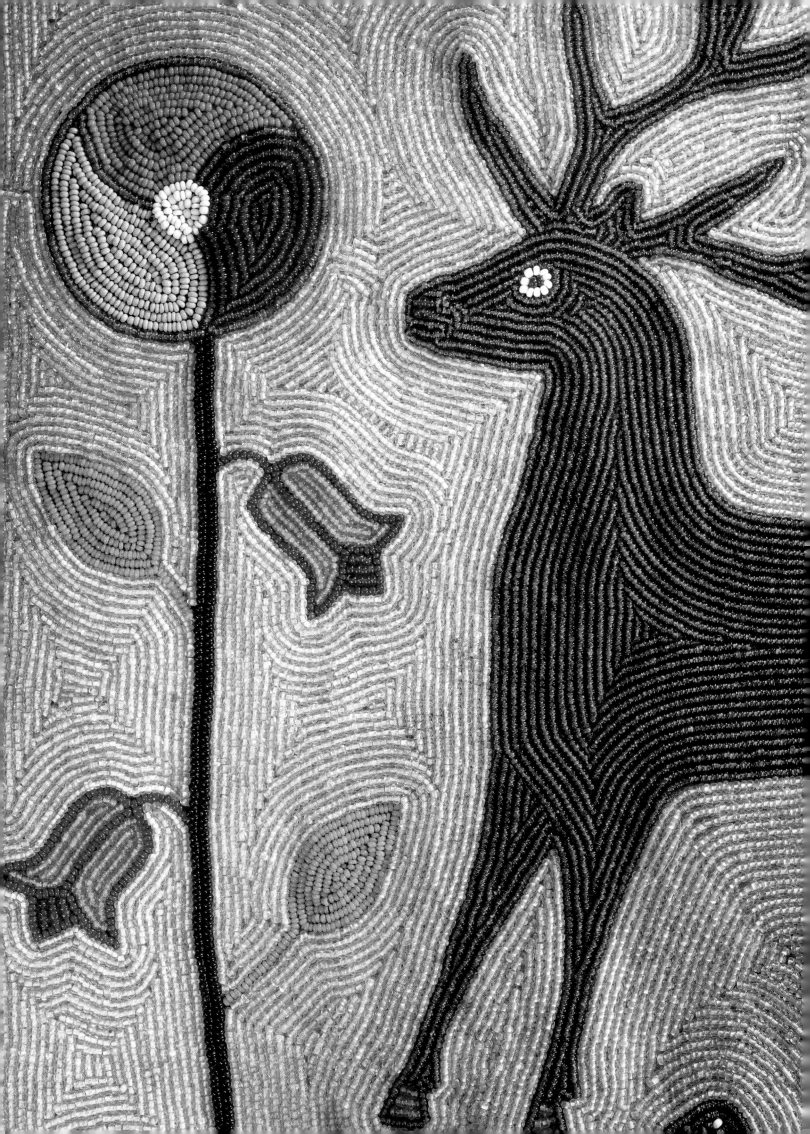

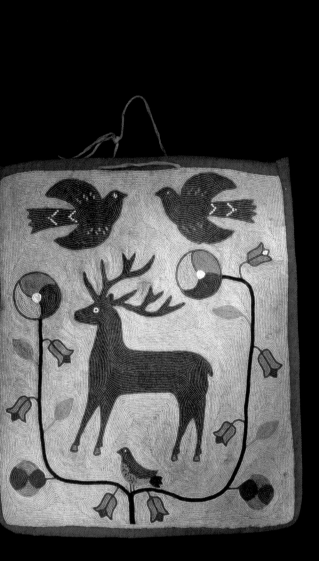

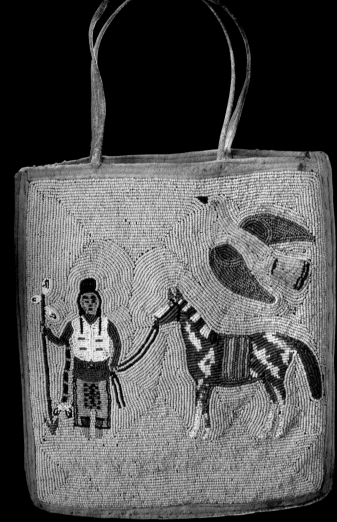

PLATEAU BEADWORK

Beaded bags are in the line of a long tradition of Plateau tribes' craft. Earlier woven bags of hemp and cornhusk to carry and store root crops were modified to hold personal items. Then European influences arrived by way of glass beads, wool trade cloth, and cotton. A bag from a Yakama maker (above left and detail opposite) sets the animals and flowers in a sinuous background pattern. A Umatilla bag of a slightly later date (above, right) portrays a warrior, his horse, and a bird in a beaded appliqué style.

KLIKITAT, YAKAMA NATION, BEADED BAG, CA. LATE 1800S. GLASS BEADS, COTTON, WOOL TRADE CLOTH, LEATHER, 42.5 X 36.2 CM. 13/8466

UMATILLA BEADED BAG, EARLY 20TH C. GLASS BEADS, DEERSKIN, WOOL, TRADE CLOTH, LINEN, COTTON THREAD, 25.4 X 23.3 CM. 21/7902

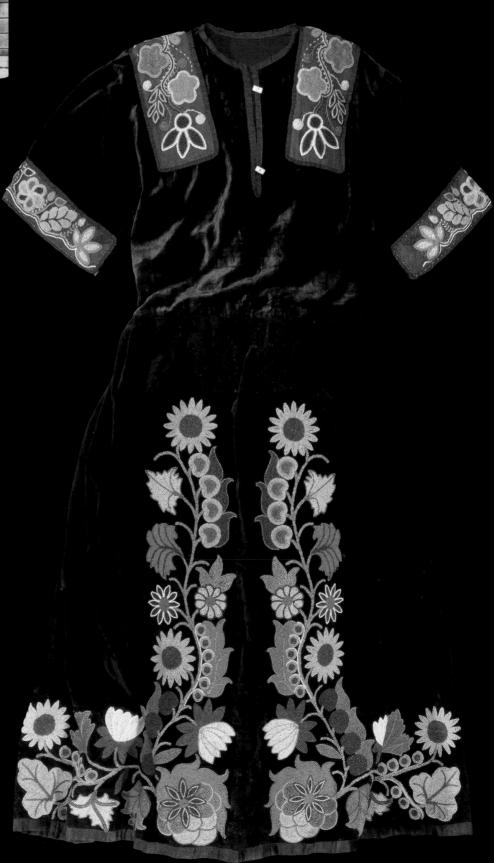

FLORAL WONDERS

Fur traders introduced velvet, silk ribbons, glass seed beads, and thread to the Ojibwe in the mid to late 1800s, and those new goods were incorporated into garment-making. Dresses of striking beauty (above) were stitched, and notable examples (right) have been preserved. Beads were attached by the two-needle appliqué method, and designs depicted realistic representations of local flowers and leaves. A variety of beads were sewn, including metallic, cut, lined, transparent, translucent, and opaque varieties.

TINTED LANTERN SLIDE, EASTERN OJIBWE WOMAN "OF MISSISAUGA," 1907. MUNCEYTOWN, ONTARIO. PHOTO BY MARK R. HARRINGTON. L00243

OJIBWE BEADED VELVET DRESS. WHITE EARTH RESERVATION, MINNESOTA. 18/0938

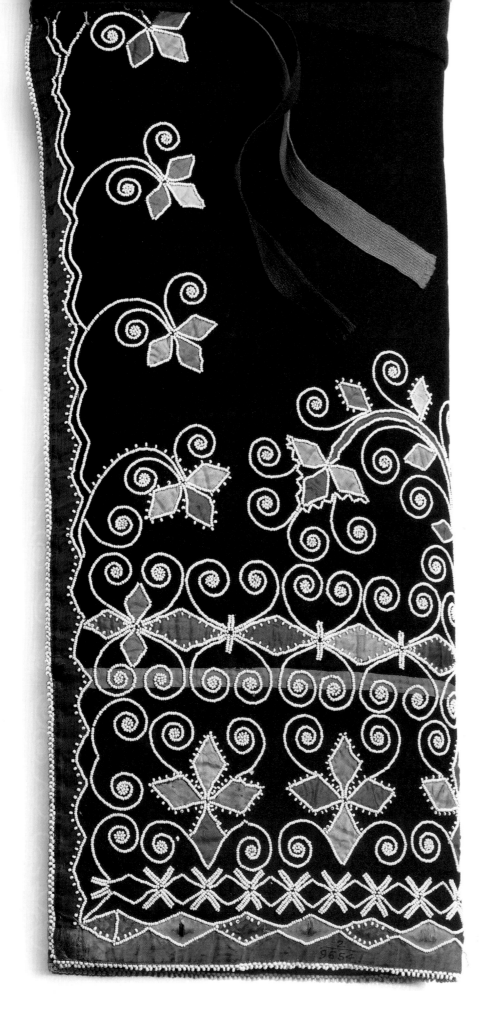

AND FOR MEN

The beaded design on a pair of Mohawk men's leggings, one of which is shown at left, reveals the care, pride, imagination, and skill of the woman who created it. As trade cloth became available, women made from it the type of wrapped and folded clothing, including leggings and breechcloths, that had previously been made of skins. On these broadcloth leggings, the beadwork replaces painted and quilled decoration found on earlier hide examples.

MOHAWK BEADED LEGGINGS, LATE 19TH C. GLASS BEADS, WOOL TRADE CLOTH, COTTON, SILK RIBBON, LENGTH 44.5 CM. 2/9654

BASKET TASKS

For centuries and longer, baskets were essential to Native life. Food was stored and cooked in them. Many things were carried in them—from babies to firewood. Apache olla baskets (right) were coiled so tightly that they could be used to carry water day after day. Materials, designs, and shapes varied from community to community, and the bowl-shaped basket of an Apache living in a desert (top) might little resemble a Penobscot pack basket used in the forests of Maine. Native baskets are now eagerly collected, and students are keen to learn the art and craft. They might keep in mind the insight of a California Native teacher: "A basket is a song made visible."

WHITE MOUNTAIN APACHE BASKET, CA. 1890. ARIZONA. HEIGHT 63 CM. 21/5350

APACHE WOMAN DISPLAYING BASKET SHE IS MAKING. PHOTO BY ERNEST S. CARTER. P20770

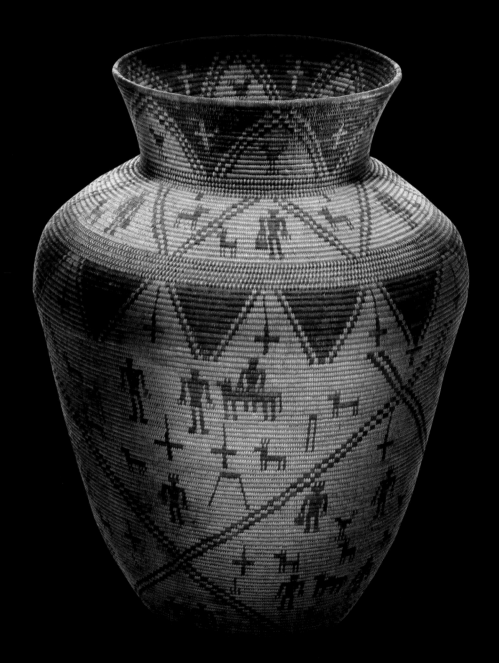

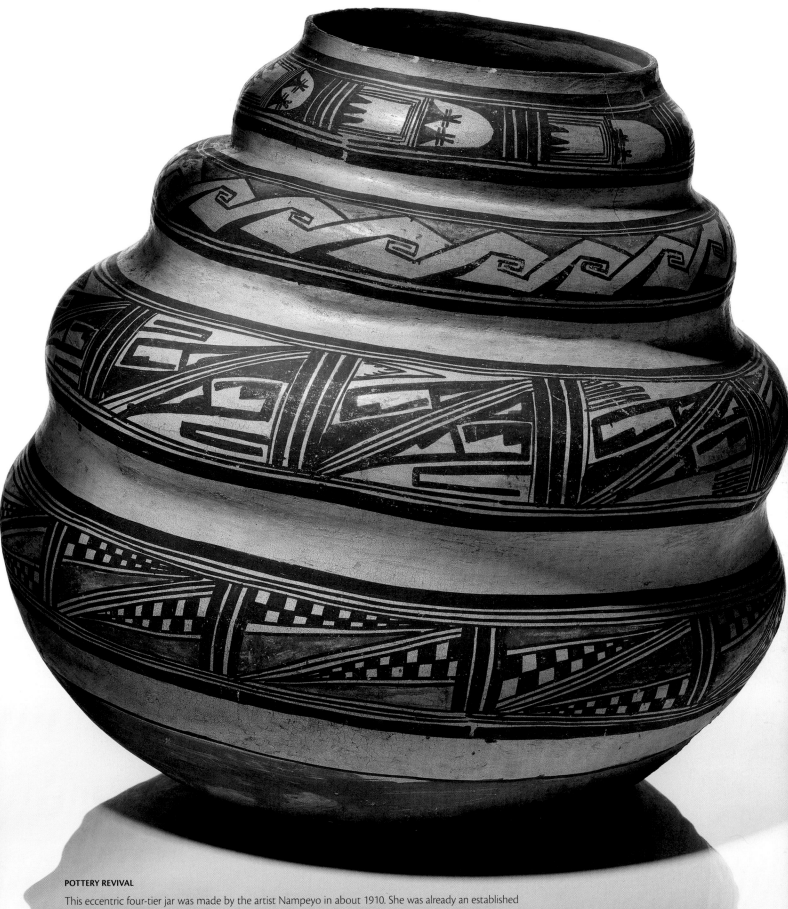

POTTERY REVIVAL

This eccentric four-tier jar was made by the artist Nampeyo in about 1910. She was already an established potter when, in the 1890s, she found in nearby abandoned Hopi ancestral villages examples of a style identified by archeologists as Sikyatki wares. Nampeyo began to experiment with various paints, clays, and designs until she was able to closely approximate the ancient style. By 1900, she had created a revival Sikyatki pottery style; in addition, she became the first Pueblo potter known by name, helping to create the Pueblo art pottery market. This virtuoso piece demonstrates her intimate knowledge of design systems, as well as of ancient shapes and clays. The four-terraced jar consists of four bowls and four separate designs.

POLACCA POLYCHROME TIERED JAR, CA. 1910. MADE BY NAMPEYO (TEWA/HOPI, 1859?–1942). HEIGHT 39.5 CM. 19/4358

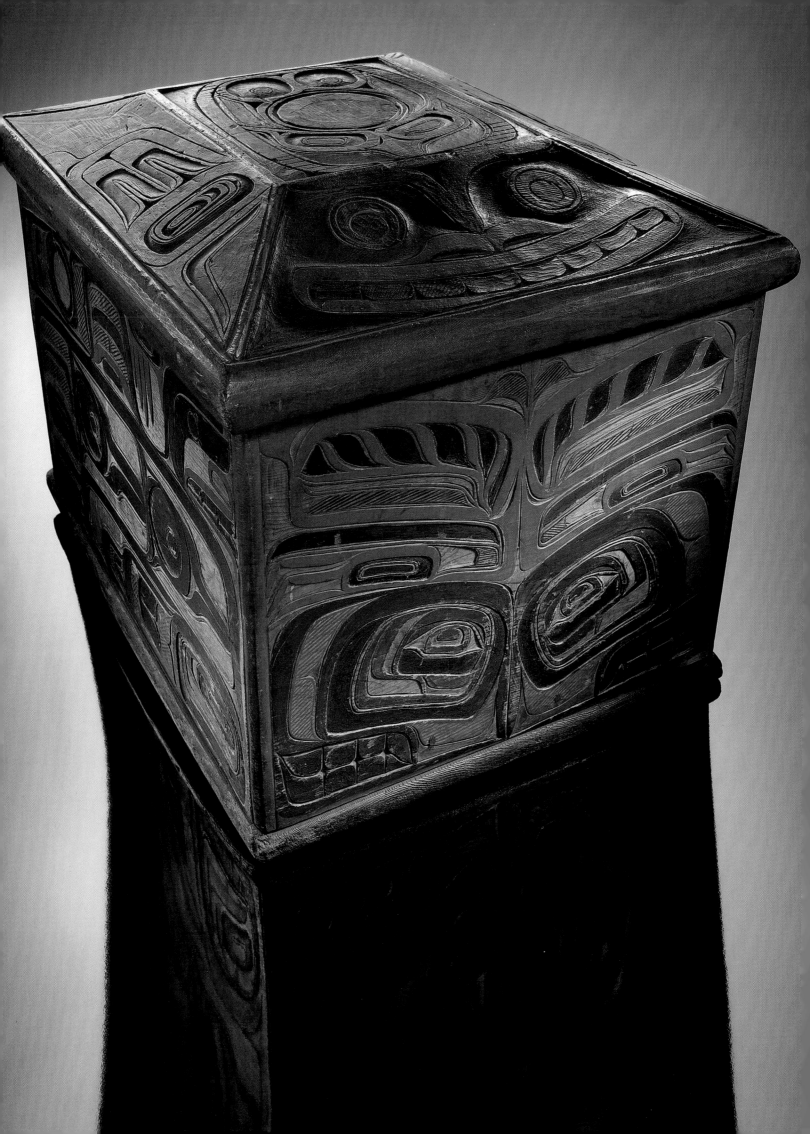

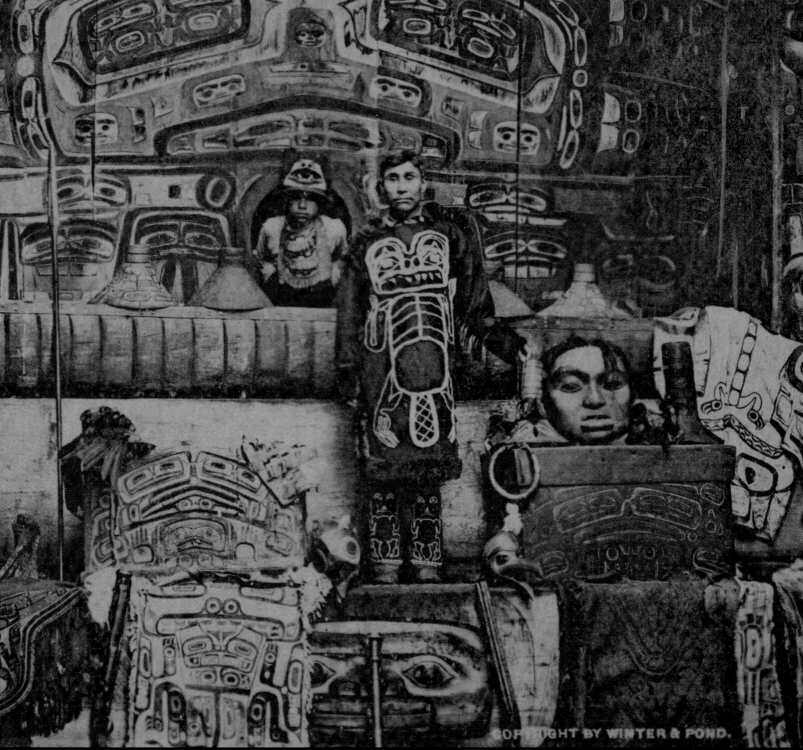

INTERIOR OF CHILKAT TLINGIT CHIEF'S HOUSE SHOWING COLLECTION OF HATS, BLANKETS, AND CARVED WOOD ITEMS, LATE 19TH C.

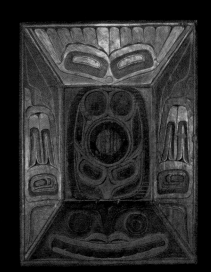

BENTWOOD MASTERWORK

During the 1880s and 1890s in the village of Bella Bella (Waglisla) on the coast of British Columbia, a small group of gifted Heiltsuk artists produced dozens of bentwood boxes, chests, wood settees, masks, and canoes. One of the finest painters and carvers (and lighthouse keeper), known by the English name of Captain Carpenter, is thought to have fashioned this box (left and detail, right). He belonged to the Blackfish Clan and inherited the right to represent his family's crests (an eagle from his father's side; a killer whale from his mother's) on ceremonial regalia as well as objects made for collectors. Some Heiltsuk goods were sold to collectors for museums as distant as New York, London, and Berlin or traded to local communities.

BENTWOOD BOX AND COVER, LATE 19TH C. ATTRIBUTED TO CAPTAIN RICHARD (DICK) CARPENTER (1841–1931). YELLOW CEDAR SIDES AND LID, RED CEDAR BASE, PAINT, 32.5 X 44.5 X 35 CM. 15/8974

The Domain
of Family

In earlier days, the objects that accompanied Native family life, from cradleboards to baskets, were created as part of daily life. When noted Kiowa beadwork artist Vanessa Jennings was a baby, her grandmother Etta Mopope (pictured here with her son Stephen Mopope, who became one of the famed "Kiowa Five" artists and Jennings' father) wrapped her in a cradleboard and said, "My prayer is you'll live a long and healthy life. Let me carry you part of the way." Jennings later learned to make cradleboards from her grandmother and her mother. In the late 19th century, cradleboards were often beaded with floral and geometric designs, while figures like buffalo, deer, and humans, and motifs such as flags, were added in the 20th century. The makers of these and other objects of everyday life took pride in the contributions that their creativity made to this intimate realm, in which the generations are nurtured and sheltered.

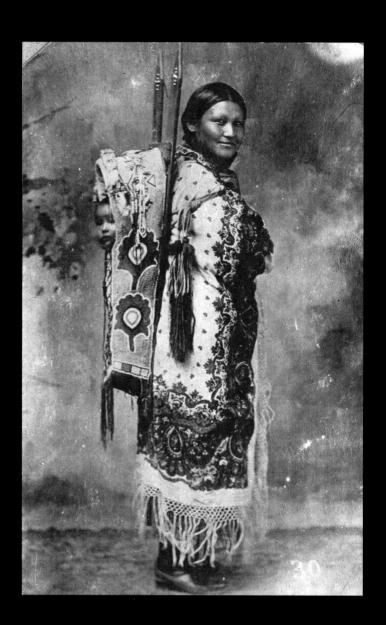

CRADLEBOARDS

Kiowa Etta Mopope (above, ca. 1899), known as Paukeigope, was the daughter of Keintaddle and the mother of artist Stephen Mopope, in cradle (see page 310 for a watercolor by this painter). Both practical and beautiful, a selection of cradleboards (right) from the National Museum of the American Indian's collection symbolizes the love and nurture of children, and the continuance of family and cultural traditions.

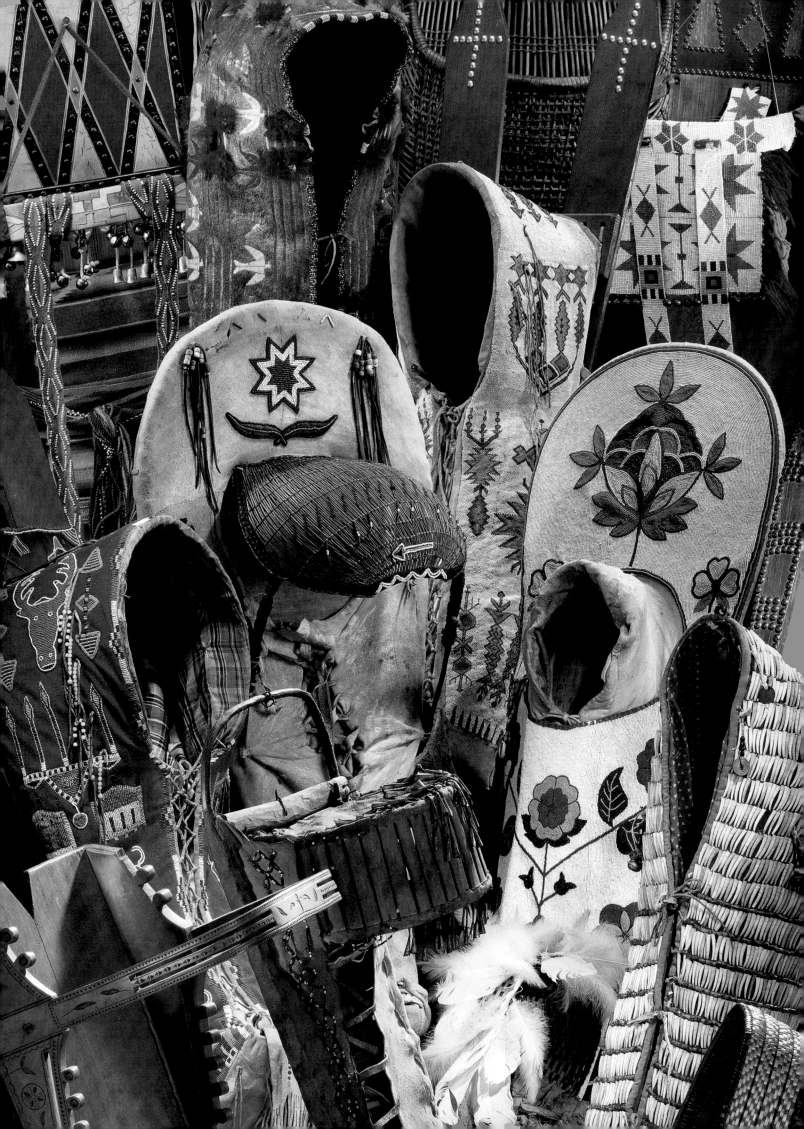

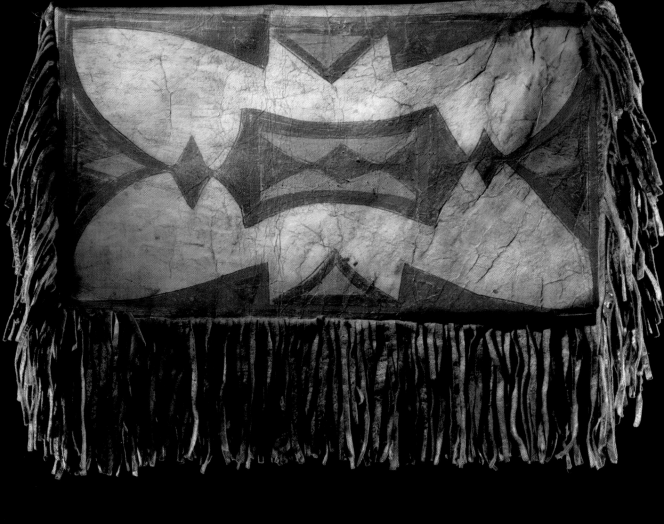

RAWHIDE CANVAS

Blackfeet women carried their sewing supplies in rawhide cases (above). The designs applied were frequently set off by curved lines and outlines, colored dots, or small circles to fill in enclosed spaces. Coloring was added from natural dyes gleaned from soils or plants. After the figures and colors were applied, the surface was varnished with a clear liquid, such as cactus juice, to seal the rawhide and maintain the colors. Fringing was added to enhance the overall effect. Before decoration, rawhide was stretched on pegs driven into the ground, much as an Absaroke (Crow) woman has done (below). When stretched tight, the rawhide gave a stable platform on which to work, and the developing design could be seen in its entirety as application of the design progressed.

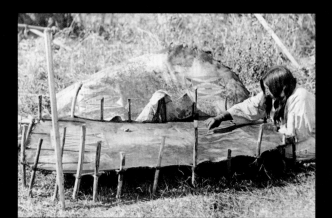

BLACKFEET RAWHIDE CASE, CA 1880. RAWHIDE, TANNED DEERSKIN, 75 X 44 CM. 14/3398

ABSAROKE (CROW) WOMAN DECORATING STAKED HIDE. CHARLES RAU COLLECTION. P09341

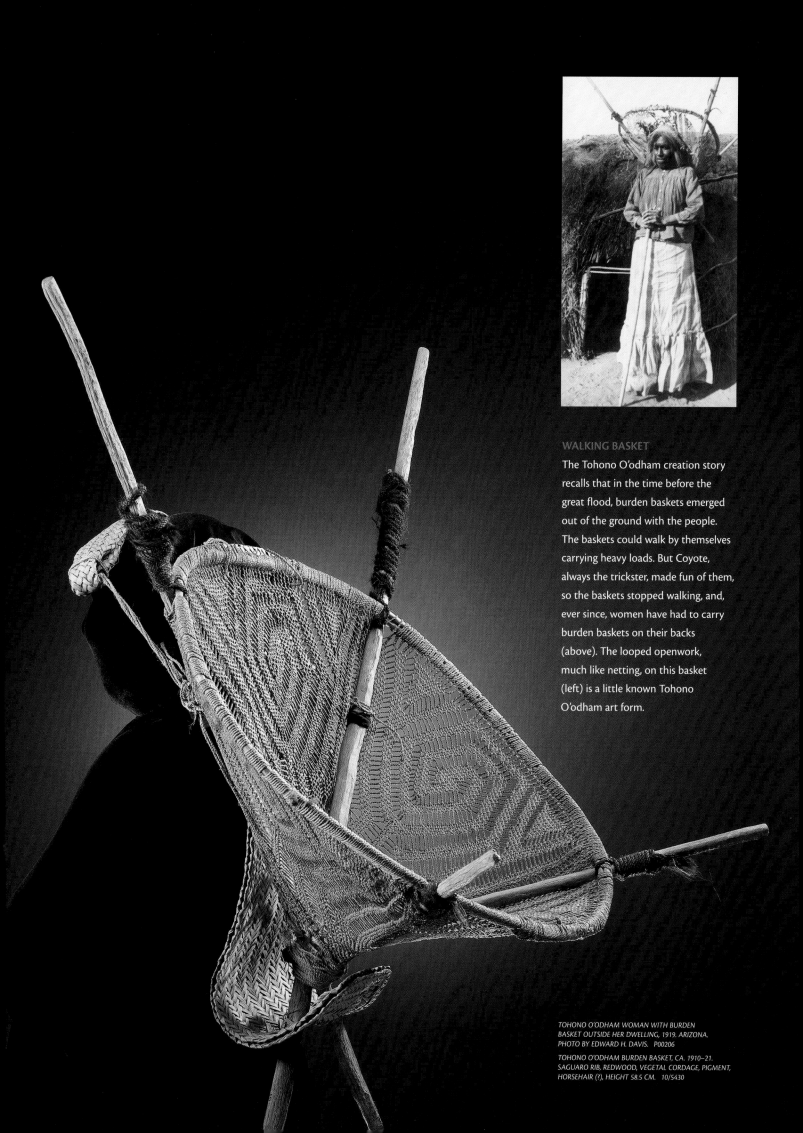

WALKING BASKET

The Tohono O'odham creation story recalls that in the time before the great flood, burden baskets emerged out of the ground with the people. The baskets could walk by themselves carrying heavy loads. But Coyote, always the trickster, made fun of them, so the baskets stopped walking, and, ever since, women have had to carry burden baskets on their backs (above). The looped openwork, much like netting, on this basket (left) is a little known Tohono O'odham art form.

TOHONO O'ODHAM WOMAN WITH BURDEN BASKET OUTSIDE HER DWELLING, 1919. ARIZONA. PHOTO BY EDWARD H. DAVIS. P00206

TOHONO O'ODHAM BURDEN BASKET, CA. 1910–21. SAGUARO RIB, REDWOOD, VEGETAL CORDAGE, PIGMENT, HORSEHAIR (?), HEIGHT 58.5 CM. 10/5430

FIT FOR A BRIDE

Several Columbia River tribes, including the Wishram, present "veils" to females who had become marriageable on reaching womanhood. The beads and Chinese coins (predominantly from the Ch'ing dynasty) used in the head covering are foreign trade items, and the tooth-shaped dentalium shells are from waters near Vancouver Island. The shells were a popular trade item among many tribes along the Pacific coast and the Plains tribes. The veil was worn atop the head (background) and was part of a bride's dowry.

WISHRAM BRIDAL VEIL, CA. 19TH C. DENTALIUM SHELLS, RAWHIDE STRIPS, GLASS AND BRASS BEADS, CHINESE COINS, COTTON THREAD, 65 X 41 CM. 22/9650 WISHRAM BRIDE, 1910. PHOTO BY EDWARD S. CURTIS.

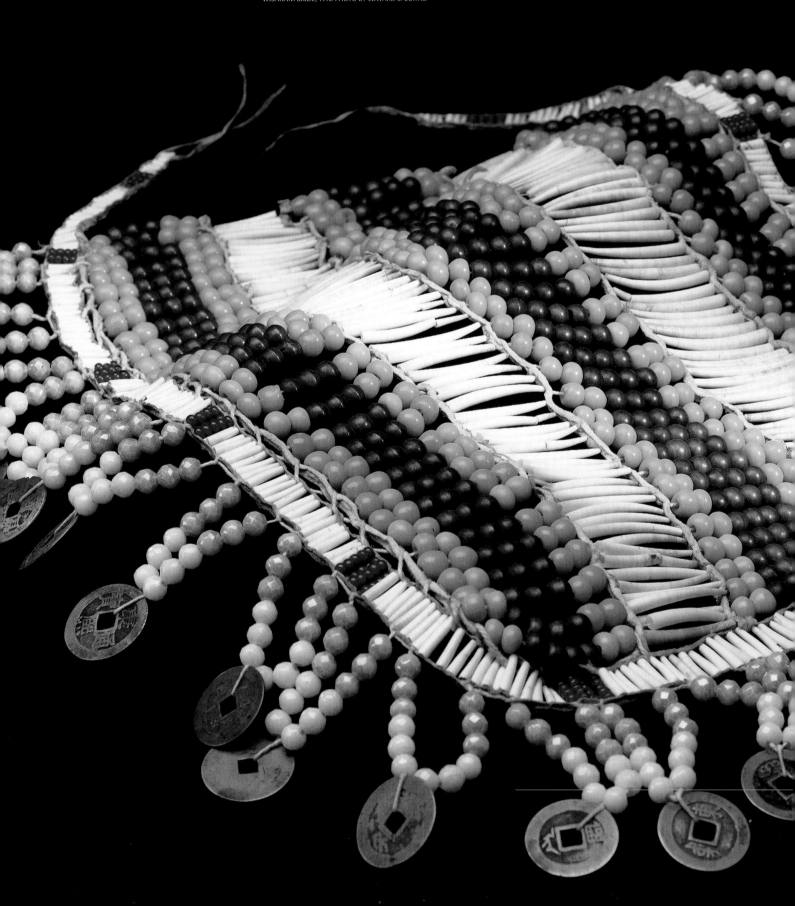

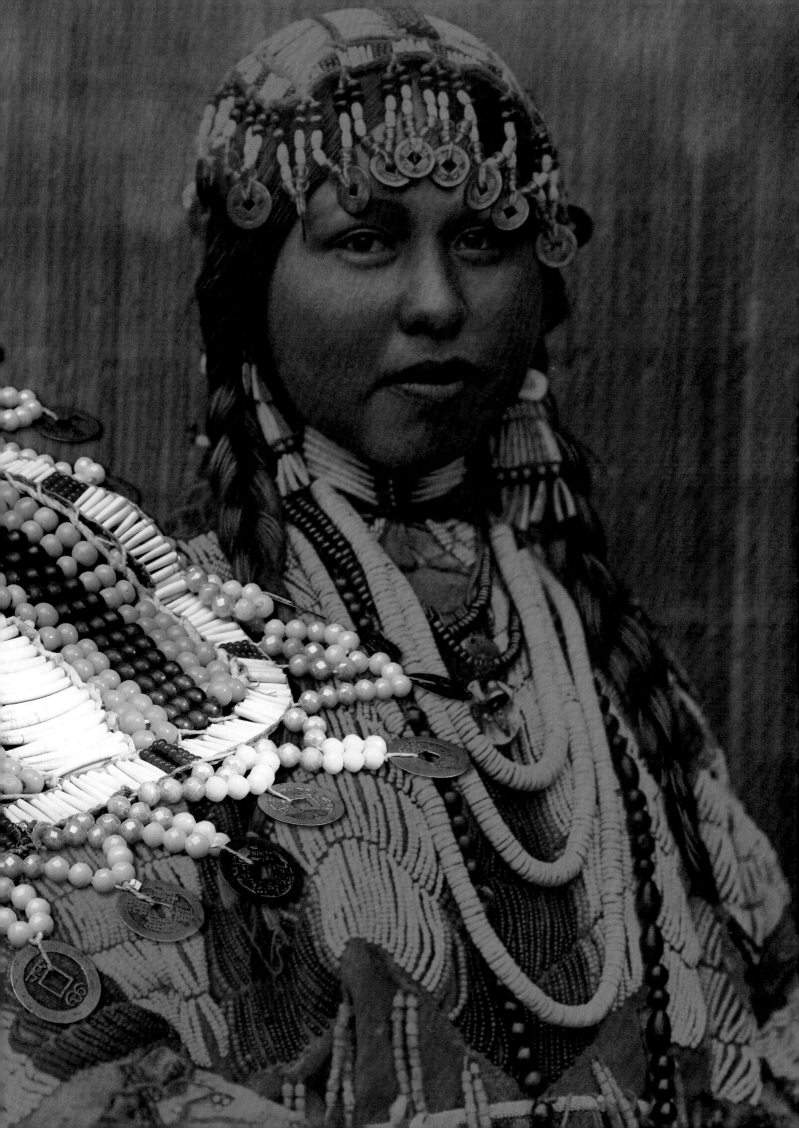

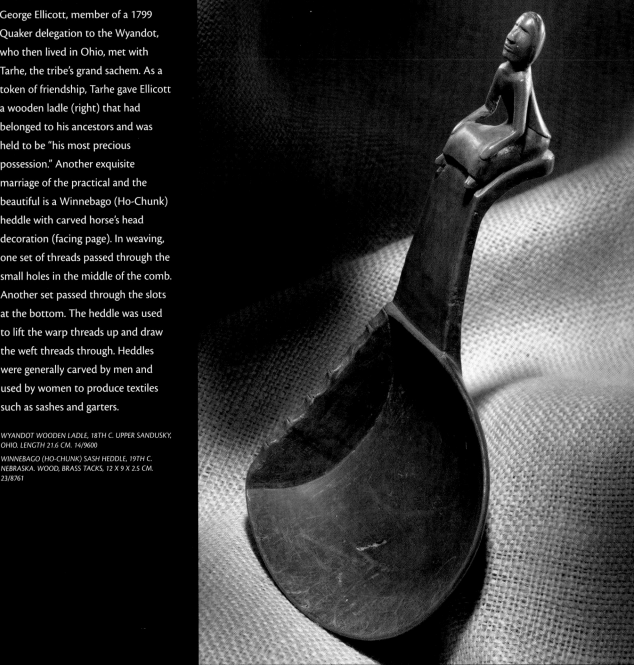

George Ellicott, member of a 1799 Quaker delegation to the Wyandot, who then lived in Ohio, met with Tarhe, the tribe's grand sachem. As a token of friendship, Tarhe gave Ellicott a wooden ladle (right) that had belonged to his ancestors and was held to be "his most precious possession." Another exquisite marriage of the practical and the beautiful is a Winnebago (Ho-Chunk) heddle with carved horse's head decoration (facing page). In weaving, one set of threads passed through the small holes in the middle of the comb. Another set passed through the slots at the bottom. The heddle was used to lift the warp threads up and draw the weft threads through. Heddles were generally carved by men and used by women to produce textiles such as sashes and garters.

WYANDOT WOODEN LADLE, 18TH C. UPPER SANDUSKY, OHIO. LENGTH 21.6 CM. 14/9600

WINNEBAGO (HO-CHUNK) SASH HEDDLE, 19TH C. NEBRASKA. WOOD, BRASS TACKS, 12 X 9 X 2.5 CM. 23/8761

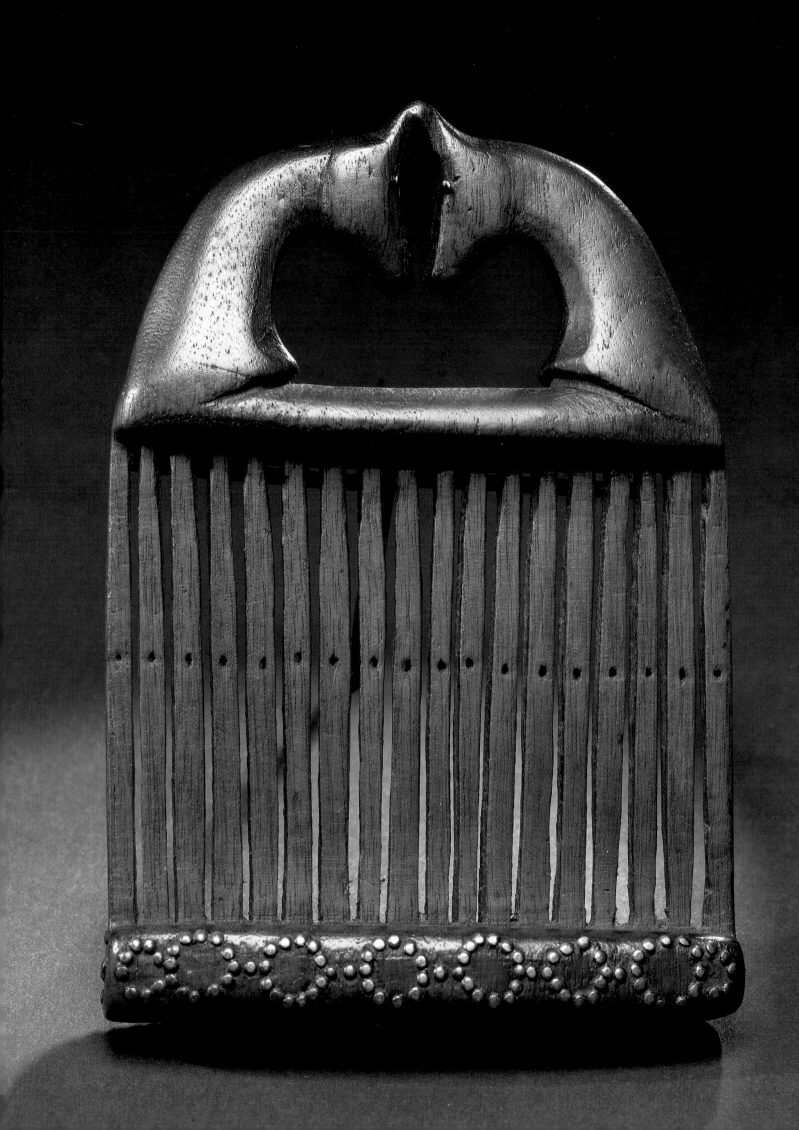

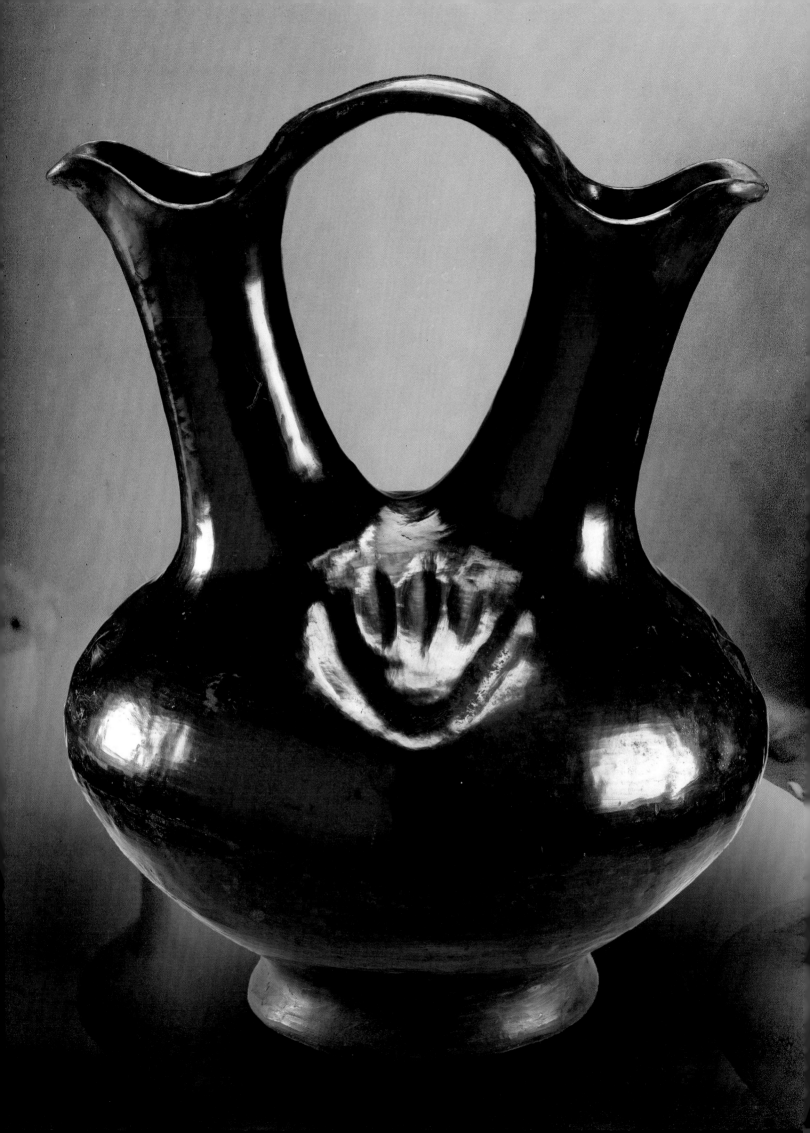

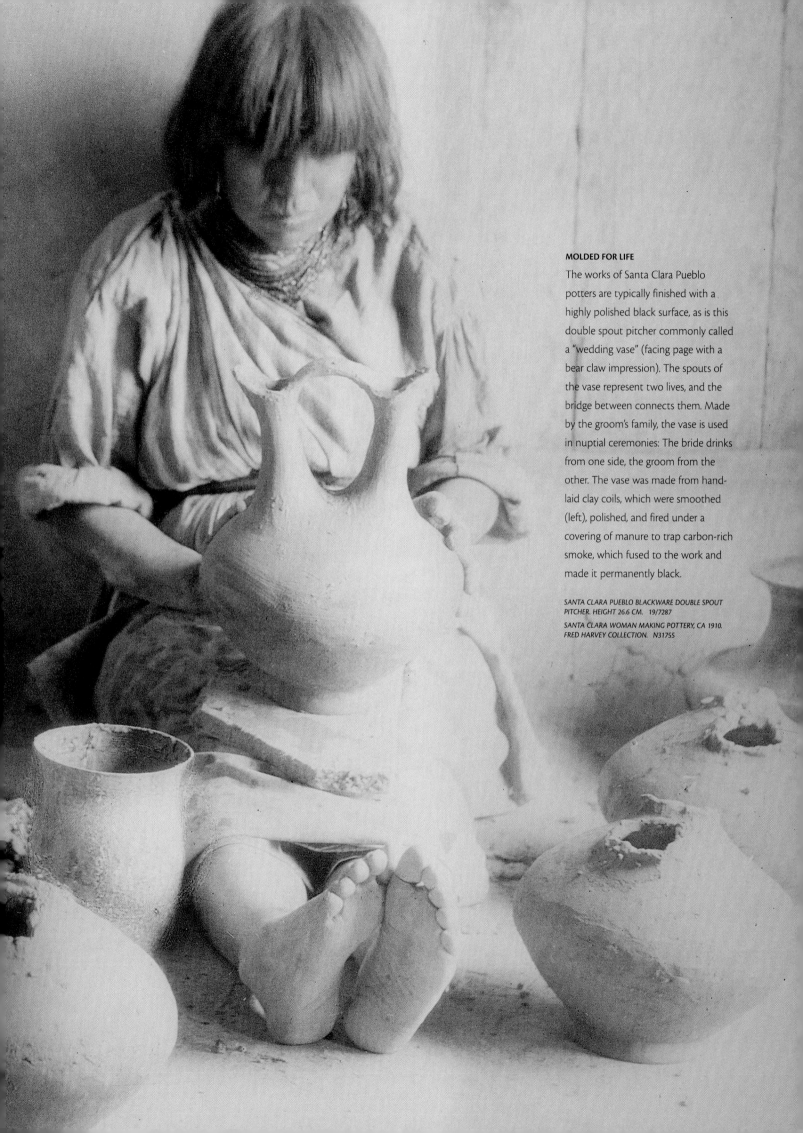

MOLDED FOR LIFE

The works of Santa Clara Pueblo potters are typically finished with a highly polished black surface, as is this double spout pitcher commonly called a "wedding vase" (facing page with a bear claw impression). The spouts of the vase represent two lives, and the bridge between connects them. Made by the groom's family, the vase is used in nuptial ceremonies: The bride drinks from one side, the groom from the other. The vase was made from hand-laid clay coils, which were smoothed (left), polished, and fired under a covering of manure to trap carbon-rich smoke, which fused to the work and made it permanently black.

SANTA CLARA PUEBLO BLACKWARE DOUBLE SPOUT PITCHER. HEIGHT 26.6 CM. 19/7287

SANTA CLARA WOMAN MAKING POTTERY, CA 1910. FRED HARVEY COLLECTION. N31755

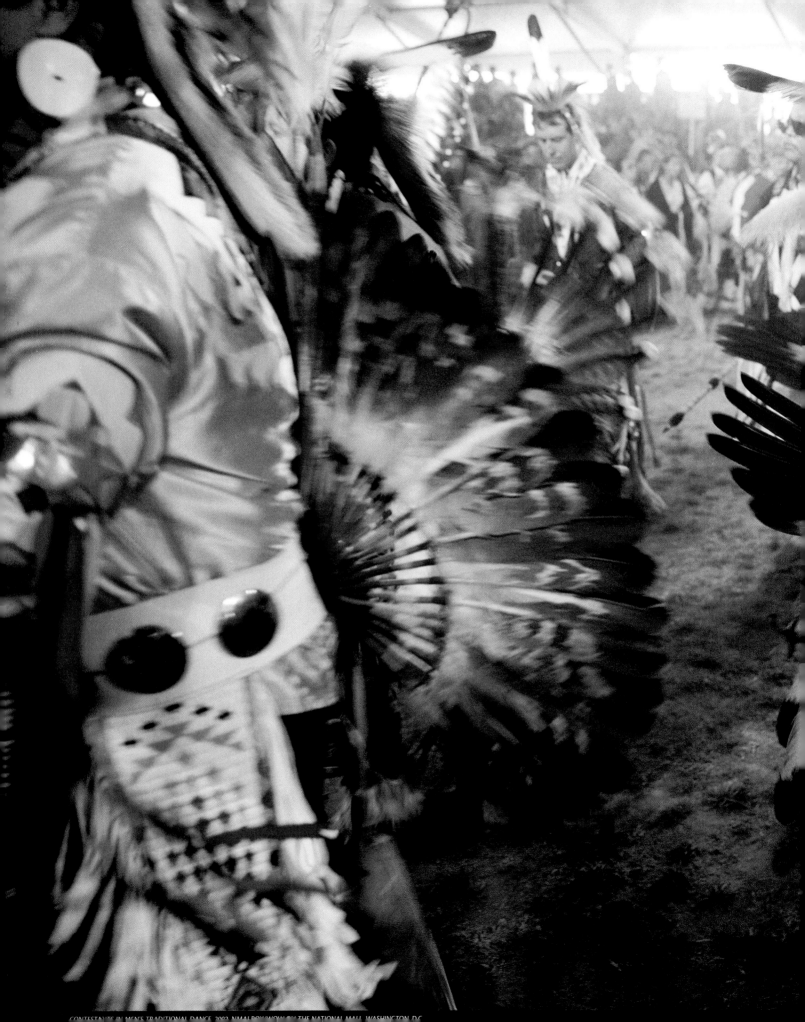

CONTESTANTS IN MEN'S TRADITIONAL DANCE, 2002. NMAI POW WOW ON THE NATIONAL MALL, WASHINGTON, D.C.

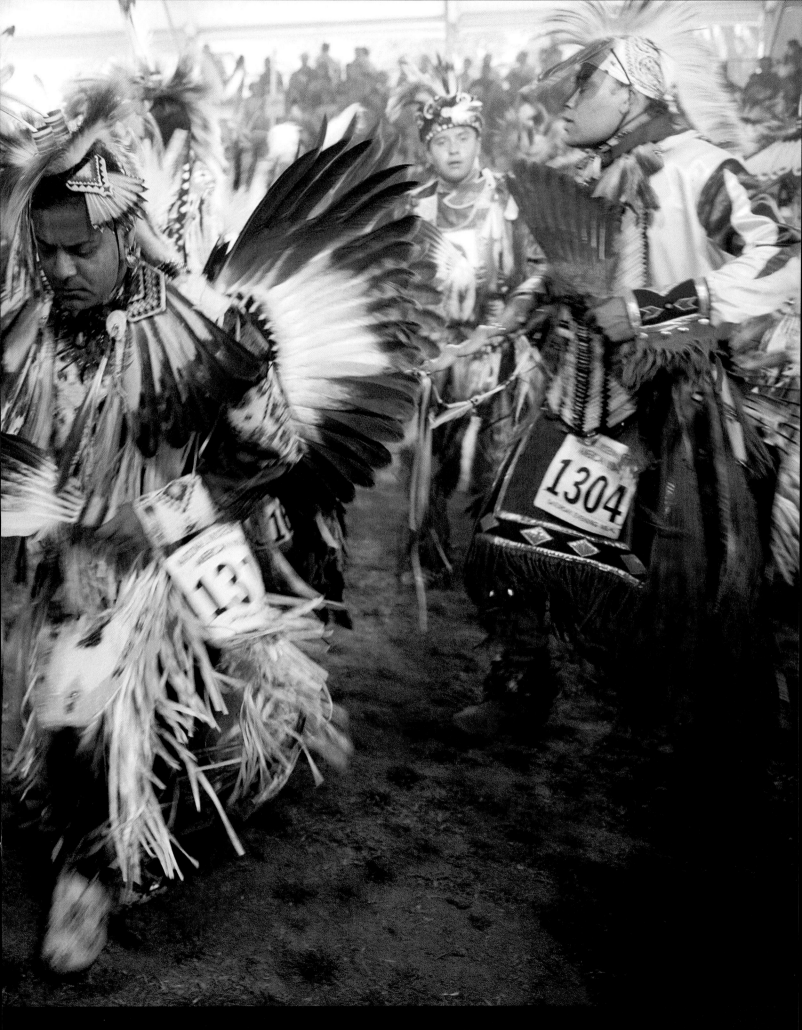

III. OUR LIVES

We persist and insist in living, believing, hoping, loving, speaking, and writing as Indians.

— SIMON ORTIZ *(Acoma Pueblo)*

NEW CIRCLES ARE BRINGING AMERICAN INDIANS TOGETHER IN WAYS unforeseen by our ancestors. Satellites are orbiting Earth beaming information from one end of Turtle Island to the next; telephone lines and fiber optics connect Indian people from the most distant regions of the Arctic, Amazon, Pampas, Caribbean, and Great Plains; and modern transportation systems allow us to gather together and celebrate more often and in greater numbers. Through books, magazines, newspapers, and the Internet, we are getting our messages across about our diverse worlds. Radio and television networks now offer programs that bring American Indian history and cultures into the homes of millions of non-Indian people. And in Canada, the new Native-run Aboriginal Peoples Television Network broadcasts throughout the country twenty-four hours a day, seven days a week, with the catchphrase, "Sharing our stories with all Canadians."

Like a great swirling hurricane, the circle of Native America has been enlarged and broadened—in many ways enriching us to see and speak with newfound authority. Kiowa writer N. Scott Momaday observes of Native peoples in the United States: "I think the Indian is more secure than he was a half-century ago. He has a much better idea of himself and of the contribution that he can make. He's only two percent of the population, but has an influence much greater than that would indicate."[1] To our credit, this has not homogenized us into the generic Indian that books and movies have depicted in the past; rather, within the Native universe, many unique worlds thrive. American Indians are vibrant, creative, and imaginative people contributing as we always have to society in local, national, and international arenas.

HAZEL MERRITT (NAVAJO) PAINTED HER SATELLITE DISH AS A TRADITIONAL NAVAJO WEDDING BASKET. ANETH, UTAH.

Seneca writer and museum professional Tom Hill speaks of the importance of demystifying ideas about Native peoples: "So often we are thought of as the stoic Indian riding on the plain or riding off into the sunset. That is such a romantic, stereotypical image, the kind that people love—these images help people evade dealing with some of the other social issues of Native identity."[2]

Identity has become increasingly objectified and globalized. For this reason, it has become paramount that we recognize the diversity and complexity that exist within the American Indian world. Indeed, in the last thirty to forty years American Indians have taken tremendous strides in articulating and expressing their identities through language, music, dance, and the visual arts, because of the historic ruptures faced by so many indigenous communities. Profound thoughts are woven, painted, sung, planted, danced, carved, and dreamt into our most common daily rituals. These expressions are not only directed outward to non-Indians, they also speak directly and powerfully to American Indian peoples.

As the indigenous peoples of the Americas, our identity is defined and expressed—tribally, collectively, and individually—in numerous and often contradictory ways. For all of us, our cultural identity serves as the foundation for constructing a life that makes sense in a complex world. Often, we are thought of as having a singular identity as "Indian." This idea, however, obscures the extraordinary variety of our tribal cultures and of our individual and communal experiences. Our identities as indigenous peoples are complex and multifaceted. And as we continue to face many difficult social, political, economic, racial, and environmental issues, our relationships to our families, clans, tribes, and nations anchor us. By understanding our positions and responsibilities, we endeavor to balance fundamental and enduring principles and philosophies—to remember who we are, where we come from, and where we are going. As Taíno editor and scholar José Barreiro points out: "Many times the media superficially portrays Native Americans as in between two worlds or that once a Native American enters the so-called modern world, he ceases to be identified as a Native person. The media portrays this as an either/or proposition, but it's not as simple as that.... Native American culture is a work-in-progress."[3]

Throughout the Americas our social identities continue to alter. In the midst of this change, people still contribute to a community's identity. Like our tribal ancestors who expressed in their daily lives the concept "to do things in a good way," the people of today express this goal in their terms. It is a way to conduct

one's life within the philosophical framework of one's community, to aspire to this ethical ideal. Like a braid of hair, individual identity and community history are woven together with a philosophical system that gives meaning to the world. This braid is the tripartite link among our ancestors, our communities, and individuals.

Our identity has many aspects. Some of our deepest connections are with the places and people associated with home: where we come from; the family that nurtures us; the community that cements its relationships through tradition and ceremony; and the languages we speak. Clan and extended families bind us together as Native people. We take these elements and weave them together into a life that makes sense for us and keeps our cultures alive. Above all, our identities persist as an important part of everyday life against the backdrop of a constantly changing world: We continue to be Indian.

Although American Indian identity has been inextricably tied to place, in modern times this seems paradoxical in that nearly half of all indigenous peoples throughout the Western Hemisphere now live in urban environments. Thus being aboriginal or indigenous, which often meant having a strong association with a historical place, has a different resonance for a modern-day American Indian. These terms are useful, but they can be misleading, in that most, if not all, tribes have always called themselves by some variant of the term "the people," such as: "Exact People," "People of the Longhouse," "Sturgeon People," "Beaver People," "People of the Two Lakes," "Cat Peoples," "Red Earth People," "People of Rabbits," "People of the Sea," and so on. To be tribal, or in other words, to be "the people," alleviates any confusion or contradiction about being tied to place, since it is not unusual for many generations of tribal people to remain "the people," despite living away from their ancestral homelands. This is the reality of the modern Native universe—complex, contradictory, yet sovereign, people.

IDENTITY AS PLACE AND SPACE

American Indian identities continue to be linked to sacred geographical places, geological formations, and reserved lands. Many urban Indians return periodically to these places to reconnect with their people and the land. City residents travel to tribal communities to visit family and friends or vote in tribal elections. Others return to attend sings, ceremonies, and powwows. Many make a final journey home

FAMILY TIES

Framed by roofed houses and illumined by rich colors, four generations of the artist's family look out in the multimedia work titled *Who Stole the Tee Pee Series*. In his art, George Littlechild, a Plains Cree born in Alberta, Canada, offers a powerful exploration of Native identity and heritage.

GEORGE LITTLECHILD (PLAINS CREE, B. 1958). WHO STOLE THE TEE PEE SERIES, 1994. MIXED MEDIA ON PAPER, 103 X 352.8 CM.

(PICTURED FROM LEFT TO RIGHT IN PLATES ONE THROUGH SIX) PLATE ONE: MARY JANE (SISTER), RACHEL (MOTHER), ROSALIE (SISTER), ERMINESKIN INDIAN RESERVE, 1940S. PLATE TWO: MARIE ISABELLA BULL, EDWARD LITTLECHILD (GRANDPARENTS), WEDDING DAY, FEBRUARY 1, 1915. PLATE THREE: JENNY CARDINAL, ALEXANDER LITTLECHILD (GREAT-GRANDPARENTS). PLATE FOUR: PEGGY LOUIS NATUASIS, CHIEF FRANCIS BULL (GREAT-GRANDPARENTS). PLATE FIVE: BETSY SAMSON, HEADMAN LOUIS NATUASIS (GREAT-GREAT GRANDPARENTS). PLATE SIX: MARIANNE SIKAK (SKUNK), CHIEF LOUIS BULL (GREAT-GREAT GRANDPARENTS).

to be laid to rest on ancestral land. The land contains great meaning for many, particularly those raised with knowledge and understanding of sacred places. When we return to these lands, we rejoin our people—past and present—and the unseen forces that are part of our being. When prayers and ceremonies begin, many will utter, "To all my relations," evoking the plant and animal worlds, the animate and inanimate.

In a very real sense, the land is a source of healing for some Indians. Healing landscapes dot the four corners of the Earth, and people go to these places to think, sing, and pray. Navajo journalist Valerie Taliman points out that special "places in the natural world—mountains, rivers, forests, springs, canyons, mineral deposits, rock formations, echo canyons, lava tubes, craters, and areas where spiritual events occurred or medicines grow—are among the sites sacred to Native peoples."[4] Some of these places are on reservations; others are not. Many are no longer under Native control and are endangered by coal mining, timber harvesting, oil drilling, metal extraction, and rock climbing. Native communities leading struggles to protect their lands are joining forces with tribal leadership, conservation groups, and social justice organizations to secure sacred sites and religious freedom.

Ba Whyea (Blue Lake), cradled in a deep, forested mountain valley, is an ancient sacred site for the Taos Pueblo community in New Mexico. According to oral tradition, the Taos tribe was created out of its sacred waters. After the United States government appropriated Blue Lake and the surrounding area and placed it under the control of the Forest Service—which designated it as a "multiple-use" area for recreation, grazing, and extraction of natural resources—the protracted battle for Blue Lake became a symbol of Native Americans' struggle for religious freedom and protection of sacred land. Decades of protests, lobbying, and appeals ensued. Taos elder Juan de Jesus Romero explained the essential importance of the lake to his people as a place of worship and as an historic site: "If our land is not returned to us, if it is turned over to the government for its use, then it is the end of Indian life. Our people will scatter as the people of other nations have scattered. It is our religion that holds us together."[5] By taking Blue Lake, which is inherently tied to his people's cultural traditions, he argued, the government threatened Pueblo unity and their very identity. After sixty-four years of hard-fought struggle, the United States returned Blue Lake to the Pueblo in 1970.

Despite victories such as the return of Blue Lake and the restoration of Pahto (Mount Adams) in Washington State to the Yakama Nation, American Indians are in continuing battle over our sacred spaces throughout the Western Hemisphere. While rock climbers have free access to Mato Tipi (Bear's Lodge), also known as Devil's Tower, in Wyoming or Mato Paha (Bear Butte) in South Dakota, Lakota are given only a few days out of the year to hold sacred ceremonies, something their ancestors did without constraint. In the 1950s, Iroquois in upstate New York fought to protect more than three thousand graves when the government dammed the Allegheny River. They lost the battle, and the dam created a lake that flooded the final resting place of many of their people. In South America, tribes face a fierce struggle to protect their lands and resources. Videotaping their own actions for protection and for documentation, the Amazonian Kayapo, for example, garnered global support in their efforts to protect their areas of the rain forest. Most notably in

HONORING CHIEF JOSEPH

To remember a renowned leader of the Nez Perce, artist Kay WalkingStick, daughter of a Cherokee father and non-Native mother, created a 36-painting cycle during the mid-1970s. She titled the work *Chief Joseph Series,* and three of the paintings are reproduced below. From left: #29, #14, and #32. Each of the paintings measures 50.8 by 38.1 centimeters; the media used are acrylic, ink, and wax on canvas. WalkingStick's work deals with issues of mixed ancestry, the balance between land and space, and the relationship between the physical and spiritual self.

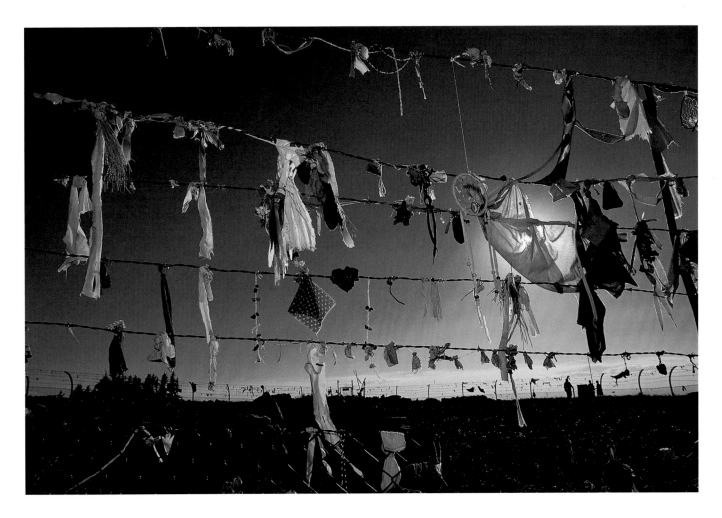

the 1990s, the Kayapo used processions, dances, and chants to demand legal rights and the power to control their own destinies.

The destruction and desecration of sacred and burial sites affect the well-being of American Indians. Many non-Natives cannot comprehend how the health of land, burial sites, and sacred places could influence the health of tribal cultures connected to such a place. American Indians continually point out that the destruction of sacred places puts human beings in jeopardy, because the spirit of the Earth has been harmed.

To save lands important to American Indians, Natives and non-Natives from many walks of life formed the Native American Land Conservancy in 1998. Led by the Twenty-Nine Palms Band of Chemehuevi, the Conservancy negotiated and bought from various non-Native owners 2,500 acres of desert in the Old Woman Mountains, a sacred site and home of former Mojave and Chemehuevi villages. On the preserve—home to the endangered desert tortoise and big horn sheep—cultural preservation and environmental protection are intertwined in a management plan that protects ecological processes while encouraging indigenous ritual and ceremony.

When the Native American Land Conservancy negotiated with representatives of the Presbyterian Church over the purchase, one seller explained that he was unmoved by the purported "sacredness" of the land because it had no meaning to him. He wanted the money for his congregation, and said that since he was dealing with Indians who were members of gaming tribes, he had increased the purchase price. Fortunately, the Conservancy reached an agreement with other Presbyterians and the remaining titleholders, but the views expressed by this official are unfortunately prevalent and an impediment to the preservation of Indian lands.

In past decades, much of Indian activism has moved from the streets to the legal arena. Native Americans have gained sophistication in negotiating—and when

SKY MESSAGES

Material offerings to the spirits from those seeking hope, help, guidance, strength, and wisdom are tied to the fence protecting the Big Horn Medicine Wheel in Wyoming. The wheel is an arrangement of stones on the ground about 80 feet in diameter with 28 radiating spokes. A sacred site to Native Americans, it may have been a kind of calendar that tracks seasonal events such as the summer and winter solstices and spring and autumnal equinoxes.

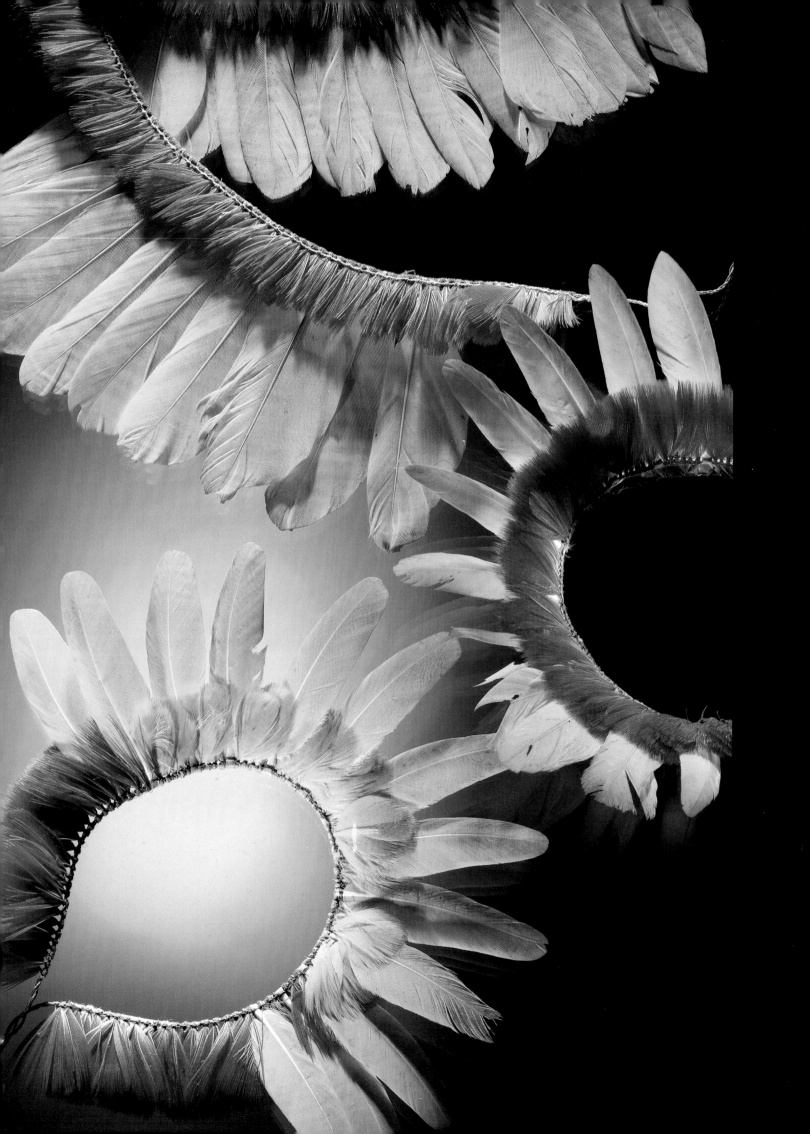

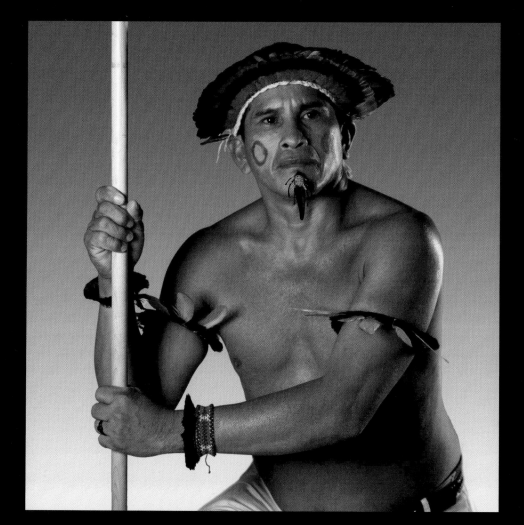

SYMBOLS OF IDENTITY

The headman of the Ka'apor village Xiepihŭrenda, Petrônio Ka'apor, wears the beautiful featherwork made by him, while the headdress (top right), lip pendant (bottom right), and armbands (left) are from NMAI's collections. The Ka'apor use feathers from Brazilian rain forest birds and other natural materials to create splendid featherwork that is worn during ceremonies and to express political and cultural identity. They trace their craft to the teaching of Mair, their creator and culture hero. The fine, elaborated feather arrangements are a sign not only of the skills of the maker but of the status of certain community members. For this reason, the headman Petrônio uses a finely made headdress with several rows of valuable feathers. Usually the village leaders also are the most skillful artisans.

KA'APOR WIRARA (HEADDRESS), HEMBEPOR (LIP PENDANT), AND YIWAPITARUPIHAR (ARMBANDS), CA. 1960.
23/3283, 23/3267, AND 23/3259

necessary, litigating—the legal complexities of land claims, resource disputes, repatriation, and sovereignty.

LAND USE AND ECONOMIC DEVELOPMENT

Lands reserved for American Indians is an old concept that was based on land-cession treaties. Yet much of what American Indians ended up with was unusable land. In some cases, governments forced nomadic tribes to settle in very limited

NEW WAYS AND OLD

Even as snowmobiles have replaced some sleds and dog teams, and polarized sunglasses have arrived, snow goggles of slotted caribou antler and hide lacing (above) will still cut glare and protect eyes from blasting winds. Filmed in the Canadian Arctic, the 2002 film *Atanarjuat—The Fast Runner* marries Inuit storytelling skills with contemporary cinematography in a compelling exploration of the danger of setting personal desire above community needs. The first feature-length fiction film written, produced, directed, and acted by Inuit has won many significant awards.

SNOW GOGGLES, 2002. MADE BY ISSAC PAKAK, IGLULINGMIUT. CARIBOU ANTLER AND HIDE, LENGTH 16 CM. 25/9656

POSTER FOR THE FILM ATANARJUAT—THE FAST RUNNER.

spaces; in other instances, governments recognized no tribal lands. For most of the nineteenth and twentieth centuries, federal governments defined how Indians should use their own lands. Since the latter half of the twentieth century, American Indians have negotiated and exercised a unique form of sovereignty that allows them to take control, deciding for themselves how to use tribal lands.

Today, individual Indians and some tribes own lands in fee simple. Collectively, tribes own reserve lands that the government holds in trust. Through treaties, executive orders, and agreements, Indian tribes hold trust lands today that belong to sovereign Native nations, and the United States recognizes these lands and holds them in trust so that the lands have a special legal tie to the federal government. Neither the tribes nor the government may divest these lands without special agreements. The tribes and the Bureau of Indian Affairs have trust responsibility over these lands. American Indians decide how they will use much of their land, although the Bureau of Indian Affairs, Congress, and federal courts assert their influence over some land-use decisions of the tribes. Furthermore, state and local governments also attempt to influence land use by Native nations throughout the hemisphere. Indian peoples pursue their own agendas regarding their lands, however, believing they have primacy in land-use issues. In recent years, tribes have engaged in many economic enterprises. A number of tribes have developed tourism on their reservations, encouraging non-Natives to visit Iroquois, Cherokee, Lumbee, or Yakama country, among others.

For many years, the Navajo have encouraged filmmakers to shoot movies, television series, and commercials on their vast reservation. Spokane/Coeur d'Alene writer and director Sherman Alexie filmed his groundbreaking movie *Smoke Signals* on the Pechanga Indian Reservation in southern California. In the Canadian Arctic, Inuit filmmaker Zacharias Kunuk created *Atanarjuat—The Fast Runner*, the first all-Inuit directed, acted, and written feature film, which won the

2001 Camera d'Or at Cannes and swept the 2002 Canadian Oscars, including Best Picture. In Inuktitut with English subtitles, the movie melds visually compelling contemporary moviemaking with the richness of Inuit oral tradition as it explores universal human conflicts. Indian people have proven to be creative with their economic developments, drawing on their own expertise.

In the Northwest, Lummi Indians and their neighbors in the Puget Sound emphasize fishing, owning fishing businesses and operating their own aqua farms. Indian peoples throughout the Western Hemisphere living in forested regions have developed lumber industries, hiring their own people to log the forests and mill lumber. The San Carlos Apache, Chickasaw, Lakota, Comanche, and Kiowa are among the tribes that emphasize cattle raising. The Coeur d'Alene enjoy a successful farming enterprise in the rolling hills southeast of Spokane, Washington. The San Manuel launched a bottled water company called Big Bear Water, and other tribes are considering the development of their water resources. Mississippi Choctaw developed electronic manufacturing on their lands, and they have led the way for years in the establishment of light industry. On the Caribbean island of Dominica, the Kalinago (often referred to by outsiders as Carib) have long been proud of their basketmaking tradition. Today, with agriculture in decline, Kalinago sell baskets, woven from a local reed called larouma, and other crafts to tourists throughout their territory. Kalinago Chief Garnette Joseph believes that traditional craft-making not only helps the Kalinago survive—it also reinforces cultural pride within the community: "Tourism encourages the production of crafts, which is one of the strongest aspects of Kalinago identity."[6]

GAMING AS ECONOMIC DEVELOPMENT

In spite of these economic gains, poverty plagues much of Native America. Economic survival remains a critical issue for many tribes. In some instances, economic development among Native American tribes on a large scale has been tempered by the lack of land and water, and the loss of traditional food sources. The Lakota people at Pine Ridge, South Dakota, have encouraged the raising of buffalo through a successful recovery program, while tribes in the Pacific Northwest have initiated salmon restoration programs. New economic opportunities emerged in the 1970s for some tribes after the Seminole of Florida and Cabazon of California led Indian Country into high-stakes bingo enterprises.

In 1979, the Seminole established a bingo parlor with 1,700 seats and $10,000 jackpots. Business proved so successful that they set up more bingo parlors, which significantly helped the Seminole with other economic enterprises, including the eventual building of casinos. The Cabazon of southern California followed suit, and by the year 2000, many other tribes in the United States had established high stakes gaming enterprises that have brought fortunes to a few notable tribes such as the Mashantucket Pequot, Agua Caliente Band of Cahuilla, Pechanga Band of Luiseño Indians, Viejas Band of Kumeyaay, and several tribes in Minnesota. Non-Native gaming interests in New Jersey and Nevada opposed Indian gaming from the start, worried that it would cut into the profits made by companies in Atlantic City, Reno, and Las Vegas. They enlisted considerable political support for their opposition. In spite of the fact that Indian gaming brought thousands of new jobs to Indian Country and the surrounding communities, employing both Indians and non-Indians, and greatly enhancing local economies, it has created opposition and controversy in some quarters.

Some tribes have become rich as a result of gaming, but others continue to struggle economically. Because of the rapid wealth that has visited some Indian

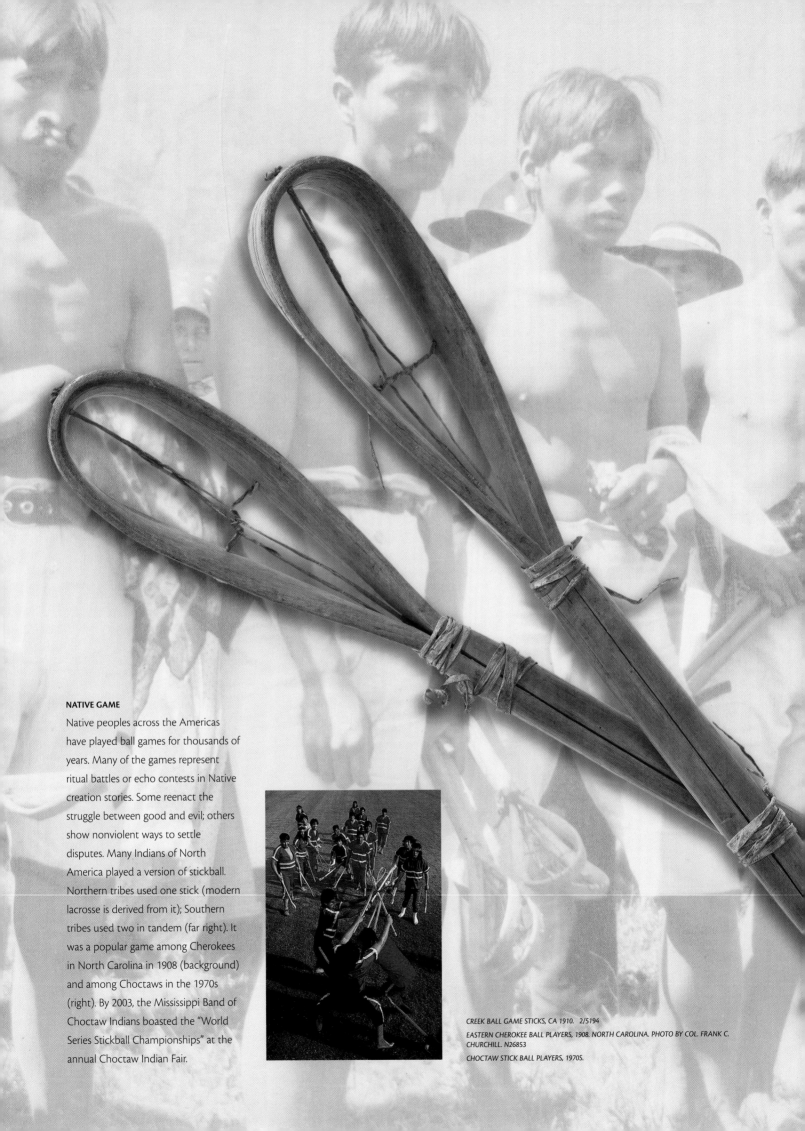

NATIVE GAME

Native peoples across the Americas have played ball games for thousands of years. Many of the games represent ritual battles or echo contests in Native creation stories. Some reenact the struggle between good and evil; others show nonviolent ways to settle disputes. Many Indians of North America played a version of stickball. Northern tribes used one stick (modern lacrosse is derived from it); Southern tribes used two in tandem (far right). It was a popular game among Cherokees in North Carolina in 1908 (background) and among Choctaws in the 1970s (right). By 2003, the Mississippi Band of Choctaw Indians boasted the "World Series Stickball Championships" at the annual Choctaw Indian Fair.

CREEK BALL GAME STICKS, CA 1910. 2/5194

EASTERN CHEROKEE BALL PLAYERS, 1908. NORTH CAROLINA. PHOTO BY COL. FRANK C. CHURCHILL. N26853

CHOCTAW STICK BALL PLAYERS, 1970S.

tribes, a false image of prosperity among all Indians has emerged. But most tribes continue to live at or below the poverty level, and many reservations still lack adequate housing, water, and utilities. Most tribes deal daily with poor roads, inadequate health care, and lack of food. Stereotypes persist that all Native Americans receive monthly checks from their national governments, and that governments give all Indians complete funding to attend colleges and universities. In the United States, the Bureau of Indian Affairs has a scholarship program, but it is competitive and not guaranteed to every Native student. While it is true that a few tribes offer higher education to Indian students through tribal community colleges, students have to pay their own way at most of these schools.

CULTURAL AND LANGUAGE PRESERVATION

Over the years, many Indian people spent a good deal of their time eking out a living, often seeking wage-labor jobs off the reservations. Some had little time to continue cultural traditions or to use their Native languages. Those who lived in towns and cities often stopped using their Native languages, sometimes having no one with whom to speak. Even on reservations or towns located near Indian Country, some parents discouraged the use of Native languages, fearing that such usage would further separate the children from mainstream society and economic or educational opportunities. Native languages fell into disuse and ceremonies declined in importance. Of course this scenario was not universal among all tribes and Indian people, but by the middle of the twentieth century, a cultural crisis loomed in Indian Country. Many Indian communities responded by renewing their interest in preserving their ceremonies, songs, dances, arts, and languages. Native peoples throughout the Western Hemisphere have taken a newly invigorated interest in protecting their unique cultural heritages. As poet Linda Hogan writes, "We are building the future out of the shards of the past; we are now recovering ourselves and reclaiming our traditions."

Tribal elders have long understood the connection between language and culture, so it is not surprising that in recent years tribes have made a special effort to preserve their languages, which are threatened throughout the Americas. Ojibwe scholar Basil Johnson led the way in Canada and the United States to preserve his own language, and his students are now teaching Ojibwe in many parts of Indian Country. Teddy Draper, Sr., a Code Talker during World War II, spent years teaching the Navajo language at Diné College in Tsaile, Arizona. In the early 1980s, Maoris in New Zealand and Native Hawaiians founded childhood language immersion centers known as "language nests," in which students are taught in Maori or Hawaiian all day and study English only as a second language. Mohawks in upstate New York and Canada, and Blackfeet in Montana are among the tribes who have continued and expanded the immersion method of teaching their languages, focusing on children and encouraging them to become speakers and teachers of the language. As Chief Tiorahkwathe of the Kahnawake Mohawk observes, "When I speak the language, I feel as if I have a 1-800 number to ancestry."[7]

Chemehuevi, Quechan, Serrano, and Cahuilla tribes of southern California and Arizona have made a special effort to preserve their languages. One of the most sophisticated and well-funded efforts was launched on the Pechanga Indian Reservation near Temecula, California. In the spring of 2002, the Pechanga Band of Luiseño Indians dedicated some of their proceeds from gaming to fund a large-scale language program. The tribe hired Eric Elliott, a professional linguist who teaches children and adults alike. Indian people in Southern California admire Elliott as a master teacher who speaks Luiseño, Cahuilla, Serrano, and Chemehuevi.

NEW STEREOTYPES

Choctaw artist Marcus Amerman
wrote in part about his 1998 work
Lucky Blanket (facing page): "The
stereotypical 'smiling Indian' images in
beadwork are from apple crate labels
and reflect society's need to
conveniently associate Indians with
casinos and to thus create a new
'casino Indian' stereotype." The growth
of Indian gaming establish-ments has
been controversial within and without
the Indian community. Questions
swirling around ideas about sovereignty,
propriety, economy, exclusion, and
many other subjects persist.

Tecumseh's early 19th-century lament,
which begins: "Where today are the
Pequot?" has one new answer.
As of 2003, the Mashantucket Pequot
of Connecticut owned the world's
largest casino, with 6,400 slot machines,
354 gaming tables, the world's largest
bingo hall, and a "Wampum Club" for
active patrons.

*MARCUS AMERMAN (CHOCTAW, B. 1959), LUCKY
BLANKET, 1998. BEADWORK ON ROULETTE TABLE
COVER, 152.4 X 177.8 CM. 25/7257*

Cahuilla/Luiseño educator Bill Madrigal has joined Elliott in teaching. Parents have taken note, and they are enrolling in language courses so that they can "keep up with their children."

Just as many Indian tribes have made a conscious decision to teach and preserve their languages, they have also encouraged the preservation of other traditional ways. Young members of the Haudenosaunee learn to play *bagattaway* (lacrosse), the ball game for which Iroquoians are so well-known. At one time, Indian groups throughout the Western Hemisphere played ball games, and in recent years, traditional ball games have experienced resurgence. Several tribes have also encouraged young people to learn various forms of stick games, played in many different ways but nearly always accompanied by betting. Native people sing when they play stick games, and elders are teaching youngsters the old songs so they can draw on the power of the songs to win the games. But Indians today play a host of other games common to many of their contemporaries. Indian boys and girls have always distinguished themselves as runners, and they put that skill to good use at baseball diamonds, football fields, hockey arenas, and track and field events. Rodeo, wrestling, rowing, and golf have found their way into the Indian world, a world widened by many kinds of sports. The realm of song and dance has experienced the same broadening and blending. Contemporary Indian people embrace these new sports and arts, but many hold on to the old ones as well, treasuring traditions of our people. As Yakama mother Marilyn Skahan-Malatare wryly observes: "My daughter's got a moccasin on one foot and a tennis shoe on the other. She's trying to balance them out—and at sixteen years old, she's having a pretty hard time."[8]

CONTEMPORARY VOICES

Humor has been used as a survival tool and a means to self-awareness by Native Americans for centuries. Northern Cheyenne artist Bently Spang (see his *War Shirt #2* on page 301) observes, "You see, regardless of how the experts define the function of humor in my culture, the bottom line is we are a pretty darn funny people. Humor has helped us deal with incredible adversity and hardship over the years and is still an integral part of life today. I just can't imagine going back to the Northern Cheyenne res and not being teased and not laughing until my stomach hurts."[9] Faces of Indians on a larger-than-life detergent bottle (see page 294), paint tube, and banana are some of the subjects of Onondaga artist Peter Jones's work. Jones, who studied at the Institute of American Indian Arts in Santa Fe during the 1960s era of social protest, uses the ceramic medium to express Indian humor through everyday items. Native-style humor blends irony, storytelling, and inside jokes in a witty, sardonic mix. Native Americans enjoy telling about the laconic Indian man who, when asked what Indians called America before Europeans arrived, replied, "Ours." Standup comedian Charlie Hill (Oneida), whose film biography, *On and Off the Rez*, limns his path from Wisconsin to Hollywood, lives and works in Los Angeles, California. His riffs on Native American identity combine humor with hard-hitting social commentary. "Then there is the mixed-blood syndrome," he laughs. "I say be proud of whatever you may be. I have a buddy who always brags about his great-grandfather who was Native American and African American. Poor guy. They not only stole his land: they made him work on it for free."[10]

Native Americans have made our mark with sophisticated participation in all areas of contemporary life. Northern Cheyenne Chief Ben Nighthorse Campbell, who is also a noted jewelry designer, serves as Colorado's senior United States Senator, while Spokane/Coeur d'Alene writer and filmmaker Sherman Alexie has captured the literary world with his new take on modern, especially urban, Indian

experience. We are electrical engineers, software designers, research scientists, doctors, geologists, lawyers, professors, and inventors. NASA technology manager Jerry Elliot (Osage/Cherokee)—who was the retrofire officer for *Apollo 13*, helping guide the damaged spacecraft to a safe return to Earth—speaks about Native contributions to science: "I feel it's actually a natural thing for Native Americans because of our relationship to the Earth, our spiritual beliefs, and respect for the Creator's great laws. Science is really just a way of understanding what the Creator has put here…. Take for example the tipi. It's a very aerodynamic shape that can withstand high winds and snow loading, with strong convection heating and cooling properties."[11]

Lori Arviso Alvord, M.D., a graduate of Dartmouth College and Stanford Medical School and now associate dean and assistant professor of surgery at Dartmouth Medical School, is highly regarded for combining high-tech modern medicine with the traditions of her Native American heritage. She titled one of her speeches to a college audience, "Ancient Wisdom for Modern Times." The first Navajo woman surgeon, Alvord began her career at the Indian Health Service in Gallup, New Mexico, near her home community, providing care to members of the Navajo and Zuni tribes. She says that her traditions, rooted in the spiritual, taught her that balance is the key to health. The Navajo belief system "sees sickness as falling out of balance, of losing one's way on the path of beauty. The body must live in harmony with the spirit." In a book about her experiences, *The Scalpel and the Silver Bear*, Alvord recounts how integrating surgical skills with a Navajo approach to healing—"Walking in Beauty"—gained the trust of patients and aided her in the operating room.

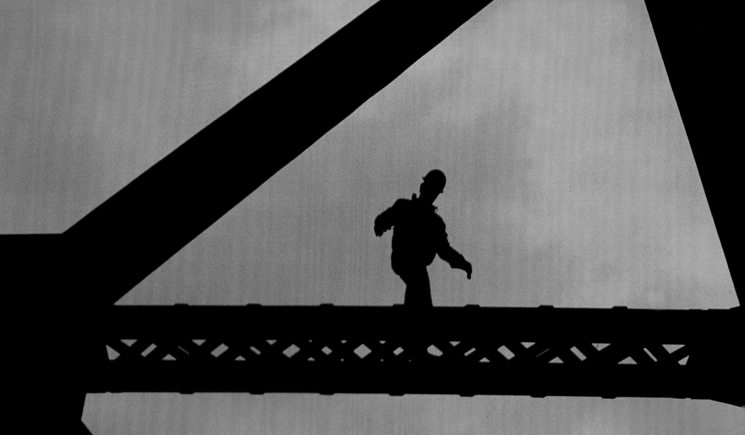

HIGH IRON HEROES

For more than six generations, ironworkers from the Iroquois Confederacy nations have assembled frameworks for skyscrapers and bridges (background). This tough and dangerous work also inspires humor, as in an artist's highly decorated hardhat (above, right). Sometimes the work is much darker. Mohawk ironworkers Brad Bonaparte and Andy Jacobs (above, at right) were crossing the George Washington Bridge on foot when they saw the 110-story twin towers of the World Trade Center collapse in utter devastation. They signed on to help with the emergency, cutting through jumbles of twisted steel so that cranes could remove pieces to let rescue workers advance. They were burned, gashed, and nearly suffocated, but they kept on.

The conscious and highly visible expression of identity is nowhere to be seen as much as in the visual arts. Native artists are trying to make sense of the complexities and contradictions, not only of everyday life in the modern world, but in the Indian world as well. Take, for example, Tlingit James Schoppert (1947–1992), one of the most accomplished and innovative Alaskan Native artists of the twentieth century. Schoppert was simultaneously a painter and sculptor, a poet and writer, an artist whose work was grounded in traditional Northwest Coast and Eskimo art styles but which dazzled the viewer with a modern interpretation of those styles. He once remarked, "I often wonder how Tlingit art would look today if left unscathed from contact with the Western world. The question can't be answered; however, it can, is, and will continuously be pondered. In my work it serves as a departure point."[12] Curator Mary Jane Lenz points out that Schoppert's painting *Another Feather from Moon's Nest* (see page 292) exemplifies his approach—he has used the quintessential Northwest Coast design element, the "formline"—a strong calligraphic sweeping line—but has broken it up into five separate panels. He has eschewed the traditional red and black colors for a brilliant blue. And, in the creation of a complex sculptured panel that is empty of cultural context, he has challenged the viewer to move beyond traditional Northwest Coast art to a new way of seeing the old forms.

In the Southwest, Tony Jojola is one of few Native American glass blowers. Born on the Isleta Pueblo in New Mexico, Jojola began as a potter. He discovered the art of glass blowing at the Institute of American Indian Arts in Santa Fe and furthered his study as a studio assistant to renowned glass artist Dale Chihuly. For his blown glass, Jojola draws upon traditional and ceremonial forms from his Native heritage, "old forms that my culture has respected throughout time," such as the luminous seed jar form that he titled *Lightning Strikes* (see page 288). Jojola also lives the old concept "to do things in a good way." He helped found the Taos Glass Arts and Education program, a branch of Chihuly's Hilltop Artists in Residence program, which helps disadvantaged youth value education, culture, and themselves by way of mentoring and learning the art of blown glass. Designed to serve the community as a whole, a percentage of its artwork sales goes to the artist, while the rest goes to a special fund for local programs, from organic agriculture to preserving the Tiwa language.

The highly original works of Choctaw Marcus Amerman reflect a different reality. He adapts traditional beadworking to new uses, experiments with Pop Art techniques, and injects humor and social commentary into his creations, such as his *Lucky Blanket* (see page 243). "I don't think my work so much displays a style as it does reveal an attitude towards art and creating," Amerman says. "It's like a warrior's attitude towards war, but instead of taking on opponents, I challenge myself with different techniques, materials, art forms, and ideas. When I seek and find that new idea which is both beautiful and powerful, then I take it on, I confront it, fearlessly."[13]

These few artists, thinkers, leaders, and others are only a handful of those today exploring identity and what it means to be Indian; reflections of the burgeoning profiles of tribal nations across the hemisphere as we articulate ourselves within the signs of reclamation and sovereignty. The spirit of the people lives on in a continuing dialogue about the meaning of Native identity in a changing world. As W. Richard West, Jr. (Southern Cheyenne), director of the National Museum of the American Indian, observes about this dynamic element of American cultural heritage, "Native culture sits right at America's beginning point, is very much a part of its present, and will be a part of its future."[14]

Coming Home

By James Pepper Henry

REPATRIATION

The story of how the Bear Clan Hat was eventually made ready by the NMAI for return to the Tlingit people of an Alaskan village and entrusted to village president Joe Hotch (facing page) is told in detail in the text opposite.

JOE HOTCH WEARING THE BEAR CLAN HAT, 1994.

On April 7, 1999, a ceremonial hat in the shape of a bear, carved from a single block of wood, was permanently removed from the National Museum of the American Indian's George Gustav Heye Center in New York City and repatriated to a Tlingit Indian community in Alaska. This stunning object, acquired by the museum's predecessor, the Museum of the American Indian, from a private collector in 1907, was on display in *Creation's Journey*, one of the exhibits that opened the new museum in New York in 1994. Curators had selected the hat not only for its aesthetics, but also for its cultural significance as a powerful emblem of the Bear Clan and its ceremonial importance.

The Bear Clan Hat is known to Tlingit people of the Chilkat Indian Village of Klukwan as *Xoots Shada Koox'* (Bear Crest Hat). This magnificent hat, with glittering abalone shell eyes and ears and eight twined spruce root rings attached to its top, represents the cultural patrimony of the clan, embodying its history, identity, and status. The hat is displayed on ceremonial occasions when the Tlingit community validates the Bear Clan ownership of the crest and thus the clan's existence.

The National Museum of the American Indian (NMAI) had been created in 1989 after a period of activism by Native people who sought a more sensitive, respectful approach to American Indian cultures and their heritage. The same process ushered in laws concerning Native human remains and sacred objects. Public Law 104-278 provides for the repatriation of specific kinds of cultural items in the possession of the Smithsonian Institution to recognized American Indian, Native Hawaiian, and Alaska Native communities that can prove their right to ownership. The Native American Graves Protection and Repatriation Act (NAGPRA), passed by Congress in 1990, mandates that all federally funded museums and agencies repatriate human remains, sacred objects, funerary objects, and objects of cultural patrimony upon the valid request of an affiliated tribe or tribes. Despite hard feelings in the past, repatriation signifies a healing between the Indian and museum communities. In this particular instance, the Bear Clan Hat was removed from the Tlingit community under questionable circumstances that invalidated the museum's title to it. Joe Hotch, a traditional Tlingit house leader and President of the Chilkat Indian Village, requested repatriation of the hat, and NMAI research found

that it was eligible. Prior to its repatriation, Hotch and NMAI agreed to the hat's display in the *Creation's Journey* exhibition. Although the exhibition was extended for an additional two years, it was decided not to delay the hat's repatriation.

Joe Hotch and his wife Georgianna traveled from Klukwan to New York for the hat's transfer ceremony. According to Tlingit tradition, a member of the opposite moiety of a tribe must legitimize the right of possession of an object by witnessing and facilitating its transfer and acceptance. In this instance, Georgianna, a member of the Raven moiety, symbolically took possession of the hat from the museum and presented it to her husband, a member of the Eagle moiety.

The ceremony marked the first time an object had been repatriated directly from an NMAI exhibition to its respective community. Life-size images of Mr. Hotch wearing the hat and performing a traditional Tlingit dance surrounded the hat's display case and presented the perfect backdrop for the day's events.

After a recitation of her lineage and public recognition of the presence of the Eagle moiety, Georgianna Hotch removed the Bear Clan Hat from the display case (and from the possession of the museum) and presented it to her husband, who accepted it on behalf of his clan, moiety, and forefathers. Hotch then explained that his people have waited generations for the return of the hat and that its loss was like "losing a family member." He exclaimed that now his people could rejoice! A grand celebration was planned in his village upon the hat's return. Explaining that the eight cedar rings displayed on the top of the hat represented great deeds of honored past leaders, Hotch said he was humbled by the honor of claiming the hat. "Perhaps a ring will be added to the hat for this occasion," he said.

Joe Hotch then presented an engraved plaque to W. Richard West, Jr., director of the National Museum of the American Indian, in appreciation of the museum's efforts in returning the Bear Clan Hat to his people. Inscribed at the bottom of the plaque are the names of the young men who eventually will become the caretakers of the hat when Mr. Hotch's time has passed. Today, Xoots Shada Koox' is back home in the Chilkat Indian Village of Klukwan, fulfilling its intended purpose as a proud emblem of the Bear Clan, providing continuity of tradition and history to future generations of Tlingit people.

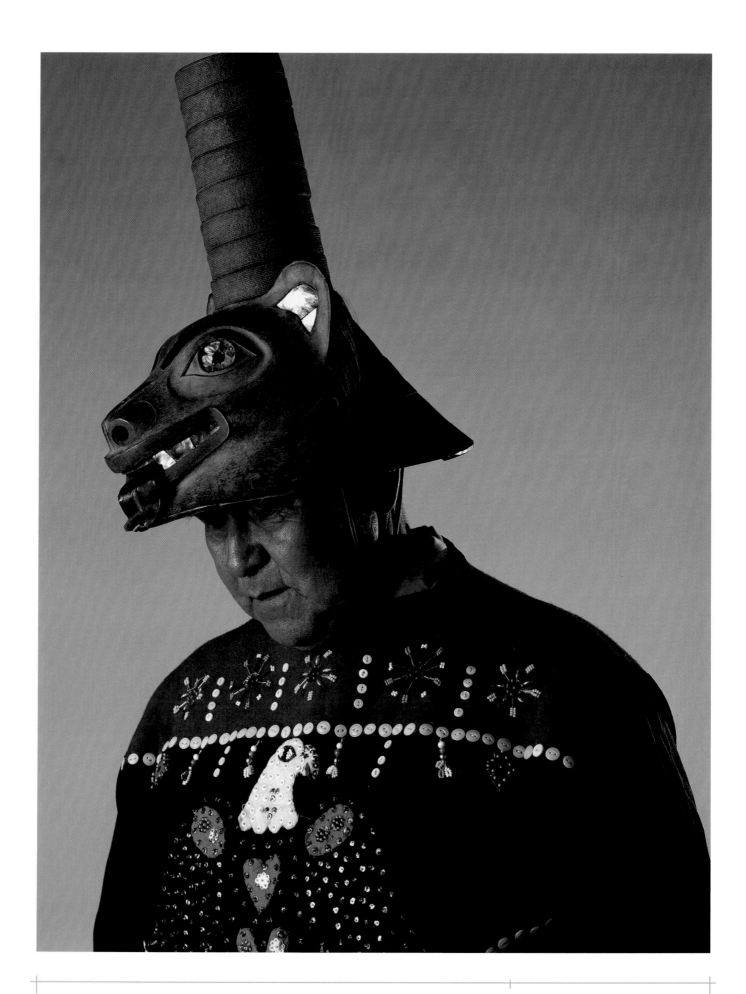

A New Path for the People

Wilma Mankiller

When the Cherokee Nation of Oklahoma elected Wilma Mankiller principal chief in 1987, the combination of being the first woman chief of one of the largest tribes in the United States and her eye-catching name brought her widespread attention. Mankiller is a surname derived from an ancient title given to the person who watched over a Cherokee village—although Wilma once told an impertinent questioner that it was a nickname she had earned! Mankiller spent her early years in a close-knit Cherokee community in rural northeastern Oklahoma. "I saw people helping each other," she recalls, "and not being self-absorbed and acquisitive." She drew on the lessons of her youth to guide the Cherokee Nation. While she served as principal chief, tribal enrollment burgeoned, employment doubled, and the people created new health centers and established programs for children. These achievements led to national and international recognition. In 1993 the National Women's Hall of Fame inducted Mankiller into their prestigious institution, and in 1998 President Bill Clinton awarded her the Presidential Medal of Freedom, the highest civilian honor given to an American. Mankiller tells us about her formative experiences and her personal relationship with the history of Cherokee people. She stresses to Indian people "to put our current work and our current issues in historical context." She invites us to join her during her activism on Alcatraz Island and work on behalf of the Pit River Tribe of northern California. These experiences informed her life, preparing her to return to the Tsalagi, the Cherokee people. As deputy chief and then principal chief, she served with great distinction, conducting the affairs of the tribe in the best interest of her people. Mankiller emphasizes the importance of ceremony, working together, community, land, self-determination, sovereignty, and spirit. She looks to a better day for the Cherokee and all Indian people based on a shared concern for the benefit of others.

WILMA MANKILLER WEARING THE TURTLE SHELLS SHE WORE AT CHEROKEE STOMP DANCES, AS SHE RELAXES BY A SPRING ON HER FAMILY ALLOTMENT IN OKLAHOMA.

WORD POWER

In the early 1800s, Sequoyah (below) developed a system of writing to teach his fellow Cherokee. Based on a syllabary of 85 characters in which each symbol stood for a sound, the system worked so well that within three years about three-quarters of the people were literate in Cherokee. Today, language programs such as that of the Piegan Institute on the Blackfeet Indian Reservation start with an immersion program for youngsters (opposite) to save and expand the use of a language that was rapidly dying. As one boy said, "I can talk with my grandparents now. Before, I couldn't understand them."

COLOR ENGRAVING OF SEQUOYAH FROM MCKENNEY AND HALL'S HISTORY OF THE INDIAN TRIBES OF NORTH AMERICA. PHILADELPHIA: 1837–44. P27706

ADY DAWN DESCENDED ON THE NEAR EMPTY STREETS OF Fisherman's Wharf bearing the gift of a brand-new day. Fishing boats rocked in their slips, awaiting the day's journey, as shop owners sleepily prepared for the onslaught of tourists. An occasional foghorn or the barking of a stray dog were the only sounds other than the steady lap of the ocean against the docks. Alcatraz Island, several miles across San Francisco Bay, was barely visible as I boarded a boat for the former military and federal prison, which had recently been taken over by indigenous people and declared "Indian Land." Mist and fog gave the island a visionary quality that seemed fitting for a place where the American Dream had been found wanting and an Indigenous Dream declared. In November 1969, a number of young indigenous people had taken over Alcatraz and informed the world that attempts to erase them had failed. They clamored for a just society in which treaties, land rights, and tribal sovereignty were honored and respected.

The occupiers of Alcatraz Island claimed that federal surplus lands like Alcatraz should be returned to tribal peoples on legal and moral grounds. This was not the first relationship between indigenous people and Alcatraz. Long before Europeans arrived, Ohlones and other indigenous people of the coast rested and got their bearings on Alcatraz Island, called the Island of the Pelicans (Isla de los Alcatraces) after the sea birds that gathered there. Later, Modocs and other indigenous people were imprisoned at Alcatraz for fighting the United States Army in a desperate attempt to retain their ancestral homelands. When the Spanish first settled in the mid-1700s on the land that is today California, there were more than 300,000 indigenous people living there. That changed very quickly. By 1900, only about 16,000 indigenous people remained. It is a miracle that even that many survived. Indigenous people of California endured widespread violence, starvation, disease, genocide, rape, and slavery. As late as 1870, a few communities in California were still paying bounties for Indian scalps or severed heads. One hundred years later, the progeny of some of the indigenous people who survived the conquerors, miners, and settlers joined others at Alcatraz to find their bearings just as their ancestors had done so long ago.

I was a frequent visitor to Alcatraz during the nineteen-month occupation of the island. At any given time, the Alcatraz community was composed of an eclectic group of activists, Civil Rights veterans, students, and people who just wanted to be at a "happening." Richard Oakes, a visionary young Mohawk who emerged as an early spokesman for the Alcatraz occupiers, said, "There are many old prophecies that speak of the younger people rising up and finding a way for the People to live." (In their own languages, many Indian tribes call themselves by words that mean "the People.") Alcatraz was a catalyst for many young people who would spend their lives forging a new path for the People.

The Alcatraz experience was certainly a watershed for me. The leaders articulated principles and ideas I had pondered but could not express. Anything seemed

possible. Inspired by Alcatraz, I began a four-year association with the Pit River Tribe, which was involved in a legal and political struggle to regain their ancestral lands near Mt. Shasta. Mostly I worked as a volunteer at the tribe's legal offices in San Francisco, but I frequently visited Pit River lands, where I learned about the history of indigenous people in California from traditional leaders. Occasionally one of the leaders would bring out an old cardboard box filled with tribal documents supporting their land claims. They treated the precious documents almost as sacred objects. At Pit River, I learned that sovereignty was more than a legal concept. It represents the ability of the people to articulate their own vision of the future, control their destiny, and watch over their lands. It means freedom and responsibility.

The Oakland Intertribal Friendship House was an oasis for a diverse group of indigenous people living in a busy urban area, far from their home communities. We gathered there for dinners, meetings, and to listen to a wonderful array of speakers, including Tom Porter, a Mohawk leader who spoke about his tribe's fight to remain separate and independent. He explained that the Mohawk's 1795 treaty with the United States, which was commemorated by the making of a wampum belt, provided that they had the "perpetual right to live on their reservations in independent sovereignty, never to be disturbed." Tom Porter also showed a film that depicted women working in full partnership with men to revitalize their community and protect tribal sovereignty. We learned that traditional Iroquois women selected the chiefs and could depose them if they did not perform their duties properly. The film and speech had a powerful, lasting impact on me.

My experiences at Alcatraz and Pit River led me to cofound, with Joe Carillo, California Indians for a Fair Settlement, which encouraged California tribal people to reject a proposed settlement of all land claims for only pennies per acre. All this work helped me to understand more fully the historical context in which we live our

contemporary lives—and it put me on a path that eventually led me home to my own people, the Cherokee.

In 1976, I was further galvanized by a treaty conference at the Standing Rock Sioux Reservation in Wakpala, South Dakota, that readied delegates to the first ever United Nations conference on indigenous rights held in Geneva in 1977. I had been working as a volunteer to help indigenous people prepare documentation for the Geneva Conference showing that many different tribal people, not just the Iroquois, were guaranteed rights to self-governance by the United States. From the time of initial contact with Europeans, tribal communities were treated as separate nations, and numerous agreements between the emerging United States and tribal nations were signed.

At Wakpala, tribal sovereignty was framed as an issue of international significance. The concept of self-determination in international law, as defined by UN General Assembly Resolution 1514, resonates with indigenous people: "All peoples have the right to self-determination. By virtue of that right they freely determine their political status and freely pursue their economic, social and cultural development." I also learned that the United States Constitution, particularly the Bill of Rights, was based in part on the democratic principles of indigenous people. Senator Daniel Inouye, Chairman of the Senate Select Committee on Indian Affairs, later affirmed this during hearings to collect testimony and scholarly work on the extent to which tribal lifeways of "life, liberty and the pursuit of justice" influenced the framers of the U.S. Constitution.

HOLDING FAST

In the early 20th century, Wilma Mankiller's paternal forebears sat for a photographic portrait. Her grandfather John (Yona) sits in the front center, holding Charley, who would become her father. The family was given an allotment in Oklahoma, which it held on to through hardscrabble times and even relocation.

As this history was reviewed at the Wakpala treaty meeting, my thoughts turned to my childhood home on the Mankiller family allotment in Oklahoma. The land was allotted to my grandfather John (Yona) Mankiller just after Oklahoma became a state in 1907. I am grateful that my father held on to the land. There were many lean times when he rejected lucrative offers. The land held deep memories of my family and the first ten years of my life. During my early childhood, my siblings and I gathered water from a cold spring that we shared with bobcats, mountain lions, wild pigs, and an occasional deer. During the day, we spent scant time in the small house built by my father—our work and play was mostly outside. In our isolated, predominately Cherokee community, time was defined by the natural rhythms of the land. Many Cherokee ceremonies, like the Green Corn Dance, commemorate gifts of nature or changing seasons. Even today some Cherokee elders describe events by the time when certain crops are ripe or foods are gathered, rather than by a calendar.

MY PEOPLE—THE TSALAGI

Not long after the conference at Wakpala, my daughters and I loaded a rental truck with our belongings and headed for Oklahoma. Although I wasn't sure what I would do when we got there, I knew it was time to go home. When my father led his family from Oklahoma to San Francisco twenty years earlier, as part of the Bureau of Indian Affairs Relocation Program, he was convinced there was a better life there for his children. After time, we adjusted to life in the city, but never felt whole again until we returned to our land. San Francisco, particularly in the 1960s, was a fascinating place to be—but it was never home.

Soon after returning to Oklahoma, I began working as an Economic Stimulus Coordinator with the Cherokee Nation. I came to the position with absolute faith and confidence in our people and our own ability to solve our problems, and I began developing community programs with that philosophy.

There were no female executives with the Cherokee Nation—and there had never been a female deputy chief or principal chief. In historic times, women played an important role in Cherokee government and in tribal life but that role had diminished over time. In Cherokee traditional culture, it was believed that the world existed in a precarious balance and that only right or correct actions maintained that balance. An important part of the balance was equity between men and women. Women were consulted in matters of importance to the community, the clan, the family, and the nation. Cherokee people trace their clan ancestry through women— when a man married, he took up residence with his wife's clan. Female warriors called War Women or Pretty Women were tribal dignitaries. A woman's power was considered so great—the Great Spirit was believed to send messages through women—that special women were able to declare whether pardon or punishment was to be inflicted on those who offended the behavioral mandate.

As Cherokee people began to intermarry with whites and adopt the values of the larger society, women increasingly assumed a secondary role. When I first ran for election in 1983, it seemed the strong role of women in Cherokee life had been forgotten by some of our own people. There was considerable opposition to my candidacy, but I was elected to serve a four-year term as the first female deputy principal chief in Cherokee history. I thought this was my summit in tribal government, but I was elected to serve as principal chief in 1987—the first woman to lead the Cherokee Nation—and resoundingly re-elected again in 1991. Our people are very

CITIZEN CHEROKEE

The Eastern Band of Cherokee Indians are descendants of those Cherokee who remained in the East after the Trail of Tears. These Cherokee were known as the Citizen Cherokee because they managed to become citizens of the state of North Carolina and were, on those grounds, exempt from removal. Up until the early 1900s, they lived a somewhat isolated existence in the Great Smoky Mountains. The objects from daily life pictured below—a bread mixing tray, cooking jar, and basketry sifter—have a simple elegance of form.

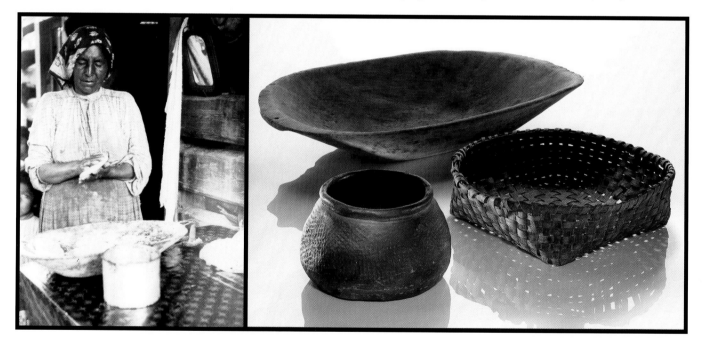

tenacious, and we built on this strength to develop many programs in health, education, and rural community development, and to run our own businesses.

Two years after I was elected deputy principal chief, I had the honor of co-chairing a historic reunion of the Eastern Band of Cherokee from North Carolina and the Cherokee Nation in Oklahoma. Members of the two bands of Cherokee were separated when the entire Cherokee Nation was forcibly removed to Indian Territory in 1838 and 1839. While the majority of Cherokee people reestablished the Cherokee Nation in Indian Territory, tribal members who evaded the removal or

AN EASTERN CHEROKEE WOMAN MIXING CORN BREAD, 1908. NORTH CAROLINA. PHOTO BY MARK R. HARRINGTON. P12181

CHEROKEE WOODEN BREAD MIXING TRAY, CLAY COOKING JAR, AND BASKETRY SIFTER. 18/0490, 20/4387, AND 23/7841

JEROME TIGER, FAMILY REMOVAL, 1965. TEMPERA ON
PAPERBOARD, 25.6 X 13.9 CM. 23/6112

TEARS AND DEATH

Enduring sickness, near starvation, crippling cold, and loss of their ancient homelands, many thousands of members of the so-called Five Civilized Tribes (Cherokee, Chickasaw, Choctaw, Creek, and Seminole) were forced to march westward, without preparation, in the "Removal" that began in 1830. Many died along the "Trail of Tears." Those who lived found themselves jettisoned west of the Mississippi River without supplies or knowledge of the alien land and its resources. The Creek/Seminole artist of the painting reproduced above took that horror as one of his major themes, but had his own artistic career—and life—cut short in 1967 at age 26 by an accidental self-inflicted gunshot wound.

returned to the Southeast formed the Eastern Band of Cherokee. At the 1985 reunion of the two bands, we met at Red Clay, Tennessee, on the very spot where our ancestors had met more than 150 years earlier to engage in a wrenching debate about the removal issue. It was an emotional experience that once again reminded us of the terrible confluence of events that led the United States Army to round up our people like cattle, hold them in stockades in the Southeast, and drive them hundreds of miles to Indian Territory. In order to understand the contemporary issues we're dealing with today—and how we are digging our way out—you have to understand a little bit about history.

THE TRAIL OF TEARS

There were many precipitating factors for the Cherokee Removal, including racism and greed. However, states rights advocates, including leaders of the infant State of Georgia, were the strongest proponents of Cherokee removal. Though Georgia had developed within the historic boundaries of the Cherokee Nation, state leaders bitterly resented the presence of this separate, sovereign entity. Nevertheless, on July 26, 1827, the Cherokee people adopted a new Constitution that, among other things, proclaimed complete dominion over tribal lands in Georgia, Tennessee, North Carolina, and Alabama. White Georgians were enraged by what they considered to be the impudence of Cherokee claims. Even as Georgia leaders pressed for federal legislation to remove the Cherokee, the new State of Georgia passed a series of anti-Cherokee measures—including one that nullified all Cherokee laws, confiscated Cherokee property and gold, and prohibited Native people from testifying in court. In anticipation of the federal removal legislation, Georgia leaders also provided for a survey of Cherokee land and a lottery to distribute that land to white Georgians.

Angry Georgians found a vigorous champion of states rights and Cherokee removal in Washington, D.C., in the person of President Andrew Jackson, who took office in 1829. Jackson soon urged the passage of legislation to enable removal of the Cherokee Nation and other Southeastern tribes. After bitter debate, Jackson's Indian Removal Act of 1830 passed by a narrow margin despite opposition by noted

political leaders like Daniel Webster and Davy Crockett. The Removal Act authorized President Jackson to establish districts west of the Mississippi to exchange for Indian-held land in the Southeast.

Cherokee people overwhelmingly opposed the Removal Act, refusing to leave their homelands voluntarily. With no authorization from the Cherokee people, a small band of pro-removal Cherokee people signed the Treaty of New Echota agreeing to the land exchange, and in 1838, the United States Army began the process of forcing Cherokee people from their homelands to Indian Territory. By the time the removal ended in April of 1839, approximately 4,000 Cherokee people—almost one-fourth of the entire Cherokee population—had died either while being held in stockades or during the removal process, which was conducted in all seasons, including the cold winter months and the extreme heat of the summer. Because of the devastating toll in lives and land, the Cherokee Removal is often referred to as the Trail of Tears or the Trail Where They Cried.

REBUILDING THE CHEROKEE NATION

What gives me hope and strength is to remember how our people—reeling from terrible losses and separated from everything familiar to them—created life anew after the Trail of Tears. Cherokees in Indian Territory soon began rebuilding their families, their communities, and the Cherokee Nation. They developed a sophisticated judicial system, created an extensive educational system with schools for both boys and girls, printed newspapers in Cherokee and English, and erected beautiful institutions of government that stand today as some of the oldest buildings in what is now the State of Oklahoma. In the early twentieth century, there were a number of unsuccessful legislative attempts to abolish the Cherokee Nation. The Cherokee Nation not only survived, it is thriving. It is the second largest tribal government in the United States with a membership exceeding 230,000. Besides the Cherokee Nation in Oklahoma, there are two other federally recognized Cherokee tribal governments, the United Keetoowah Band of Cherokee in Oklahoma and the Eastern Band of Cherokee in Cherokee, North Carolina.

Though the Cherokee removal story is most often cited, all of the Southeastern tribes—Creek, Choctaw, Chickasaw, Shawnee, and other indigenous communities—were moved forcibly to Indian Territory. Indian Territory was not the only federal land designated as a repository for indigenous people whose land had been taken. Reservations were established in a number of states, often in remote areas. The Navajo have their own story of the Long Walk in 1863 and 1864, when more than 8,000 Navajo and some Mescalero Apache were marched by the U.S. Army 350 miles through the desert to new land set aside for them by the federal government.

SOLVING THE "INDIAN PROBLEM"

After the Removal and Reservation Eras, the United States initiated a number of misguided federal policies designed to solve the "Indian problem," including the 1887 General Allotment Act or Dawes Act that set the stage for breaking up commonly held tribal lands. The Dawes Act and other tribal-specific allotment acts had a profound effect on tribal life. Cherokee people who had always held lands in common were devastated by the individual allotment of lands. By 1990, Cherokee people had less than one percent of the land they had immediately after the Trail of Tears. Another significant federal policy was the Indian Reorganization Act of 1934, which encouraged indigenous groups to form federally recognized governments

OFF TO THE CITIES

The third "R" of Indian policy, after "Removal" and "Resettlement" to reservations, was "Relocation," begun in 1948. Paul C. Billie and his family (below), Choctaw living in Philadelphia, Mississippi, were relocated to Chicago in 1953, five of the 33,446 people moved by 1960 under the program. Enrollment was voluntary, and the aim was to bring Indian families to cities and other employment centers where they could learn skills, prosper, and become assimilated into mainstream American life. Some have cited successes; others felt Indians were encouraged to leave reservations and traditional ways of life without being given adequate training or housing. The program expired in 1979.

PAUL C. BILLIE AND FAMILY, 1953.

(sometimes displacing traditional forms of government), and the Termination Act of 1953 that attempted to abolish some tribal governments.

The U.S. Government also instituted the Relocation Program, an assimilation effort in the 1950s that moved indigenous people from their tribal lands to distant cities, far from their culture, communities, land base, and tribal governments. Administered by the Bureau of Indian Affairs, the Relocation Program encouraged thousands of indigenous families—including mine—to move from their homelands to urban areas with the promise of a better life for their children. Too often, the better life turned out to be a backbreaking minimum wage job and an apartment in a rough housing project. Many of those who were relocated eventually returned to their tribal homelands but others tried to carve out a life in the city. Approximately half of the more than two million indigenous people in the United States now reside in urban areas where they have built impressive community centers in many of the cities that once served as Bureau of Indian Affairs Relocation Centers. These urban indigenous organizations offer intertribal social and cultural events as well as much-needed human services. Many urban indigenous people maintain close relationships with their people and the land, lending valuable support to tribal communities in their continuing struggle to retain homelands and the right to self-governance.

SEEING THE FUTURE

Misperceptions about us abound. Many believe that tribal people still live and dress as we did in historic times, and that all tribal people are alike. When national news agencies requested interviews during my tenure as principal chief, they would often ask if there was a tribal dance they could film or if I would wear tribal dress for the interview. I doubt they asked the president of the United States to dress like a Pilgrim for an interview. More than one visitor to the Cherokee Nation capital in Tahlequah, Oklahoma, has expressed disappointment because they see no tipis or tribal people dressed in buckskin. When these crestfallen tourists ask, "Where are all the Indians?" I sometimes place my tongue in my cheek and respond, quite truthfully, "They are probably at Wal-Mart."

There are more than 562 federally recognized nations, tribes, bands, and villages in the United States, each with a distinct history and culture. Though indigenous people share many common values, there are significant differences between tribal groups. Because of the dearth of accurate information about Native people, stereotypes persist, particularly with regard to spirituality. The myth of a universal Native American spirituality that can be codified into dogmatic religious teachings is perpetuated by self-designated "medicine people" who dream up fanciful notions about indigenous spirituality. There is no all-embracing Native American spirituality. Each community of indigenous people derives its unique spiritual identity from ancient knowledge, stories, and relationships with each other, the Creator, and the natural world around them. Though outsiders sometimes try to replicate discrete practices or ceremonies of traditional tribal groups, they fail to understand the complex belief systems and lifeways these practices and ceremonies represent. Outsiders tend to categorize events or objects, and detach them from their context while traditional indigenous people tend to view things in a more interconnected way. Outsiders often want to explain everything in linear terms. But context is everything. The very identity of traditional tribal people is derived from the natural world, the land, and the community.

Ceremonies are the essence of our culture and existence. The Creator provided ceremonies to remind us of our place in the universe and of our responsi-

OLD WRONG RIGHTED

A dispute over land rights brought a 1993 protest from members of the Siksika (Blackfoot) Nation to the Trans-Canada Highway where the Bow River curves by it and the Sawback Range rises beyond. In September 2003, after three years of negotiations, the Siksika accepted a payment of $82 million to compensate for land that had been set aside for settlers in 1910 without adequate notice. The payment will be put in trust to ensure benefits for future generations.

bilities as human beings. When I step onto our ceremonial grounds and hear the steady sound of turtle shell rattles and the call and response of the ancient songs, the barrier between past, present, and future fades away. I feel connected to the many generations of Cherokee people who have come before me, and to those yet to be born. Among the many different tribal groups in the United States, there are hundreds of ceremonies and rituals commemorating events or acknowledging, even mirroring, certain functions of the natural world or members of animal nations. Ceremonies cement a relationship between the people and the land.

Land is critical to the cultural survival of indigenous people. The land base of indigenous nations ranges from the vast Diné (Navajo) Nation—which spans parts of several states—to some tiny reserves of less than twenty acres. Some tribal governments, like the Onondaga, continue their ancient original form of government, and even issue their own passports for international travel, while some of the California *rancherias* (small reservations) must fight for federal recognition after centuries of outrageous exploitation. Tribal governments are formed in many different ways—some according to ancient tribal traditions, others as an adaptation of ancient governments. For example, some Pueblo leaders are selected by gifted spiritual people while the neighboring Diné Nation selects its leaders by popular vote. In the Cherokee Nation in Oklahoma, the current system of tribal government bears little resemblance to traditional governance, which was a system of semi-autonomous communities. Leaders of all the Cherokee people were necessary only in times of catastrophe or when the people had to defend themselves from an external threat. In Cherokee historic times, no single leader would have the unilateral authority of a present-day principal chief. No matter what form contemporary tribal governments take, the spirit of sovereignty survives, even among those people who have lost much of their ancestral land and rights. Native Hawaiians, in particular, are waging an inspiring battle to retain their rights to some of the most coveted land in the Western Hemisphere. In 2001, Alejandro Toledo became the first Native person to be elected president of Peru. His people, the Quechua, are the decendants of the Inka, and Toledo held his inauguration ceremony at the royal Inka site of Machu Picchu, high in the Andes Mountains. As he speaks about his plans to help Peru's indigenous population,

AGENTS OF CHANGE

The first person of Indian descent elected president of Peru, Alejandro Toledo (top) has said: "It has taken us, my people, 500 years to have this opportunity to finally control the destiny of our nation." Ojibwe activist Winona LaDuke (above), candidate for vice president in 2000 on the Green Party ticket, rallied support for threatened buffalo of the Yellowstone region. Tohono O'odham Joseph T. Joaquin (above, left) works to preserve his people's culture. He is standing in front of an emblem representing the Man in the Maze, or I'itoi Ki (literally, I'itoi's house). This image symbolizes the O'odham journey through life. I'itoi is the O'odham's Creator, teacher, and "Elder Brother."

Toledo observes, "It has taken us, my people, 500 years to have this opportunity to finally control the destiny of our nation."

Myriad indigenous communities face a daunting set of critical social and economic issues, including double-digit unemployment, poor housing, and epidemic health problems like diabetes. And tribal governments face continual attempts to further erode their remaining rights, often in the United States from their old foe—state governments. The stress between state and tribal governments continues unabated as they grapple with issues of jurisdiction, law enforcement, and taxation.

While the top priorities for each tribal community differ widely, almost all tribal communities share two common goals: to protect tribal land and sovereignty, and to recapture, protect, and maintain traditional tribal knowledge systems and lifeways. Many tribal elders have expressed concern that the traditional values and ceremonies that have sustained us since the beginning of time are now slipping away. In response, some communities have initiated aggressive projects to preserve tribal culture and heritage. The Blackfeet have started a number of highly successful language immersion programs; the Onondaga School teaches tribal history and language; the Hopi Foundation works to protect ancient tribal knowledge and structures; and the Cherokee language is taught in many communities, in language immersion programs and the Cherokee Nation Head Start Program.

More and more, we are beginning to trust our own thinking and look within our own communities for solutions to entrenched problems. In response to the shocking number of indigenous people who do not complete a course of higher education, Native Americans have developed an extensive system of tribal community colleges. Tribally controlled community colleges have made a profound difference in the overall educational attainment level of tribal people. Tribal communities and governments are running their own enterprises, health clinics, and hospitals; certifying their own foster homes; handling their own adoptions; negotiating their own leases; and taking charge of their future. The American Indian Science and Engineering Society, started by indigenous people, has produced Native scientists, physicians, and other professionals while reinforcing the value of traditional knowledge. The Institute of American Indian Arts in Santa Fe has spawned several generations of award-winning artists who are reshaping the image of indigenous people. Indigenous journalists, filmmakers, museum curators, historians, and educators are destroying age-old stereotypes of indigenous people as either mystical children of nature incapable of higher thought or bloodthirsty pagans.

I am often asked why I remain optimistic about the future of indigenous communities and governments given the litany of social and economic problems we face. As always, we need only look back to the past to see our future. We have endured war, removal, loss of land, resources, and rights, and wholesale attempts to assimilate us—and yet we continue to have strong, viable indigenous communities. If we have managed to hold on to a robust sense of who we are despite the staggering amount of adversity we have faced, how can we not be optimistic? After every major tribal-wide upheaval, we have almost had to reinvent ourselves as a people—but we have never given up our sense of community, of clan, of family, of nation. Despite everything, we rejoice in the knowledge that ceremonies given to us by the Creator continue, the original languages are still spoken, and our governments remain strong. We acknowledge the hardships of the past without dwelling on them. Instead, we look to the future with the same faith that kept us together thus far. The Mohawk speak for all when they say, "It is hard to see the future with tears in your eyes." With no tears in our eyes, we accept our responsibility to make sure the unborn will always know what it means to be descendants of the original people of this land called America.

Deer Dance

By Linda Hogan

This morning
when the chill that rises up from the ground is warmed,
the snow is melted
where the small deer slept.
See how the bodies leave their mark.
The snow reveals their paths on the hillsides
the white overcrossing pathways into the upper meadows
where water comes forth and streams begin.
With a new snow the unseen becomes seen.
Rivers begin this way.

At the Deer Dance last year,
after the clashing forces of human good and evil,
the men dressed in black,
the human women mourning for what was gone
the evergreen sprigs carried in a circle
to show the return of spring.
That night, after everything human was resolved,
a young man, the chosen, became the deer.
In the white skin of its ancestors,
wearing the head of the deer
above the human head
with flowers in his antlers, he danced,
beautiful and tireless,
until he was more than human,
until he, too, was deer.

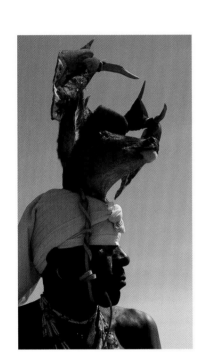

Of all those who were transformed into animals,
the travelers Circe turned into pigs,
the woman who became the bear,
the girl who always remained the child of wolves,
none of them wanted to go back
to being human. And I would do it, too, leave off being human
and become what it was that slept outside my door last night,
rested in my sleep.

One evening I hid in the brush south of here
and watched at the place where they shed their antlers
and where the deer danced, it was true,
as my old grandmother said,
water came up from the ground
and I could hear them breathing at the crooked river.
The road there I know. I live here,
and always when I walk it
they are not quite sure of me,
looking back now and then to see that I am still
far enough away, their gray brown bodies,
the scars of fences
the fur never quite straight,
as if they'd just stepped into it.

One morning last week, an elk stood outside my rural home, frost on one side of him, the other warm against earth where he slept. Often there are deer. We become familiar. One year in Arizona, I was fortunate enough to attend the Yaqui Deer Dance. As a Chickasaw, I am not a part of the knowledge systems of other tribal nations, and there are complexities within each that are shared understandings of the culture. But I do know we all share the underlying understanding that the world is alive and sentient. As Western science now verifies, this is a belief that holds important truths.

While *The Odyssey* of Homer, which echoes in my poem, is considered among the oldest literature in the world, indigenous peoples have literatures, stories, and ceremonies, some at least twenty thousand years in existence. These depend on a longstanding body of knowledge about the natural world and what is now called ecology. We use this to find our own humble place within the larger world. In this place is harmony. Wholeness and balance are valued states of being for Native peoples.

The Yaqui are some distance from the forest, yet in the Deer Dance, the knowledge of the land is significant. The ceremony, as literature, has roots that go back into the long ago, the enchanted world. Enchantment here comes into its true meaning as "incanted." It is song.

Catholicism has been absorbed into the traditions, and the dance begins in front of the Catholic mission. There is a struggle between human evil and human beauty. Flowers are thrown. Clowns appear. Women stand in the center mourning. Then, at night the deer dancer becomes the Deer. He is transformed dancing there, alone, with the little deer head and antlers worn above his head. He dances all night.

The origins of this enchanted world began long ago when a deer was seen coming from the forest with flowers on its antlers, a vision of great beauty. The forest is the place of holiness, where the ancestors lived. Now, this is enacted each year. A song opens the way to retell the enchantment of the world. The song is inseparable from the people, the flower world, and the deer. These are all one: "You, deer, are an enchanted wilderness world, beautiful with the dawn wind."

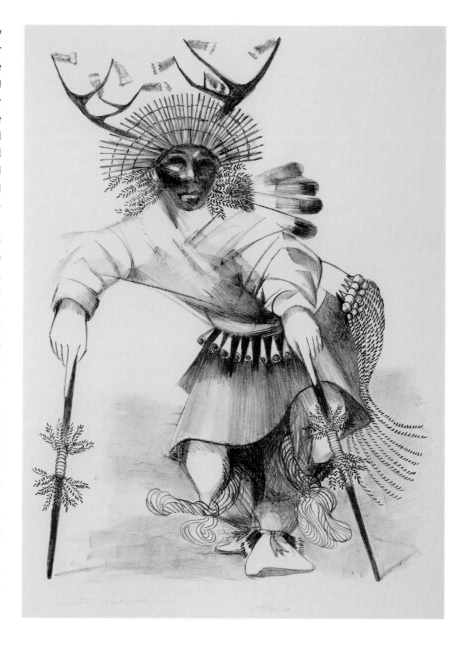

EVOKING THE SPIRIT

Whether a deer dancer is photographed (facing page) or drawn by artist Patrick Swazo-Hinds (above), the intensity and power of the dance shines through.

YAQUI DEER DANCER

PATRICK SWAZO-HINDS (TESUQUE PUEBLO, 1924–1974), CHANT TO THE DEER SPIRIT, 1973. LITHOGRAPH ON ARCHES PAPER (48/70), 76.5 X 56.5 CM. INDIAN ARTS AND CRAFTS BOARD COLLECTION, DEPARTMENT OF THE INTERIOR, AT THE NATIONAL MUSEUM OF THE AMERICAN INDIAN, SMITHSONIAN INSTITUTION. 25/9596

The Radiant Curve:
Navajo Ceremony in Contemporary Life

Luci Tapahonso

Here poet and professor Luci Tapahonso invites the reader into the ceremonial universe of her people, the Diné, or Navajo. "I was born in Shiprock, New Mexico, on the Navajo Nation," she says. "My family and home community have always been a major influence." We must thank Tapahonso for welcoming us into her world, family, and home. She conveys the beauty and meaning of ceremony, and the familial aspects.

Tapahonso introduces us to the Holy People who have great power in the lives of their relatives — Navajo people living today. Navajo stories establish this relationship. In the origin story recounted in the Nightway Ceremony, Talking God asked the Red God, "Do you know who these people are?" When the Red God said he did not, Talking God explained that the people were their kin. The ancient connection is still alive, no matter where the Diné live. This is extremely important in the Native universe, past and present. Although this essay is specifically Diné, ceremony plays an important role in the lives of many contemporary Native peoples. Hopi present their children to Tawa, the sun, placing a small portion of cornmeal into the baby's mouth, saying, "This is what we eat." Many Native people introduce their children to the larger community, including the animals, plants, and special places of their region. Some people take their children into the night to tell them their relatives still live, out there in the Milky Way among the stars. When girls come of age among the White Mountain Apache, they participate in a sacred Sunrise or Na-ih-es (preparing her, getting her ready) Ceremony. Each stage of life is recognized and celebrated, as is the cycle of the seasons.

AS PART OF HER COMING OF AGE RITUAL, CALLED KINAALDÁ, JENNIFER HIGDON RUNS AND YELLS TO SIGNIFY TO THE HOLY PEOPLE THAT SHE IS A NAVAJO WOMAN.

NE FALL AFTERNOON IN 1998, MY DAUGHTER, MISTY, CALLED TO tell us that her infant son had just laughed aloud. It was an anticipated event because when a Diné baby laughs aloud for the first time, a First Laugh Ceremony is usually held. *Shísóí* Isaiah (shísóí means "my daughter's child") had laughed softly before in his sleep, but as a baby, he still lived in the world of the *Diyin Dine'é*, or the Holy People, and this laughter in his sleep occurred when they were playing with him. But he was awake when his father, Lloyd, tickled him and made him laugh. It was meaningful because his laughter showed he had connected thinking with emotion. This relates to the concept of *Nitsáhaákees*, thinking, which is associated with the beginning of creation, childhood, and the sunrise.

THE FIRST LAUGH CEREMONY

NURTURING ARMS

In the First Laugh Ceremony, a Diné (Navajo) medicine woman blesses the baby with corn pollen (below). Whoever makes an infant laugh first must put on a feast, and salt is placed at the foot of the infant to season the feast. Women are cornerstones of Navajo society, and R. C. Gorman's work (facing page) does them honor, for, as he has said, "their infinite variety invites an infinity of interpretations."

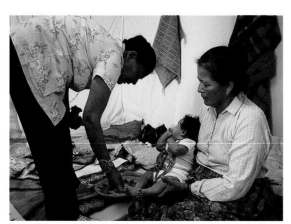

There was much excitement regarding the necessary preparations, as the First Laugh Ceremony is usually held within four days of the first laugh. Since Lloyd had made Isaiah laugh, he would normally be obligated to host the dinner, but Lloyd and Misty lived in an apartment, so the ceremony and dinner would be held at my house, which could accommodate people comfortably. My other grandchildren were giddy with delight; they, too, had had the ceremony when they were infants and now they recalled different details. The house was filled with laughter and cheer as we began to plan, and to issue invitations via phone and notes on friends' doors.

This ceremony, rich with time, was first performed for White Shell Girl, who grew to become Changing Woman, a principal deity who created the ancestors of the present-day Diné. Today the Navajo Nation encompasses more than 25,000 square miles in the states of Utah, New Mexico, and Arizona. Near the center of this land is *Diné Táh*, where the Holy People resided after the emergence.

The current population of the Diné is estimated to be 270,000. Over time, many people left Navajo country for various reasons including kidnappings by the Spanish and other intruders, and escape from enemies. Later, off-reservation boarding schools, the military draft, and government relocation programs became the major basis for the continuing displacements. The change from the traditional Diné lifestyle to a wage economy in the mid-1900s also caused many people to seek employment away from the Navajo homeland.

In spite of these departures, which were often involuntary, many of the venerable and essential tenets that Changing Woman and the Holy People outlined at the beginning have endured. Each time these rituals are performed, specific stories, songs, and prayers accompany them. The First Laugh and the *Kinaaldá*, a coming-of-age ceremony for Navajo girls, are part of the Beauty Way, which are part of the Beauty Way Ceremony.

R. C. GORMAN (NAVAJO), MOTHER AND CHILD, 1972. LITHOGRAPH ON ARCHES PAPER (44/70), 76.3 X 56.6 CM. INDIAN ARTS AND CRAFTS BOARD COLLECTION, DEPARTMENT OF THE INTERIOR, AT THE NATIONAL MUSEUM OF THE AMERICAN INDIAN, SMITHSONIAN INSTIUTION. 25/9597

Although my husband and I were working in Lawrence, Kansas, when Isaiah laughed for the first time, and although my children and grandchildren were in Lawrence also, we consider "home" to be Navajo Country. My family and extended family live in and around Shiprock, New Mexico. Over the years, I've learned that we are truly blessed to have a homeland that composes our strong identity, history, language, and spiritual beliefs. It teaches us the ways of *Hózhó*, or beauty.

For the First Laugh Ceremony, the essential items are *'áshįįh*, natural rock salt, and a *tsaá"*, the ceremonial basket that is used in all rituals. The main event occurs when the baby gives *'áshįįh* and gifts to everyone. A line forms before the baby, and as he or she (with the parents' help) distributes salt and gifts, each person asks the baby to grant a wish. Everyone in attendance, even the children, consumes the salt. In the original ceremony, Old Salt Woman made the White Shell Girl laugh, so she assumed the role of "sponsor"—helping the baby and "directing" the event.

My mother had given me a tsaá years before, and it has always held an honored place in our home. In essence, the designs and colors in this ceremonial basket contain a symbolic cosmos of Diné history, homeland (Diné Táh), and teachings of the Holy People. The center is considered a direct connection to Changing Woman.

My daughters and I communicated via cell phones, and voice and email as we, and at times our husbands, prepared food for the First Laugh Dinner. That evening everything was ready, except for the mutton stew, which would be made in the morning. Because sheep are important Diné symbols of sustenance, prosperity, and kinship, mutton or lamb is served at all events or ceremonies.

HOME MATTERS

Standing in the east-facing doorway of a hogan, the traditional style of Diné home, which always faces the sun's rise, Lillie Joe Hathaley welcomes the day (facing page). Navajo weavers may work in traditional styles or contemporary ones, as in the miniature rugs of Nellie Tsosie (above) with a Christmas theme and of Elizabeth Begay (top), featuring a pick-up truck.

MINIATURE PICTORAL RUG, CA. 1986. MADE BY NELLIE TSOSIE (DINÉ). WOOL, 16.4 X 13 CM. 25/5964
MINIATURE PICTORAL RUG, CA. 1985. MADE BY ELIZABETH BEGAY (DINÉ). WOOL, 13.8 X 11.4 CM. 25/5962
BOTH, INDIAN ARTS AND CRAFTS BOARD COLLECTION, DEPARTMENT OF THE INTERIOR, AT THE NATIONAL MUSEUM OF THE AMERICAN INDIAN.

The children were noisily occupied with making gift bundles—shiny cellophane packages of treats fastened with ribbon. They assumed this "job" because as children, they "just knew" what their little brother Isaiah wanted to give as gifts. (In Diné families, the children of one's aunts and uncles are considered siblings, rather than cousins.) The bundles are an influence from their Acoma grandfather's pueblo, where baskets and pottery filled with gifts are given on feast days. As the children assembled the gifts, they talked about Changing Woman's upcoming visit to our home, as well as the wishes they would request of Isaiah and Changing Woman.

The men brought home bags of fruit to be placed in large bowls and given along with the gift bundles. They prepared a section of the west side of the living room; Isaiah would sit here with his parents. They draped Pendleton shawls over the couches and chairs, and cleared a space for the baskets, which would not be moved from the east wall until the next morning because it is said that the Holy People arrive daily at sunrise from the east. Additionally, it is always mentioned in prayers, songs, and ceremonies that all of creation began in the east.

ORIGINS OF THE CEREMONY

That evening, as we gathered for dinner, we reviewed details. Everything seemed to be on track. Then my husband suggested that I tell the story again of the First Laugh Ceremony. Everyone agreed readily, and we settled in for a session of *Hane'*.

This story, like many others that guide Diné life today, can be traced back to 'ałk'idą̄ą', or the beginning of Diné time. Hane' means "stories," and includes a sense of history (hence "'ałk'idą̄ą'"), but also serves as a signal for people to pay attention. In order for one to grasp the meaning of the story, his or her mental and emotional participation are necessary. Even though 'ałk'idą̄ą' means "long ago" or "of an ancient time," in such stories, the literal date is not questioned because it is understood that aspects of "'ałk'idą̄ą' Hane'" are connected to the time when Diné concepts were being formed. Thus children can understand how events that occurred many centuries ago are important in their own daily lives. On one hand, they will quiet down for a story, as all children will, but they also know that because they are Diné and from specific clans, 'ałk'idą̄ą' Hane' can teach them new things about who they are. The story begins 'ałk'idą̄ą' jiní," which means "long ago they said."

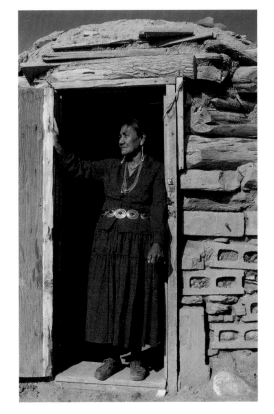

'Ałk'idą̄ą' jiní, long ago they said, Ałtsé Asdzáá, First Woman, and Ałtsé Hastiin, First Man, called upon Asdzaa 'áshiih sání, Old Salt Woman, to come to Dziłná'ooditii, or Huerfano Mesa, where they lived. This is in New Mexico near the place the Diné emerged from the Third World long ago and in the homeland of the Diyin Diné'e, the Holy People. When the Holy People lived here, the principles of Diné thinking, knowledge, and way of life were set and much of 'ałk'idą̄ą' hane' originated here.

'Ałk'idą̄ą', long ago, on this day, Old Salt Woman was called because First Woman and First Man's baby, White Shell Girl, was listless and seemed unhappy. White Shell Girl was the first Diné child, and her parents, as well as the other Holy People, were very mindful of their sacred responsibilities. White Shell Girl would grow up to become the primary deity, Changing Woman.

White Shell Girl was found on a small hill (Gobernador Knob) by First Man, who was guided by her infant cries, as well as the unusual sight of a dark cloud atop a hill on an otherwise clear day. After singing certain songs and offering prayers, he was able to retrieve her and bring her home to First Woman. She was wrapped in the cloud beneath a rainbow drenched in dewdrops, and they said with each breath, "the dawn lifted." White symbolizes birth or the beginning of life for the Diné because "everything came to life" when First Man found White Shell Girl. The songs and prayers that First Man sang as he neared the baby long ago make up a Blessing Way Ceremony to ensure a safe and healthy childbirth. Like the songs of Old Salt Woman, these songs are still used today in raising Diné children.

Much later Changing Woman raised her sons, the Twin Warriors, on Huerfano Mesa. They, too, played crucial roles in the development of the Diné history and beliefs. So each time we have a First Laugh Ceremony or other ceremonies, we demonstrate that her teachings are still important after all these centuries. Regardless of where the ceremony is held, it is a way for us to invite the Holy People into our home and let them know that we remember what it means to be good parents and good relatives.

It is said that the Holy People appear at dawn each morning. After they set the world in place for us, they retreated to live within the sacred mountains: Sisnaajiní (Blanca Peak), Tsoodził (Mt. Taylor), Dook'o'oosłííd (the San Francisco Peaks), and Dibé Nitsaa (the La Plata Mountains). But they did not abandon us; they return each morning to "check on us." Thus we are told to go outside and pray with corn pollen facing the sunrise. The Holy People will offer blessings and gifts for the day. "Get up early and go pray," parents and grandparents say, "so that you can get your blessings. Otherwise, you'll grow up to be lazy and poor."

Today, Diné away from home and far from the sight of the sacred mountains can be comforted by praying at dawn, no matter where they are, and the Diyin Diné'é will acknowledge them because they are within the light of dawn. This is one way that the Holy People know us as their children, and they are grateful that we remember their teachings.

Old Salt Woman was known for her cheerful and generous nature. Once she had

WOVEN BEAUTY

The words *Ye'ii Bicheii* are literally translated as "Grandfather of the Gods," but the anglicization of this expression is used generally to describe all of the masked dancers of the Nightway Ceremony, a curative ceremony that restores harmony. So-called Yeibechai or Yei rugs such as this example were woven as early as the 1890s for sale to Anglos taken with Navajo religion, ceremony, and culture. They became important as a source of income, and controversy still attaches to them because some Navajo believe that a Holy Being does not belong on something made for sale.

DINÉ YE'II BICHEII (YEIBECHAI) TEXTILE, CA. 1900. ARIZONA. WOOL, 232.5 X 107.3 CM. 22/9296

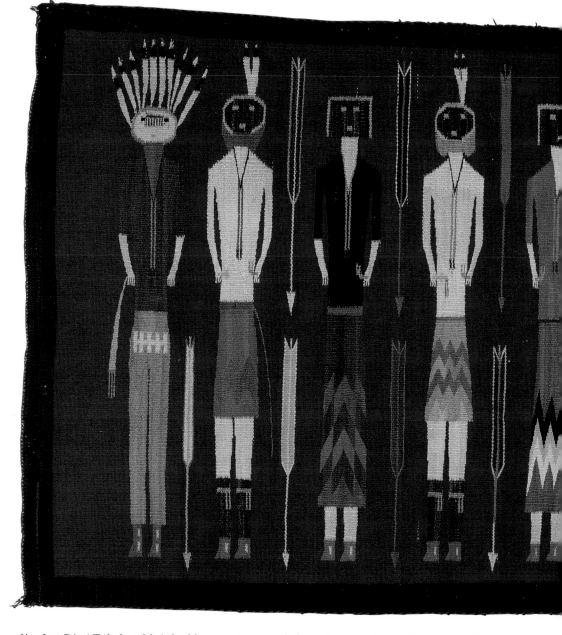

lived at Diné Táh, but felt it had become too crowded, so she moved near the present-day Fence Lake (New Mexico), which was a considerable distance away. They said that as she walked from her home across the many miles to Dzilná'o odłii, or Huerfano Mesa, she created baby songs and lullabies; these songs included gestures, imitations of animals and birds, and other unique expressions. Thus we learn the origin of lullabies and children's songs, and also that traveling songs existed early on. The Holy People gave much thought and deliberation to how babies would be raised: their physical care, the songs that would be sung to them, and the ways they would be talked to.

Meanwhile, there was quite a gathering at the White Shell Girl's hooghan *(hogan or home)*; many people and animals had arrived. At this time, all beings were able to communicate freely and easily. Much food had been prepared and gifts of various crops, fruit, herbs, and miniature replicas of animals and household utensils were spread on a blanket. First Woman and First Man were very thankful for Old Salt Woman's concern and willingness to help. They believed in sharing everything they had and that reciprocity was important to Diné life.

As Old Salt Woman approached from a distance, they could hear her singing, and an aura of happiness and gaiety preceded her. She was wearing a dress created of crystalline grains of salt and seemed to glow with cheerfulness. Everyone smiled when she came into the hooghan, and after greetings and handshakes, she approached White Shell Girl and cradled her carefully. Her eyes glistened with tears as she looked into the baby's face. Her voice rose and fell in lilting, rhythmic songs as she rocked and swayed with White Shell Girl. As Old Salt Woman carried her, she paused at the east side of the

The Radiant Curve

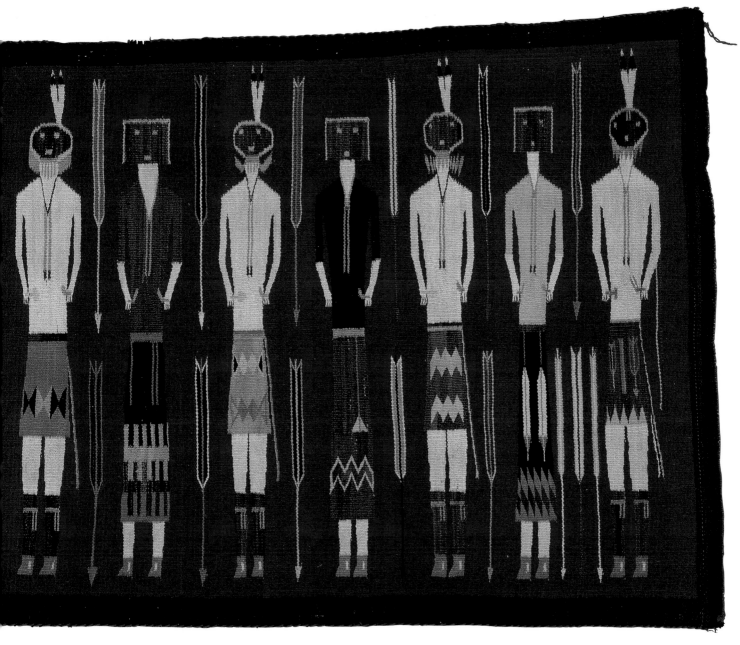

hooghan, and tickled the baby's chin: she said "wooshie, wooshie" (still a Diné way of making someone laugh). Then she put a grain of salt in the baby's mouth, and White Shell Girl laughed aloud—her bright laughter filling the hooghan. Such a radiant sound had never been heard before. This moment became one of the most sacred acts of Diné life because the baby showed her thoughts were connected to feelings.

Everyone was overjoyed, and as the baby beamed with happiness, Old Salt Woman helped her give salt to all who came to the ceremony. Old Salt Woman then told them to ask for blessings from the baby, because she was a holy being, who could grant such wishes. White Shell Girl then gave out herbs, fresh corn, and small clay toys as gifts from the blanket. This ensured she would always be a generous person.

The hooghan was filled with great laughter, songs, and stories as the food was served. As White Shell Girl giggled, kicking and waving her arms about, the First Laugh Ceremony was born; a celebration that ensures the baby's happiness and emphasizes the importance of a sense of humor. At that time, the Holy People decided that all Diné children would be honored in like fashion because until this first genuine expression of emotion, he or she still "belonged to" and lived in the world of the Holy People. The Holy People are involved in the development of the child from conception, and the first laugh marks the first step of her detachment or moving away from this sphere and the beginning of the child's participation in the human family's network. The next step occurs when the child speaks his or her first words.

Many relatives and friends are invited to this event so that the baby will never experience loneliness and will always know that he or she is surrounded by the love and

concern of many. The Holy People said this was necessary so that the baby would know he or she belongs to an extended family and the Diné community.

The ceremony also honors Old Salt Woman because she taught that one needs 'áshįįh, salt, to remain strong and healthy. In fact, medicine man Raymond Jim, who specializes in the Wind Way and Blessing Way ceremonies, teaches that we need nine types of salt to subsist. Old Salt Woman is a role model of Diné ideals: remaining physically healthy, maintaining a positive attitude, and attaining old age.

Sometimes it is suggested that a person who is sullen be given a dose of 'áshįįh salt; this makes members of the Salt Clan happy. But it is also said that Clan people are naturally good-natured and generous—a tribute to 'Asdzáá 'áshįįh saní as she is said to have been the progenitor of the Salt Clan.

The various beings and Diyin Dine'é took part in White Shell Girl's upbringing. They talked to her constantly about all that happened and the nature of her surroundings. She was taught songs and prayers about every facet of daily life: cooking songs, weaving songs, songs to keep animals healthy, songs for fixing one's hair, hooghan songs, songs for bird and other creatures, planting songs, and so on. There are songs associated with most daily activities, and so they remain meaningful. This is why parents are encouraged to talk to their children; it helps to develop the child's sense of identity, and shows how the child is related to her ancestors. Parents are grateful when someone says, "Your child is so well-behaved and respectful; you must really talk to them." In "talking to" a child, our traditional beliefs are passed on in a respectful and spiritual way, much like White Shell Girl was treated. This is connected with Blanca Peak (the sacred mountain in the east), childhood, and the careful deliberation required before undertaking tasks.

This is the basic level of The First Laugh Ceremony. When we listen to 'ałk'idąą' hane', stories from the beginning of Diné time, it shows how much we care about each other, and that we respect and continue to adhere to the Holy People's teachings. They laid out a diagram of life for us, the Diné, to follow, and no matter where we live or what path we undertake, their teachings always guide us.

ROCK OF ESCAPE

In geology it is the remnant of an explosive volcanic eruption that occurred about 30 million years ago. In Navajo mythology it is *Tsé Bit' A'í*, "Rock with Wings." Long ago when the Diné were attacked by enemies, their medicine men prayed for deliverance. The ground began to rise, lifting the people and settling them where the rock now rests. In the 19th century the formation took the name Shiprock for its resemblance to a clipper under sail.

SHIPROCK, NAVAJO NATION, NEW MEXICO.

The Hane' concluded that evening: the second day after Shisoi Isaiah laughed. Our children and grandchildren got up to leave, and they checked everything one more time in the living room. I made certain they all had corn pollen for prayers at dawn. Of course, it is important to offer prayers daily, but even more vital on the day of a ceremony.

After they left, and the house quieted, joyful expectation lingered in the air. I smiled and whispered a prayer of gratitude as I looked again at the gift baskets, the huge bowls of fruit, the rearranged room, the blanket-draped furniture, and the many containers of prepared food. I recalled the First Laugh Ceremonies held for my children, then my grandchildren, and the ways they embodied, perhaps without realizing it, the many qualities that Changing Woman and the Holy People hoped to instill: respect, sharing, and the appreciation of family and kin. This must have been how First Woman and First Man felt, I thought, as they prepared for Old Salt Woman's arrival. They were thankful, happy, and they believed in what the future held for them and their descendants.

SUNRISE AND THE EAST

Early the next morning, though the sun was obscured by thick mist, I stood on the front porch and offered prayers. When my husband, Bob, and I looked for a home in Lawrence, I told the real estate agent that one main consideration was that the front door should face the east. In fact, we did not look at houses otherwise. In each home we have lived, this has always been the case. Even though we live away from Diné Táh, this factor has always been a way to maintain part of the traditions regarding the hooghan, the home.

This concept of the east and sunrise relates to the day when First Man found

the baby who was a "white shell held by glistening mist," and when the Diyin Dine'é created Blanca Peak, along with the other sacred mountains. It is considered the doorway to life, thus Diné homes face the rising sun. All prayers and songs begin with references to Blanca Peak and White Shell Girl, among other aspects, and so one enters a ceremonial hooghan from the east and proceeds in a clockwise pattern. So the proper way to begin any task or project is to start in the east, then south, west and finally, the north.

Today this idea can be applied to cleaning a home, stirring a pot of food, leading a discussion, developing a project, or in this case, preparing for a First Laugh Ceremony.

As Misty and Lloyd greeted people, the grandchildren took turns offering coffee, water, or soft drinks. Shísóí Isaiah was very observant and curious about the attention directed at him. We had purposely arranged the ceremony in the afternoon, after his usual nap, so he would be alert. He shook hands politely with everyone when his parents said, *"Yá'át'ééh diníí"* (shake hands hello). His eyes sparkled, and though he didn't smile readily at the guests, he had an open and thoughtful expression.

After the meal, we gathered in the living room. Since many of the guests were non-Diné, I spoke about the significance of Isaiah entering a new stage of life, and about the origins of the tradition. In an abbreviated form, I talked about White Shell Girl and the intentions of the Holy People. It was important to emphasize how everyone's presence would benefit Isaiah, as well as our family.

A line formed as Isaiah sat on his mother's lap and listened calmly to the various wishes of his guests. Lloyd helped him place salt in their palms and, after they pronounced their wishes, give them the wrapped gifts and some fruit. As each person knelt in front of him, he seemed to assume an air of serenity and calmness. Perhaps as Changing Woman did, he understood what one of his first roles as a Diné entailed.

After this, Misty and Lloyd rose and thanked everyone for their expression of support and caring in their son's upbringing. Isaiah's aunt, Lori, also spoke about the meaning of such events in a child's life. Bob and I expressed our gratitude. As people left, Isaiah stayed with his parents at the door to bid farewell, and as if on cue, when the last guest departed, he began whimpering and wiggling to get out of his father's arms. We laughed, and let his sisters and the other children take him to join in their play.

As we began to clear the kitchen and restore the house to its usual state, we were elated because this ceremony was reassuring in many ways.

Journeys of the Diné

As explained in the Diné story, this ceremony was first performed for White Shell Girl, who grew to become Changing Woman. It was said that White Shell Girl was the first Diné person to have human form. Before she existed, our ancestors journeyed through three prior worlds and did not acquire physical form until after they emerged in the present world—the Fourth World. (In some stories, the present world is referred to as the Fifth World. Variations depend upon the storyteller and

his or her age, dialects in the language, and regional differences.) They were then called the *Nihookáá Diné*, or Earth Surface People, because the Diyin Dine'é decided that this was where the Diné would live. The designation as Earth Surface People is linked with Changing Woman because in some accounts, when First Man found her, she did not actually assume the human form until she was placed in First Woman's arms.

The three worlds through which the original Diné and various beings journeyed before they emerged in northwest New Mexico were characterized by the

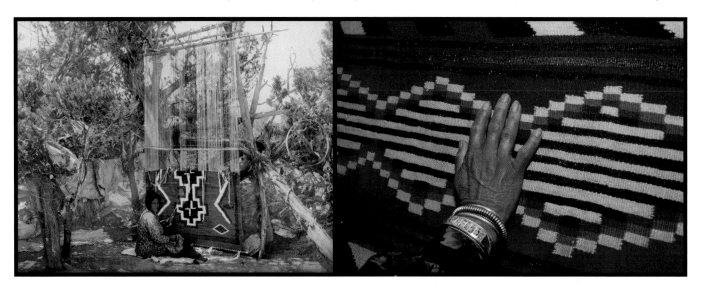

colors of black, blue, and yellow. The journeys were filled with fear, starvation, warfare, and other dangers. Unseen Holy Beings guided the people from each world after they experienced these perils. As they traveled, they realized that their survival, and that of their descendants, depended upon the knowledge and wisdom they acquired in the process. During this time, they attained skills such as toolmaking, food preparation, farming, hunting, and other practical skills. They also learned that having respect for all living things was essential to survival. This early body of Hané comprised the origin of Diné philosophy and teachings, and demonstrates that the ability to remember, to pay attention to details—including place and language—and to be able to relate this information accurately was essential to the people. These accounts also contained symbolism, repetition, and rhythm.

Many of the experiences of the people during this journey shaped aspects of contemporary Diné life. For instance, the origin of the sacred mountains evolved when First Man took a handful of soil as he left each world. And when the group emerged in this world, the Fourth World, First Man had with him handfuls of black soil, blue soil, and yellow soil—the colors of the previous worlds—in his medicine pouch. When the Holy People began to conceive of a home for the People in the Fourth World, they placed the soil in the center of the four mountains that they created to serve as boundaries of the Navajo homeland. Blanca Peak was set in the east and is white (which represents the Fourth World); Mt. Taylor in the south is blue; the San Francisco Peaks in the west are yellow, and the La Plata Mountains in the north are represented by black soil. There are additional sacred mountains, but these comprise the primary four.

ENDURING WISDOM

As White Shell Girl grew, she was fed ordinary food, as well as specific types of pollen that caused her to mature quickly. This is one reason that corn pollen would

later be essential in all ceremonies and prayers: it is considered "the food of the Gods." When she began to menstruate, it was decided that a special ceremony would be held in her honor and the first Blessing Way, the Kinaaldá, was held. There was much rejoicing at the news of this event because it represented the renewal and rejuvenation of the Earth. She assumed the name of Changing Woman.

The Kinaaldá is closely associated with a sacred mountain in the south, Tsoodził, or Mt. Taylor, because of the emphasis on Changing Woman's attire. She was adorned with turquoise jewelry just as Tsoodził was "dressed" in turquoise by the Diyin Dine'é when the mountains were placed. Tsoodził is also known as Blue Bead Mountain and Turquoise Mountain; it symbolizes adolescence when one is at her healthiest and strongest stage. Changing Woman ran to the east each day to reiterate the importance of physical strength and endurance. The *biił* (woven wool dress), moccasins, and jewelry she wore became complex symbols for the history and stories of the Diné.

At some time after the Kinaaldá, her coming-of-age ceremony, Changing Woman became pregnant with twins, whose father was the Sun. Her sons, Born for Water and Monster Slayer, were closely watched and raised at Huerfano Mesa. When they became older, they set out to find their father, who put them through a series of tests to prove their worthiness. During this period, Spider Woman guided them and provided them protection from their father, as well as the various monsters that roamed about. It was said that these monsters were a result of the people's misconduct in the previous world. In the end, the Sun provided the twins with magical tools so that they slew the evil beings, therefore ensuring a peaceful Fourth World for the Diné.

As an adult, Changing Woman became lonely for companionship, so she created humans from her body, and the first four clans came into existence. Today there are more than sixty clans, and all originate from the original four. It is with respect and pride that one introduces oneself by clan because it acknowledges a fundamental link to Changing Woman and to the Holy People.

Shortly after Changing Woman created the Earth Surface People, the Diyin Dine'é decided the time had come for these humans to inherit the Earth. The Holy People left various drawings, primarily at Diné Tah, so that the medicine people would have a source of knowledge, and we would retain essential songs, prayers, symbols, and stories. Changing Woman now resides in the center of the Earth, and the changing of seasons and the stages of our lives remind us that indeed, she is our mother and that all comes to life as she breathes.

The Holy People traveled by means of a rainbow to take their places in the sacred mountains; thus the word for mountain, *Dził*, is very much like *Dziił*, which means "to be strong" or "strength." The mountains reassure us of their presence, but also recall to us that the people acquired strength and endurance during their journeys in the prior worlds, and on our journey in the Fourth World. The mountains serve as literal reminders that, like our ancestors, one can persevere in difficult situations. Since the mountains are images of eternity, attaining old age is a worthy goal. The Holy People set the intricate and complex pattern of Diné life when they decreed that we should live here, but took care to ensure these concepts could be integrated into modern life.

When a rainbow appears after a cleansing rain, we know that the Holy People have returned. When they return, they marvel at the growth of new spring plants, they revel in the laughter of children splashing in the fresh puddles, and like us, they inhale deeply of the sweet, clean air. We understand that a rainbow sparkles with particles of dew, pollen, and the blessings of the Diyin Dine'é. We exist within the radiant curve of their care and wisdom.

LOOMS OF LIFETIMES

Weaving has been for the Navajo more than an art or a trade; it has been threaded deeply into the heart of culture, and it has been a whole-family effort. There are sheep to guard, feed, and shear. Looms must be built (facing page, far left). As weaver Kalley Keams has written: "In the past, weavers made blankets to be worn as clothing, for sleeping…. Today, when I finish a rug, I sell or trade it to provide for my family. My rugs pay for food, college tuition … and the mortgage." The beautiful weavings invite touch (opposite).

NAVAJO WOMAN WEAVING BLANKET. NEW MEXICO. WILLIAM M. FITZHUGH COLLECTION. P12031

HANDS OF RUTH ROESSEL, JULY 1995. NED A. HATATHLI MUSEUM, NAVAJO COMMUNITY COLLEGE, TSAILE, ARIZONA.

Powwow

By George P. Horse Capture

A brilliant sea of color flows into the arena as the Grand Entry begins. Feathers, beadwork, ribbons, and silver flash in the sun. The pulsating rhythm of the drum sounds the heartbeat of powwow, as dancers whirl to its cadence and song fills the air. A celebration of tradition and survival, powwow comes alive each year when Indian communities host powwows across Indian Country.

In the days of the buffalo Indian people, when the primary duty of the men was to protect the tribe, warrior societies developed, each with its own special requirements. Members of these societies wore certain items that represented something significant to them and celebrated their warrior status with powerful songs and special dances. Powwow may have originated in the Heluska society of the Omaha Indian tribe, as warriors reenacted their victories to the proper song and dance step. Their spectacular regalia may have included a roach headdress made of porcupine hair, a breastplate, and a belt of braided grass that eventually changed to a bustle of the sacred feathers of the golden eagle. The dance, known as the Grass Dance, made its way from tribe to tribe, each group altering it in some way to suit their needs and the changing times. Originally steeped in religious beliefs, the powwow was such a colorful and exciting ceremony that it soon spread northward from the Omaha to the Sioux people in the mid-1870s. It extended to their relatives, the Assiniboine

in Montana, then to the A'aninin (Gros Ventre), to the Blackfeet, and beyond.

Over the years, external forces caused massive changes in the Indian world, and people adjusted just to survive. The powwow (said to be a Narragansett Indian word referring to the sacred) took a new form as the people rallied around it as a focus for the concentration of their culture. As powwow increased in prominence, some dances slowly changed in form and name, and the movement also experienced entirely new dances and attire, often the result of a dream or vision. Women and children began to take part. Powwow was often scheduled around July 4th, a date already associated with celebration in the United States. Today most powwows still take place in the summer and have become an important means of cultural expression for the surviving tribes—a place in which we honor our spiritual beliefs and share the triumph of the gathering.

Due to the continuing pressures from a largely non-Indian world, the survival of Native cultural expressions is not easy. While a portion of the Indian population assimilates, others continue their traditional ways by coming together to powwow at least once a year. An increasing number of tribal cultural activities now take place at the powwow, such as holding a pipe ceremony, honoring a veteran or esteemed visitor, having a memorial for a deceased relative, or recognizing tribal people who have distinguished themselves by earning a college degree or other accomplishment. Afternoons are filled with special events such as giveaways or honor dances, which may mark the first time a child dances at a celebration or receives an Indian name.

The powwow is so popular today that it has spread across the country from the Plains area to Europe—it knows no boundary. Every viable Indian community in the Northern Hemisphere sponsors at least one each year. The National Museum of the American Indian sponsored an inaugural powwow on the National Mall in Washington, D.C., in September 2002; thousands attended and took part in the celebration. With feasting, drum music, and dancers representing hundreds of tribal nations in full regalia, it was truly something be a part of and to see. Meskwaki/Diné Larry Yazzie, a powwow champion who makes his living as a baggage handler for Northwest Airlines in Minneapolis, competed in a dazzling ensemble that included black and white lightning bolts painted

POWWOW ON THE MALL

With a Capitol background, Native dancers (facing page) competed at the National Museum of the American Indian's two-day powwow on the National Mall in September 2002, an event shared by 25,000 others. Among the most celebrated dancers, Meskwaki/Diné Larry Yazzie (right) poured energy into the Men's Fancy Dance contest. Known worldwide, Yazzie says that, "Through my dancing and singing, I experience a free spirit, where everyday problems and worries are left behind."

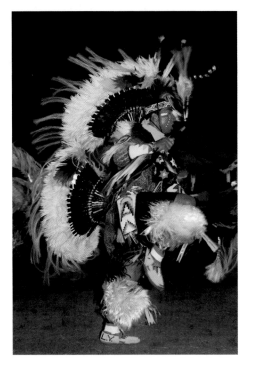

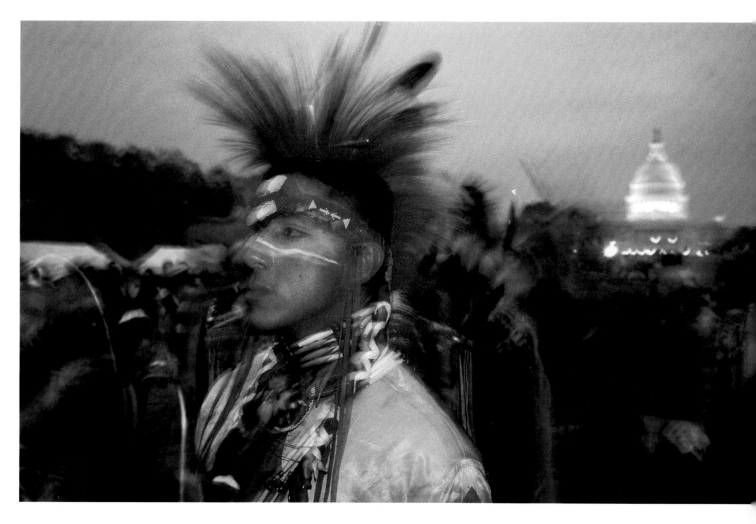

on his face. From a family of dancers, Yazzie attended his first powwow in his home village of Tama in Iowa at the age of four. "It caught my spirit," Yazzie says of powwow.[1]

To me, having this unique Indian ceremony in the midst of a non-Indian world is an extraordinary experience. Being on the scene, hearing the music and vibrant voices, enjoying the beauty in its various forms, and savoring the aroma of traditional foods—fry bread, Indian tacos, corn soup—returns me, however temporarily, to my roots on the Fort Belknap Reservation in Montana where I was born many years ago. Powwow enriches me, and is both relaxing and exciting. It is an honor to don one's traditional dance outfit, lovingly beaded and sewn, and join with your people in the music that sets the Earth in rhythm as we all become a part of the Grand Entry, dancing as one into the arena, sharing our culture.

Led by two veterans, one carrying the Stars and Stripes and the other holding the Indian flag—a buffalo fur-wrapped curved staff, decorated with feathers from the golden eagle—we form a large circle in the entry procession. Like tipis, drums, Sun Dance lodges, and the Earth itself, the dance arena shares in the ancient and sacred Native symbolism of the circle. We move clockwise, first the honored flag bearers and the special guests, then the various dancers. Men compete in such categories as Men's Traditional, Men's Fancy, or Grass Dance. For women, dance categories include Fancy Shawl and Jingle Dress (in which dancers wear costumes embellished with small metal cones that jingle in time to the drumbeat). Dancers perform in a certain dance category and must wear the appropriate attire and dance according to that style.

As we fill the arena we see relatives, friends, new dancers with new steps and attire, and other wonderful things. Amid all of this, if we are lucky, the drum group will sing a special song in a certain way, and the heat, dust, rhythm, pride, heritage, and continuity combine to provide a sense of euphoria as you briefly enter a new height of awareness, knowing that your culture and your ancestors are here as well, "shaking the Earth." Nothing is as grand as this moment. This is powwow.

"The real art occurs in the imagination: then the work begins," says Buffy Sainte-Marie, whose adventurous digital self-portrait animates the opposite page. "The tools are whatever we can get, beads or pixels, hunting bows or a computer." Sainte-Marie, an Oscar-winning American Indian musician, was born on a Plains Cree reserve in Canada, but was adopted by non-Native parents and raised in Maine and Massachusetts. In addition to her visual art and her highly successful career as a singer-songwriter, she established the Nihewan Foundation, a nonprofit organization dedicated to improving the education of, and teaching about, Native peoples and cultures. Groundbreaking artist Fritz Scholder (see pages 185 and 299) did not connect with his Luiseño heritage until he was an adult. "I painted the Indian 'real not red'.... I wanted to get beyond the clichés and the preconceived ideas," he says. Such quests for identity and cultural roots mirror those of Native people throughout the Western Hemisphere today, enacted in arenas that include language, family, place, and self-determination. During a recent rally for indigenous rights, for example, thousands of Native Hawaiians filled the streets of Waikiki, chanting to the accompaniment of blowing conch shells, "*Kū i ka pono. Kū'e i ka hewa!*" ("Stand up for justice. Resist injustice!"). The compelling works in the following pages—humorous, ironic, serene, spiritual, scathing—offer varied views of the diverse realities of contemporary Native American experience, reflecting their creators' beliefs, identities, visions, and responses to the challenge of enormous social and political changes.

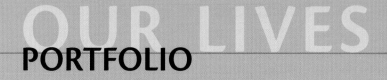

OUR LIVES

PORTFOLIO

New Visions
of the
Ancient World

Inuit artist Karoo Ashevak, from the Canadian territory now known as Nunavut (created in 1999 as a result of the largest Native land claim settlement in Canadian history), was often inspired by traditional stories about creatures from the spirit world. Yet his brilliantly surrealistic sculptures (see a wonderful example rendered in whalebone on the opposite page) reflect a unique vision of extraordinary expressiveness—at times both frightening and humorous—that brought the artist international acclaim before his tragic death at age 34 in 1974. Contemporary painter Carlos Jacanamijoy, born and raised in a valley on the eastern slope of the Andes in Colombia, comes from a vastly different geographical area of the Native world, but his work draws upon cultural roots equally ancient. His tribe, the Inga, were once part of the Inka Empire and still speak Quechua, which was the official language of the Inka state. Works by these and other artists in the following pages offer powerful visions of how the Native past, creatively transformed, lives on.

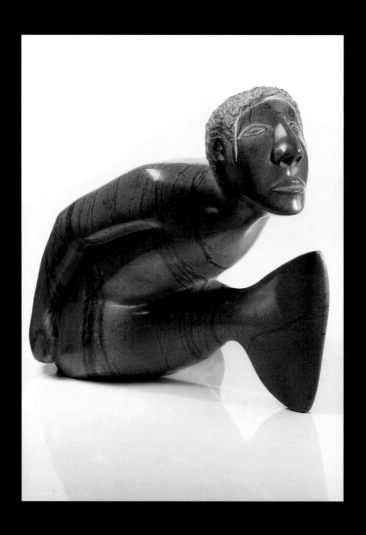

NORTHERN LIGHTS

Themes of shamanism and associated drum dancing and the relation between the physical and spiritual were central to the work of Karoo Ashevak. His *Spirit Drummer* (opposite), with its whalebone form, transported expression, and hands holding removable drum and drum beater, seems at once comic and ecstatic. Pioneering woman sculptor Ovilu Tunnille's *Merman* (top) of mottled green and striped serpentine appears full of animal tension yet contained and thoughtful. The market for Canada's Nunavut art sold through cooperatives generates income from individual expression for isolated communities.

KAROO ASHEVAK (INUIT, 1940–1974), SPIRIT DRUMMER, 1973. WOOD, BONE, STONE, ANTLER, 32.5 X 63 X 53.4 CM. 26/382
OVILU TUNNILLE (INUIT, B. 1949), MERMAN, 1981, SERPENTINE, 41 X 20 X 37CM. 26/384

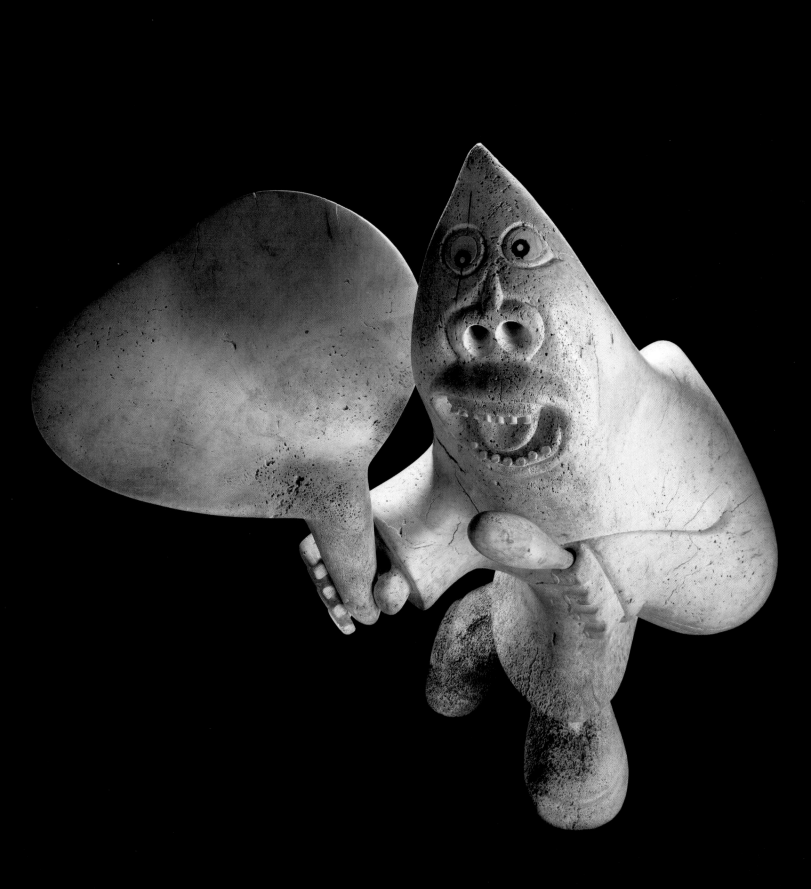

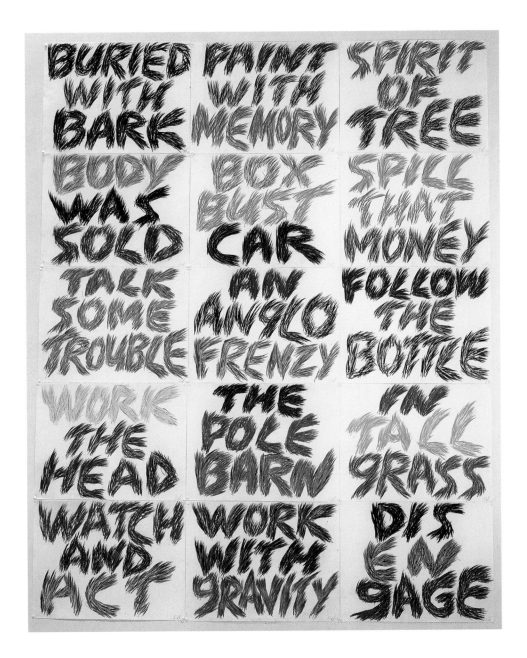

INTO THE STREAM

Transforming conventions of Yup'ik masks, Jack Abraham (Ayap'run) carved *Visions of a Nuclear Future* in 1987 (left). Of unpainted cedar, this mask looks out with an agonized human expression, eyes that cannot see, and a mouth open to speak but mute. One in a series of "Wall Lyrics," the 1993 work *Standing Before You* (above) by Hock E Aye Vi Edgar Heap of Birds speaks in bursts of three-word phrases arrayed in columns or rows, and suggests that the words could also be read as acrostics. The literal becomes an impenetrable code, ending with one three-syllable word: "DISENGAGE."

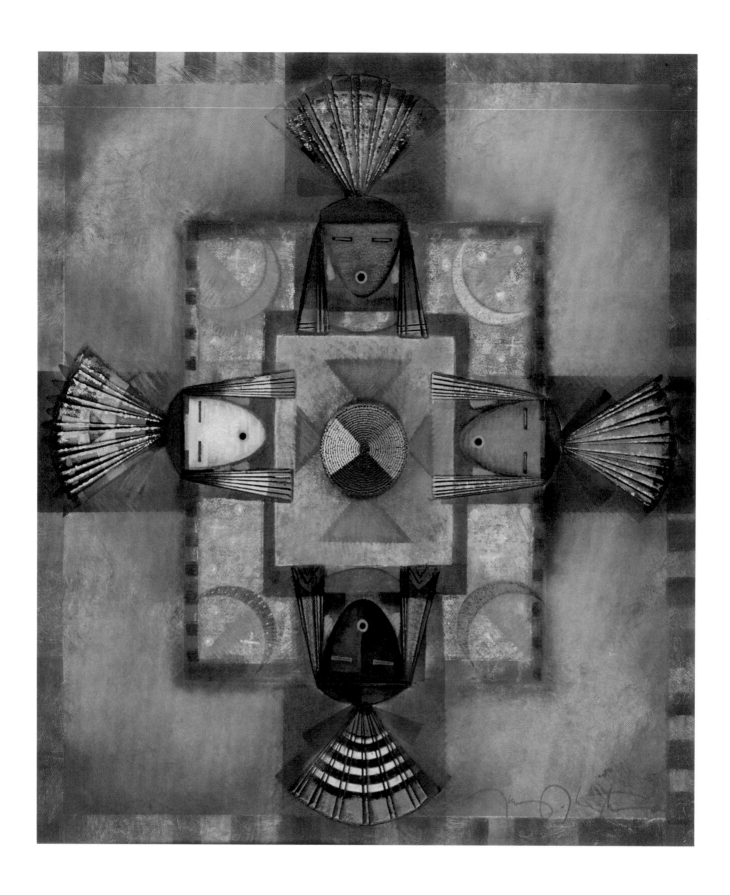

PERSPECTIVES

Many contemporary Indian artists reinterpret old symbols or anneal them into abstract expressions. Navajo Tony Abeyta says of his work (opposite): "[T]his composition is my interpretation of four directional figures representing north, south, east, and west. It also represents a congregation of all peoples from all places." Carlos Jacanamijoy grew up amid the rain forest of the eastern slope of the Colombian Andes with its play of light, birds, and exuberant plants. He says of his technique, as in the painting above: "I am able to find new paths and create, for example, the language of symbols and geometry in the collective art of my people. My pictures flow from the experiences of everyday life."

TONY ABEYTA (NAVAJO, B. 1965), GATHERING FROM FOUR DIRECTIONS, 1999. MIXED MEDIA ON PAPER, 93.7 X 80 CM. 25/4996

CARLOS JACANAMIJOY (INGA, B. 1964), ROSE IN TRIBUTE, 2001, OIL ON CANVAS, 170 X 140 CM. 26/1565

Beauty
Renewed

The works presented here highlight the continuing beauty of Native artistic expression. Tewa/Hopi Dan Namingha, the great-great grandson of the legendary Pueblo potter Nampeyo, trained at the Institute of American Indian Arts in Santa Fe, founded in 1962, whose graduates have played a vital role in expressing self-determined identity, as Indians and as individuals. Namingha seeks to capture the spirit of the land in his own way. In *Blue Door at Hano* (right) he breaks up a scene of buildings from a Hopi village and re-creates the geometric forms, infused with light and color. On following pages, examples of contemporary Native painting, pottery, sculpture, printmaking, and jewelry testify to the resurgence of Native culture. As Namingha observes, "If there is value to my work, it is that I am helping my heritage to survive, not only among my people, but among all people who understand and appreciate beauty."

REALITY REORDERED

It seems like a European Cubist construction, but Dan Namingha's painting (above) is rooted in the kivas and adobe construction of the village of Hano on the Hopi Reservation's First Mesa (see text at left). Frank LaPena's work, such as *Foot Steps* (opposite), incorporates items he picked up while cleaning laundromats at night to help support his art. Those found objects combined with paint "broadened the boundaries of the canvas." This piece suggests the continuum of life, "generations following generations," with the center the universe, the rows of nails progression and evolution, and the animal bones on the left signs of death and mortality.

DAN NAMINGHA (TEWA/HOPI, B. 1950), BLUE DOOR AT HANO, 1979. LITHOGRAPH ON ARCHES PAPER (13/50), 71 X 57 CM. 25/9556
FRANK LAPENA (NOMTIPOM WINTU, B. 1937), FOOT STEPS, 1968. CASEIN WITH NAILS, WOOD STRIP, AND PHOTOGRAPH FRAGMENT ON MASONITE, 61 X 43 CM. 26/1026
BOTH, INDIAN ARTS AND CRAFTS BOARD COLLECTION, DEPARTMENT OF THE INTERIOR, AT THE NATIONAL MUSEUM OF THE AMERICAN INDIAN, SMITHSONIAN INSTITUTION.

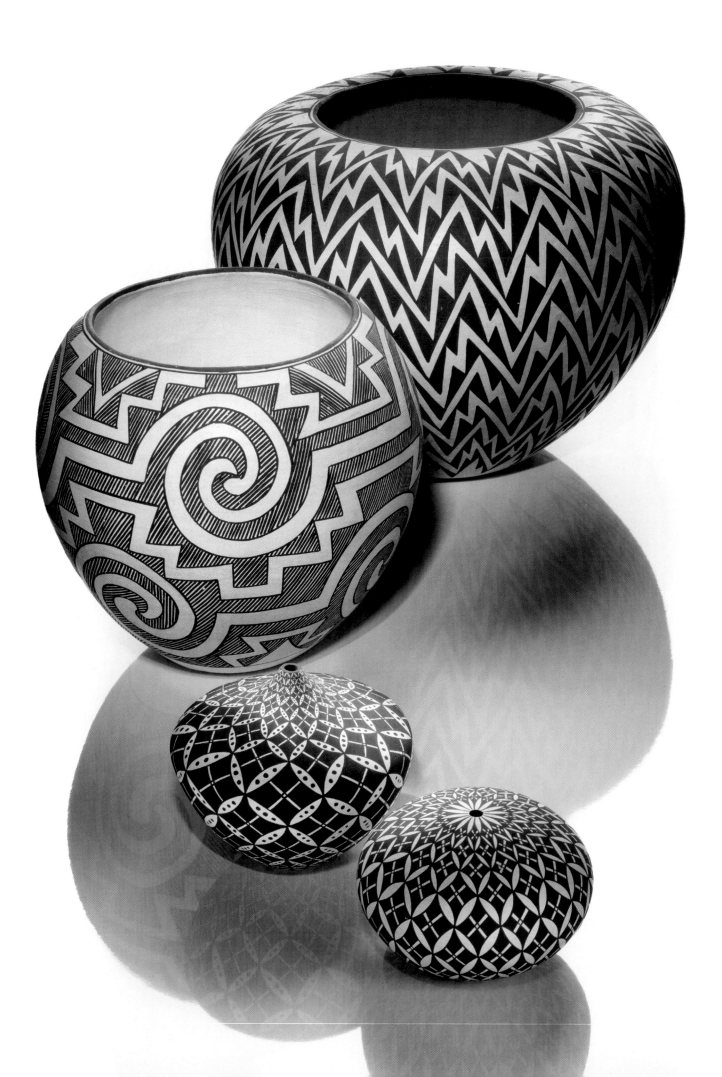

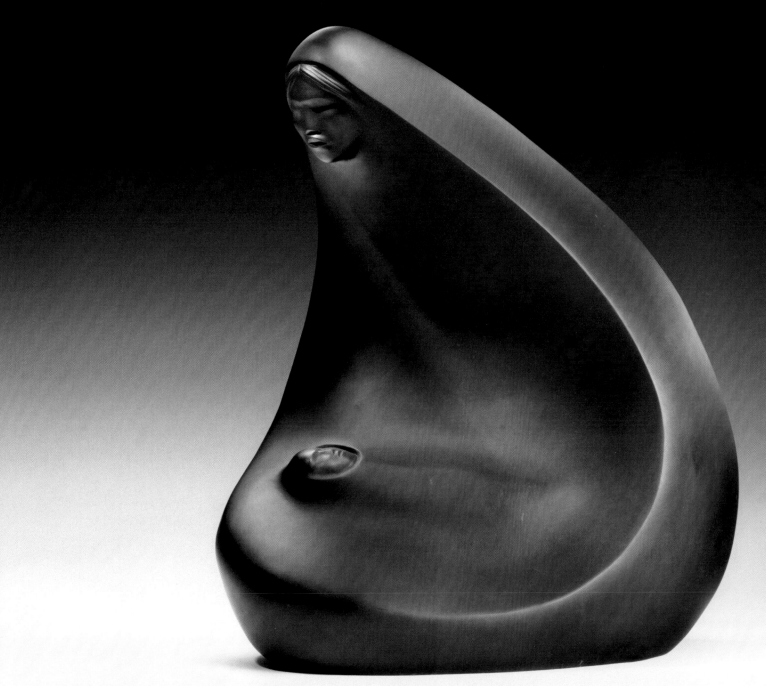

REPRISE AND REPOSE

After World War II, potters from Acoma Pueblo accelerated a revival that had begun in the 1870s of a still older black-and-white style that itself dated to the A.D. 850–1275 period. The work of Lucy Lewis, Marie Z. Chino, and others (opposite) ignited a new movement that spread to hundreds of potters who accepted the old style but added innovations in form and line. Allan Houser is often called the father of contemporary Native American sculpture, and his powerful yet tender *Reverie* (above) makes mother and child one united sculptural form and emotional being.

ACOMA POTTERY (FROM TOP): LUCY LEWIS, 1962, HEIGHT 20.6 CM. 25/5415; MARIE Z. CHINO, 1963, HEIGHT 18.3 CM. 25/8853;
DOROTHY TORIVIO, 1986, HEIGHT 9.3 CM. 25/5816; RACHEL CONCHO, 1987, HEIGHT 7 CM. 25/5817.
ALL, INDIAN ARTS AND CRAFTS BOARD COLLECTION, DEPARTMENT OF THE INTERIOR, AT THE NATIONAL MUSEUM
OF THE AMERICAN INDIAN, SMITHSONIAN INSTITUTION.

ALLAN HOUSER (WARM SPRINGS CHIRICAHUA APACHE, 1914–1994), REVERIE, 1981. BRONZE, 63.5 X 58.4 X 33 CM. 25/7238

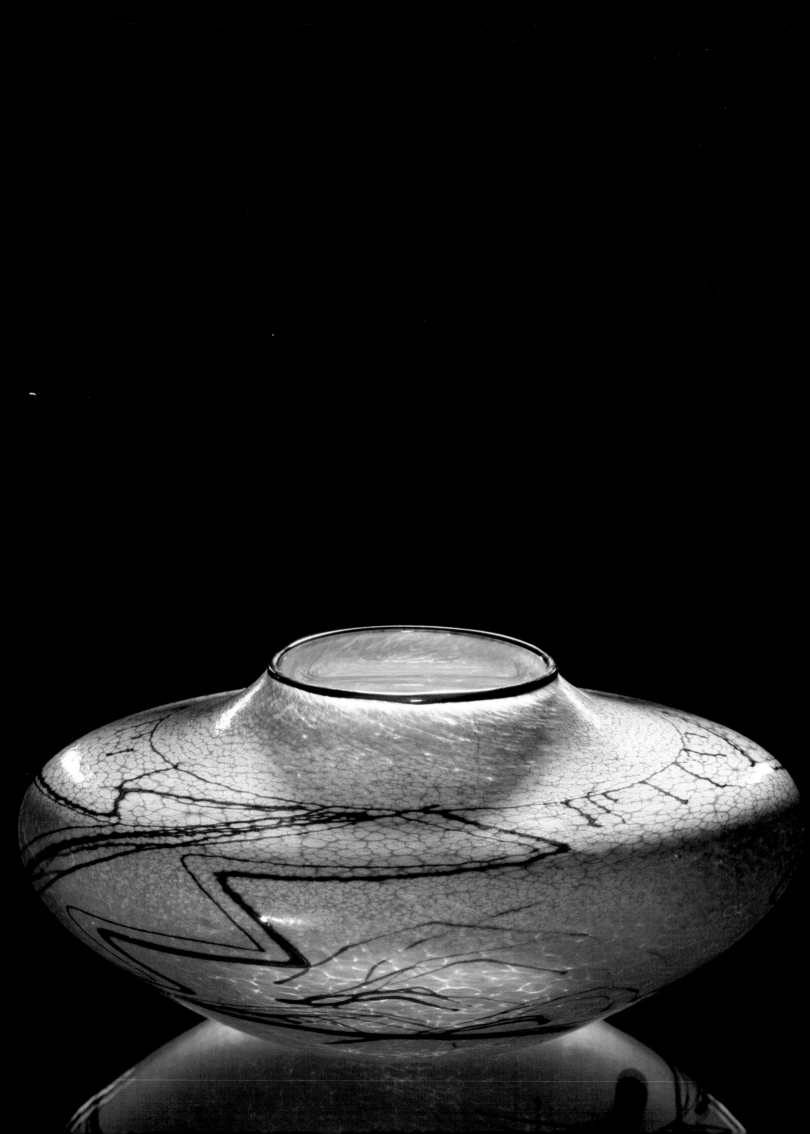

BLOWN AWAY

Take a traditional shape, but work it in a new medium. Pay homage to an old design, but turn a modern one on its head. Glassblowing is not a traditional Native craft, but Tony Jojola masters it to echo forms "that my culture has respected throughout time," such as baskets, ollas, and seed jars (left). In works such as the blown, sandblasted *Tire* (above), Joe Feddersen explores the basketry designs of his people in a fresh approach—energized by his interest in investigating signs—that places a contemporary grid over the older pattern. Others of his similar pieces are: *Chain Link, Parking Lot, High Voltage Tower,* and *Freeway with HOV.*

TONY JOJOLA (ISLETA PUEBLO, B. 1958), LIGHTNING STRIKES, 1989. BLOWN GLASS SEED JAR FORM, HEIGHT 12.5 CM. 25/4780

JOE FEDDERSEN (COLVILLE, B. 1953), TIRE, 2003. SANDBLASTED BLOWN GLASS, HEIGHT 36.8 CM. 26/2874

NECKLACE WITH PENDANT REPRESENTING AN OOGRUK
MASK , CA. 1969. MADE BY RONALD SENUNGETUK, INUPIAT
ESKIMO. SILVER WITH GOLD ACCENTS. 25/7529

NECKLACE WITH PENDANT REPRESENTING A MASK , CA.
1969. MADE BY PETER JOHN SEEGANNA, ESKIMO. JADE AND
SILVER WITH LEATHER STRAP. 25/7534

NECKLACE WITH PENDANT REPRESENTING A SEAL MASK ,
CA. 1969. MADE BY RONALD SENUNGETUK, INUPIAT ESKIMO.
SILVER. 25/7532

A WORLD ADORNED

When Europeans entered the Americas, they found people adorned with gold, silver, copper, bone, wood, stone, and turquoise ornaments. Contact disrupted Native patterns of distribution but added new ideas and materials. In the Southwest, blacksmithing was first taught to Navajo at Fort Defiance in the 1850s, and the techniques were applied to jewelry making. Navajo and Pueblo peoples quickly adapted silver to use with their coral and turquoise work. Within 50 years the Southwest became famous for silver and turquoise jewelry. Native makers everywhere have continued to innovate and now serve an ever-growing base of customers, from casual purchasers to private collectors, galleries, and museums.

NORTHERN SWEEP

A painter and sculptor, a poet and writer whose work is grounded in traditional Northwest Coast and Eskimo art styles, James Schoppert created art that dazzles with a modern interpretation of those styles. In *Another Feather from Moon's Nest* (above), he uses a traditional element, the "formline"—a strong calligraphic sweeping line—but breaks it up into five separate panels. Blue is substituted for traditional red and black, and cultural context is missing. Schoppert remarked: "The exquisite work of our ancestors teaches us to create work suited for the day in which we live. By taking the old, breathing new life into it, and developing a new creation, the spirit of our people lives."

ROBERT JAMES SCHOPPERT (TLINGIT, 1947–1992), ANOTHER FEATHER FROM MOON'S NEST, 1990. ACRYLIC ON WOOD, 46 X 76.6 CM. 25/4629

DEEP HORIZON

Born on the Grand Portage Reservation near Grand Marais, Minnesota, painter, sculptor, and printmaker George Morrison spent many years on the East Coast and in Europe before returning home to the North. Visual memories of the horizon over Lake Superior formed during his childhood on the North Shore intensified when he returned there later in life. In his series of wood collages begun in the 1960s, Morrison created abstractions of the landscape, always focused on a horizon line, incorporating pieces of found driftwood. In these works, the shapes and textures of the wood pieces suggest the forms and movement of the water, shore, and sky. In the 1970s, Morrison began a series of lithographs based on rubbings taken from the wood collages. These prints beautifully capture the patterns and surface textures of the wood collages, revealing the grain, knots, and character of the wood. He once remarked, "In this search for my own reality, I seek the power of the rock, the magic of the water, the religion of the tree, the color of the wind, and the enigma of the horizon."

GEORGE MORRISON (GRAND PORTAGE BAND OF CHIPPEWA, 1919–2000), UNTITLED (HORIZON), 1987. LITHOGRAPH (23/30), 66 X 182.9 CM. 25/9064

The Ironic Vision

"I believe that my people are natural beings and that they do not need to be romanticized as stoic, red, colorful, cultural oddities...." declares Peter Jones (Onondaga). His *Joy Bottle* calls to mind the cultural importance of humor and irony in tribal communities. A wry, ironic sensibility, with connections to the timeless trickster figures of Native oral narrative, has long served as a survival tool and means of communication with a hostile or uncomprehending world. Shared across geographical divides and tribal boundaries, it comes into play as Native peoples confront social and political problems or explore issues of identity and change, from Chnagmiut Inuit Lawrence Beck, a hunter-gatherer of the junkyard, assembling an homage to the spirit of the walrus from chair legs, hubcaps, and tires to Cheyenne Bently Spang, crafting a modern "war shirt" out of family photographs and film strip fringes.

CREATOR AND TRICKSTER

Coyote is sometimes the Creator in Native story and sometimes the trickster. Shift the context, and make Coyote the artist. Then creator and trickster can be one. Peter B. Jones' *Joy Bottle* (above) plays trickster with words, shapes, image, materials, and commercialism (see text at left). Larry Beck's *Ooger uk inua* (Walrus Spirit), at right, has wheel covers for a face and muzzle, kitchen chair legs for tusks, and a chunk of tire for a neck. For all of that, the sense of walrusness is powerful and the connection to traditional masks is strong. Beck's materials at hand came from junkyards, but the spirit reaches back to whale bones, ivory, and fur. It's as if a narwhal could be a Warhol.

PETER B. JONES (ONONDAGA, BEAVER CLAN, B. 1947), JOY BOTTLE, CA. 1968. GLAZE PAINTED STONEWARE, 53 X 18 X 16 CM. 25/5420

LAWRENCE BECK (CHNAGMIUT INUIT), OOGER UK INUA, 1982. MIXED MEDIA, 55.2 X 30.8 X 48.5 CM. 25/5423

BOTH, INDIAN ARTS AND CRAFTS BOARD COLLECTION, DEPARTMENT OF THE INTERIOR, AT THE NATIONAL MUSEUM OF THE AMERICAN INDIAN, SMITHSONIAN INSTITUTION.

Scene from Smoke Signals

By Sherman Alexie

Sherman Alexie's screenplay for the 1998 movie Smoke Signals *explores the relationship between two very different young men from the Coeur d'Alene Indian Reservation in Idaho, and the movie challenges audience preconceptions about Native Americans. In this scene, Victor Joseph and his gregarious, storytelling friend Thomas Builds-the-Fire are on a bus trip to Arizona to collect the ashes of Victor's alcoholic, estranged father, who has recently died.*

THOMAS
Hey, what do you remember about your dad?

Victor ignores Thomas.

THOMAS
I remember one time we had a fry bread eating contest and he ate fifteen pieces of fry bread. It was cool.

Victor sits up in his seat and looks at Thomas.

VICTOR
You know, Thomas? I don't know what you're talking about half the time. Why is that?

THOMAS
I don't know.

VICTOR
I mean, you just go on and on talking about nothing. Why can't you have a normal conversation? You're always trying to sound like some damn medicine man or something. I mean, how many times have you seen *Dances With Wolves*? A hundred, two hundred times?

Embarrassed, Thomas ducks his head.

VICTOR
(cont'd) Oh, jeez, you have seen it that many times, haven't you? Man. Do you think that shit is real? God. Don't you even know how to be a real Indian?

THOMAS
(whispering) I guess not.

Victor is disgusted.

VICTOR
Well, shit, no wonder. Jeez, I guess I'll have to teach you then, enit?

Thomas nods eagerly.

VICTOR
First of all, quit grinning like an idiot. Indians ain't supposed to smile like that. Get stoic.

Thomas tries to look serious. He fails.

VICTOR
No, like this.

Victor gets a very cool look on his face, serious, determined, warriorlike.

VICTOR
You got to look mean or people won't respect you. White people will run all over you if you don't look mean. You got to look like a warrior. You got to look like you just got back from killing a buffalo.

THOMAS
But our tribe never hunted buffalo. We were fishermen.

VICTOR
What? You want to look like you just came back from catching a fish? It ain't Dances with Salmon, you know? Man, you think a fisherman is tough? Thomas, you got to look like a warrior.

Thomas gets stoic. He's better this time.

VICTOR
There, that's better. And second, you can't be talking as much as you do. You got to have some mystery. You got to look like you have secrets, you know? Like you're in a secret conversation with the earth or something. You don't talk. You just nod your head.
(beat to nod his head) See! That makes you look dangerous.

Thomas nods his head.

Victor and Thomas nod back and forth.

VICTOR
And third, you got to know how to use your hair.

THOMAS
My hair?

VICTOR
Yeah, I mean, look at your hair, all braided up and stuff. You've got to free it.

Victor shakes his hair out very vainly.

He runs his hands through it sexily.

VICTOR
See what I mean? An Indian man ain't nothing without his hair. You got to use it.

Thomas slowly fingers his tightly braided hair as Victor talks to him.

VICTOR
And last, and most important, you've got to get rid of that suit, Thomas. You just have to.

Thomas looks down at his three-piece suit.

R. C. GORMAN (NAVAJO), SELF-PORTRAIT, 1973. LITHOGRAPH PRINT ON PAPER (16/60), 33.2 X 24.3 CM. INDIAN ARTS AND CRAFTS BOARD COLLECTION, DEPARTMENT OF THE INTERIOR, AT THE NATIONAL MUSEUM OF THE AMERICAN INDIAN, SMITHSONIAN INSTITUTION. 25/9364

METAMORPHOSES

Refracting his own internal struggles—including recovery from horrors in Vietnam and alcoholism—
Rick Bartow's works such as *Raven* (opposite) evoke mythic powers of transformation not limited to Native
context: "I am as much taken by the myth of Sisyphus as I am by Coyote." For Bartow, "[One] of my all-time
[artist] heroes too was Fritz Scholder…. Fritz came along and kicked the bottom out." Scholder's *Indian at the
Bar* (above) engages at a level far from his view of the "cliché … flat-style, colorful paintings for the tourists."
Scholder's insistence on painting the "real, not red" Indian raised a dust storm of criticism early on.
That settled out long ago, and his vision remains direct and forceful.

RICK BARTOW (YUROK, B. 1946), RAVEN, 2001. ACRYLIC AND GRAPHITE ON PANEL, 61 X 61 CM. 26/2872

FRITZ SCHOLDER (LUISEÑO, B. 1937), INDIAN AT THE BAR, 1971. LITHOGRAPH (21/75), 30 X 22 CM. INDIAN ARTS AND CRAFTS BOARD COLLECTION,
DEPARTMENT OF THE INTERIOR, AT THE NATIONAL MUSEUM OF THE AMERICAN INDIAN, SMITHSONIAN INSTITUTION. 25/9561

AVANT AND GUARD

The form looks familiar, but the material is hypermodern. Here's something like Onondaga and Mi'kmaq basketry, but *Strawberry and Chocolate* (left) is not something for toting a burden. It's not a basket of woven splints from black ash trees felled in the Northeast. The new raw material of this woven construction of 16mm film and fullcoat comes from the cutting room floor at film school, and the title derives from a movie in which social and sexual identity in Cuba is somehow equated with choices of ice cream. In much the same way, *War Shirt #2* (above) by Bently Spang is not something to wear. It is, he says, "Like the war shirts of my relatives in the past ... [and] is about honoring, protecting, and gathering strength." The place to protect is the Northern Cheyenne Reservation, and the images also honor the horse. "These horses ... have willingly taken us across our beautiful homeland for years, reinforcing a symbiotic relationship between man and animal that is centuries old.... This shirt is a symbol of my commitment to this place, my people, and the animals we cherish."

GAIL TREMBLAY (ONONDAGA/MI'KMAQ, B. 1945), STRAWBERRY AND CHOCOLATE, 2000. 16MM FILM AND FULLCOAT, HEIGHT 22.9 CM. 25/7273

BENTLY SPANG (NORTHERN CHEYENNE, B. 1960), MODERN WARRIOR SERIES: WAR SHIRT #2, 2003. PHOTOGRAPHS, IMITATION SINEW, 16MM FILM, VELVET, GLASS BEADS, METAL, PLASTIC, 141 X 15 X 63.5 CM. 26/2745

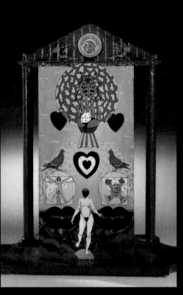

PLAYING WITH TRADITION

"Tradition is the Enemy of Progress," or "Progress is the Enemy of Tradition." Richard Glazer-Danay's hinged construction (above), seen in three aspects, offers the viewer both interpretations. With plastic figurines, glitter, wooden nickels, and multicolored buffalo, the artist plays with issues of tradition and innovation, and with the very real ironies and problems that Native Americans encounter in contemporary society. With *Big Fish's Baby Mask* (right; see p. 312 for a view of the entire object) George Longfish mixes tradition and sentiment with wit and magic. It was made to honor the birth of his first son, and while the piece uses Iroquois motifs and echoes the importance of masks in Native celebrations, the use of bottle nipples, pacifiers, baby rattles, and thimbles gives it a touch of the domestic and personal, much the way its title is a play on words of the artist and son's surname.

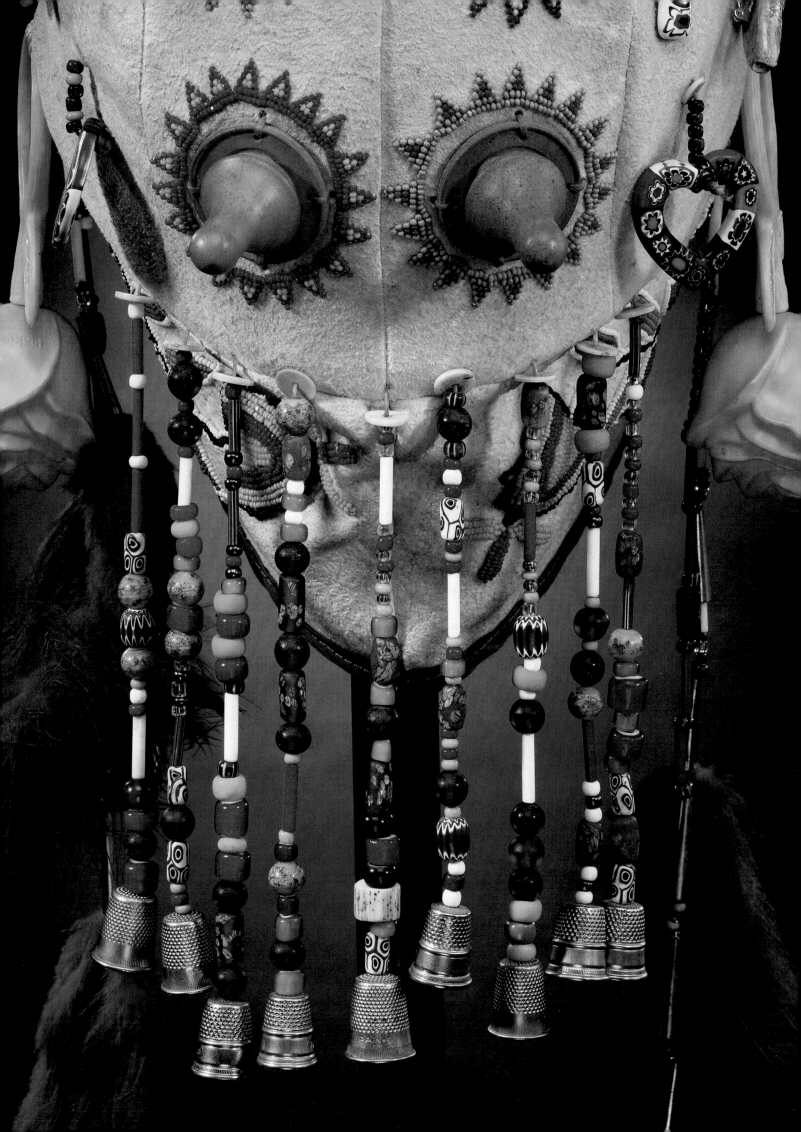

Dear John Wayne

By Louise Erdrich

August and the drive-in picture is packed.
We lounge on the hood of the Pontiac
surrounded by the slow-burning spirals they sell
at the window, to vanquish the hordes of mosquitoes.
Nothing works. They break through the smoke screen for blood.

Always the lookout spots the Indians first,
spread north to south, barring progress.
The Sioux or some other Plains bunch
in spectacular columns, ICBM missiles,
feathers bristling in the meaningful sunset.

The drum breaks. There will be no parlance.
Only the arrows whining, a death-cloud of nerves
swarming down on the settlers
who die beautifully, tumbling like dust weeds
into the history that brought us all here
together: this wide screen beneath the sign of the bear.

The sky fills, acres of blue squint and eye
that the crowd cheers. His face moves over us,
a thick cloud of vengeance, pitted
like the land that was once flesh. Each rut,
each scar makes a promise: *It is
not over, this fight, not as long as you resist.*

Everything we see belongs to us.

A few laughing Indians fall over the hood
slipping in the hot spilled butter.
The eye sees a lot, John, but the heart is so blind.
Death makes us owners of nothing.
He smiles, a horizon of teeth
the credits reel over, and then the white fields
again blowing in the true-to-life dark.
The dark films over everything.
We get into the car
scratching our mosquito bites, speechless and small
as people are when the movie is done.
We are back in our skins.

How can we help but keep hearing his voice,
the flip side of the sound track, still playing:
Come on, boys, we got them
where we want them, drunk, running.
They'll give us what we want, what we need.
Even his disease was the idea of taking everything.
Those cells, burning, doubling, splitting out of their skins.

AUTHORS

Editors

GERALD McMASTER (Plains Cree and member of the Siksika Nation), co-editor of *Native Universe*, was born in Saskatchewan, Canada, and grew up on the Red Pheasant Reserve. McMaster, of the Cultural Resources Department of the Smithsonian's National Museum of the American Indian, is responsible for the design and content of exhibitions at NMAI's new museum on the National Mall in Washington, D.C. From 1981–2000, McMaster was Curator of Contemporary Indian Art at the Canadian Museum of Civilization and then Curator-in-Charge of that museum's First Peoples Hall, during which time he produced many exhibitions and publications. His awards and recognitions include the 2001 ICOM-Canada Prize for contributions to national and international museology, as well as being selected as Canadian Commissioner to the prestigious international exhibition, the XLVI 1995 Biennale di Venezia. McMaster holds a Ph.D. from the University of Amsterdam, and degrees from the Institute of American Indian Arts, the Minneapolis College of Art and Design, and Carleton University. His books include *Reservation X: The Power of Place in Aboriginal Contemporary Art, Edward Poitras: Canada XLVI Biennale di Venezia,* and *INDIGENA: Contemporary Native Perspectives.* McMaster is also the author of numerous essays in books and journals.

CLIFFORD E. TRAFZER, of Wyandot ancestry, co-editor of *Native Universe,* is Professor of History and Director of American Indian Studies at the University of California, Riverside, where he also directs the Public History Program. Trafzer holds a Ph.D. in American history from Oklahoma State University with a specialty in American Indian history and has worked as a museum curator. His recent books include *As Long As the Grass Shall Grow and Rivers Flow: A History of Native Americans; The People of San Manuel; Chemehuevi People of the Coachella Valley; Medicine Ways; Earth Song, Sky Spirit: Short Stories of the Contemporary Native American Experience; Death Stalks the Yakama; Blue Dawn, Red Earth: New Native American Storytellers;* and *Exterminate Them! Written Accounts of Murder, Rape, and Enslavement of Native Americans During the California Gold Rush.* His books have won the Governor's Award, Pen Oakland/Josephine Miles National Literary Award, and Wordcraft Circle of Native American Writers and Storytellers Award.

Contributors

SHERMAN ALEXIE (Spokane/Coeur d'Alene), acclaimed poet, fiction writer, and filmmaker, was born in 1966 on the Spokane Indian Reservation in Wellpinit, Washington. In addition to screenplays for *Smoke Signals* and *The Business of Fancy Dancing,* he is the author of six books of poetry; several novels, including *Reservation Blues* and *Indian Killer;* and collections of short fiction, including *The Lone Ranger and Tonto Fistfight in Heaven* and *Ten Little Indians.*

BRENDA J. CHILD (Red Lake Ojibwe) earned a Ph.D. in history from the University of Iowa and is Associate Professor of American Studies and American Indian Studies at the University of Minnesota. She is the author of *Boarding School Seasons: American Indian Families, 1900–1940,* winner of the North American Indian Prose Award. Child served as consultant to the Heard Museum exhibition, *Remembering Our Indian School Days,* and is co-editor of the companion book to the exhibition, *Away From Home: American Indian Boarding School Experiences, 1879–2000.* Her grandmother, Jeanette Auginash, was a student at the South Dakota boarding school, Flandreau Indian School, in the 1920s.

VINE DELORIA, JR. (Standing Rock Sioux), one of Native America's leading spokesmen, is an eminent scholar and writer whose fields of expertise include history, law, religious studies, and political science. Deloria earned a master's degree in theology from the Lutheran School of Theology in Chicago and a law degree from the University of Colorado. He was formerly executive director of the National Congress of American Indians, and served on the faculties of the University of Arizona and the University of Colorado. Deloria's book, *Custer Died for Your Sins,* garnered national attention, and he has since authored more than twenty books, including *Behind the Trail of Broken Treaties; God Is Red; Spirit and Reason: The Vine Deloria, Jr., Reader; Power and Place: Indian Education in America;* and *Documents of American Indian Diplomacy: Treaties, Agreements, and Conventions, 1775–1979.* Deloria received the 1996 Native Writers' Circle of the Americas Lifetime Achievement Award.

LOUISE ERDRICH (Turtle Mountain Band of Chippewa), a major voice in American letters, is the author of nine novels, including, most recently, *The Master Butchers Singing Club,* the National Book Critics Circle Award-winning *Love Medicine,* and the National Book Award finalist *The Last Report on the Miracles at Little No Horse,* as well as poetry and children's books.

LINDA HOGAN (Chickasaw) is a recipient of a National Endowment for the Arts grant in fiction, a Guggenheim Fellowship, a Lannan Fellowship, and the Five Civilized Tribes Museum Playwriting Award. She has been shortlisted for the Pulitzer Prize (for her novel *Mean Spirit*) and the National Book Critics Circle Award (for *The Book of Medicines: Poems*), and she won the American Book Award for *Seeing Through the Sun.* A prolific essayist on environmental issues, she lives in the mountains of Colorado. Hogan is most recently co-author of *Sightings: The Gray Whales' Mysterious Journey.*

GEORGE P. HORSE CAPTURE (A'aninin) was born on the Fort Belknap Indian Reservation in Montana. He earned a B.A. in anthropology from the University of California at Berkeley and an M.A. in history from Montana State University, Bozeman. He was awarded an Honorary Doctorate of Letters from Montana State University in 1996. Horse Capture is the author of *Powwow*, and with his son, Joseph D. Horse Capture, of *Beauty, Honor, and Tradition: The Legacy of Plains Indian Shirts*, as well as being a contributor to a number of books. He has taught college classes and served as a curator for the Plains Indian Museum in Wyoming, in addition to lecturing and working as a consultant for museums and other cultural organizations around the country. He has been with the National Museum of the American Indian since 1994.

WILMA MANKILLER (Cherokee) was elected in 1983 to serve as first female deputy chief and later first female principal chief of the Cherokee Nation for three four-year terms. She has received many honorary doctorates and awards, including the Presidential Medal of Freedom, the highest civilian honor of the United States. She co-authored *Mankiller: A Chief and Her People* and co-edited *The Reader's Companion to U.S. Women's History*. Mankiller's latest book, *Every Day is a Good Day*, is based on a series of interviews with indigenous women. She continues to work on a range of community development and social justice issues.

JOHN C. MOHAWK (Seneca) is from the Seneca Nation's Cattaraugus Territory in Western New York. He is a former editor of *Akwesasne Notes* and *Daybreak Magazine*, author/editor of *Basic Call to Consciousness*, co-editor of *Exiled in the Land of the Free*, and author of *Utopian Legacies: A History of Conquest and Oppression in the Western World*. He has degrees from Hartwick College (B.A., L.H.D.) and the State University of New York at Buffalo (M.A., Ph.D.). His areas of scholarship include contemporary Native American life and culture, Iroquois history, and Iroquois agriculture.

N. SCOTT MOMADAY (Kiowa) is a poet, novelist, playwright, storyteller, artist, and a professor of English and American literature. He has received the Pulitzer Prize (for *House Made of Dawn*), a Guggenheim Fellowship, numerous honorary degrees, and is a Fellow of the American Academy of Arts and Sciences. Author of such works as *The Way to Rainy Mountain, The Man Made of Words*, and *In the Presence of the Sun*, he is an extraordinary storyteller whose heritage and identity are steeped in oral tradition.

JOSÉ MONTAÑO (Aymara) was born in the small highland village of Incalacaya, Bolivia. At an early age, he learned from his elders to make and play a wide variety of traditional wind, percussion, and stringed instruments. Montaño is the director of Grupo Aymara, Bolivia's premier folk music troupe, and the author of *Pachamama Project*, a monograph on Bolivian music accompanied by a sound recording. He has toured and recorded albums and sound tracks throughout North America, South America, Europe, and Japan. He currently works in the Cultural Resources Department of the Smithsonian's National Museum of the American Indian.

VICTOR MONTEJO (Maya) teaches in the Department of Native American Studies at the University of California at Davis. Professor Montejo is one of Guatemala's foremost Maya intellectuals and writers. His work centers on Maya cultural revitalization, the impact of Guatemala's civil war on Maya communities, and the transnational Maya diaspora as a consequence of the war. His books include: *Sculpted Stones; Testimony: Death of a Guatemalan Village; The Bird Who Cleans the World and Other Mayan Fables; Voices from Exile: Violence and Survival in Modern Maya History*; and for young people, *Popol Vuh: A Sacred Book of the Maya*.

JAMES PEPPER HENRY (Kaw/Muscogee) is Assistant Director for Community Services at the Smithsonian's National Museum of the American Indian. For the past decade, he has been active in Native American repatriation efforts as director of the Kaw Nation's Kanza Museum and its Historic Preservation Officer, and as the former Repatriation Program Manager for NMAI. In his spare time, he enjoys traditional dancing in the Southern Plains style at area powwows.

PAUL CHAAT SMITH (Comanche) is a writer, critic, and curator. At the age of nineteen, he joined the Wounded Knee Legal Defense/Offense Committee in Sioux Falls, South Dakota, and worked with the American Indian Movement for five years. His highly praised book, *Like a Hurricane: The Indian Movement from Alcatraz to Wounded Knee*, written with Robert Allen Warrior, established him as one of the most articulate young voices in Indian America. In addition to essays in books and magazines, Smith has also written for film and television. He is currently on the curatorial staff of the Smithsonian's National Museum of the American Indian.

LUCI TAPAHONSO (Navajo), whose first language is Navajo, was born in Shiprock, New Mexico, where she grew up as one of eleven children on a farm within the Navajo Nation. She is the author of several books of poetry and stories, including *A Breeze Swept Through, Sáanii Dahataa/The Women Are Singing: Poems and Stories*, and *Blue Horses Rush In*. Winner of the 1999 Wordcraft Circle of Native American Writers "Storyteller of the Year" Award, Tapahonso has been an Associate Professor of English at the University of Kansas and is now Professor of English at the University of Arizona in Tucson.

GABRIELLE TAYAC (Piscataway), the author of *Meet Naiche: A Native Boy from the Chesapeake Bay Area*, was born and raised in New York City. She received her undergraduate education at Cornell University and has a doctoral degree from Harvard University. The granddaughter of the late medicine man Chief Turkey Tayac, she has worked with a number of organizations to promote education about the rights of indigenous peoples around the world, including the League of Indigenous Sovereign Nations, which she helped found. Her scholarly research focuses on American Indian identity and social movements. Tayac is on the curatorial staff of the Smithsonian's National Museum of the American Indian.

TLINGIT CARVED FIGURES OF WHITE MEN, CA. 1860. ALASKA. WOOD, IVORY, PAINT, HEIGHT 38 AND 32 CM. 14/7375 AND 12/3127

SELECTED BIBLIOGRAPHY

Manuscripts, Archives, and Collections

Annual Reports of the Commissioners of Indian Affairs.

Annual Reports of the Secretary of War.

Frank, Benis M. Oral Interviews with Navajo Code Talkers, 1976. United States Marine Corps. History and Museum Division.

McWhorter, Lucullus V. Manuscripts, Archives, and Special Collections, Holland Library. Washington State University, Pullman, Washington.

National Archives, Adjutant Generals Office, Record Group 94.

Papers of Mission Indian Agency. National Archives, Pacific Southwest Region, Laguna Nigel, Record Group 75.

Papers of Northern Idaho. National Archives, Pacific Northwest region, Seattle, Record Group 75.

Smith, Gerald. "Serranos." Manuscript, A. K. Smiley Library, Redlands, California.

Secondary Sources

Akers, Donna L. "Removing the Heart of Choctaw People: Indian Removal from a Native Perspective." Clifford E. Trafzer and Diane Weiner, eds., *Medicine Ways: Disease, Health, and Survival Among Native Americans.* Walnut Creek, California: Alta Mira Press, 2001.

Archuleta, Margaret L., Brenda J. Child and K. Tsianina Lomawaima, eds. *Away from Home: American Indian Boarding School Experiences.* Phoenix: Heard Museum, 2000.

Barbeau, C. M. *Huron and Wyandot Mythology.* Ottawa: Government Printing Bureau, 1915.

Bierhorst, John. *The Red Swan: Myths and Tales of the American Indian.* New York: Farrar, Straus, and Giroux, 1976.

Brown, Dee. *Bury My Heart at Wounded Knee.* New York: Holt, Rinehart & Winston, 1970.

Castillo, Edward D. "Blood Came from Their Mouths: Tongva and Chumash Responses to the Pandemic of 1801." Clifford E. Trafzer and Diane Weiner, eds., *Medicine Ways: Disease, Health, and Survival Among Native Americans.* Walnut Creek, California: Alta Mira Press, 2001.

Champagne, Duane. *The Native American Almanac.* Detroit: Gale Research, 1994.

Child, Brenda J. *Boarding School Seasons.* Lincoln: University of Nebraska Press, 1998.

Crosby, Alfred. *The Columbian Exchange: Biological and Cultural Consequences of 1492.* Westport, Connecticut: Greenwood Publishing Company, 1972.

Debo, Angie. *And Still the Waters Run.* Princeton: Princeton University Press, 1940.

Deloria, Jr., Vine, and Raymond J. DeMallie, eds. *Documents of American Indian Diplomacy: Treaties, Agreements, and Conventions, 1775–1979.* Norman: University of Oklahoma Press, 1999.

Edmunds, R. David. *Tecumseh.* Boston: Little, Brown, and Company. 1984.

———. *The Shawnee Prophet.* Lincoln: University of Nebraska Press, 1983.

Erdoes, Richard and Alfonso Ortiz, eds. *American Indian Myths and Legends.* New York: Pantheon Books, 1984.

Fienup-Riordan, Ann. *The Living Tradition of Yup 'ik Masks.* Seattle: University of Washington Press, 1996.

Hill, Rick. *Creativity Is Our Tradition: Three Decades of Contemporary Indian Art at the Institute of American Indian Arts.* Santa Fe: IAIA Press, 1992.

Hittman, Michael. *Wovoka and the Ghost Dance.* Lincoln: University of Nebraska Press, 1990.

Idell, Albert, trans. and ed. *The Bernal Diaz Chronicles: The True Story of the Conquest of Mexico.* Garden City: Doubleday, 1956.

Jemison, G. Peter and Anna M. Schein, eds. *Treaty of Canandaigua, 1794: 200 Years of Treaty Relations Between the Iroquois Confederacy and the United States.* Santa Fe: Clear Light Publishers, 2000.

Jennings, Francis. *The Invasion of America.* Chapel Hill: University of North Carolina Press, 1975.

Kugel, Rebecca. *To Be the Main Leaders of Our People.* East Lansing: Michigan State University Press, 1998.

McCutcheon, David. *The Red Record: The Wallum Olum.* Garden City Park, Avery Publishing Group, 1989.

Margolin, Malcolm. *The Way We Lived: California Indian Stories, Songs, and Reminiscences.* Berkeley, California: Heydey Books, 1981.

Meriam, Lewis. *The Problem of Indian Administration.* Baltimore: Johns Hopkins University Press, 1928.

Momaday, N. Scott. *House Made of Dawn.* New York: Harper and Row, 1966.

Mooney, James. "The Ghost Dance Religion and the Sioux Outbreak of 1890." *Fourteenth Annual Report of the Bureau of American Ethnology.* Washington, D.C.: Government Printing Office, 1896.

Murrillo, Pauline Ormego. *Living in Two Worlds.* Highland, California: Dimples Press, 2001.

Nabokov, Peter. *A Forest of Time: American Indian Ways of History.* Cambridge: Cambridge University Press, 2002.

Nahwooksy, Fred and Richard Hill, Sr. *Who Stole the Tee Pee?* Phoenix: Atlatl, Inc., 2000.

Neugin, Rebecca. "Memories of the Trail of Tears." *Journal of Cherokee Studies* 3 (1978).

Neihardt, John G. *Black Elk Speaks.* New York: Washington Square Press, 1932.

Phinney, Archie. "Nez Perce Texts." *Columbia University Contributions to Anthropology* (1969).

Prucha, Francis Paul. American Indian Policy in the Formative Years: *The Indian Trade and Intercourse Acts, 1790-1834.* Cambridge: Harvard University Press, 1962.

———. *American Indian Treaties.*

Rawls, James J. *Indians of California: The Changing Image.* Norman: University of Oklahoma Press, 1984.

Silko, Leslie Marmon. *Storyteller.* New York: Little, Brown, and Company, 1981.

Sioui, Georges E. *Huron-Wendat: The Heritage of the Circle.* East Lansing: Michigan State University Press, 1999.

Smith, Paul Chaat and Robert Allen Warrior. *Like a Hurricane: The American Indian Movement from Alcatraz to Wounded Knee.* New York: New Press, 1996.

Sword, Wiley. *President Washington's Indian War: The Struggle for the Old Northwest, 1790–1795.* Norman: University of Oklahoma Press, 1985.

Tedlock, Dennis, trans. *Popol Vuh: The Mayan Book of the Dawn of Life.* New York: Simon & Schuster, 1996.

Thornton, Russell. *The American Indian Holocaust and Survival.* Norman: University of Oklahoma Press, 1987.

Trafzer, Clifford E. and Joel Hyer. *Exterminate Them!: Written Accounts of the Murder, Rape, and Enslavement of Native Americans During the California Gold Rush.* East Lansing: Michigan State University Press, 1999.

Trafzer, Clifford E., Luke Madrigal, and Anthony Madrigal. *Chemehuevi People of the Coachella Valley.* Coachella, California: Chemehuevi Press, 1997.

Trafzer, Clifford E. and Richard D. Scheuerman. *Renegade Tribe: The Palouse Indians and the Invasion of the Pacific Northwest.* Pullman: Washington State University Press, 1986.

Trafzer, Clifford E. *As Long As the Grass Shall Grow and Rivers Flow: A History of Native Americans.* Fort Worth: Harcourt, 2000.

———. *Death Stalks the Yakama: Epidemiological Transitions and Mortality on the Yakama Indian Reservation, 1888-1964.* East Lansing: Michigan State University Press, 1997.

———, ed. *Grandmother, Grandfather, and Old Wolf: Tamanwit Ku Sukat and Traditional Native American Narratives from the Columbia Plateau.* East Lansing: Michigan State University Press, 1998.

Velie, Alan R. *American Indian Literature.* Norman: University of Oklahoma Press, 1979.

Vizenor, Gerald R. *The Everlasting Sky: New Voices from the People Named the Chippewa.* Minneapolis: University of Minnesota Press, 1972.

Walker, J. R. "The Sun Dance and Other Ceremonies of the Oglala Division of the Teton Dakota." *Anthropological Papers of the American Museum of Natural History* 16 (1917).

Wall, Steve and Harvey Arden. *Wisdomkeepers.* Hillsboro, Oregon: Beyond Words Publishing, 1990.

Wallace, Anthony F. C. *The Death and Rebirth of the Seneca.* New York: Random House, 1969.

Oral Interview Subjects

Joe Benitez	Theresa Mike
Theresa Brown	Pauline Ormego Murillo
Delbert Castro	Jack Norton
Jim Clarke	Ferron Owl
Lame Deer	Emily Peone
Teddy Draper, Sr.	David Red Bird
Lee Emerson	Charlene Ryan
Andrew George	Eleonore Sioui
Carl Gorman	Georges Sioui
Kitty Greyeyes	Dillon Story
Geraldine Guie	Mary Lou Henry Trafzer
Mary Jim	B. N. O. Walker
Catherine Johnson	Mrs. Isaiah Walker
Matthew Leivas	Jenny Zane Waters
Josie Limpy	Darryl Wilson
Mary McKee	Lucy Winnie
Mrs. Medicine Bull	Star Young
Dean Mike	

This Chipewyan tea cosey is a perfect example of European influence on the production of Native American material culture. Intricately beaded with an ornate floral design, this tea cosey is a testament to the blending of European and Native cultures, which began on the East Coast and spread throughout Canada, where it was made.

CHIPEWYAN TEA COZY FOR TEA POT, LATE 19TH/EARLY 20TH C. GLASS BEADS, SATIN, HEIGHT 30 CM. 18/7472

AUTHOR NOTES

STEPHEN MOPOPE (KIOWA, 1898–1974), BUTTERFLY DANCER, 1930. WATERCOLOR ON PAPER, 8.3 X 18 CM. 22/8619

INTRODUCTION

1. Quotation from Tim Johnson in "From Six Nations, Uplink to Chickasaw Astronaut," *Indian Country Today,* December 6, 2002. Quotation from John Herrington in "To My Many Friends in Indian Country," an open letter by Herrington published in *Indian Country Today,* January 17, 2003.

2. From *Pathways of Tradition: Indian Insights into Indian Worlds.* An exhibition at the George Gustav Heye Center of the Smithsonian's National Museum of the American Indian, New York City, November 15, 1992, to January 24, 1993.

3. Mary Jane Lenz, "On the Totem Trail," *Smithsonian* (June 2001).

OUR UNIVERSES OVERVIEW

1. N. Scott Momaday, *House Made of Dawn* (New York: Harper and Row, 1966), 88.

2. Tom Hill and Richard W. Hill, Sr., editors, *Creation's Journey: Native American Identity and Belief* (Washington, D.C.: NMAI and Smithsonian Institution Press, 1994), 18.

3. Richard Hill, *Pathways of Tradition: Indian Insights into Indian Worlds.* An exhibition at the George Gustav Heye Center of the Smithsonian's National Museum of the American Indian, New York City, November 15, 1992, to January 24, 1993.

4. J. R. Walker, "The Sun Dance and Other Ceremonies of the Oglala Division of the Teton Dakota," *Anthropological Papers of the American Museum of Natural History* 16 (1917), 181-182.

5. Oral Interview of B. N. O. Walker by C. M. Barbeau, September 1911, Wyandotte Reservation, Oklahoma, as found in C. M. Barbeau, *Huron and Wyandot Mythology* (Ottawa: Government Printing Bureau, 1915), 40. Barbeau also interviewed other Wyandot elders from Wyandotte, Oklahoma; Ontario, Canada; and Kansas City who contributed their memories to the origin story, including Mrs. Isaiah Walker, Lucy Winnie, Mary McKee, Jenny Zane Waters, Star Young, Kitty Greyeyes, Theresa Brown, and Jim Clarke. Eleonore Sioui and her son, Georges, of Wendake also contributed to our understanding of the Wyandot origin story.

6. From *Our Universes.* An exhibition at the Smithsonian's National Museum of the American Indian, Washington, D.C., opened on September 21, 2004.

7. David McCutchen, *The Red Record: The Wallam Olum* (Garden City Park, New York: Avery Publishing Group, 1989), 52–55.

8. Ibid., 52; see other symbols of the *Walam Olum* in Alan R. Velie, *American Indian Literature* (Norman: University of Oklahoma Press, 1979), 96–135.

9. Leslie Marmon Silko, *Yellow Woman and a Beauty of the Spirit: Essays on Native American Life Today* (New York: Simon & Schuster, 1996), 27.

10. Oral interview of Dalbert Castro by Clifford E. Trafzer, July 1988, Auburn Rancheria, California.

11. John Bierhorst, *The Red Swan: Myths and Tales of the American Indian* (New York: Farrar, Straus, and Giroux, 1976), 192–194.

12. Barbeau, *Huron and Wyandot Mythology,* 37.

13. Clifford E. Trafzer, editor, *Grandmother, Grandfather, and Old Wolf: Tamanwit Ku Sukat and Traditional Native American Narratives from the Columbia Plateau* (East Lansing: Michigan State University Press, 1998), 97–109.

14. Richard Erdoes and Alfonso Ortiz, editors, *American Indian Myths and Legends* (New York: Pantheon Books, 1984), 127.

15. Oral interview of David Red Bird by Richard Erdoes, 1974, New York City as found in Ibid., 150–151.

16. Bierhorst, *The Red Swan,* 294–296.

17. Malcolm Margolin, editor, *The Way We Lived: California Indian Stories, Songs and Reminiscences* (Berkeley, California: Heyday Books, 1981), 120–121.

18. Peggy V. Beck, Anna Lee Walters, and Nia Francisco, *The Sacred: Ways of Knowledge, Sources of Life* (Tsaile, Arizona: Navajo Community College Press, 1975), 270.

19. Oral interview of Josie Limpy and Mrs. Medicine Bull by Richard Erdoes, 1972, Birney, Montana, in Erdoes and Ortiz, editors, *American Indian Myths and Legends,* 34–37.

20. Oral interview of Lame Deer by Richard Erdoes, 1967, Rosebud Indian Reservation, South Dakota, in Ibid., 47–52.

CEREMONY AND RITUAL: LIFE IN MOTION

1. W. W. Hill, et al., *Ethnography of Santa Clara Pueblo* (Albuquerque: University of New Mexico Press, 1982), 256.

2. Ibid., 263–264.

3. Ann Fienup-Riordan, *The Living Tradition of Yup'ik Masks* (Seattle: University of Washington Press, 1996), 38.

4. Ibid., 69.

5. Ibid., 394.

6. Ibid., 261–262.

7. Ibid., 175–252.

8. Ibid., 199.

9. Ibid., 120–121.

10. Ibid., 85.

11. Hupa/Yurok dancer Jack Norton provided details of Hupa dances on September 26, 2002. His analysis of the dances is somewhat different from that provided by anthropologists at the turn of the twentieth century. See Pliny Earle Goddard, "Life and Culture of the Hupa," *University of California Publications in American Archaeology and Ethnology* 1 (Berkeley: University of California Press, 1903), 82.

12. Walter R. Goldschmidt and Harold E. Driver, "The Hupa White Deerskin Dance," *University of California Publications in Archaeology and Ethnology* 35 (Berkeley: University of California Press, 1940), 121.

13. Ibid.; Goddard, "Life and Culture of the Hupa," 85.

14. John A. Gibson, "The Myth of the Earth Grasper" (trans. John N. B. Hewitt), in "Iroquois Cosmology, Second Part," *Forty-Third Annual Report of the Bureau of American Ethnology, 1925–1926* (Government Printing Office: Washington, D.C., 1928), 579.

HEART OF HEAVEN, HEART OF EARTH: THE MAYA WORLDVIEW

1. Victor D. Montejo, *Popol Vuh: A Sacred Book of the Maya* (Toronto, Canada: Groundwood Books, 1999), 61.

2. Ibid., 63.

3. Ibid., 18–19.

4. Ralph Metzner. "The Emerging Ecological Worldview." In *Worldviews and Ecology: Religion, Philosophy and the Environment.* Mary Evelyn Tucker and John Grimm, editors (New York: Orbis Books, 1998), 166.

5. Elizabeth Burgos Debray, *Me llamo Rigoberta Menchú y así me nació la conciencia* (México: Siglo XXI Editores, 1996), 11.

6. Edward O. Wilson, *Biophilia* (Cambridge: Harvard University Press, 1995), 74.

7. Didier Boremanse, "Ortogénesis en la literatura maya lacandona," en *Mesoamérica*, No. 17 (South Woodstock, Vermont: Plumsock Mesoamerican Studies, June 1989), 73.

KEEPING THE ORIGINAL INSTRUCTIONS

1. Harvey Arden, ed., *Noble Red Man: Lakota Wisdomkeeper Mathew King* (Hillsboro, Oregon: Beyond Words Publishing, 1994), 10.

OUR PEOPLES OVERVIEW

1. Chief Joseph, "An Indian's View of Indian Affairs," *North American Review* 128 (1879): 412-433; Oliver O. Howard, *Nez Perce Joseph* (Boston: Lee and Shepard, 1881), 57–71.

2. Howard, *Nez Perce Joseph*, 30.

3. Georges E. Sioui, *Huron-Wendat: The Heritage of the Circle* (East Lansing: Michigan State University Press, 1999), 36–41.

4. This information is based on conversations with Donna Akers of Purdue University during the early 1990s and Donna L. Akers, "Removing the Heart of the Choctaw People: Indian Removal from a Native Perspective," in Clifford E. Trafzer and Diane Weiner, eds., *Medicine Ways: Disease, Health, and Survival Among Native Americans* (Walnut Creek, California: Alta Mira Press, 2001), 5, 8–12.

5. Albert Idell, trans. and ed., *The Bernal Diaz Chronicles: The True Story of the Conquest of Mexico* (Garden City: Doubleday, 1956).

6. Alfred Crosby, *The Columbian Exchange: Biological and Cultural Consequences of 1492* (Westport, Connecticut: Greenwood Publishing Company, 1972), 58.

7. Clifford E. Trafzer, *As Long as the Grass Shall Grow and Rivers Flow: A History of Native Americans* (Fort Worth: Harcourt, 2000), 26–28.

8. Edward D. Castillo, "Blood Came from Their Mouths: Tongva and Chumash Responses to the Pandemic of 1801," in Trafzer and Weiner, *Medicine Ways*, 23–24.

9. Trafzer, *As Long as the Grass Shall Grow and Rivers Flow*, 62–77.

10. The life and teachings of Handsome Lake are detailed in the oral traditions of the Haudenosaunee and a written account, Anthony F. C. Wallace, *The Death and Rebirth of the Seneca* (New York: Random House, 1969). The quotes by Irving Powless are found in Steve Wall and Harvey Arden, *Wisdomkeepers* (Hillsboro, Oregon: Beyond Words Publishing, 1990), 115.

11. A Cherokee historian has conducted the most research on Tecumseh and Tenskwatawa, and anyone interested in these two figures must consult R. David Edmunds, *Tecumseh and the Quest for Indian Leadership* (Boston: Little, Brown, and Company, 1984) and R. David Edmunds, *The Shawnee Prophet* (Lincoln: University of Nebraska Press, 1983). Also, see Trafzer, *As Long as the Grass Shall Grow and Rivers Flow*, 123–137.

12. Akers, "Removing the Heart of Choctaw People," 5, 8–12.

13. James Rawls presented this story at a lecture at the University of Redlands. His book details the killings in California during the Gold Rush. See James J. Rawls, *Indians of California: The Changing Image* (Norman: University of Oklahoma Press, 1984), 116–128. See the population estimates in Thornton, *American Indian Holocaust*, 109.

14. Gerald Smith Manuscript on Serranos, A. K. Smiley Library, Redlands, California, and an analysis of the manuscript in Clifford E. Trafzer, *The People of San Manuel* (Highland, CA.: San Manuel Band of Mission Indians, 2003).

15. James H. Carleton to Lorenzo Thomas, September 6, 1863, National Archives, Adjutant General's Office, Record Group 94, Letters Received. Also, see Clifford E. Trafzer, *The Kit Carson Campaign: The Last Great Navajo War* (Norman: University of Oklahoma Press, 1982), 228–233.

16. Trafzer, *The Kit Carson Campaign*, 224–244.

17. James Mooney, "The Ghost Dance Religion and the Sioux Outbreak of 1890," *Fourteenth Annual Report of the Bureau of American Ethnology* (Washington, D.C.: Government Printing Office, 1896), 771–772. The best source on the Paiute Prophet is Michael Hittman, *Wovoka and the Ghost Dance* (Lincoln: University of Nebraska Press, 1990).

18. John G. Neihardt, *Black Elk Speaks* (New York: Washington Square Press, 1932).

19. Lewis Meriam, *The Problem of Indian Administration* (Baltimore: Johns Hopkins University Press, 1928).

20. Oral Interview of Mary Jim by Clifford E. Trafzer and Richard D. Scheuerman, November 9–10, 1979, and April 25, 1980, Yakama Indian Reservation.

21. Clifford Trafzer learned a great deal about Navajo Code Talkers from Teddy Draper, Sr., and Carl Gorman at Navajo Community College (Diné College) in 1976–1977 when he taught both of them and took Navajo language classes from Draper. During this time Trafzer also conducted interviews with Dillon Story about his association with Navajo Code Talkers. Benis M. Frank interviewed a number of Code Talkers for the History and Museums Division of the United States Marine Corps in 1976; also see Martha Davidson, "Secret Warriors," *American Indian* 3, no. 2 (Spring 2002): 15–20.

AUTHOR NOTES

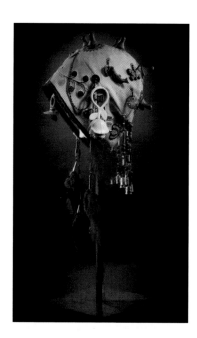

*GEORGE LONGFISH (SENECA/TUSCARORA, B. 1942), BIG
FISH'S BABY MASK, 1981. GLASS BEADS, MOLDED GLASS
ORNAMENTS, CERAMIC PINS, PLASTIC BABY RATTLES,
RUBBER BOTTLE NIPPLES, PLASTIC PACIFIER, METAL
CONES, THIMBLES, FLUFFS, AND FABRIC ON TANNED
HIDE, 28 X 31 X 72.1 CM. 26/1486*

PROMISES MADE, PROMISES BROKEN

1. Joseph Epes Brown, ed., *The Sacred Pipe: Black Elk's Account of the Seven Rites of the Oglala Sioux.* (Norman: University of Oklahoma Press, 1953), 109.

2. Donald Jackson, ed., *Black Hawk: An Autobiography* (Urbana: University of Illinois Press, 1955), 87.

3. Virginia Armstrong, *I Have Spoken: American History Through the Voices of the Indians* (Chicago: Swallow Press, 1971), 37.

4. Quoted in Charles Lanham, *Recollections of Curious Characters and Pleasant Places* (Edinburgh, 1881), 211–212.

5. Letter from "The Glass, " August 1828, printed in the *Cherokee Phoenix*, October 29, 1828.

INDIAN EDUCATION, AMERICAN EDUCATION

1. Frances Densmore, *Chippewa Customs* (1929; reprint, St. Paul: Minnesota Historical Society Press, 1979), 119–123.

2. The letters for this essay are from Record Group 75, National Archives, Bureau of Indian Affairs, Haskell or Flandreau School Records. Some have been examined in Brenda J. Child, *Boarding School Seasons: American Indian Families, 1900–1940* (Lincoln: University of Nebraska Press, 1998).

3. Thomas Vennum, Jr. *Wild Rice and the Ojibway People* (St. Paul: Minnesota Historical Society Press, 1988), 155.

4. Child, *Boarding School Seasons*, 74.

5. K. Tsianina Lomawaima, *They Called It Prairie Light: The Story of Chilocco Indian School* (Lincoln: University of Nebraska Press, 1994), xi.

6. Scott Riney, *The Rapid City Indian School* (Norman: University of Oklahoma Press, 1990), 151–152.

7. James C. Scott, *Weapons of the Weak: Everyday Forms of Peasant Resistance* (New Haven: Yale University Press, 1985), xvi.

8. Basil Johnston, *Indian School Days* (Norman: University of Oklahoma Press, 1989), 29–30.

9. David Wallace Adams, *Education for Extinction: American Indians and the Boarding School Experience, 1875–1928* (Lawrence: University Press of Kansas, 1995), 209–238.

10. John Rogers, *Red World and White: Memories of a Chippewa Boyhood* (Norman: University of Oklahoma Press, 1974), 93.

SEASON OF STRUGGLE

1. Richard M. Nixon, *RN: The Memoirs of Richard Nixon* (New York: Grosset & Dunlap, 1978), 19–20.

2. Roxanne Dunbar Ortiz, *The Great Sioux Nation: Sitting in Judgment on America* (New York: The American Indian Treaty Council Information Center, 1977), 197.

3. Ibid., 38.

4. Paul Chaat Smith and Robert Allen Warrior, *Like a Hurricane: The Indian Movement from Alcatraz to Wounded Knee* (New York: New Press, 1996), 275.

OUR LIVES OVERVIEW

1. N. Scott Momaday, Interview in Sun Valley, Idaho, June 28, 1996. http://www.achievement.org/autodoc/halls/art

2. Tom Hill, "A Question of Survival," in *All Roads Are Good: Native Voices on Life and Culture* (Washington, D.C.: NMAI and Smithsonian Institution Press, 1994), 191.

3. José Barreiro, Interview in *Cornell Chronicle* 30, no. 29 (April 1999).

4. "Places of Power," *American Indian* 3, no. 1 (Winter 2002): 23.

5. "Taos Blue Lake," in Earth Island's Sacred Land Film Project, http://www.sacredland.org/taos_blue_lake.html. See also R. C. Gordon-McCutchan, *The Taos Indians and the Battle for Blue Lake* (Red Crane Books, 1991).

6. From *Our Lives.* An exhibition at the Smithsonian's National Museum of the American Indian, Washington, D.C., opened on September 21, 2004.

7. Ibid.

8. Ibid.

9. Sara Bates, ed., *Indian Humor.* (San Francisco: American Indian Contemporary Arts, 1995).

10. "Charlie Hill Offers a Taste of Indian Humor," *American Indian* 2, no. 2 (Spring 2001): 30.

11. See Daniel Gibson, "The American Indian Science and Engineering Society," *Native Peoples* (November/December 2002).

12. James Schoppert, "Of Clouds and Sacred Cows: A Personal Interpretation of Alaskan Native Cultural Art." Paper presented at Alaska Anthropological Association Annual Meeting. Anchorage. March 13–14, 1987.

13. See Marcus Amerman, "Art Is War," 13th Oscar Howe Memorial Lecture on Contemporary American Indian Art, University of South Dakota, September 26, 2002.

14. Quoted in Daniel Rothbart, "Native Visions in History and Modernity: An Interview with W. Richard West, Founding Director of the Smithsonian National Museum of the American Indian," *NY ARTS* 7, no.12 (December 2002).

POWWOW

1. For this and more on the NMAI powwow, see Tom Dunkel, "Powwow on the Potomac," *Smithsonian* (November 2002), pp. 44–46.

INDEX

CREDITS

POEMS AND EXCERPTS

Excerpt from Robert H. Davis's poem, *Saginaw Bay: I Keep Going Back*, from *Soul Catcher* by Robert H. Davis (Sitka, Alaska: Raven's Bones Press, 1986), reprinted with the permission of the author.

"Carriers of the Dream Wheel" from *The Gourd Dancer* by N. Scott Momaday (New York: Harper & Row, 1976), reprinted with the permission of the author.

Excerpt from *Smoke Signals* by Sherman Alexie. Copyright © 1998 Sherman Alexie. Reprinted by permission of Hyperion.

"Dear John Wayne" Copyright © 1984 by Louise Erdrich, reprinted with the permission of The Wylie Agency, Inc.

NMAI OBJECT PHOTOGRAPHY

Ernest Amoroso: pages 2, 3, 15, 22, 26, 33, 37 right, 38, 39 low, 45, 52, 54 right, 58, 63, 64, 65 low, 78 up and low left, 86, 87, 88, 91, 94 up, 95, 97, 98-99, 100, 102, 103, 106, 107, 108 up, 109, 121, 126, 127, 128, 129, 189, 194-195, 196, 197 up right, 198 low, 199 up, 204, 208, 209, 211 right, 212 right, 213, 214 low, 215, 216, 219, 224, 226, 236, 237 right, 238 left, 244 left, 253 right, 278, 279, 286, 287, 288, 291, 293, 300, 301, 318.
Jason Cullison: page 1.
Pam Dewey: page 254.
Katherine Fogden: pages 50, 53 up left and low right, 104 up, 105, 133 low, 141 right, 165, 172, 176, 202, 240 up, 243, 250, 268-269, 274, 282, 292, 294, 295.
Gina Fuentes Walker: page 42.
Will Greene: page 312.
Carmelo Guadagno: page 41 right.
David Heald: pages 10, 69 low, 119, 203, 205.
Walter Larrimore: pages 8, 30, 34, 35 up, 49, 85, 90, 92, 101, 116, 117, 120, 123, 136, 137 up, 142, 146-147, 149, 174, 182, 185, 190-191, 193, 197 low left, 201, 206, 220 up, 221 low, 261, 265, 266, 277, 280, 283, 284, 285, 290, 299, 302, 303, 305, 311, 317.
Amanda McClean: page 297.
R. A. Whiteside: pages 4, 5, 51, 53 up right and low left, 57, 67, 110-111, 124, 154-155, 210, 211 left, 217 low, 222, 225, 314.

Cynthia Frankenburg, Supervisory Photographer
Shelley Uhlir, Mountmaker

PICTURE CREDITS

Historical images from the Photo Archives of the National Museum of the American Indian are identified where they appear by photograph or negative numbers. Sources for the remaining photographs are given here.

Cover right, Keri Pickett; 6-7, Lee Marmon; 9 left, Gordon Gahan; 12, © Roberto Ysáis and National Museum of the American Indian, Smithsonian Institution; 17, José Luis Stephens; 20-21, Gordon Gahan; 27, courtesy National Anthropological Archives, Smithsonian Institution (NAA) (Neg. 77-2861); 29, Ira Block; 37 left, Raymond Gehman; 38-39 back, NAA (Neg. 41400E); 39 up, Alaska State Library (39-443); 41 left, Jim Richardson; 43, © Canadian Museum of Civilization, photographer Charles Marius Barbeau, 1949 (Neg. # J3107); 61, Kenneth Garrett; 65 up, Stuart Franklin; 69 up left, David Alan Harvey; 69 up right, Gianni Vecchiato; 70, David Alan Harvey; 72, courtesy of the Trustees of the British Museum; 75 left and right, Gwendolen Cates; 77, courtesy of the Trustees of the British Museum; 80, John Harrington; 81, NAA (Photo lot 79-22); 82, photo by Richard Strauss, © 1999 Smithsonian Institution; 88-89 back, Kenneth Garrett; 98 left, Royal British Columbia Museum (PN 241); 108 low, Courtesy of Siglo Veintiuno Editores, Mexico City; 118, courtesy The Newberry Library, Chicago; 131, courtesy Clements Library, University of Michigan; 139, Bettmann/CORBIS; 141 left, courtesy Department of Defense/Marine Corps (#69889-B); 151, courtesy William H. Marr; 152, photo by DeLancey W. Gill, courtesy NAA (Neg. No. 06608200); 157, Museum of New Mexico; 158, Bettmann/CORBIS; 171, Saskatchewan Archives Board; 177, Bettmann/CORBIS; 180 left, Hulton|Archive by Getty Images; 180 right, AP/Wide World Photos; 181, AP/Wide World Photos; 207 up left, Library of Congress (LC-USZ62-11463); 217 up, NAA (INV 00120300); 218, Museum of the Great Plains (Sam DeVenney Coll. 754); 223, McCormick Library of Special Collections, Northwestern University Library; 228-229, R. A. Whiteside; 230, Stephen Trimble; 232-233, photo by Lawrence Cook, courtesy Indian Art Centre, Department of Indian and Northern Affairs Canada; 234, photo by Cascadilla Photo, courtesy Kay WalkingStick, painting #29 from the collection of Tony Abeyta; 235, Raymond Gehman; 237 left, R. A. Whiteside (NU.DVD.03.04); 238 right, courtesy of Odeon Films; 240 low, Richard S. Durrance; 244 right, Jeffrey J. Foxx; 244 back, Todd France; 247, David Neel; 248, hand-tinted silver print © 1997 Hulleah J. Tsinhnahjinnie; 251, Ken Blackbird; 252, courtesy of Wilma Mankiller; 255, courtesy The Newberry Library, Chicago; 257, Raymond Gehman; 258 top, courtesy of the Peruvian Presidential Press Office; 258 low left, R. A. Whiteside; 258 low right, Keri Pickett; 260, Stephen Trimble; 262, Monty Roessel; 264, Monty Roessel; 267, Paul Chesley; 271, Harvey Lloyd/Getty Images; 272 right, Monty Roessel; 274, Katherine Fogden; 275, Victor Cobo; 276, courtesy Buffy Sainte-Marie; 281, photo by Gina Fuentes Walker, courtesy of Atlatl, Inc.; 289, photo by Richard Nicol, courtesy of Joe Feddersen; 298, Rebekah Johnson.

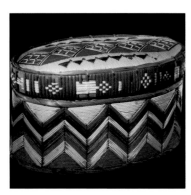

MI'KMAQ QUILLED BIRCHBARK BOX, CA. 1910-20. NOVA SCOTIA, CANADA. PORCUPINE QUILLS, BIRCHBARK, METAL TACKS, FIBERS, HEIGHT 12.7 CM. 18/2180

ACKNOWLEDGMENTS

First of all, we would like to thank the writers who contributed to this volume. A book of the scope of *Native Universe*, however, is the result of the talent and dedication of many people. NMAI Director Rick West was (and is) unswerving in his dedication to the Native voice that this volume exemplifies. All departments of NMAI—Administration, Community Services, Cultural Resources, Exhibitions, Office of External Affairs and Development, and Public Programs—played a role in the book's realization. Nearly every member of the museum's staff assisted in some way in its development, and our grateful acknowledgment goes to each and every one of them. In particular, Terence Winch, Head of Publications, conceived the project and oversaw its development, working closely with Kevin Mulroy, Vice President and Editor-in-Chief of National Geographic Books. Tim Johnson provided significant editorial direction in the early stages of the book. Project editor Elizabeth Kennedy Gische guided the book through the multifaceted editorial process with skill and tenacity. NMAI curatorial staff helped in the selection of objects for the book and provided invaluable scholarly information and review. Collections, Conservation, and Registration staff carefully readied the objects, while a core group of staff that included Fran Biehl, Cynthia Frankenburg, Elizabeth Kennedy Gische, Jessica Johnson, Ellen Simmons, Lou Stancari, and Shelley Uhlir worked over a period of many months to ensure that the objects would be photographed in a manner that would honor their life and spirit. NMAI staff photographers, chiefly Ernest Amoroso, Katherine Fogden, Walter Larrimore, and Roger Whiteside, produced the beautiful color photographs of objects from the collections that grace these pages. Will Greene acted as digital imaging specialist for the book. Thanks also to Sandra Starr for research and fact-checking assistance, and to Leslie Wheelock for managing the permissions process. Ann Kawasaki attended to multitudinous paperwork with competence and good humor. Maria McWilliams unfailingly answered every call for object information. Herman Viola, Curator Emeritus at the Smithsonian's National Museum of Natural History, offered support and advice throughout the project. National Geographic picture editor Sadie Quarrier and National Geographic editorial consultant Walton Rawls added their talents to the book. Bill Marr created a striking and sensitive design for the book, while David Jeffery adeptly edited the captions.

Many other individuals and organizations, both Native and non-Native, contributed their expertise, heart, and spirit to *Native Universe.* All share in the accomplishment, and all have our warmest thanks and deepest appreciation.

Megwitch!

Gerald McMaster (Plains Cree and member of the Siksika Nation)
Clifford E. Trafzer (Wyandot ancestry)

NMAI's entire curatorial and research staff worked with community curators from Native groups throughout the Western Hemisphere on the opening exhibitions for NMAI's new museum in Washington, D.C., that *Native Universe* complements. The following curators and researchers also provided caption material for NMAI objects in the book:

Carmen Arellano, Bruce Bernstein, Cécile R. Ganteaume, Alicia M. González, Emil Her Many Horses, George P. Horse Capture, Emily Kaplan, Mary Jane Lenz, Amber Lincoln, Casey Macpherson, Ramiro Matos, Gerald McMaster, Ann McMullen, Anya Montiel, Arwen L. Nuttall, Emile Osborn, Gabrielle Tayac, Rebecca Trautmann

In addition, Dr. Geert Bastiaan van Doesburg of the Francisco de Burgoa Library, Centro Cultural Santo Domingo, Oaxaca, Mexico, provided caption information for the *lienzo* on p. 30, and Dr. Javier Urcid of Brandeis University provided information for objects on pp. 33 and 100.

NATIVE UNIVERSE
VOICES OF INDIAN AMERICA

Edited by
Gerald McMaster and Clifford E. Trafzer

NATIONAL GEOGRAPHIC

Smithsonian
National Museum of the American Indian

PUBLISHED BY THE NATIONAL GEOGRAPHIC SOCIETY

John M. Fahey, Jr., *President*
and Chief Executive Officer
Gilbert M. Grosvenor, *Chairman of the Board*
Nina D. Hoffman, *Executive Vice President*

PREPARED BY THE BOOK DIVISION

Kevin Mulroy, *Vice President and Editor-in-Chief*
Charles Kogod, *Illustrations Director*
Marianne R. Koszorus, *Design Director*

STAFF FOR THIS BOOK

Walton Rawls, *Project Editor*
Bill Marr, *Art Director*
Sadie Quarrier, *Illustrations Editor*
Sandra Starr, *Researcher and Map Editor*
David Jeffery, *Picture Legends Editor*
R. Gary Colbert, *Production Director*
Richard S. Wain, *Production Project Manager*

MANUFACTURING AND QUALITY CONTROL

Christopher A. Liedel, *Chief Financial Officer*
Phillip L. Schlosser, *Managing Director*
John T. Dunn, *Technical Director*
Vincent P. Ryan, *Manager*
Clifton M. Brown, *Manager*

One of the world's largest nonprofit scientific and educational organizations, the National Geographic Society was founded in 1888 "for the increase and diffusion of geographic knowledge." Fulfilling this mission, the Society educates and inspires millions every day through its magazines, books, television programs, videos, maps and atlases, research grants, the National Geographic Bee, teacher workshops, and innovative classroom materials. The Society is supported through membership dues, charitable gifts, and income from the sale of its educational products. This support is vital to National Geographic's mission to increase global understanding and promote conservation of our planet through exploration, research, and education.

For more information, please call 1-800-NGS LINE (647-5463) or write to the following address: National Geographic Society, 1145 17th Street N.W., Washington, D.C. 20036-4688 U.S.A. Visit the Society's Web site at www.nationalgeographic.com.

Published in conjunction with the opening of the new museum on the National Mall of the Smithsonian's National Museum of the American Indian, Washington, D.C., September 21, 2004.

Head of Publications, NMAI: Terence Winch
Project Editor, NMAI:
Elizabeth Kennedy Gische
Supervisory Photographer, NMAI:
Cynthia Frankenburg
Photo Editor, NMAI: Lou Stancari
Researcher and Map Editor, NMAI:
Sandra Starr

The Smithsonian's National Museum of the American Indian is dedicated to working in collaboration with the indigenous peoples of the Americas to protect and foster Native cultures throughout the Western Hemisphere. The museum's publishing program seeks to augment awareness of Native American beliefs and lifeways, and to educate the public about the history and significance of Native cultures.

For information about the Smithsonian's National Museum of the American Indian, visit the NMAI Website at www.AmericanIndian.si.edu.

Library of Congress Cataloging-in-Publication Data
Native universe: voices of Indian America / edited by Gerald McMaster and Clifford E. Trafzer ;
[by native American tribal leaders, writers, scholars, and storytellers ; with a foreword by W. Richard West, Jr.].
p. cm.
"Smithsonian National Museum of the American Indian."
Includes bibliographical references and index.
ISBN 0-7922-5994-7
1. Indians—History. 2. Indian cosmology. 3. Indians—Material culture. 4. Indians—Social life and customs. 5. America—Antiquities. I. McMaster, Gerald, 1953- II. Trafzer, Clifford E. III. National Museum of the American Indian (U.S.)

E77.N365 2004
970.004'97—dc22

2004040221